ZBrush Character Sculpting V1

Projects, Tips & Techniques from the Masters

ZBrush Character Sculpting

V1

Projects, Tips & Techniques from the Masters

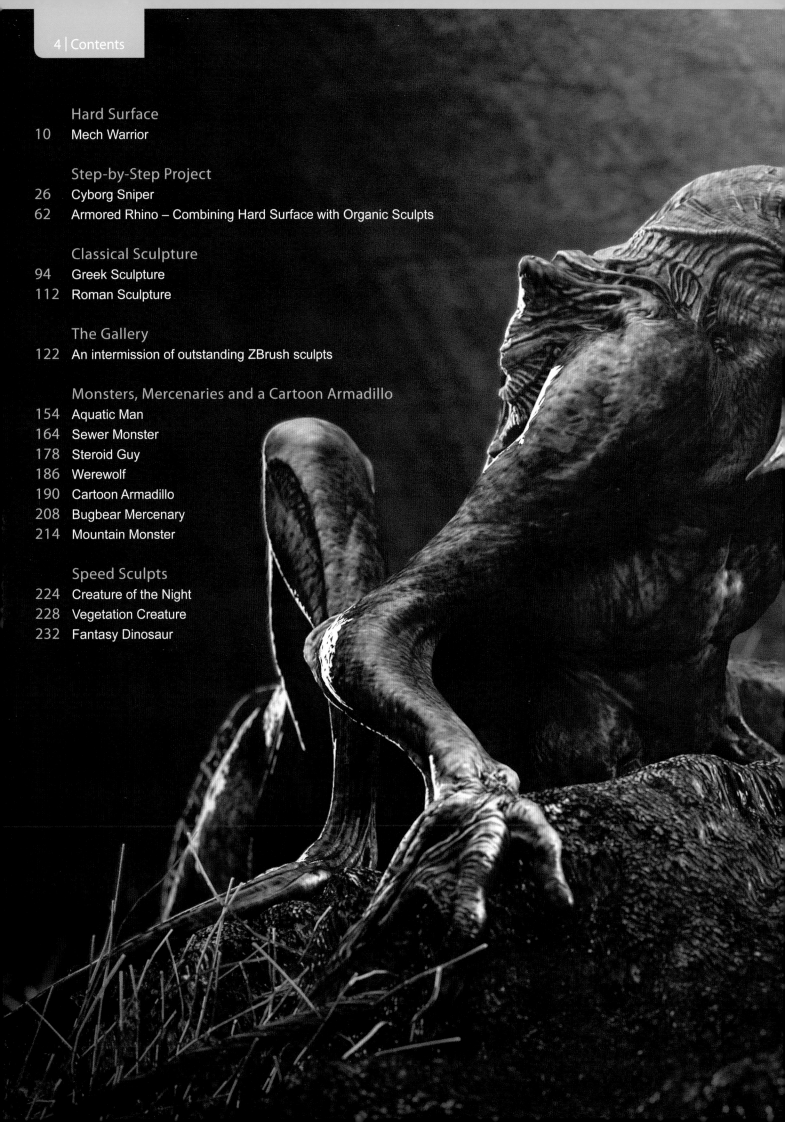

3DTotal Publishing

Correspondence: publishing@3dtotal.com
Website: www.3dtotalpublishing.com

Reprinted and Published in 2012 by 3DTotal Publishing

Softcover ISBN: 978-0-9551530-8-2

Printing & Binding
Everbest Printing (China)
www.everbest.com

Editor: Simon Morse
Sub-editor: Jo Hargreaves
Design and Layout: Christopher Perrins

Visit www.3dtotalpublishing.com for a complete list of available book titles.

ZBrush Character Sculpting V1

Projects, Tips & Techniques from the Masters

Anyone that is involved with or interested in 3D will be more than aware of the many developments and advances that have taken place in the CG industry in the last decade. New techniques have been discovered, new software packages have been developed and anyone who has watched a film featuring CG lately has witnessed the progress that has been made in this field. Of all the advances, one of the most impressive came in 1999 with the launch of the pioneering modeling software, ZBrush.

Since its release, ZBrush has become an integral part of the movie industry. I'm sure that all of you can remember the first time you saw Iron Man, Gollum from *The Lord of the Rings*, Davey Jones from *The Pirates of the Caribbean* and the Na'vi in *Avatar*; well, they all have something in common. They were all created in ZBrush. However, it would be wrong to assume that it is only the movie industry that uses ZBrush; this innovative software has also revolutionized the games industry and had a huge impact on the way that companies create characters for their best-selling titles.

But I'm sure I don't need to tell you all of this. If you have picked up this book then you probably already know what ZBrush is and the amazing things it is capable of. So all I can suggest is that you sit back, flick through the varied chapters *ZBrush Character Sculpting* contains and bask in the stunning quality of the images on display. And make sure that you look a little further as you will discover that this book is not just a gallery

Compiled by the 3DTotal Team

Tom Greenway

Simon Morse

Jo Hargreaves

Chris Perrins

Richard Tilbury

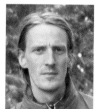

demonstrating what ZBrush is capable of, but will also provide you with all of the knowledge you will need to start creating work of the highest quality yourself.

So what will that next project be? A realistic head? A cartoon animal? Maybe a muscle-bound monster, ready for battle? The choice really is yours and I hope the wealth of inspiration and advice that this book has to offer will help you on that journey. You never know; the next character gracing our cinema or computer screens could be the result of what you have learnt from these pages.

Simon Morse

Editor

Free Resources

Some of our *ZBrush Character Sculpting* tutorial artists have kindly supplied, where appropriate, free resources to accompany their tutorials for you to download to follow along with their teachings. You will find base meshes and also some video footage donated by Rafael Ghencev.

All you need to do to access these free resources is to visit: **www.3dtotalpublishing.com**, go to the "Resources" section, and there you will find information on how to download the files. Simply look out for the "Free Resources" logo that appears on articles within this book where there are files for you to download.

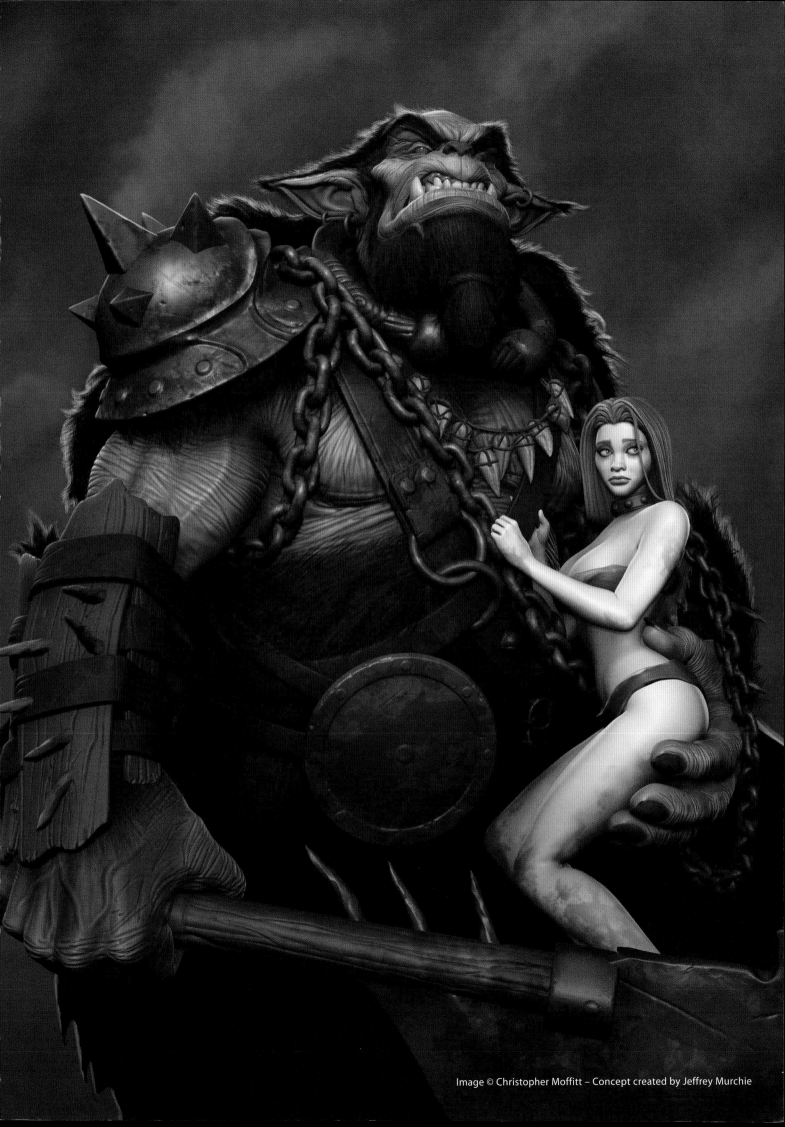

Image © Christopher Moffitt – Concept created by Jeffrey Murchie

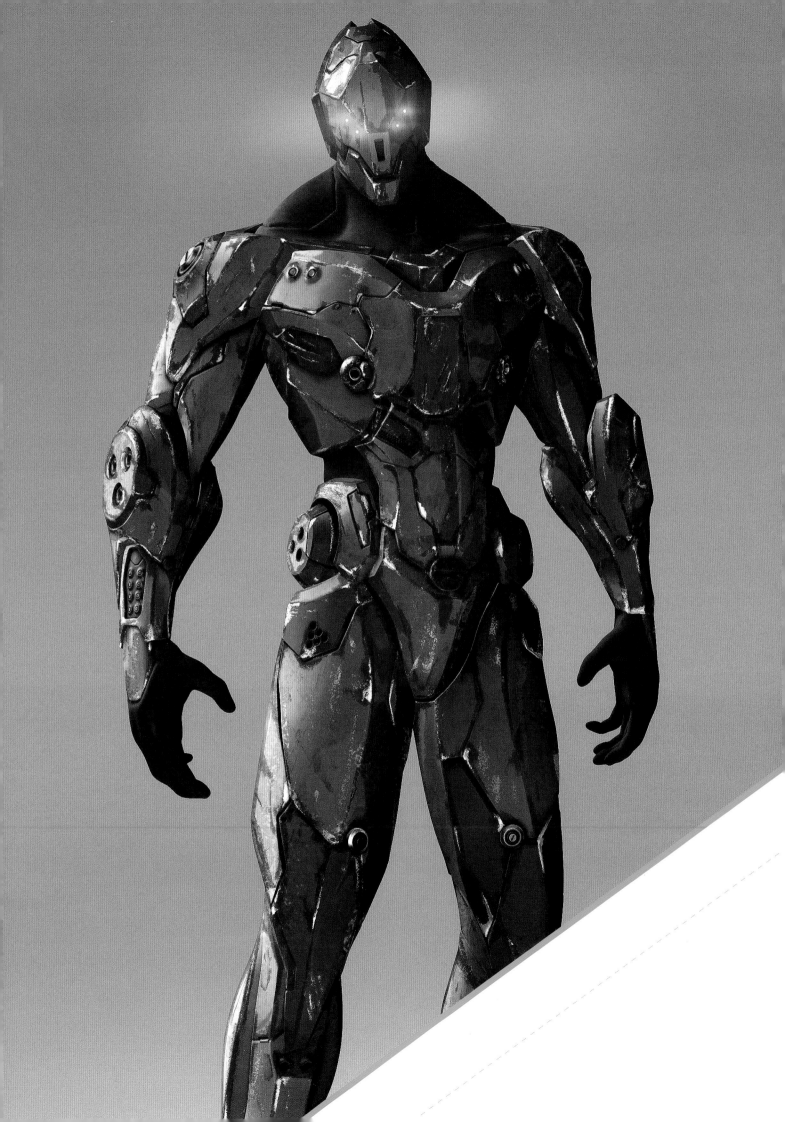

Hard Surface Sculpting

ZBrush is an outstanding piece of software. Its ability to create organic forms has led it to become the premier 3D software for creating CG characters and creatures. However, this description sells the program short as ZBrush cannot be limited to creating organic forms alone. In the first section of this book, the king of the mechs, Mike Jensen, will show us how to use the tools in ZBrush to create a high quality hard surface character. If you are interested in creating armor for your character, futuristic robots or perhaps even cyborgs, you need look no further. From a base mesh to the fully rendered sculpt, Mike covers everything that you will need to know to enable you to start creating your own hard surface characters.

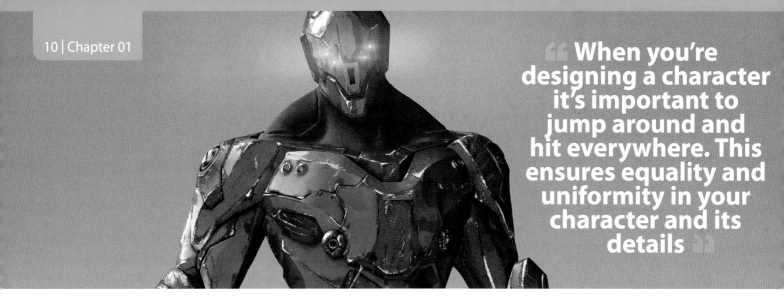

When you're designing a character it's important to jump around and hit everywhere. This ensures equality and uniformity in your character and its details

Mech Warrior By Michael Jensen

Introduction

In this tutorial we're going to be starting from a base primitive (sphere) and through the use of DynaMesh and several other tools, we'll model it into a highly detailed mechanical model (Fig.01).

When the goal of a sculpt is to get it done as fast as possible (for a client, for example) it's best to start with a base mesh that already has many forms established. However, when you have the time and are keen to learn and refine your process, it's best to start from a primitive. This kind of repetition at the lowest level will help sharpen your eyes.

Modeling

To get things started simply click on the Sphere tool in the tool palette, and click Make PolyMesh3D. This allows the mesh to be edited using the sculpting tools.

Once the mesh is editable, go to the geometry subpalette under the tool palette and select DynaMesh (available in ZBrush 4R2). DynaMesh is a tool that allows you to redistribute polygons throughout your mesh whenever you want by pressing Ctrl and dragging (like masking) outside the model in the document. This way, if you ever stretch things too much, you can simply re-DynaMesh the model and the polygon distribution will be even again (Fig.02).

In DynaMesh you'll notice there are a few modifiers that will change the functionality of

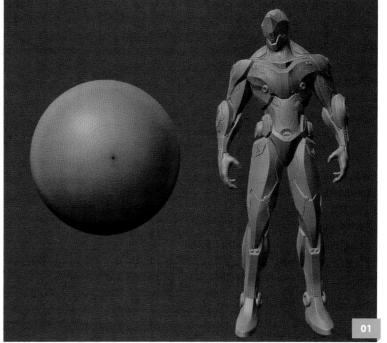

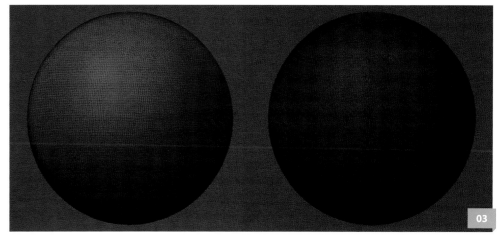

DynaMesh. The first and most important is resolution. Resolution will decide how dense your model is; the lower the resolution the fewer polygons there will be and vice versa. Also important to note is the fact that the size of the object will affect the Resolution slider.

So if you have a large subtool and a small subtool, and you set both resolutions to 128 and activate DynaMesh, their resolutions will not be the same. For this reason it's always good to test the resolution for each subtool until you find something that works well.

Fig.03 shows examples of the effect of changing the resolution on DynaMesh. The left sphere has a resolution of 128 and the right sphere has a resolution of 512. When first starting a character, I recommend using a lower resolution until you have defined the silhouette and proportions. Only increase the resolution when you need to add details.

The Blur slider of DynaMesh controls how much the mesh will blur when DynaMeshing it. Higher numbers will yield a more blurred result, and a number of 0 will not blur the model at all. I personally like to set this number to 0 in an attempt to reduce the number of details lost during a re-DynaMesh.

The Project feature will re-project all details from before a re-DynaMesh. In my opinion it's best to leave this feature off, unless you have some fine details that need to be preserved.

The Group feature will break the mesh into separate groups depending on their polygroups. This feature is best used with the Slice brush to separate meshes. To test this out, simply activate the Slice-Curve brush from the brush palette. To activate the brush hold Ctrl + Shift and draw a curve through the mesh. You'll notice that the polygroups will be split along the curve. Activate Groups in DynaMesh, and re-DynaMesh. The result will give you two separate meshes. This is extremely useful for separating armor pieces from each other (Fig.04).

The Polish feature will sharpen the edges of your mesh when you re-DynaMesh. This feature is extremely useful for creating hard surface edges and clean looks. It's best to experiment with this feature to see the types of results it yields. For this project leave this off (Fig.05).

So we will now get started with the mech. The first thing to do is define the shape of the torso. For this use the Move brush, the Clay brush, and the Dam_Standard brush

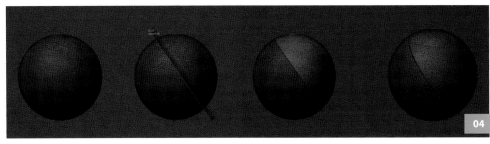

 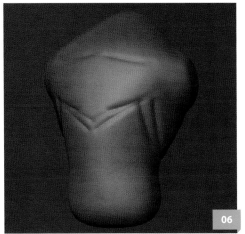 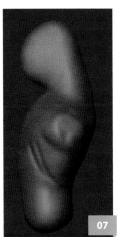

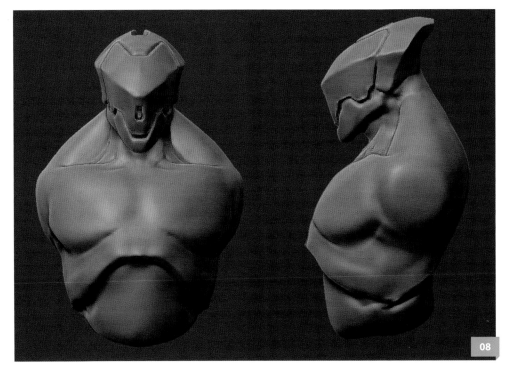

(Fig.06). Notice the sharp cuts into the torso. These cuts are to define certain areas (pectorals, latissimus etc). Whenever you feel like you are lacking some polygonal resolution in a part 6of the mesh due to an edit you've made, it's time to re-DynaMesh! This regularly happens when adding limbs.

Once you have the general torso, pull out the neck and work the shape until it's correct, re-DynaMeshing whenever needed (Fig.07).

When you're designing a character it's important to jump around and hit everywhere. This ensures equality and uniformity in your character and its details.

We will add some type of horns to this character (Fig.08). Make sure not to make it blatant as it's a mechanical character. Shape the front of the helmet to somewhat mimic a skull. Also notice that I am often changing MatCaps. It's important to switch up your

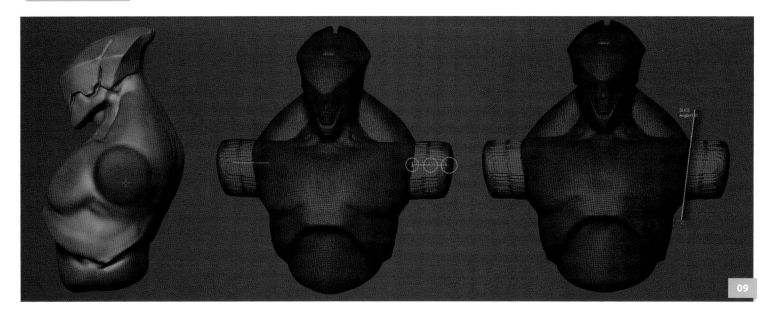

MatCaps to view your model in different lighting situations. This will help you notice different forms you've created.

At this point it's time to add some limbs. To add the arms, simply mask off a portion of the arms and use Transpose to pull that area out. Re-DynaMesh once to get polygons in the pulled out arm area and then used the Slice Curve brush to break off the arms (Fig.09). Turn on groups, re-DynaMesh again to break off the arms and separate them into their own subtool.

After they are in their own subtool, mask off the lower part of the arms and transpose them down to create a starting point for making the upper arms. I'm heavily influenced by human anatomy for the design of the arms. For now there are no mechanical parts; only muscles (Fig.10).

Use the same process to create the legs. The only exception is that they will be connected to the character and not separated out as a new subtool (Fig.11 – 12).

After pulling out the feet and defining the legs a bit, it is time to add the lower arms. Using the same technique of masking and transposing, pull out a piece for the arms and re-DynaMesh. It's important to note that when you are working on overall shapes like these, the most important thing

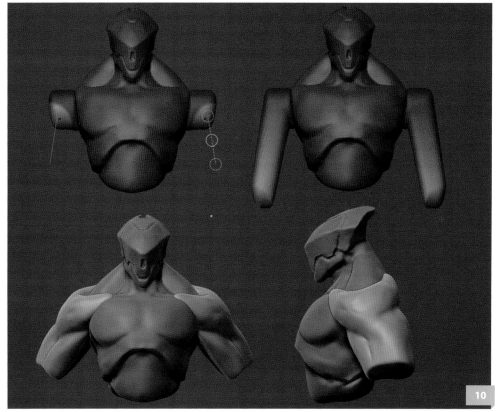

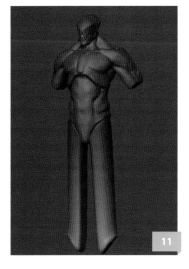

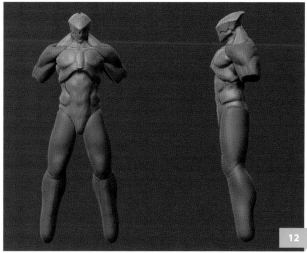

is general shapes and silhouettes. Once these are correct, details will fall into place appropriately. An example of this is the hands. They are not separated out like they should be with fingers. Instead make a fist shape out of a single mass (Fig.13 – 14).

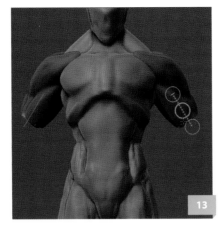

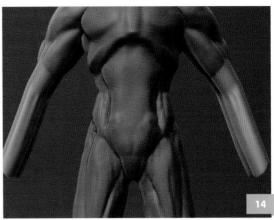

After all the basic shapes are in place, it is time to move onto the design for the armor. For the armor follow the anatomy of a human or whatever creature you're making the armor for (Fig.15).

Fig.16 shows some of the progression of the sculpt, which was achieved using the Clay, H Polish, Trim Dynamic, Dam_Standard, Standard and Flatten brushes. When concepting try to focus on the major armor shapes and how you want to break them up. Once you have all the shapes broken up, use the H Polish brush to clean up each piece to an extent. It's important to note that at this point in the modeling stage, cleanliness is not very important. All of these shapes will eventually be rebuilt in any case, so any extra cleaning at this stage would be overkill.

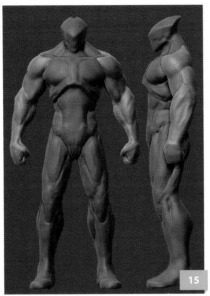

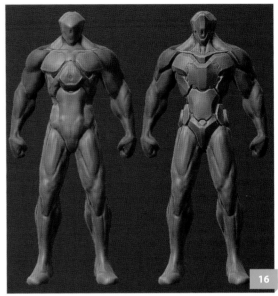

After finishing up the concept for the upper torso and head, move onto the legs. Concepting these is a pretty simple process. The main thing to pay attention to is how they will move. If the leg armor makes it look like the character can be protected and be mobile at the same time, then the design is a success. Break up the leg armor into three pieces: upper, lower and kneepads. Once you have these areas you can break them up further if necessary, but remember that detailing should be saved for later (Fig.17).

The arms can be done in a similar way. Break up the major armor parts based on human anatomy. My exception to this is always the forearm armor. My reasoning for this is if there is some type of visual interaction between the character and the suit, the forearm would be the best way to illustrate this. As such, use this area to add technology to the suit (Fig.18).

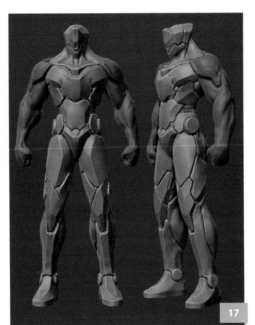

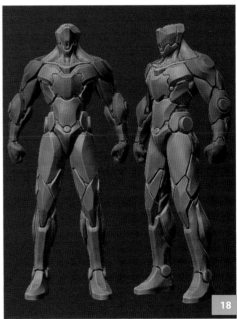

At this point the base armor is pretty much defined. Use this stage as an opportunity to test out detail. When working on detail, it's extremely important not to overdo it. When adding details only put them in choice places and don't distribute them evenly over the model. This will keep the model from looking noisy and direct the viewer's eye around the character to certain points of interest. The best way to add detail is to think about it logically. Where are the vents on your character? Where do bolts need to be to

keep the armor together? Where do there need to be separations in the plating so the armor can be successfully disassembled? These are all things you should be thinking about (Fig.19).

Now that the model is fully designed, it's time to clean the mesh and create a final model. This is done one morsel at a time. For this part we're going to start with the chest.

Start by hiding all parts of the model except for the chest, since this speeds things up a bit and makes it easier to zoom in on the model. Make sure Select Rectangle is selected as your brush and hide (Ctrl + Shift drag) the area that you are not working on (Fig.20).

Now it is time to create new topology on top of the concept we have. All topology work in ZBrush is done using the ZSphere tool. Use the slider in the tool palette and locate the ZSphere.

With the ZSphere selected as the current tool, go to the rigging subpalette of the tool palette, and choose Select Mesh (Fig.21). This will open up a pop-up box where you can choose the mesh you want to draw your new topology on. Select the concept mesh you have, with the un-needed parts hidden. Once you do this you'll see your mesh ghosted on top of the ZSphere (Fig.22).

To create the new topology, go to the topology subpalette in the tool palette, and click Edit Topology. If you're working on an area that needs symmetry, it's important to turn it on at this point before any topology is created. To create topology make sure the Draw tool is selected and simply click on the area you want to make a polygon. Each point you click will act as a vertex for a polygon. If you want to move any of the vertices, simply change from the Draw tool to the Move tool, and move the vertex around to the desired location. To delete a vertex Alt + click on an existing vertex with the Draw tool selected.

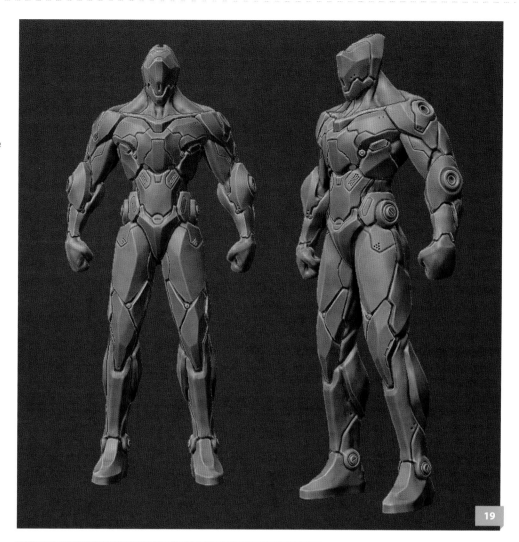

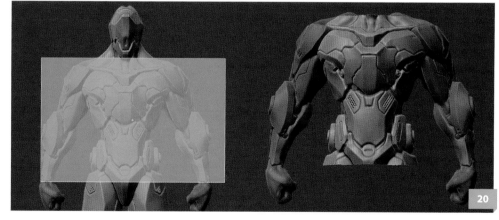

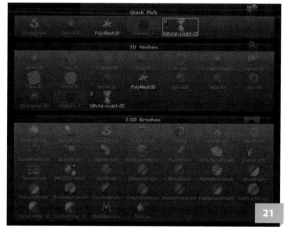

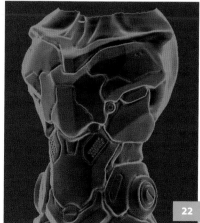

Hitting the A key will allow you to preview your topology, however when you do this you'll notice that the geometry is subdivided once (Fig.23).

We don't want any subdivisions in the resulting mesh, so we have to turn this off. To turn off subdivisions, simply go to the adaptive skin subpalette in the tool palette and change Density to 1. Preview the mesh again using A and there will be no subdivisions.

Another thing to note is that in all of the resulting meshes, we want thickness. In order to add thickness, change the Skin Thickness slider in the topology subpalette. For this project a value of +/- 0.1 works well. The reason I say +/- is because the direction of the extrusion will change depending on the topology of the mesh. We want all the extrusions to be inward facing, so this number must be tweaked until the mesh is extruded toward the inside of the body (Fig.24).

Once the topology for the chest piece has been finished and the thickness is appropriate, go to the adaptive skin subpalette and click Make Adaptive Skin. This will make a new tool for you to append to your current model (Fig.25 – 26).

Note: There is a lot to be said about topology and edge flow. Usually edge flow is extremely important for animation and good subdivision. In the case of making this topology however, edge flow and using triangles is fine. The reasoning for this is that these meshes are all going to be turned into a DynaMesh, so the topology you make will become irrelevant. As long as the topology accurately represents the surface you're trying to mimic, the result will be a good one. That being said, however, using good topology and edge flow will not harm your results.

After the chest piece is created, the next step is to control the edge hardness when

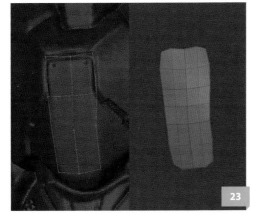

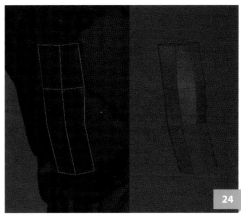

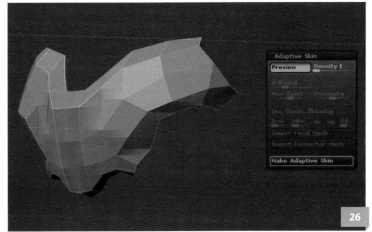

subdividing. In ZBrush this is done using the Crease tool in the geometry subpalette of the tool palette. The first step is to set CTolerance to something around 100. This will make sure only the areas you define will be creased (Fig.27).

The way you define creased areas is by hiding polygons along the edge you want the crease to appear on. Once you hit the crease button, you'll notice that if you turn on PolyFrame (Shift + F) there will be a double dotted edge around the newly creased area.

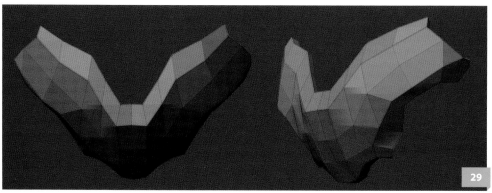

You'll also notice that the extruded area has a crease around its entirety. This is to your advantage, as we want these areas to be creased (Fig.28).

In Fig.29 you can see all the correct edges creased.

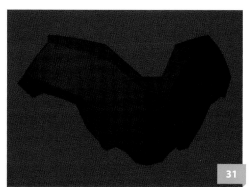

When the mesh is subdivided, notice the nice sharp edges we get in the correct areas. This is the perfect foundation to work with. There are a few imperfections on some edges, such as the pinching occurring in the lower outer parts of the chest. This type of artifact can be easily fixed using the H Polish brush (Fig.30). If the subdivided mesh has the correct and desired shape, then it's the perfect time to enter DynaMesh (Fig.31).

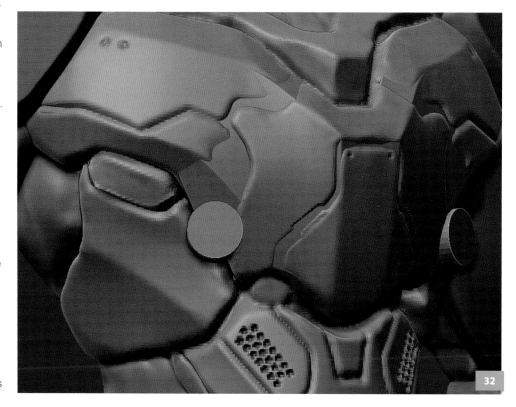

After the DynaMesh is created, it is time to refine the shape. A circular area needs to be cut away, so select the Insert Cylinder brush and while holding Alt draw a cylinder over the section you want to cut away (Fig.32).

Then it is time to use the Slice Curve brush to break apart the chest into the minor chest pieces. In my experience it is best to use no more than one angle in each slice curve. This will ensure that when you break up the mesh using Groups in DynaMesh, the edges will be intact. Repeat the slice curve a few times until you have the shape you want. Using the Mirror and Weld tools in the geometry subpalette, mirror the changes to the other side of the mesh (Fig.33 – 34).

Select a duplicate mesh of the original and use the Slice Curve tool to create the other

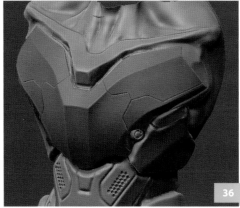

side of the chest and to break it up further. You can then use this technique repeatedly until you are happy. Once everything is correct and in place use the Clay Brush to depress the concept part of the chest, so the clean area can be seen with the other parts of the concept mesh. This helps to get a better idea of how things are looking overall (Fig.35 – 36).

Then move onto the area above the serratus anterior. In my case the topology here was extremely simple and quick to create. Using the same process as mentioned earlier crease the desired edges, subdivide them and apply DynaMesh to finish them off (Fig.37 – 38).

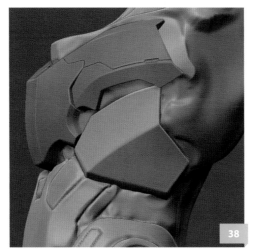

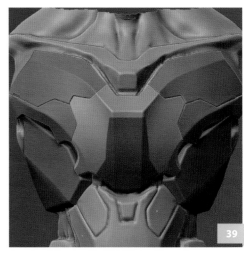

Next, we're going to create a little plate covering for the center chest piece. To do this mask off the area you want to create the plate on and transpose it inwards. Once you have the correct depth smooth out the edges (Fig.39 – 40).

Using the same topological process as before, start and create the outer plate piece (Fig.41).

Fig.42 – 43 show some images of the belly. Notice how the topology is denser at the bottom, where it is required to hold form. In the upper area the geometry is sparse. After you have the correct shape crease it, subdivide it and DynaMesh.

For the hip circle it is best to start with a cylinder primitive. Append a cylinder and

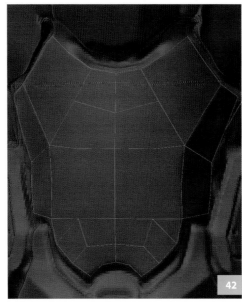

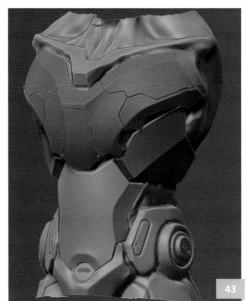

mask off a large amount of it. Once the mask is correct, use Transpose to pull out the top area (Fig.44).

Once you have the correct height for the extrusion, use the Transpose Scale tool to bevel the top inward, creating a nice angle to work with (Fig.45).

When you have done this move on to the leg topology. Tackle this area in the same way as you did the torso. Note the triangles used, since using pure quads is unimportant (Fig.46 – 47).

Then move onto the arms. On the shoulder make two separate meshes for the armor, remembering that the middle piece is a circular shape. This would be hard to separate if you made everything in one piece initially and then tried to break it up after (Fig.48).

Finish off the head topology in a similar fashion, breaking it up into the major shapes (Fig.49).

At this point all the topology is done and all the clean meshes created. This means it is time to add details around the mesh. For this character I followed the details I outlined in the concept art. Many of the details were made using brushes I made a long time ago. Stamp brushes are an easy way to add good looking, clean details (Fig.50 – 51).

To make the nose area, mask off a rectangular area and use Transpose to move

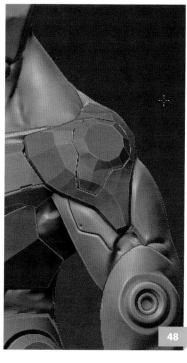

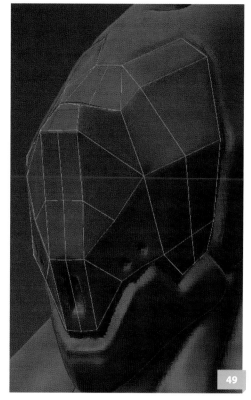

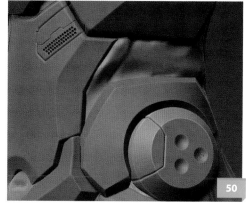

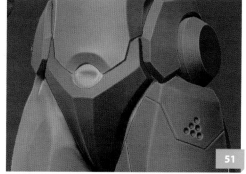

the mesh inward. After you have done that, use the Smooth brush to clean the edges up (Fig.52).

To create the arm details use stamps as you did earlier. To add detailed cut lines to the major pieces use the Dam_Standard brush. This will allow you to give the illusion of breaks in the armor, and will also save time by not having to break up the actual geometry (Fig.53).

To space the forearm stamps use Curve mode. In the stroke palette enable Curve mode and set the Max Points to 4. This tells the brush to only use four stamps in total. Then you draw the curve line on top of the mesh and click anywhere on the line to apply the stamps. You can click the end points of the curve to move the points around and adjust their location (Fig.54).

Fig.55 shows an image of the final model with all the details included. As you can see the details are fairly spaced apart and no part of the mesh looks too noisy with detail. Moderation is the key.

Now that the model is complete it is time to choose a pose. In my case I'm not going to go for a crazy action pose, but just something simple to break up the symmetry of the model. This allows the model to feel much more natural. Using the Transpose Master, create an asymmetric pose (Fig.56).

At this point everything is ready for a render. ZBrush has a set of very powerful tools to create render passes for a final composite. The first thing to do is find an appropriate HDR image to light the scene. To load an HDR image into ZBrush go to the background subpalette (in the light palette) and click Texture. A pop-up will appear and in the bottom left, click Import. All you have to do then is locate your HDR image (Fig.57).

It's important to adjust the Gamma and Exposure (in the background subpalette)

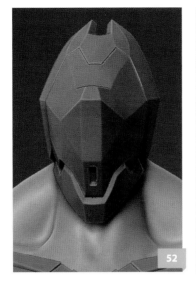
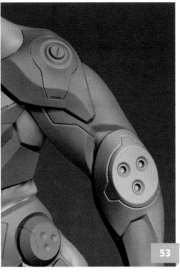
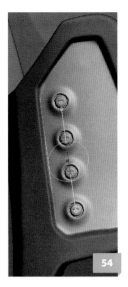

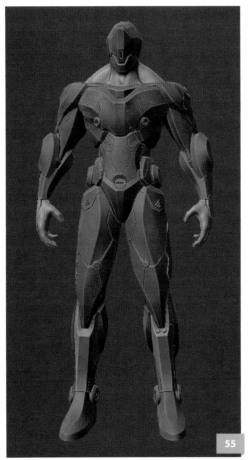
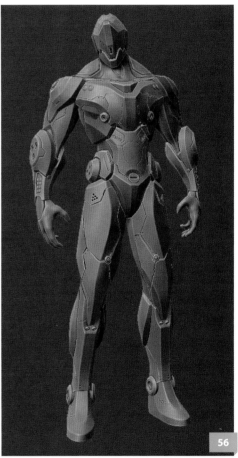

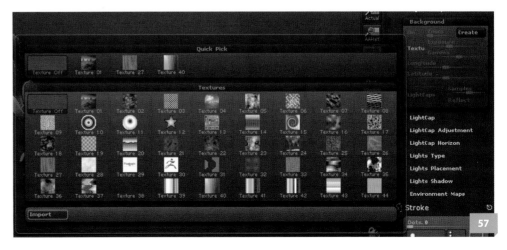

to get a desirable result. This is the most important thing to make the lighting look natural. In Fig.58 are the Gamma and Exposure settings I used for my renders.

Next you need to make several render passes for your composite. I like to use the skin shade material as my base material for editing.

Once you have everything loaded click the LightCaps button in the background subpalette. This feature evaluates the HDR image you currently have loaded and will creating a lighting setup based upon it. This is an extremely quick and easy way to get a great lighting setup.

When I create mech renders I have certain passes that I always create. The first is the base paint layer. This is the paint that would be on the mech if it was newly manufactured. Usually something similar to car paint is good to use. Fig.58 shows a resulting pass using my settings.

The next pass I'll create is one for minor scuffs for the main paint layer. With minor scuffs there is less reflection and a minor color variation. In the case of my image I chose to go with a darker blue color with less reflection in the material. In Fig.59 you can see the settings and results for this pass.

It's also a good idea to make mechanical characters dual-toned. This allows you to further separate and pop shapes using color variation. This means that we need a new car paint render of a different color, as well as a minor scuff render with the same color (but with a slightly darker variation). For this character I decided to go with an extremely dark gray that was almost black. It's important when rendering that you never use absolute colors. Absolute white and absolute black do not occur in nature, so it's always good to use subtle variations that are never quite perfect. Fig.60 shows my settings and the results of my second tone.

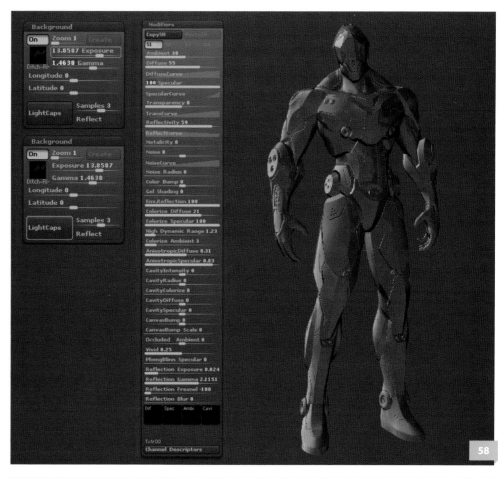

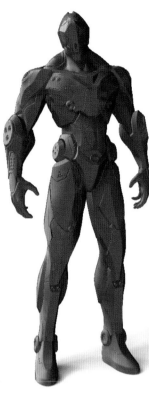

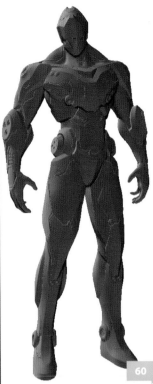 60
 61

The next thing we need is a render for the rubber areas of the mech. These areas would be used in the joints, such as the elbow area and the neck. For this material you want a dark color (almost black) that has very low reflectiveness as well as low glossiness. Fig.61 shows my settings and the results of this new pass.

We also need a render pass for the deep scratches on the metal plating. The deep scratches are essentially the metal that is under the paint layer. As such it'll usually be a highly reflective material with a gray color. Fig.62 shows my settings and the resulting pass.

An Ambient Occlusion pass is always important. This allows you to pick out the details (such as cuts or plates close to each other) by marking the areas that light can't reach. The result is a black and white pass that will be used in Multiply layer mode to pop out the crisp shadows all over the character. In ZBrush the way I create Ambient Occlusion passes is with the masking function. In the masking subpalette of the tool palette there is a function called Mask Ambient Occlusion. Clicking this will mask

 62

all the areas that would be light occluded. To make this mask useful simply invert the mask and fill the inverted mask with RGB black. Once this is done for each subtool, you can apply the flat color shader, change

the background to black and then render. The result is a pass that will accentuate the shadows for the final render. Fig.63 shows my settings for this and the Ambient Occlusion pass itself.

It's also important to note that if your computer cannot calculate the Ambient Occlusion map in a timely fashion, it may be necessary to decimate the mesh using the Decimation Master to reduce the polygon count and the calculations. For this pass I also separated the subtools for the major limbs (torso, arms, legs and head etc.). This allowed my computer to handle the Ambient Occlusion calculations in a reasonable time frame.

You will also need a simple masking pass. This can be done by creating a black background, and choosing the flat color shader and setting it to white.

Finally it's on to the compositing. To start it's important to break up all the areas by their material. I started by breaking up the blue paint and then black paint. I then defined the neck and other rubber areas, and added in the metal parts. This was all done using masks in Photoshop to keep the process non-destructive (Fig.64).

Once you have everything laid out by material, it is time to start adding in shallow scratches. To do this, add the shallow scratch layers you created earlier and mask them off completely. Then paint in areas of the mask to reveal scratched parts. In my case I did this using a Grunge brush. When painting scratches ask yourself, where would this object get scratched? The answer is usually on the corners of objects where they protrude the most. Since these areas stick out the most, it's most likely that they will come into contact with other surfaces and will therefore be scratched (Fig.65).

Using the same technique, paint in the deep scratches. Usually there are less deep scratches since it's harder to produce a deep scratch in real life than a shallow one. Deep scratches require more contact with surfaces, so the points that stick out the most on the mesh should be scratched deeply. I used the same Grunge brush for this (Fig.66).

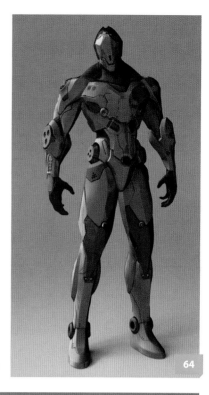

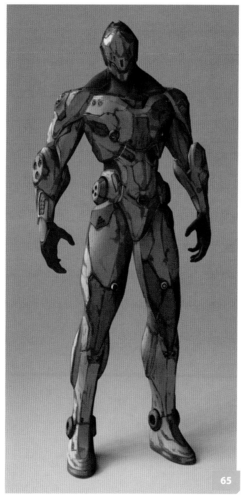

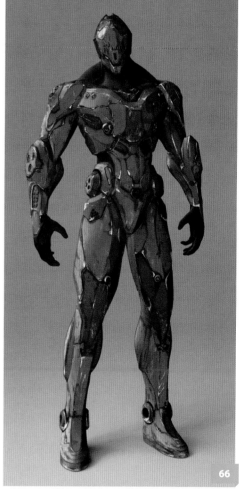

After you have done this add a dirt layer. My logic for this is that the character probably gets a lot of action and not always in pristine environments. The dirt layer helps to show this and also unifies all the pieces.

Finally it's time to call it a day on this character but before I sign it off I'm going to paint in some cool eye-glows and use adjustment layers to tweak the overall colors and light values (Fig.67).

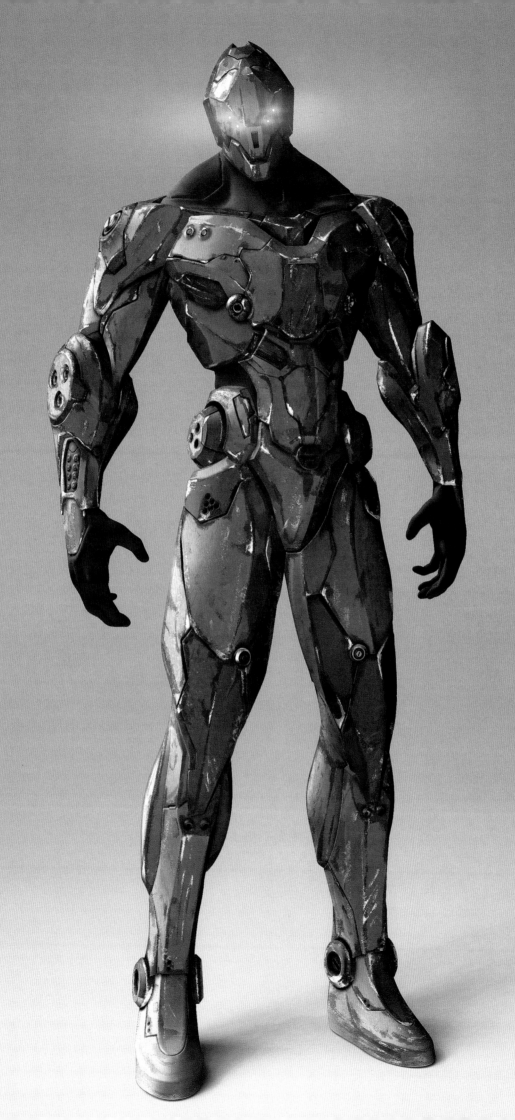

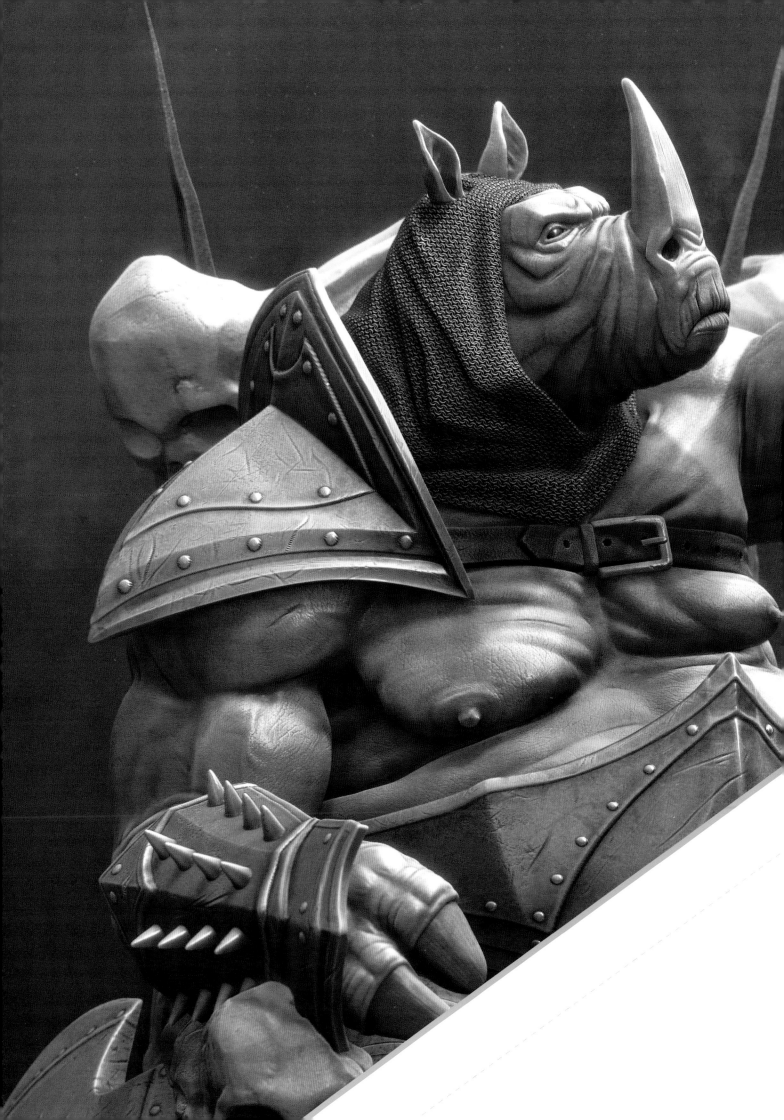

Step-by-Step Projects

It is sometimes liberating to improvise and create a sculpt in an intuitive fashion, however, at other times guidelines are a much needed prerequisite. In this section we will be in the more than capable hands of Cédric Seaut and José Alves da Silva, who will talk us through the creation of their very different images. The artists will not only cover the principal techniques behind their creative process, but will also walk us through every step they took to complete their work. This section provides you with all the information you need to either follow their steps and create a similar image, or take inspiration from their workflows and create images based on your own designs.

> *It's good to make a handful of basic elements that you can use on some of your creatures or characters. They can prove very helpful when it comes to developing a 3D concept quickly*

Cyborg Sniper By Cedric Seaut

The Concept

There are several ways to come up with a concept – the most obvious one being to draw a quick shape in 2D to define the main volumes – but you can also start from a very simple base mesh and play with volumes in ZBrush. The first advantage of this technique is that you can make one base mesh that you can then reuse for many other concepts and the second is that you will have a solid 3D base to then work from to polish the character.

Simple Base Mesh Creation

For this character I used an old base mesh that I changed slightly for this tutorial (Fig.01). You could either make your own or download one from the internet.

Basic Sculpting

The next step is to start to think about how to come up with more interesting shapes and volumes in ZBrush. First of all, import your base mesh into ZBrush. There are two different ways to do this: you can either use the import option when launching ZBrush, or you can press Escape and then, under the Tool tab, click Import.

Here is a preview of what you will see on your ZBrush canvas when you import your base mesh (Fig.02).

When you sculpt, it's important to keep 3D world camera constraints in order to be sure that you have the right proportions if you

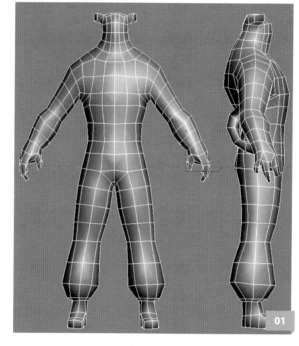

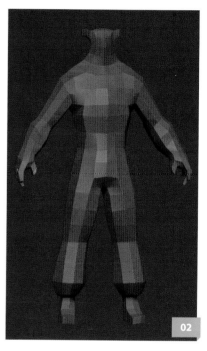

decide to then import your final model into another 3D package, like 3ds Max, to make some renders. You have two options: you can go to the Draw tab and press Persp, or just press the P hotkey.

On the left of the screen you should see a red ball which represents the Material Editor in ZBrush. Feel free to try some of them out to get a better idea of how it works. I usually use a very simple one, close to a standard blinn material in 3ds Max (Fig.03).

In ZBrush you are able to preview some real-time shadows, like screen space Ambient Occlusion. This can be pretty useful when it's time to make some renders, but for the brute sculpting it's nice to disable this option. It will be easier to sculpt some of the difficult areas, like under the shoulders. To disable shadows go to the Render tab and, under Preview Shadows, slide the ObjShadow value to 0.

Here is how our base mesh should currently look on the ZBrush canvas (Fig.04).

In the Tool tab, under Geometry, press Divide twice to add more subdivision to your model (Fig.05).

We can activate the symmetry now to save some time, so go to the Transform tab, press Activate Symmetry and choose the axis you wish to use for the symmetry. You can just choose X (Fig.06).

We are now going to create some selection sets, thanks to ZBrush's Transpose function. This allows us to sculpt some of the difficult areas. First, press the Move button, as shown in Fig.07, or simply press the W hotkey.

Press Ctrl and drag the orange edge from the middle of the shoulder to the beginning of the arm, as shown in Fig.08, with your graphics tablet (or mouse). When you have something close to what is shown in Fig.11, release your graphics tablet first and then let go of the Ctrl key. The body should now be masked.

In the Tool tab, open the Masking drop down menu and press HidePt. This will hide the part of the mesh you haven't masked. You now have the full body available on the canvas only (Fig.09).

Go back to subdivision level 0 now.

Press the Frame button on the right tab. This will display the wire of your object.

Open the Polygroups drop down menu and select Group Visible; this option will tint the visible selection with a basic color (Fig.10). Notice that the color will only be visible if the Frame button is enabled.

Inverse the visible object part. To do this keep pressing Ctrl + Shift and drag a green square selection onto the canvas. Release Shift (the square should then become red), release the graphics tablet and finally release Ctrl. You can now see the arms instead of the body (Fig.11).

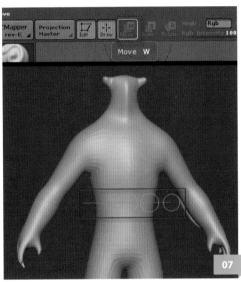
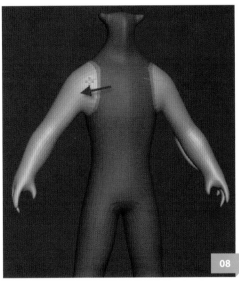

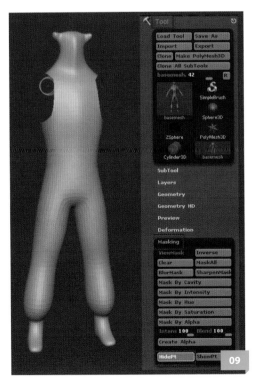
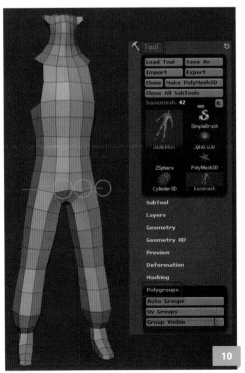

Do the same as before now: select Group Visible once again – a different color is applied to the arms (Fig.12).

You can now display the full character by pressing Ctrl + Shift and clicking on the canvas (not on the object) (Fig.13).

We are now going to select the last part of the character. Check that you are still in Move (W) mode. Uncheck the Frame button to hide the colors.

In the exact same way as before create a mask, this time including the body and arms, but not any extra element you may have created. In my case I excluded the arm element that I added (Fig.14).

Press HidePt to hide the extra element on the arms (Fig.15).

Go back to subdivision level 0, in the polygonal display.

Enable the Frame button again to see the selection sets. Now we're going to hide the remaining polygons that don't belong to the arms. Select the Lasso mode, just under the Frame button. Keep pressing Ctrl + Shift and drag a green circle around the extra polygon. Then release Shift (the circle becomes red), release your graphics tablet and release Ctrl. The polygons will disappear (Fig.16).

Do the same for the other protruding element that we want to hide (Fig.17).

You'll need to do the ones on the left arm too. Unfortunately you can't use the symmetry function for this, which is why we must do both sides one at a time (Fig.18).

Now invert the selection, as explained before, to display only the extra arm element's polygons.

Create the last selection set by pressing Group Visible once again.

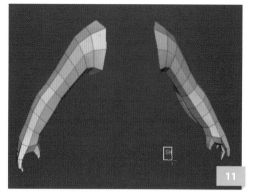

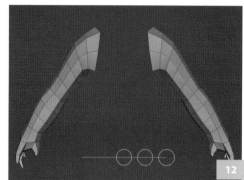

Unhide everything by pressing Ctrl + Shift and clicking in the canvas. You can now see three different colors and therefore your three different selection sets. Now, to isolate one of the selection sets, you just have to press Ctrl + Shift and click on one of the colored parts. This will hide the ones you haven't clicked on. Simply Ctrl + Shift and click on the canvas (not on the character) to display the entire mesh (Fig.19).

With the selection sets now done, it's time to start sculpting to come up with a better shape for our character concept. On the left of the screen, click on the Standard brush button. A pop-up will appear – select the Move brush. Before sculpting, we are going to move some vertices – like we can do in 3ds Max – with the soft selection.

To have a better preview of your shape, disable Frame to remove the colors (Fig.20).

Select Draw mode when you are ready to sculpt; you can then change the size and the intensity of the brush by sliding the value on the right. Notice that you can also display these options by right-clicking on the canvas; it's pretty useful when you want to limit pen tablet movements (Fig.21).

With the Move brush selected, move some areas to get a stronger shape (Fig.22).

Don't forget to use the selection sets to move vertices easily without moving unwanted parts, for example under the shoulder (Fig.23).

With the main shape defined, we are going to push the volumes a little more to add some definition. Keep in mind that it's up to you to decide the number of subdivisions; when you have been doing it for a while you will become comfortable with it. Try to keep the Active Points number under a million polygons; we are working roughly for now. For this example, divide your model six times (Fig.24).

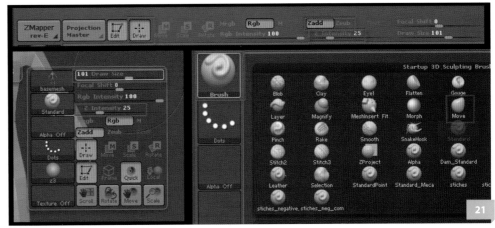

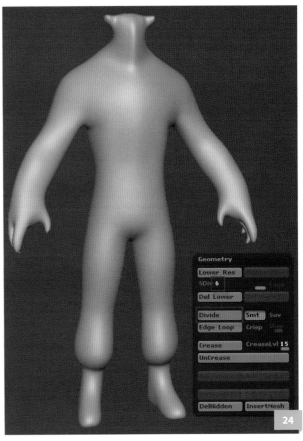

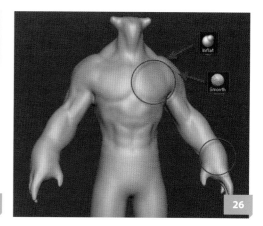

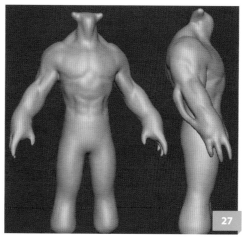

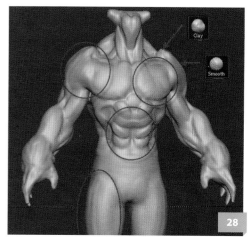

The following brushes will be the ones we use during the concept sculpting process. The Inflat brush is used to push the volumes, the Clay brush is used to define the strong volumes and the Smooth brush to soften them (Fig.25).

With your first attempt, try pushing the volumes to get your first ideas down using the Inflat and Smooth brushes. Take your time to experiment and feel the volumes; it's still very easy to go back (Fig.26).

Here is a preview from several angles (Fig.27).

Once again, don't forget to use your selection sets to simplify your sculpting process.

After doing this you can start to push the extreme volumes using the Clay and Smooth brushes. Keep in mind that you're not thinking about the final sculpt yet – this is just a rough one, so push out your main volumes for now. The polishing will be done later; just be satisfied with the silhouette for now (Fig.28).

Once again, here are previews of several angles (Fig.29).

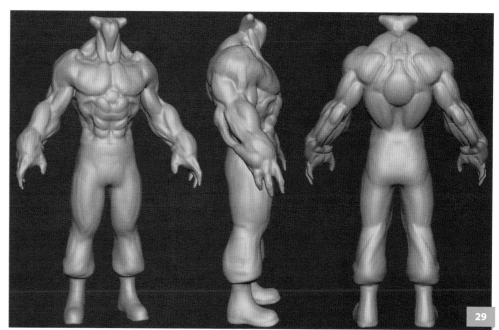

Once this is done you can use several brushes to add more definition. You will notice a brush in this set by Damien Canderle (Dam_Standard), which is a free brush available to download at the end of this tutorial (Fig.30). This is an amazing brush for exaggerating cavities!

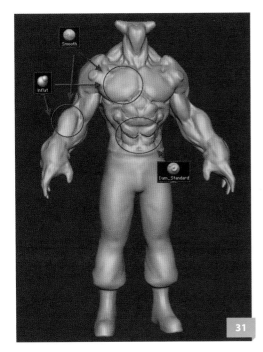
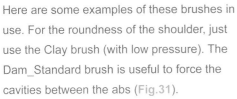

31

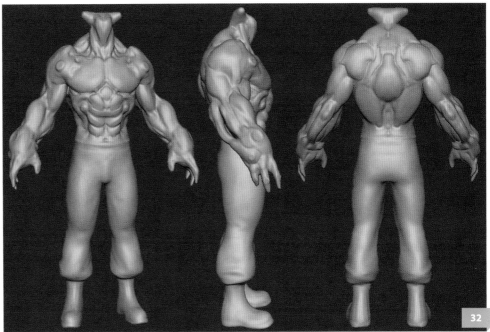

32

Here are some examples of these brushes in use. For the roundness of the shoulder, just use the Clay brush (with low pressure). The Dam_Standard brush is useful to force the cavities between the abs (Fig.31).

Again, here are some different angles that show the concept. We just need a solid base to be able to create and put accessories on for now (Fig.32). Feel free to play with volumes to try different things. Nothing is static in ZBrush; you have unlimited possibilities from only one simple base mesh!

Presentation of Accessories and Final Concept

Here are some accessories that I had in my personal library (Fig.33). Sometimes, when you have some free time, it's good to make a handful of basic elements that you can use on some of your creatures or characters. They can prove very helpful when it comes to developing a 3D concept quickly.

For the accessories that I didn't have in my library, I created a rough prototype from a picture. I will explain the technique used for this process later (Fig.34).

Here is the concept after placing in some rough objects. Please don't hesitate to place some simple boxes into your concept – it's

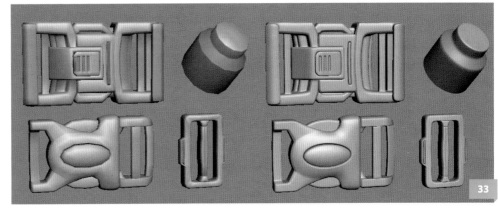

33

34

just the silhouette that is important at this stage. The preview in Fig.35 has been done in 3ds Max 2010, with real-time shadows in the viewport; it's a very nice function to properly pre-visualize objects and volumes!

Creating a Shoe

In this section you will see the step-by-step process used to create a shoe.

There are some preliminary parameters to check before starting anything. Enable Local. This function will allow you to rotate around the last area you sculpted, which is very useful if you want to focus on a particular area. Enable Lasso to activate the lasso selection mode and then change the subdivision value to the lowest level (Fig.36).

With Ctrl + Shift pressed make a selection around the right foot, as shown in Fig.37, to isolate what will become our shoe.

We are going to keep this part only to make it easier to work on. So go back to the highest level of subdivision and delete the subdivision history by pressing Del Lower. Now delete the hidden mesh and finally reconstruct your foot in order to save memory while working (Fig.38). Now go back to the highest level (Fig.39).

Divide the model once more. It's important because we are going to use the Polypaint function, which needs vertices to be able to apply color.

In the top menu select Draw mode and disable Zadd or Zsub as we just need the color painting function. In the Tool menu, on the right under Texture, press Colorize. This will switch on Polypaint (Fig.40).

We are going to draw the topology on the mesh, so right-click and a pop-up appears. Change the draw size to something thin enough to draw lines. At the bottom left of the color box, slide the white square to select a pure color – purple in this example (Fig.41).

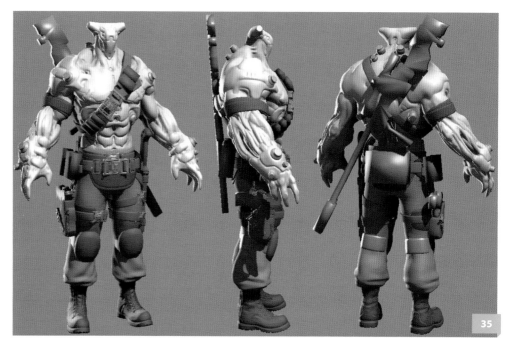

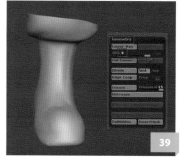

Draw a clean wireframe on the mesh (**Fig.42**)

Here is a screenshot of the result. You'll see more lines at the bottom that will allow us to put more detail on the sole (**Fig.43**).

We are now going to create the new topology. Don't forget to remove the shadows and to choose the most convenient MatCap for your purposes (**Fig.44**).

Create a ZSphere on the canvas by clicking on the ZSphere button, which can be found under the Tool tab.

Still in Tool mode, scroll down the menu until you see Rigging, open it, press Select Mesh and a pop-up appears. Select the shoe with the painted wire. Now open the Topology menu and press Edit Topology. The shoe now takes the place of the ZSphere in the canvas (**Fig.45**).

Before starting anything be sure to enable Local as it is much easier to work with this option on (**Fig.46**).

Let's create the wire on top of the painted one. With Ctrl pressed, click on the mesh. This will mask your object and make it darker. It can be useful to improve the wire display. Left-click anywhere on the mesh to start the new topology.

Some pointers about creating topology:

- If you want to create a line between two vertices, select the first one with Ctrl pressed. The node will be considered the primary one and then click on the second one.
- To remove a vertex, press Alt and select one. This will remove all connected lines.
- To create a new vertex on an existing line, just left-click on it (**Fig.47**).

A very useful function is the ability to see a preview of the result by just pressing the A hotkey (**Fig.48**).

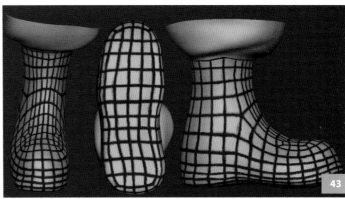

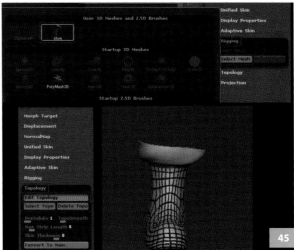

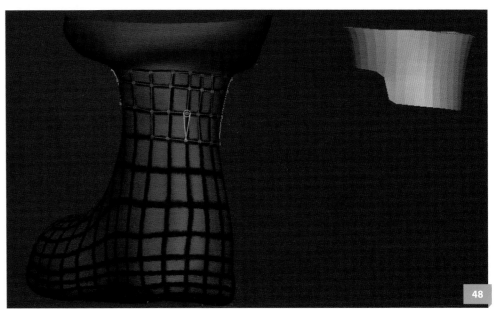

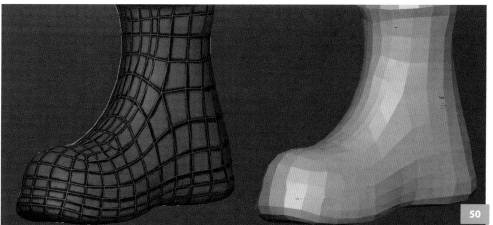

As you can see, the preview doesn't look like the created topology – it looks subdivided. In Tool, scroll down to Adaptive Skin and change Density to 1. The preview will now look right (Fig.49).

Fig.50 shows the final topology. Polypainting it first helps us to avoid mistakes and to create it more quickly and cleanly.

From this new wire we are going to create and extract the corresponding mesh. Under Adaptive Skin be sure to set the density to 1 and press Make Adaptive Skin. This will create a new tool from your mesh.

Go back to your original tool with the polypainted wire.

With the Subtool menu open click on Append and in the pop-up select the mesh you've just created. You have to do this to avoid the rescaling ZBrush bug. If you export the new mesh from its tool, the scale will be different (Fig.51).

Select the Subtool with your new mesh and export it (Fig.52).

At this stage you can import it into 3ds Max or any other 3D package to change it a little bit and tidy up the model. It would be a good idea to make the model symmetrical at this point (Fig.53).

Go back to ZBrush and import the newly created base mesh (Fig.54).

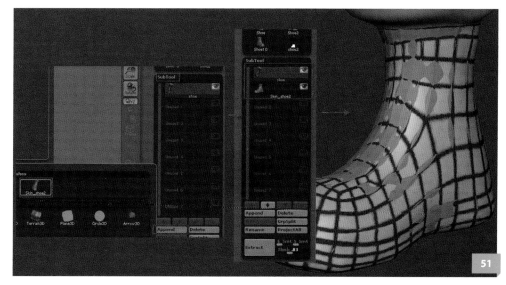

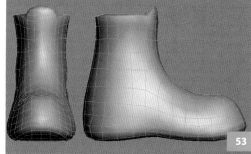

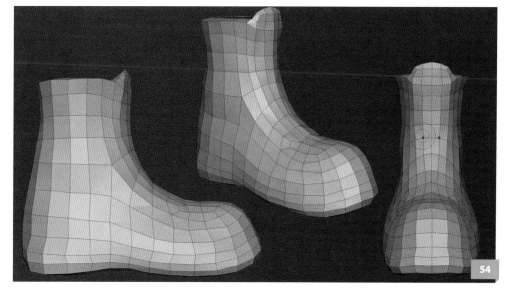

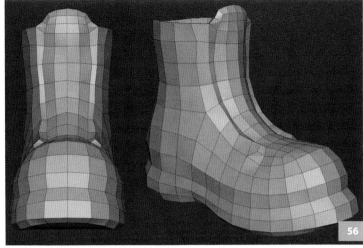

Don't forget to check some of the parameters before starting sculpting. Remove the real-time shadows, turn on Perspective view and activate the X symmetry (Fig.55).

The basic sculpt that we are going to do next will be achieved mainly thanks to the Move and Dam_Standard brushes.

Don't subdivide the shoe, but rather make the changes at level 0. This will make it easier to get a new shape by keeping something clean and sharp (Fig.56).

Now you are ready to add more subdivisions (Fig.57).

With the Pinch brush add more definition on the edge of the sole to make it a little bit sharper (Fig.58).

With the Dam_Standard brush, go to the Stroke panel, enable LazyMouse and change the LazyStep value to 0. This will then allow you to make some very clean lines. Bear in mind that you still have to draw them slowly in order to get the best results (Fig.59).

Select the Clay brush as we need to create sharp painting parameters. Then, with Ctrl pressed, paint a mask on the shoe as shown in Fig.60.

When the mask is well-defined, release Ctrl. Then press Ctrl again and click on the mesh to blur the mask (Fig.61).

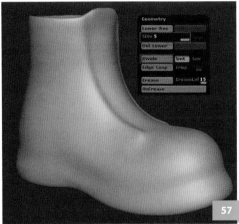

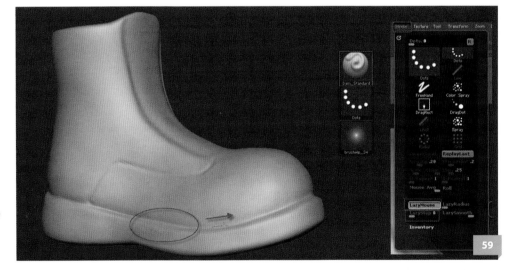

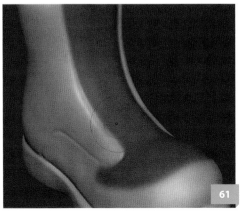

Now, with the Move brush, pull out the surface on each side of the tongue (Fig.62).

Remove the mask. To remove it press Ctrl + drag a selection box out of the mesh in the canvas, then release Ctrl and finally release the mouse .

Now with the Dam_Standard and Standard brush, add some folds at the back of the shoe to simulate some bending artifacts. Also add some lines to create more pieces of leather (Fig.63).

Divide the shoe once more. I've set it to 6 this time.

With the same technique add more lines to the sole (Fig.64).

Now we are going to add more thickness to the different leather pieces. Select the Slash 2 brush under the Stroke panel, activate LazyMouse and change the LazyStep to 0. These parameters are very important if you want to get very smooth lines. Right-click the shoe to open the pop-up menu and change the intensity to 16. Finally, add one more subdivision to increase the level of quality.

Now you just have to sculpt slowly on top of the lines you previously drew. Fig.65 shows some screenshots of what you can achieve.

As we did for the leather pieces, we are going to prepare some stitches. Select the Standard point brush, applying the same stroke changes as above and change the intensity value to 19. It's often good to keep a small value when you use LazyMouse with LazyStep at 0.

Now draw two lines for each piece: one close to the extremity and the second one alongside it (Fig.66).

Select the Stitch Simple brush, created by my friend David Giraud, and draw the stitches along the lines (Fig.67).

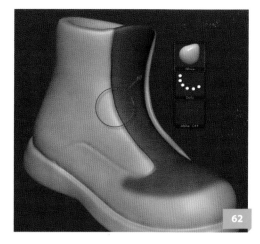

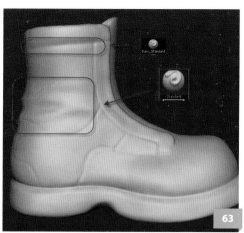

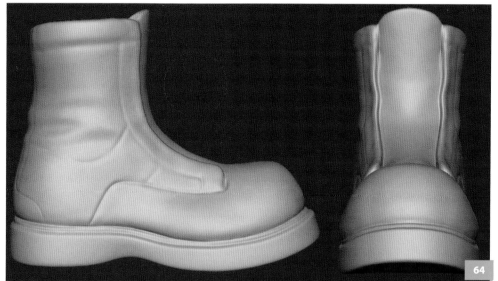

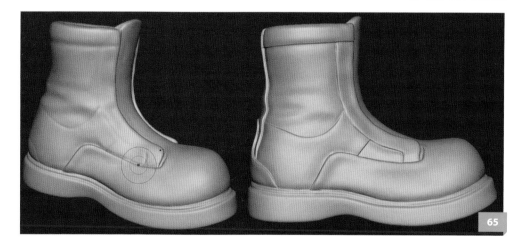

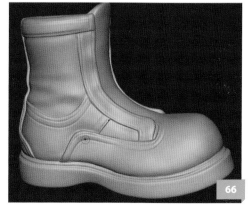

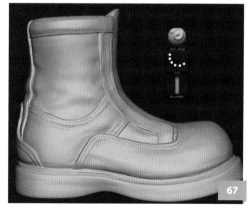

Here is a preview of what you can achieve at this stage (Fig.68).

We now need to create some simple accessories for the shoe. You can do this using a different 3D package if you find that easiest. I made mine using 3ds Max (Fig.69).

Under the Zplugin tab, scroll down to Decimation Master. You can get the plugin here: **http://www.pixologic.com/zbrush/ downloadcenter/zplugins/**. This plugin will allow you to optimize your high subdivision mesh into a mid resolution one. It will be much easier than importing the new mesh into 3ds Max and save a lot of memory. So open the Decimation Master menu, change % of decimation to 2.5 and press Pre-process Current to compute the analyzing treatment. Once done, press Decimate Current to get a new light mesh (Fig.70).

The next small section you will be able to do in any package, but I will be explaining how to do it in 3ds Max. When you put it in your software package you may see some minor artifacts but that won't cause any trouble. We just need a reference object to place the previously created accessories on. Duplicate and move as shown in Fig.71.

We are now going to create the symmetry. First press Group under the main Group menu and apply a Mirror modifier. Click on the + on the left of the Mirror modifier, highlight Mirror Center and then move it to the origin thanks to the Move Transform pop-up. We are now ready to export the eyelets. Save your file as we will use it later for more accessories (Fig.72).

Open up ZBrush and under the Zplugin tab, click on SubTool Master and a pop-up will appear with several functions. Select the first one named Multi Append and select the eyelets object (Fig.73).

You can now see a new subtool on the list; your eyelets (Fig.74).

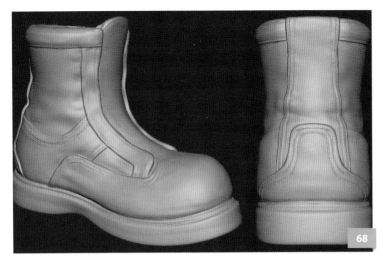

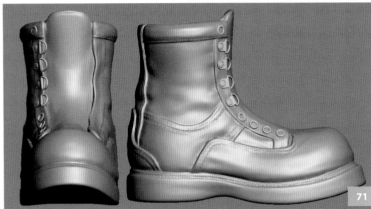

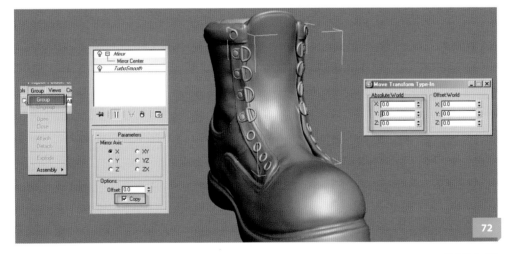

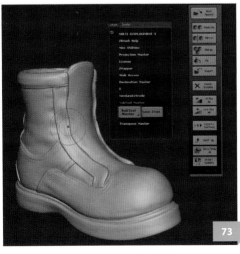

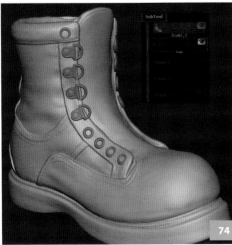

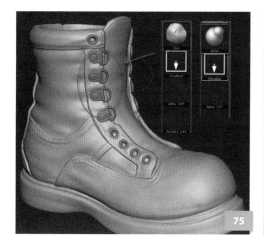

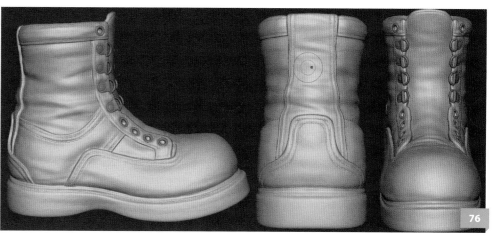

To create the feeling that the eyelets are embedded in the leather, use both the Clay and Inflat brushes to push the volumes in and out. At the same time you can fake holes in the middle of the round ones (Fig.75).

Here are some different views to show an overall preview of the shoe (Fig.76).

Re-open the 3ds Max scene with the optimized shoe and eyelets as we are now going to create the lace. Create a spline as shown in Fig.77. Make the spline go through the different eyelets. Don't hesitate to look at one of your own shoes for reference. In Vertex mode, select them all, right-click and press Corner in order to remove any Bezier/ curve configuration.

Now with the vertices still selected, right-click and press Smooth. You now have something clean and uniform Fig.78.

To add more thickness and definition to your lace go to your line parameters, enable Options and change the values as shown in Fig.79. You are now free to move some vertices to avoid any overlapping or to remove any bad tension, especially around the eyelets. When you are satisfied, export it.

Bring it into ZBrush by using the same method as explained earlier and subdivide it twice to add more definition.

As we did for the eyelets, we are going to make some changes to get something more

realistic. Use the Inflat brush to push out the volumes between the laces and to push in volumes where the lace is tight (Fig.80).

We are now going to work on the sole by adding some grip. We will use ZBrush projection so be sure to enable Persp under the Draw tab. Use Shift + move to snap the bottom of the shoe in the front of the camera. Then export the document (Fig.81).

Open the document that you just saved in Photoshop and, using the Lasso tool, draw a pattern. Once again don't hesitate to look at some references of your own shoe. You can use the Lasso tool in two different ways: you can either draw normally to make your selection or you can press Alt + click + draw to make a polygonal selection.

When the pattern is done, change the canvas size to get a square. This is really important for an alpha to work properly in ZBrush.

De-select the layer with the sole you imported, and then flatten all the layers. Go to Layers > Flatten Image.

Now invert the color to make the grip white (Image > Adjustments > Invert). The white area is what ZBrush needs for an alpha (Fig.82).

Mask the entire shoe except the sole in order to avoid any artifacts during the projection. First go down to subdivision 6 and then select Movo instead of Draw in the top menu. Then press Ctrl and drag the mouse from the middle of the sole to the bottom to get something similar to Fig.83.

Use Shift + move to lock the shoe to the bottom and change the subdivision value to its maximum (Fig.84).

We are now ready to project. Press Projection Master in the top left. Once a pop-up appears change the parameters, as shown in Fig.85.

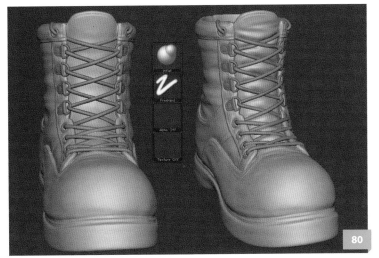

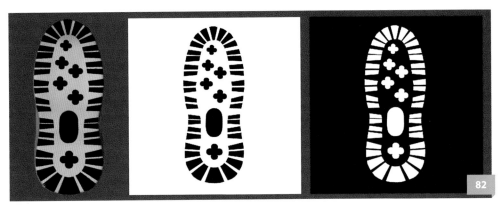

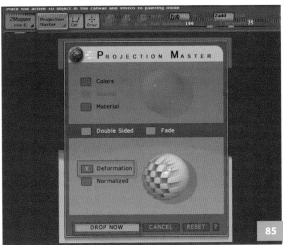

Change the stroke and alpha parameters on the left with the alpha you created in Photoshop, then right-click in the canvas and change Intensity to a lower value (Fig.86).

Drag the alpha on your object first, and then adjust it using the Move and Scale button at the top of the interface (Fig.87).

When you are satisfied, press the Projection Master button once again and, without changing anything, press Pickup Now. This will execute the projection and you can see a preview in Fig.88. There will be some artifacts, but we are going to fix those shortly.

Remove the mask and re-activate the perspective mode under the Draw panel.

Use the Clay and Smooth brushes to remove and polish the previously generated artifacts. Don't worry about the bumpy imperfections you may generate as these will add more realism.

You can then create the tab (I made mine in 3ds Max) above the heel and bring it into ZBrush (Fig.89).

Using the Clay brush, push in the surface of the shoe where it intersects with the leather piece (Fig.90).

Select the newly imported object and subdivide it three times to add more definition. This will also allow you to sculpt some additional details.

With the same techniques as you used for all the leather pieces on the shoe, add some details (Fig.91).

Now we are going to do the last detail pass on the shoe. Scroll down to Morph Target, open it and press StoreMT, which will store the current stage of your object.

Select the Standard brush and change the stroke and the alpha, as shown in Fig.92.

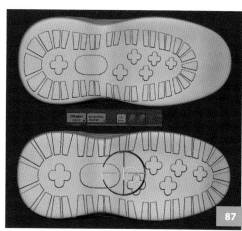

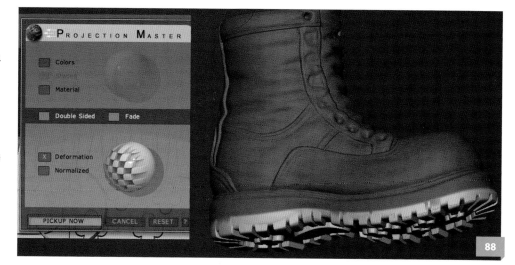

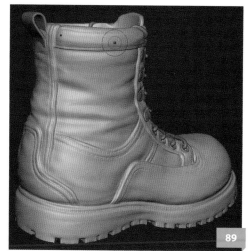

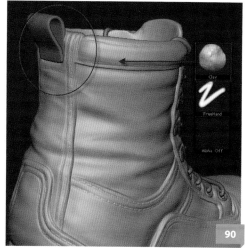

Then right-click in the canvas and change the brush intensity to 11. Fig.93 shows the alpha that I used.

Drag and drop the alpha several times into the highlighted area and try to keep the same alpha scale. Don't worry if you go over the area (Fig.94).

Select the Morph brush, change Intensity to maximum (100) and paint on the unwanted area. Then morph the selected area to the old stored one (Fig.95).

Do that for the small area on the side, using the same technique (Fig.96).

At this stage the shoe is done, but unfortunately it is too symmetrical so let's fix that. Open the SubTool Master and select Merge, which will merge all the visible subtools into one big one.

Open up an old version of your shoe – the one you used to re-create the topology. The position, rotation and scale will be used as a reference for the new version. Once opened disable Colorize to get more visibility (Fig.97).

Append the shoe version with the new one (Fig.98). Now the two versions are beside one another on the canvas.

We are going to use the Transpose function to transform and move the new shoe to match the old one. Drag the three balls as shown in Fig.99, but be sure to keep the line straight by pressing Shift each time you move the balls. To move the balls, select the circle line but do not press inside.

By pressing and moving the ball situated in the middle, move the shoe to the left (Fig.100).

Next we want to change the ball's position in the top view. Press Rotate and then, by selecting and moving the ball at the front

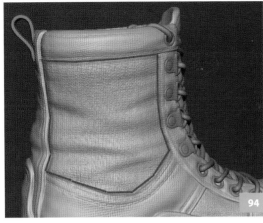

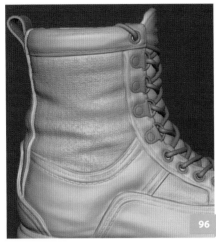

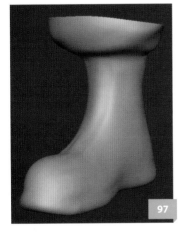

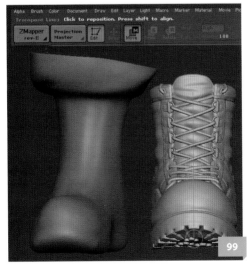

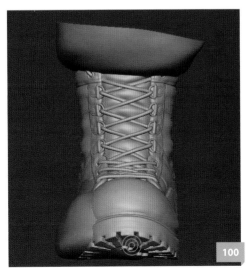

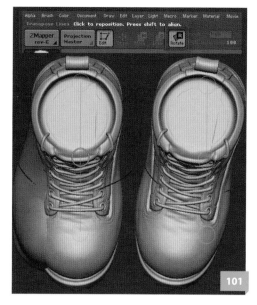

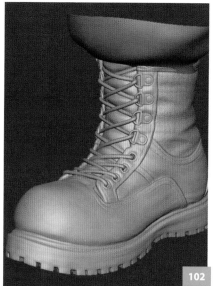

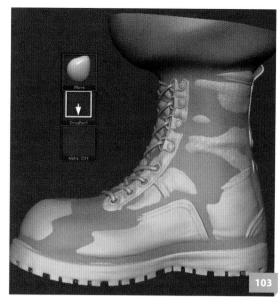

of the shoe, rotate it to match the one underneath (Fig.101).

Do this several times to match the old mesh as best as possible (Fig.102).

With the Move brush, move some areas to fit the reference underneath (Fig.103).

And here is the final shoe (Fig.104).

Adding the Mechanical Elements

In this section we are going to look at how to sculpt a mechanical object in ZBrush using the basic concept we created earlier as a starting point. We are then going to introduce several accessories that we will integrate into the chest and trousers (Fig.105).

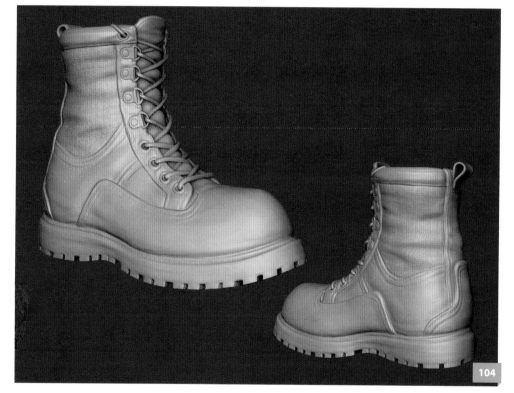

By using the Clay brush in conjunction with the Smooth brush I tried to extract more volume, which then allows for a more polished object (Fig.106).

By using the same technique I described earlier I polypainted a clean topology on the current concept. You will notice there are two different colors on the object that represent the two different objects we will create; one being the chest and the other the hands. We are going to use this technique in order to save memory and allow us to sculpt more smoothly. Usually hands require more polygons and therefore more resources due

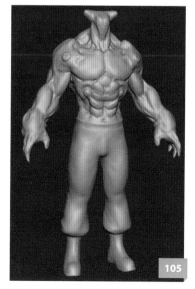

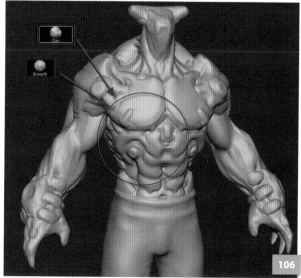

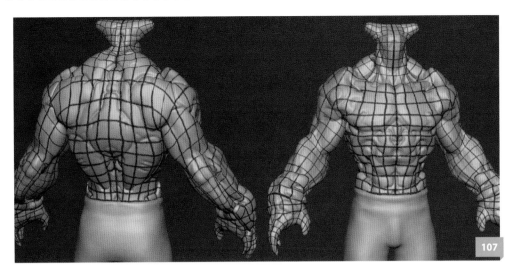

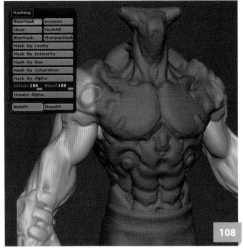

to the fingers, so it's often a good idea to find a way to detach them into a unique piece (Fig.107).

Don't hesitate to use the Transpose function in order to work on a specific area as this will allow you to paint cleaner and better topology. The arm is a good example, which might be quite hard to paint without hiding the rest of the object (Fig.108).

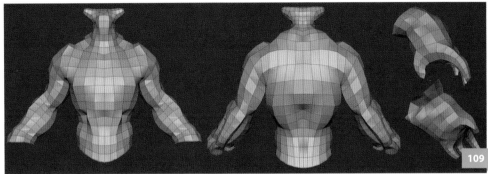

Once you're done with the polypainted topology, use the re-topology process explained earlier in this tutorial to recreate a brand new base mesh for the chest and hand. Remember to only do one hand as we will use symmetry later to duplicate it (Fig.109).

Go back to your polypainted Ztool and turn off colorize under the Texture tab. We are now going to append both previous objects with this tool (Fig.110).

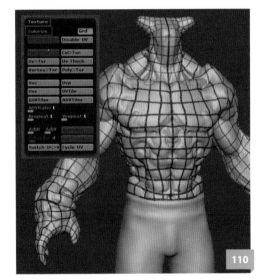

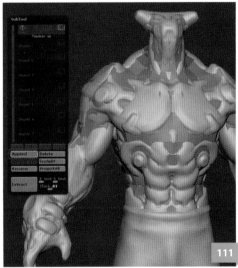

Under the Subtool tab, press Append and then choose the chest and the hand as we did in the previous section with the shoe (Fig.111).

We now have three different subtools: the old concept, the new chest and the hand. Select the chest and subdivide it (Fig.112).

Now press StoreMT under the Morph Target tab and display the old concept by pressing on the eye icon beside it (Fig.113).

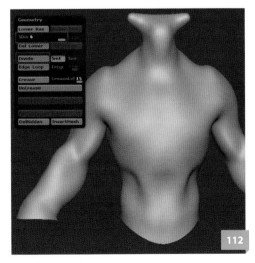

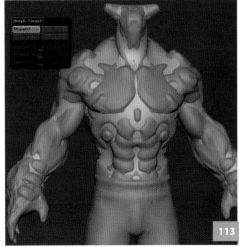

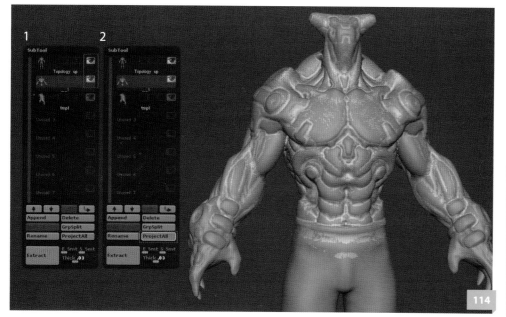
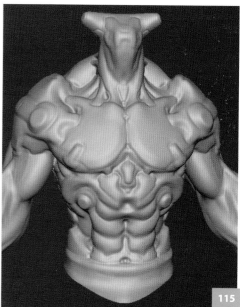

On the left (1) is the last action we did before pressing ProjectAll in order to project all of the sculpted information from the concept onto the new chest base mesh. Here are the results (Fig.114).

Hide the old concept by pressing the eye icon. We are now going to correct the minor artifacts that the projection has created (Fig.115).

On the back we can see an example of some small artifacts (Fig.116).

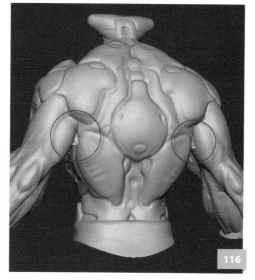

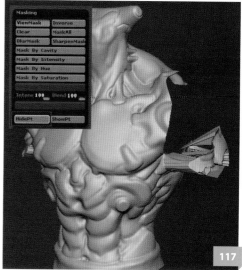

Use the Transpose function to select only the arms. Now hide them by pressing HidePt under the Masking tab. You can now clearly see the artifacts that we're going to need to fix (Fig.117).

We are now going to use the Morph data we stored earlier to remove them. Choose the Morph brush and set Intensity to 100. Now all we need to do is just paint on the artifacts (Fig.118).

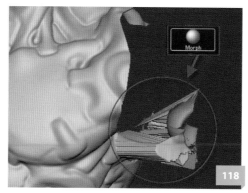

Using the Smooth brush, next we need to polish the area to get a clean junction (Fig.119).

Use the same technique to fix any other artifacts. Here is an image of the final result (Fig.120).

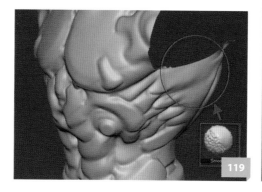

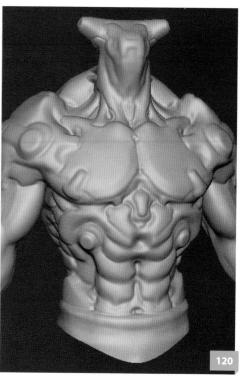

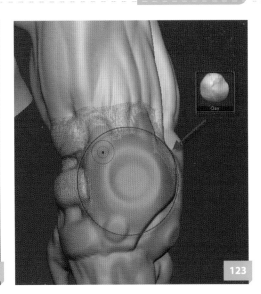

Use the same steps for the hand by first subdividing it and then storing the morph target (Fig.121). Then project the old concept onto the new hand.

In Fig.122 you can see both new objects. We are now going to clean the transition between them.

Select the chest and use the Clay brush to push in the transition area to get a perfect assembly (Fig.123).

Here is a preview from several different angles. This doesn't have to be perfect as we are going to polish and sculpt both parts later (Fig.124).

We are now going to create a symmetrical copy of the hand. First select the hand and then press Del Lower to remove the object's subdivision history. Then press the SubTool Master button under the Zplugin menu.

After a menu appears click on Mirror, make sure Merge into one Subtool and X axis are selected, and then hit OK.

Here is a preview of the result (Fig.125).

Still with the hands selected, reconstruct the subdivision. This will prove important when it comes to saving display memory (Fig.126).

Here is a final preview (Fig.127).

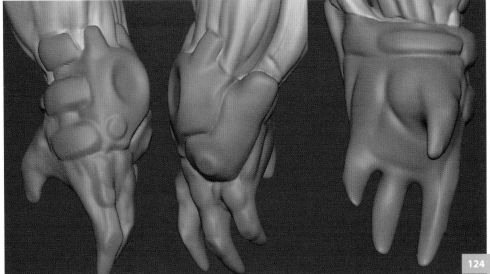

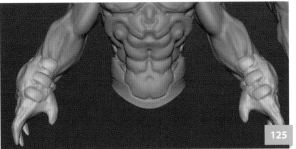

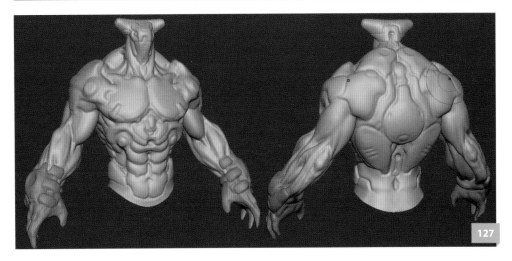

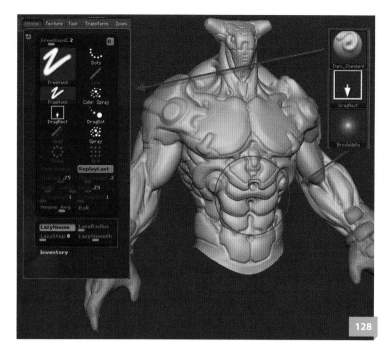

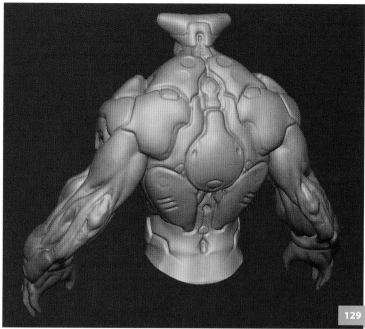

It's time now to add more detail to the chest. The Dam_Standard brush is the main key to achieve this and when used with the LazyMouse it becomes the most powerful tool. After selecting the Dam_Standard brush, press L to activate the LazyMouse and change the stroke parameters to those shown in Fig.128 to draw some perfectly smooth lines. Let's now draw some more details on the front.

Here is the back (Fig.129).

We are now going to work on a small area to explain the different steps in the process and then apply these techniques to the entire character. Using the Dam_Standard brush draw the lines slowly to avoid artifacts, and then use the Flatten brush with the same LazyMouse/stroke parameters to flatten the corresponding line above the previous one. All the green lines are done with the Dam_Standard brush, but don't hesitate to use the Smooth brush sometimes to remove bumpy effects (Fig.130).

We are now going to explain how to create and sculpt these details. This technique is probably the second main component in the mechanical sculpting process. In reality, these details began as 3D objects in 3ds Max first (Fig.131).

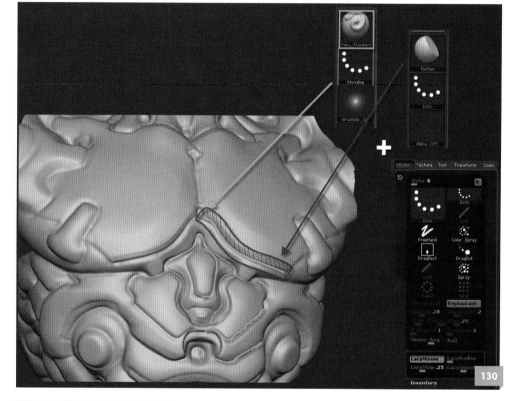

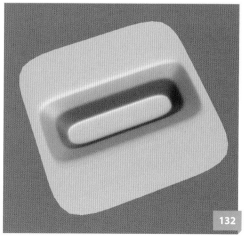

This is the object I made (Fig.132). You can make a similar object in any software you choose.

We are now going to create an alpha from this object. Go back into ZBrush and change the document parameters to 2048 x 2048 pixels as it's very important to get the maximum quality.

Use the Zoom button on the right until you can see the entire canvas on the screen as it's important to use the entire space.

Import the object created in 3ds Max (Fig.133).

Press Crease to limit the shrink effect at the extremity and subdivide it until it's perfectly smooth. Then, under the Display Property tab, press Flip to invert your object (Fig.134).

Choose MRGBZGrabber from the Tool menu. This function will allow us to grab the depth of the object.

Click on Switch when the edit/transform exit pop-up window appears.

It's now time to create the white square. Turn off Auto Crop and draw the square at its maximum size, using the entire canvas (Fig.135).

When you release the mouse, the data is sent to the alpha position. You now have your alpha (Fig.136).

Here is a quick test, which I will explain in the following paragraphs (Fig.137).

It's good to keep the original alpha (2048 x 2048) but thanks to Photoshop we can reduce it to 512 x 512 and save another iteration that we will use on the model.

Here are the different alphas I used for the chest. I used the exact same method to create them as explained earlier (Fig.138).

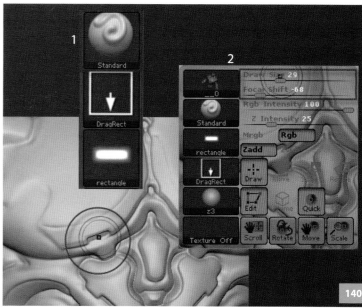

Going back to the chest it's now time to polish it a bit more in the different areas. So, still using the Dam_Standard and Flatten brushes, we can slowly clean the shape (Fig.139).

To apply the rectangles to your shape use the Standard brush with the DragRect stroke and select the rectangle alpha. Now right-click on the model to change the brush parameters, bearing in mind that the Draw Size and Focal Shift have to be close. This procedure is important if you want to create a clean rectangle. You can now place them on your object (Fig.140).

You can create some more shapes in 3D to use on your model. In Fig.141 you can see another object that I created in 3ds Max to put on the chest.

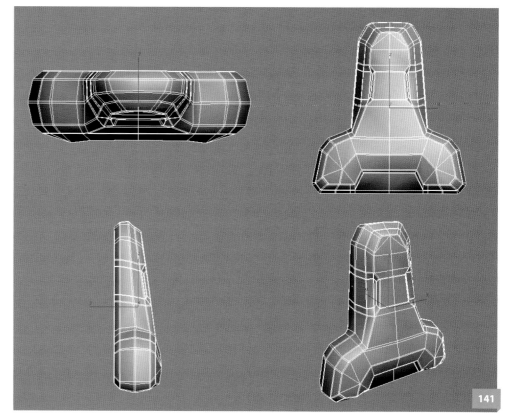

Go back into ZBrush with your chest and decimate the chest in order to avoid a possible memory crash when you bring it into 3ds Max (Fig.142).

Export the optimized chest from ZBrush and then import it into Max. Merge the newly created object and position it to mimic what you can see in Fig.143. Don't move any of the vertices as we will match both objects in ZBrush later. Export the green object as an OBJ file.

Open up ZBrush and import the object into the scene by way of SubTool Master.

Use the Move brush to push the new object a little in order to match it perfectly with the chest.

Use the SubTool Master to mirror the newly created object like we did with the hands in Fig.125.

Here is the final result (Fig.144).

Use the same technique to create these holes. You can see the alpha that was used in the bottom left of the image (Fig.145).

I used the rectangular alpha to create these small thick lines (in red), still using the Dam_Standard brush with the LazyMouse to polish the lines in green (Fig.146).

I used the same technique to create further holes and used the Clay brush with a very low value to slightly flatten the marked areas to simulate a button effect (Fig.147).

Next, create a new object in 3ds Max, starting with a simple cylinder (Fig.148).

Using the same technique, duplicate and move the different objects on the chest to get something similar to the following (Fig.149).

Once again bring these new elements into the scene by using the SubTool Master plugin.

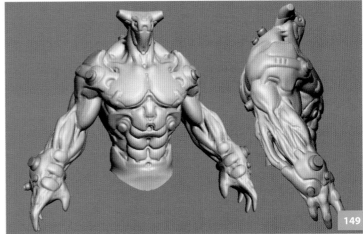

Here is a preview with some more changes using the same methods involving alphas and the Dam_Standard brush (Fig.150).

Use the same technique for the shoulders and neck (Fig.151).

With the armor area done it's now time to polish the arm, which is a more organic element. Use the Inflat and Smooth brushes to gradually fill out the volumes (Fig.152).

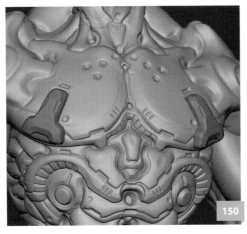
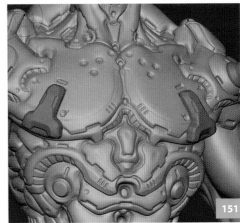

Here are some more angles where you can see the volumes (Fig.153).

When you are satisfied with the volumes, add more small skin details courtesy of a specific alpha (Fig.154).

Once again, use the Dam_Standard brush to accentuate some holes in order to make it appear more organic.

Here are some shots to represent the key areas to help you visualize the process. The same techniques were used to reach this stage and mainly incorporated customized alphas and the Dam_Standard/Flat brush with LazyMouse. It's up to you now to create more specific alphas and furnish your own library with small and simple mechanical objects (Fig.155 – 156).

I also added extra additional items to add a bit more interest to the character. Here are some images of the grenade, military pouch and rifle, all of which were created in 3ds Max (Fig.157).

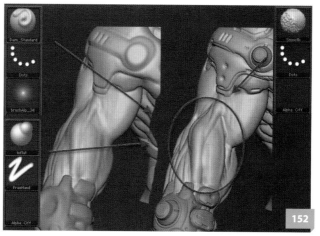

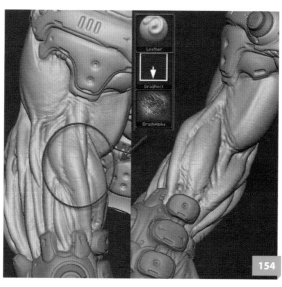

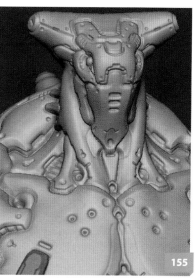

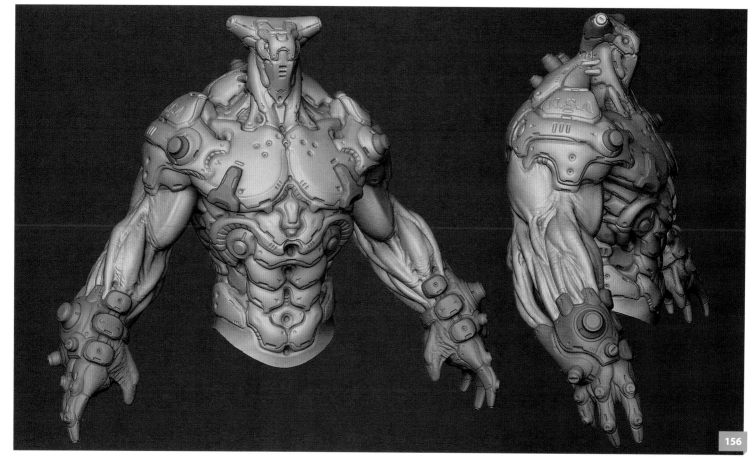

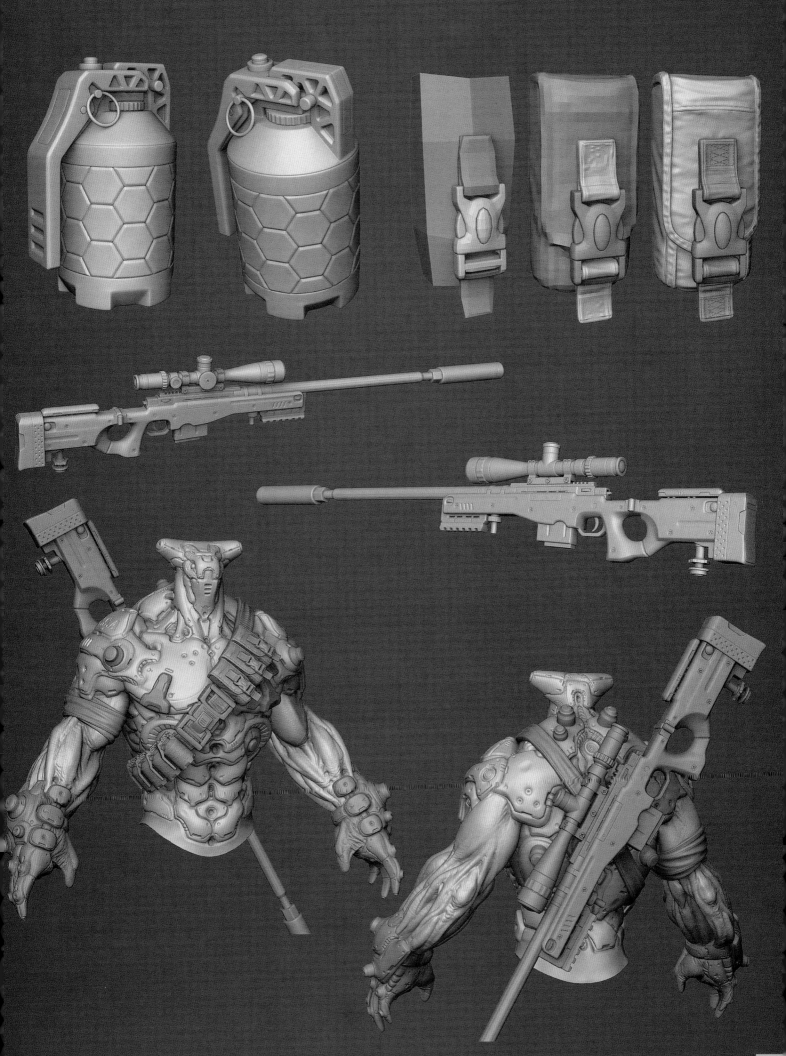

The Trousers

In the following section we are going to see how to sculpt the trousers from the basic concept we created at the start of this tutorial. We are then going to introduce several accessories that we will integrate with it.

So let's start from the concept we created earlier (Fig.158).

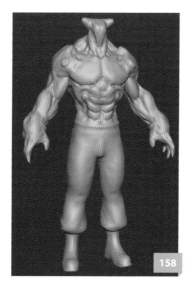

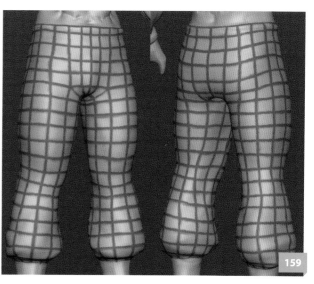

We are going to follow the same procedure as we did in the last section and also for the shoe. The first stage is to polypaint the concept to use as a guide when constructing the topology (Fig.159).

If you read the previous sections you will know how to do this. In Fig.160 you can see the new mesh I created for the trousers. The top and the bottom are still capped. It's good to close your mesh in order to get a better texture.

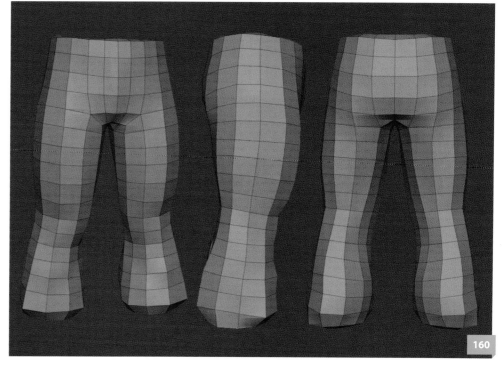

Now go back to your concept mesh as we are going to re-project all the information from the old version onto the new one. First of all turn off Colorize to hide the polypaint.

Under your subtools press Append to display the new menu that will allow you to select the new trousers mesh. After selecting it you will see it just under your main subtool.

Subdivide it several times, but be careful to keep it under 3 million polygons otherwise you will have a lack of memory which will encroach on your workflow. You just need enough resolution to get a nice projection. Go to the bottom, open up the Morph tab and press Store in order to store this current state in the memory (Fig.161).

Press Project All to transfer all the information from the old mesh onto the new version. As you can see in Fig.162 you may have some artifacts. This phenomena comes from the polygons you created to cap the mesh, but there is no need for concern as the morph will allow you to fix these bugs.

Thanks to the Morph and Smooth brushes you can correct the artifacts easily. It's important to change the intensity of the Morph brush in order to remove the distortion quickly. In Fig.163, you can see a preview of the result.

We are now going to paint a first pass of the folds on the trousers. To keep smooth, unified volumes and avoid any bumpy effects, we will use the Standard brush with LazyMouse. It is then a case of slowly drawing in some lines. Work in symmetry to save time as the accessories will break this up later. It's good to have some references when you work on folds in the cloth so don't hesitate to take some photos of yourself to help or just use the internet to find some useful images (Fig.164).

Before continuing with the folds we are going to create the base meshes for the accessories. We are going to need an iteration of the trousers for that. Open the Zplugin menu and change the Decimation parameters as shown in Fig.165. After the calculation, you'll have a lighter version that you can use in 3ds Max to figure out the accessories.

Import the mesh into 3ds Max or any other 3D software and create some accessories to add to the trousers. I started by making some generic items like the clips (Fig.166).

It is good to make a few different accessories, so that viewers' are kept entertained when looking at the image. We're going to have a gun on one of the thighs so for the other let's make a large knife (Fig.167).

Create some straps and attach the knife to the leg. I chose two straps as it seems more practical and is more interesting to look at (Fig.168).

Here you can see the gun I made and the holster for it (Fig.169).

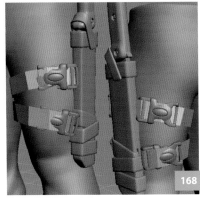

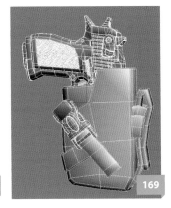

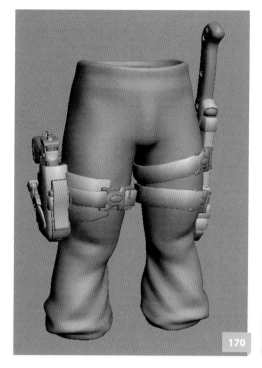

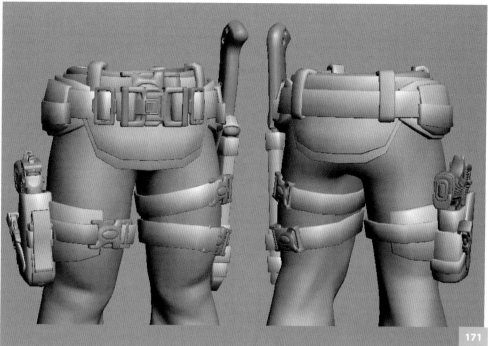

Here you can see the accessories we're created attached to the trousers (Fig.170).

With these components done, it's time now to work on the belt area. To do this duplicate existing parts of the accessories that you have already made and create simple shapes that you can add to the belt (Fig.171).

It is easier to make these base elements in your 3D package. Remember that you want your character to look well equipped as well as interesting, so create as many cool accessories as you can. These will all be modified once we take it back to ZBrush (Fig.172).

Export the newly created accessories as .OBJ files from 3ds Max. We will import these later into ZBrush to be sculpted (Fig.173).

Open up your ZBrush shoe file. We are going to use the main shoe object as a reference in the trousers ZBrush file to help sculpt the trousers and accessories (Fig.174).

Click on the Frame button on the right and you will see several colors appear on the shoe that correspond to the different objects. We just need the biggest one without the laces and everything else (Fig.175).

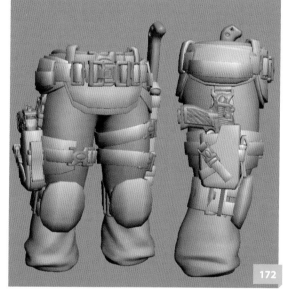

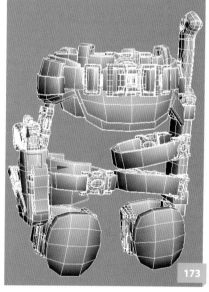

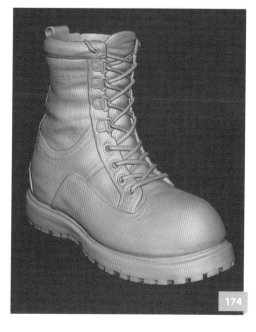

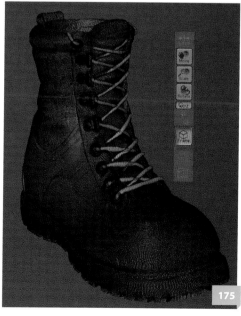

Now click on GrpSplit in the Subtool tab and you will see more subtools appear in the list. You can now delete everything one by one except the first one, which corresponds to the main shoe object (Fig.176).

You now have only one subtool in the list and you will notice that this element has lost its subdivision history. Subdivision history is really important if you want to save memory and be able to sculpt smoothly. To recover subdivisions just press on Reconstruct Subdiv several times. As you just need a reference of the shoe you could also delete the higher level of subdivision.

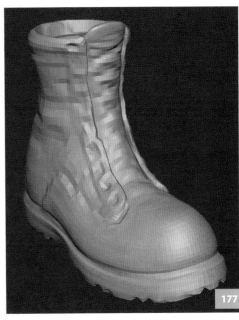

Here is a final preview of the shoe reference. There is just enough to help you when working on the rest of the trousers (Fig.177).

Once again use the plugin SubTool Master to mirror the shoe.

Now go back to the simple trousers you created at the beginning of this section and append the shoes you just created.

Append the accessories that you created in 3ds Max using the SubTool Master. You should arrive at something close to Fig.178.

In order to work properly on single elements click on GrpSplit and you should then see many more subtools appear on the right. It would be easier to work on them one at a time, which will also be much better for memory as you could easily end up with over 10 million polygons without any restrictions.

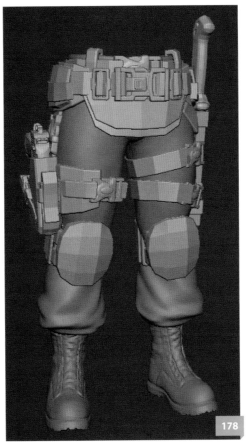
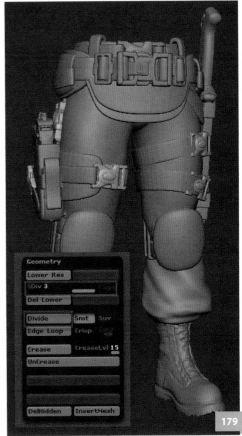

You can now add more subdivisions to the objects in preparation for the sculpting (Fig.179).

Now let's work on the first element: the pelvic protectors. Before starting do not hesitate to add more subdivisions (Fig.180).

To be able to work properly without being disturbed by other objects, hide them by

simply clicking on the eye button just to the right of your current Subtool (Fig.181).

The Dam_Standard brush will be used once again to draw the main lines, but don't forget to turn Symmetry on.

Now use the Flatten brush to flatten some areas, and the Dam_Standard brush to polish and sharpen any holes and details (Fig.182).

For the final touches keep using the Dam_Standard brush and draw some natural lines to suggest that the object is actively used.

Here is a final preview (Fig.183).

Follow the same procedure for the pelvic protector situated below this one and then repeat the process for the ones at the back of the belt (Fig.184).

Now let's work on another part (Fig.185).

First of all subdivide it (Fig.186).

Don't forget to activate the symmetry, which is something which has to be done for all the subtools as it's not a general option.

The Slash2 brush is great and thanks to this you will be able to create extra pieces of cloth apparent on jeans. Select the Slash2 brush and activate LazyMouse, making sure you don't forget to change the LazyStep value to 0 in order to get a perfect line. Now right-click and move the Z intensity value down to reduce the brush strength. You can now draw a line around your object, as shown in Fig.187.

Thanks to the customized brush that I mentioned in a previous section (the Stitch Simple brush created by David Giraud) you can draw on the stitches.

Now you can use the standard Inflat brush to add some folds to make the object look a bit more realistic (Fig.188).

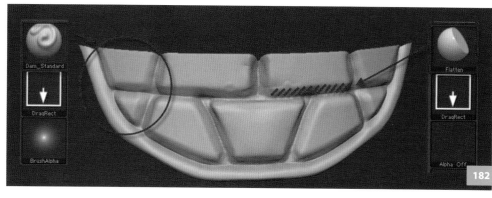

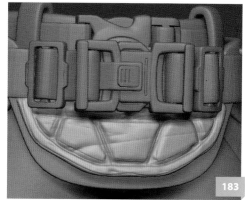

Select the next object and subdivide it (Fig.189).

We are now going to create a mask so select the Clay brush and right-click, changing its focal Shift value to make both circles closer. This will make the mask sharper (Fig.190).

Now scroll down to the Deformation tab and change the Inflat value. You can get exactly the same effect by using the Slash2 brush, as mentioned previously, but I just wanted to introduce a different way of doing it.

This time you can use the Slash2 brush to create more cloth pieces. You can also use the Standard brush with a low Z intensity to create the folds (Fig.191).

Once again use the customized brush to make the stitches and the Inflat brush for smaller folds (Fig.192).

Select another object and use the same procedure to complete it (Fig.193).

In Fig.194 you can see the result when the same technique is applied to the belt.

We are now going to work on the straps, but before we do this select the Clay brush and push in the trousers to remove any artifacts (Fig.195).

Here is a final preview of the straps, still using the same technique to sculpt them (Fig.196).

Next we will move on to the kneepads. Modify the overall shape a little to get a better shape and, with the customized brush, draw a line around them to create the seam (Fig.197).

In order to work properly on the object, click on the eye on the right of the subtool to hide all of the surrounding objects.

We are going to use the Projection Master to add a pattern across the kneepads. In order to get better results you will need to turn the Perspective button off under the Draw tab (Fig.198).

Click on the Projection Master button, which can be found along the top menu, and uncheck everything except Deformation. Now press Drop Now and you will be in the projection master mode.

Next, In the Tool menu, select SimpleBrush. Then select Line Stroke and the Dam_ Standard alpha. Don't forget to change the Spacing value to 2, which will allow you to get some very clean lines. Finally press the Zsub button.

You can now draw some lines on the kneepad (Fig.199).

Once you are satisfied with your modifications, you can go back to the previous ZBrush sculpting mode by pressing the Projection Master button, keeping Deformation on and finally clicking on Pickup Now.

Here is the result (Fig.200).

Don't hesitate to repeat this procedure if you want to add more lines. You can then reuse the alphas you created in the chest stage to add more definition (Fig.201).

You can also use the mask technique to define more volume, as explained previously (Fig.202).

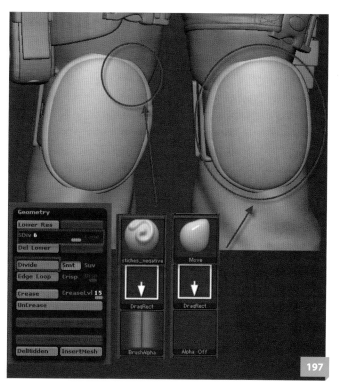

197

198

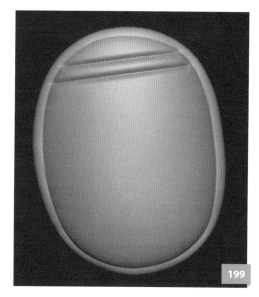

199

200

201

202

Press Ctrl and click on that area if you want to smooth the selection. Then change the Inflat value to extrude the masked selection (Fig.203).

You can now unhide the elements and use the Clay brush to push in the trousers slightly (Fig.204).

Finally, you can use the Slash brush to add some scratches (Fig.205).

Now let's move on to the straps around the knee. Use another custom brush to add different details to the strap. A very simple alpha was created by using the technique explained in the previous section. With this brush selected, right-click and change the Focal Shift value to make both circles closer. You now just have to paint on the strap (Fig.206).

Here is a final preview (Fig.207).

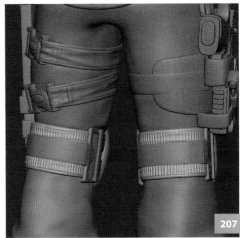

The same techniques were used to detail every part of the sculpt (Fig.208).

We are now going to work on the trousers. In order to sculpt them properly without any interference from the other objects you may wish to activate Transparency. To start sculpting folds use the Standard brush with LazyMouse, which I strongly recommend if you want smooth and clean folds. It's also good to paint these slowly as you will get better results (Fig.209).

Here are the trousers now they are adjusted (Fig.210).

Now let's move on to the seams using the Slash2 brush we used earlier (Fig.211).

Don't hesitate to hide everything except the left or the right piece of the trousers in order to sculpt the seams inside the legs.

Draw more lines with the customized stitches brush and use the Inflat brush to sculpt the

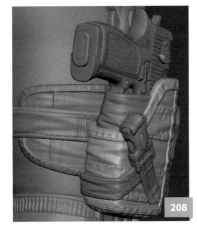
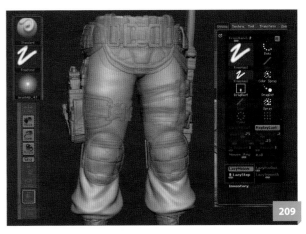
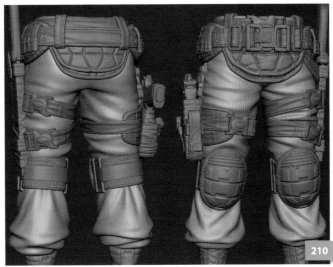
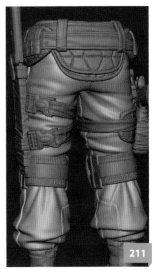

small folds on each side of the seams to finish the details (Fig.212).

We now want to replace the shoes with the real ones, so first of all delete the existing pair. Then open up your ZBrush file with your final shoes.

Next go back to your trousers tool and be sure to delete the old shoes (Fig.213). And finally, append the real shoes to the trousers.

Here is a final preview, with the completed trousers (Fig.214).

Once you have done this you will have completed all of the parts. You can then append them together and you will have something that looks a bit like the sculpt in Fig.215 – 216.

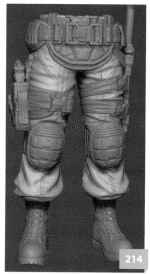

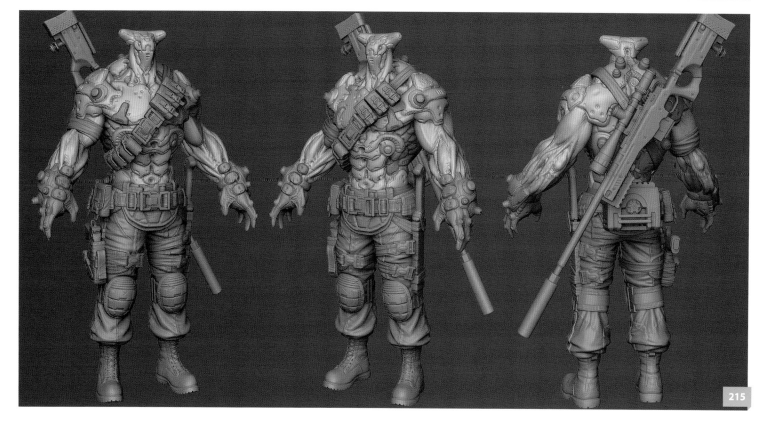

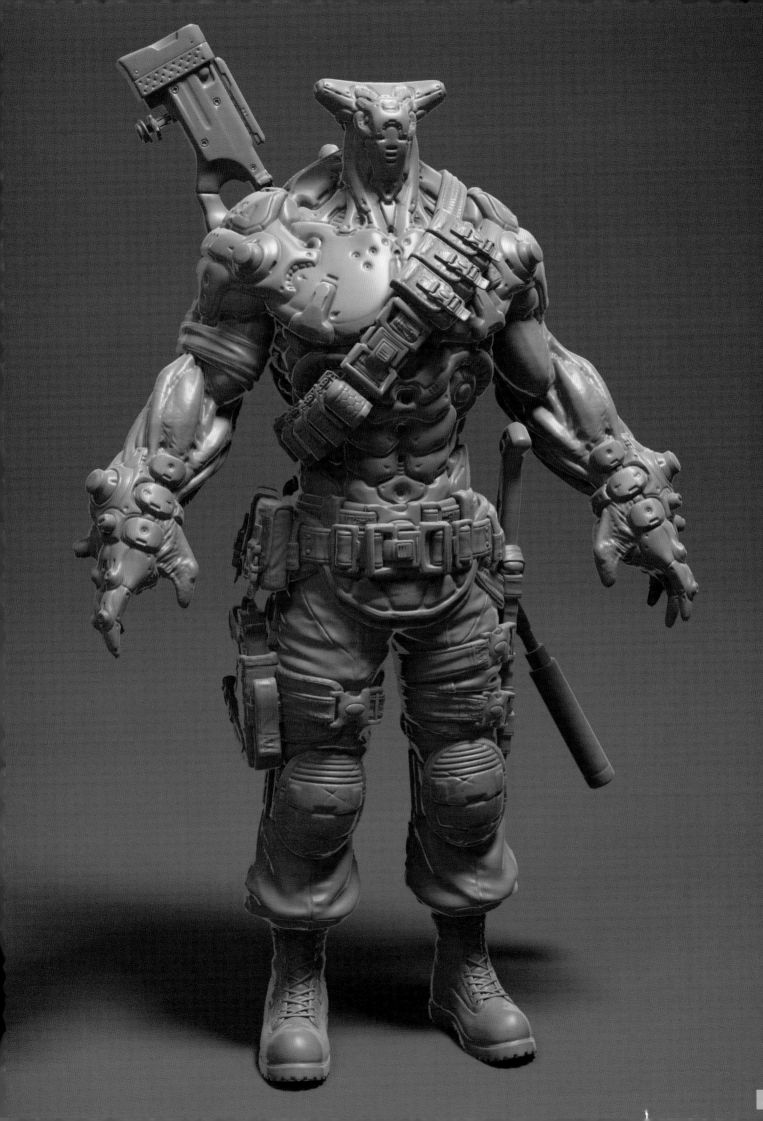

"The pose is set, the scenario is defined, the light direction is shown but, most importantly, the character's attitude and personality is set"

Armored Rhino – Combining Hard Surface with Organic Sculpts By Jose Alves da Silva

Introduction

This tutorial will focus on the creation of an armored rhino. During the creation process I will make extensive use of the tools that were made available in ZBrush 4R2. Some of the features in this version of ZBrush make it possible to unleash the artist's creativity and makes it possible to do more with the lighting system. We will be taking advantage of all these goodies.

As a starting point I think it's important to have a character sketch, or at least a scribbled idea, as this keeps the process ordered and structured. The quality of the image doesn't matter too much as the aim at this stage is to set a goal and an objective that we want to aim for. You can see the concept for my image in Fig.01.

You will notice that a lot of things are already suggested in the sketch. The pose is set, the scenario is defined, the light direction is shown but, most importantly, the character's attitude and personality is set. So with the concept in place it is time to start.

Body – Base

Open ZBrush, then select the Tool directory in Lightbox and double click the PolySphere. ZTL option. Drag on the document to create the sphere and then press the Edit button to be able to start sculpting. In the Tool menu under Geometry, enable DynaMesh. A pop-up window will ask you if you would like to freeze subdivision levels; you should choose

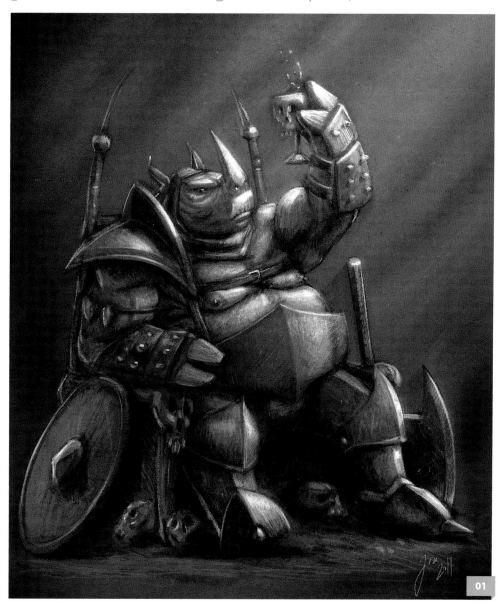

01

No. The sphere has now been converted to a DynaMesh, which is made up of regular quads projected from the X, Y and Z axis.

Press X to enable Symmetry. We will start by blocking the shape of the head (Fig.02).

Choose the Move brush with a large draw size (press S and adjust the slider) and pull the front of the sphere to create an elongated snout. Also push the lateral sides inwards to make the head thinner.

Step-by-Step Project

Using the SnakeHook brush, pull up the geometry to create a horn in the appropriate place. Don't pull the whole horn at once, pull a bit at a time. By making the Polyframe visible (Shift + F), you can confirm that the geometry has undergone extreme stretching and the resulting surface is not good for sculpting. As we are in DynaMesh mode, press Ctrl and drag on the background. All the stretched areas will be recomputed with a uniform polygon distribution of the same density as the rest of the model.

You can repeat this procedure as many times as you need. Just take into account that every time you Remesh, some details that are smaller than the grid might get lost/ attenuated. DynaMesh is not intended to be the final surface for the finer details; it is, in fact, a very powerful way to build your sculpting base, which can then be subdivided and sculpted the same as any other ZBrush model.

In my opinion the best brush for concept sculpting is the Clay Buildup brush. Its strokes create a rough look that is adequate at this point and helps you focus on the masses and planes rather than the details. By pressing Alt when applying the strokes it carves the surface. For Smoothing use the Shift key. Start sculpting your model using the Clay Buildup brush. In the Brush menu, under Auto Masking, enable BackfaceMask. This means that the strokes do not to affect the opposite side of thin surfaces. In **Fig.03** you can see my sculpting sequence.

Start by carving the eye area, then add some volume to where the eyebrows would be and give more shape to the forehead. Carve the eye orbits and add the upper and lower lips. Continue by digging out the nostrils, marking the cheekbones and then give more weight to the eyebrow area to suggest that he has a frown. The face should begin to take more of a shape now, so update the horn by making some strokes along its length to make it thicker and more angular.

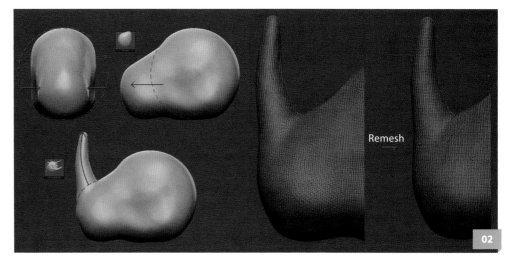

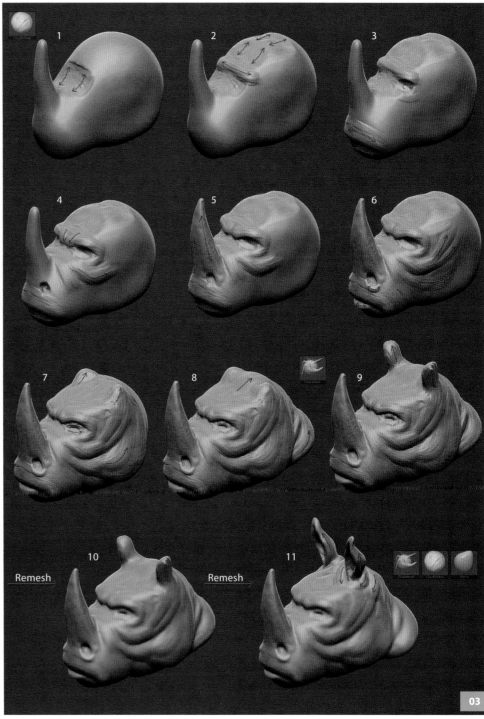

At this point the basic form of the head should be established so start to add some fleshy masses to the cheeks, lip corners, under lip and below the nostrils. Add more flesh to the cheeks/jaw area and start to mark out the eyelids. Now is a good time to start thinking about the ears, so add some volume to the area the ears would grow from. Add more volume to the back of the head and to the neck, and use the SnakeHook tool to pull out the ears.

Remesh the model by pressing Ctrl and dragging on the background. Notice how the surface gets smoother and the brush details are smoothed out and lost. This is not the right time to start sculpting tiny details, even if the sculpt is looking nice and smooth. The ears will still need more work so pull them out further with the SnakeHook brush and apply Remesh again. Carve out the interior of the ears and use the Move brush to shape the ears. Also add some fleshy patches around the base of the ears.

You can see how I added the body mass in Fig.04. Select the InsertSphere brush and click and drag at the base of the neck at the symmetry line. Make sure to create a big sphere, which will cover the head. With the Move brush, shape the sphere into a blob that connects with the head at the neck and suggests a belly at the front. Continue shaping the trunk using the Move and Smooth brushes in order to define the shoulders, a flatter back and a round belly. Ctrl and drag on the background to clear the mask and repeat the process again to remesh the model. The head and the body should now be one item.

Using the Clay brush, start defining the muscle groups on the body (Fig.05). You should use references if you need help doing this. Create the pectorals by stroking from the center of the chest to the shoulder area. Always apply brush strokes in the direction of the muscle fibers. Create the mass for the deltoids, then sculpt the trapezius and

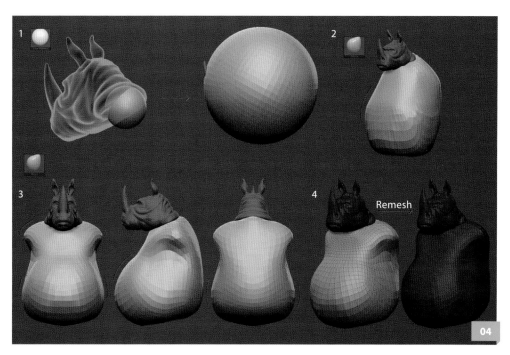

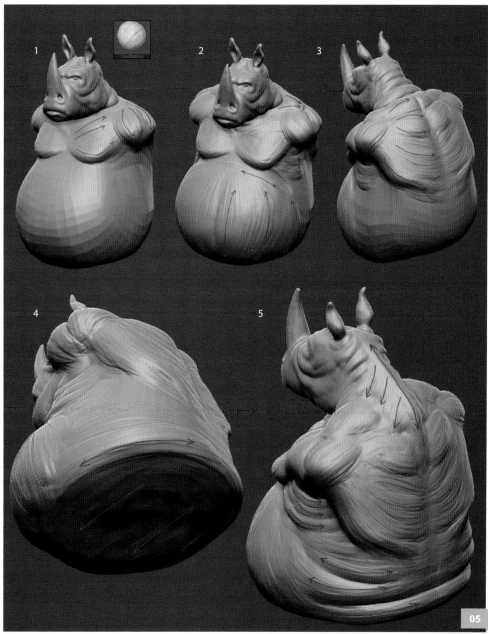

some ribs on the side. Move on to give your character a nice, big, round belly. On the back of the sculpt add some more muscle, exaggerating it to make it look powerful. Flatten the bottom of the sculpt and mark the waist line. Create some volume to suggest body fat around the waist. Add volume at the top of the spine and fuse the muscles with the head.

To create the arms select the CurveTube brush (Fig.06). In front view, apply a brush stroke the length of the arm, starting at the armpit and moving away at a 45 degree angle. Bear in mind that the thickness of the tube is determined by the size of the brush. Using the Move brush, shape the tube into the form of a basic arm in which the arm, forearm and hand are distinguishable. Press Ctrl and drag to clear the mask. Do the same again to remesh, which will fuse the arm to the body. Using the ClayBuildup brush, define the arm's muscle groups. The deltoids will have to be sculpted in order to overlap the biceps and triceps. Always apply

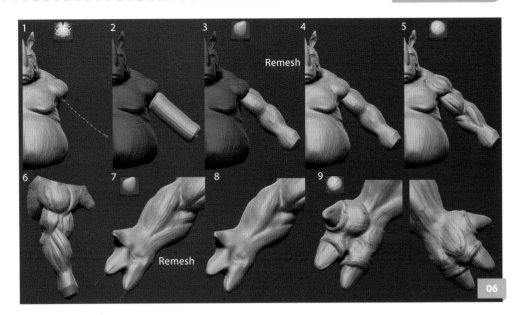

the strokes along the muscle fibers and pay attention to the insertion of each muscle.

With the Move brush, pull a thumb and two fingers out of the hand and press Ctrl and drag to remesh the model. Choose the ClayBuildup brush and create a height difference between the fingers and the nails. Carve the palm of the hand and sculpt the larger volumes to make the surface more

believable. On the top of the hand define two big knuckles and a flat back of the hand.

It is now time to create a base for the lower body (Fig.07). As this body part will be covered in armor I opted to create it as a separate subtool. In the Tool menu, under Subtool, choose Append and pick the Sphere3D tool. Turn on Symmetry by pressing X and Move it to place it under the

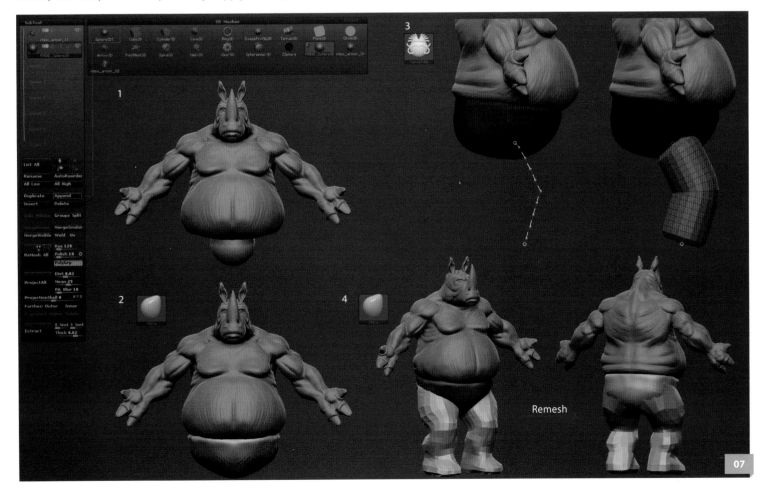

waistline. With the Move tool, stretch the sphere to create a diaper shape. Enable DynaMesh, choose the CurveTube brush and create a tube starting at the hip with a curve at the knee area. Use the Move brush to shape the legs to roughly define the thighs, lower legs and feet. Press Ctrl and drag on the background to clear the mask, then again to remesh, fusing the pelvis with the legs.

With the ClayBuildup brush I sculpted the muscles roughly on the legs so I knew where to place the armor (Fig.08).

Armor – Base

To create the base of the leg armor choose the CurveSurface brush. This brush allows you to create several curves, which will be connected by a surface. Select the brush and, in the Stroke menu, enable Snap mode so that the curves stick to the surface when they are drawn. The Draw Size of the brush will define the thickness of the surface and the CurveStep in the Stroke menu defines the distance between points in a curve. I used a Draw Size of 34 and a CurveStep of 1.2. You may need to adjust these values as the brush size is set in pixels, which are relative to your screen size and zoom level.

Create a vertical curve at the inner thigh. Keep creating vertical curves around the thigh until you reach the right side. You should now have a surface covering the front of the thigh. ZBrush automatically attributes a new polygroup to this surface, so press the GroupsSplit button in the Subtool menu. A new subtool is created, including the newly created surface. Make the contour of the surface regular with the Move brush.

The remaining leg armor will be created using the same procedure. Select the legs subtool and create vertical curves around the shin area with the CurveSurface brush. Make sure the curves cover a bit of the foot. Use the GroupsSplit button to separate the shin armor to another subtool. Use the Move brush to adjust the contour (Fig.09).

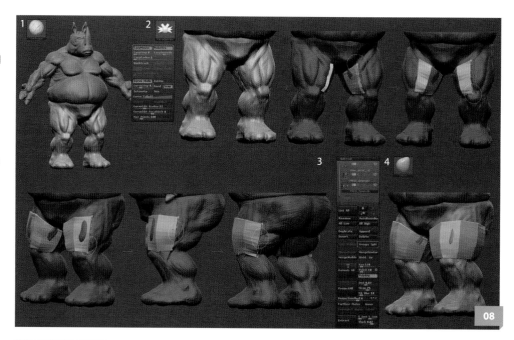

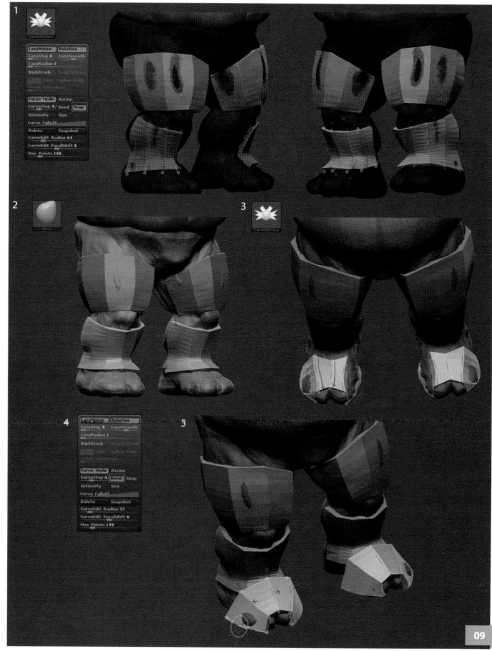

Select the lower body subtool and hide the shin armor subtool. Using the CurveSurface brush, create curves along the length of the foot, covering the top of the foot. As we need the armor piece to overlap the shin protection, disable the Snap mode and enable the Bend mode of the curves (in the Stroke submenu). Now, when your cursor is near a curve (changes to cyan color) you can manipulate the curve without restraining it to the surface. Unhide the shin armor and manipulate the curves so that you have a round contour around the foot and the armor overlaps the shin armor. Use GroupsSplit to separate the foot armor to another subtool.

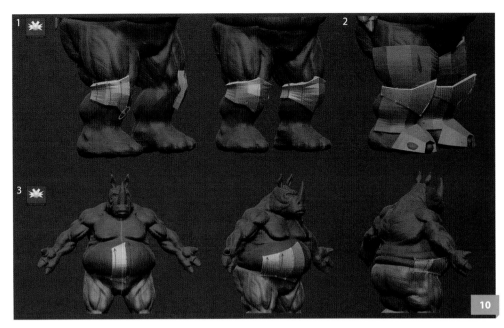

To create the knee armor (Fig.10), turn on Snap mode for the CurveSurface brush. Hide the leg armor parts and create vertical curves around the knee, keeping them short at the sides of the knee and long at the center of the knee. Unhide the leg armor and turn off Snap mode to manipulate the curves and make them cleaner, and so that the surface covers the shin and leg armor pieces. Also create an aggressive spike at the top of the knee armor.

For the belly protection start by hiding everything except the upper and lower body subtools. The CurveSurface brush doesn't allow you to create a single curve starting at the center that is symmetrical on both sides. Choose the upper body subtool, disable Symmetry by pressing X and enable Snap mode. Once you have done that draw the first curve to the right of the center of the body. Then keep drawing curves around the belly until you reach the other side.

To adjust the belly armor curves disable Snap and move each curve point to make each section perfectly round (Fig.11). You may notice that I used too many points for each curve, which might be a problem later as the surface has a lot of horizontal subdivisions compared to vertical subdivisions. To fix this reduce the Max Points to 4 and simply adjust any of the curves and the number of curve points will be reduced. Also, if you reduce your brush size while you are not over a

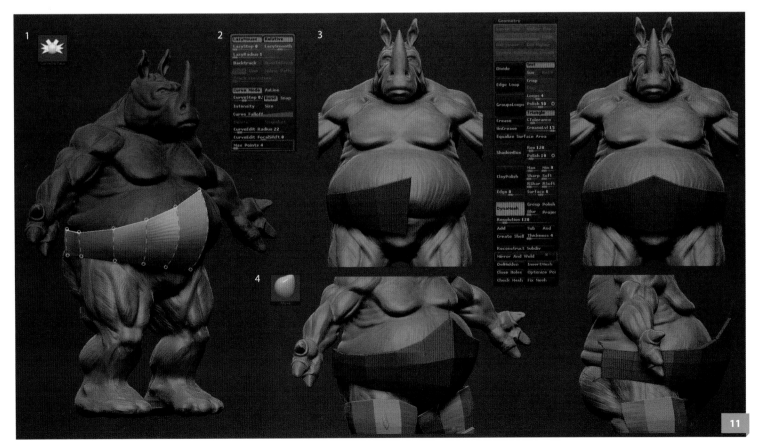

curve (when the cursor is red), when you click on a curve the thickness of the surface is changed to match the brush size.

Use GroupsSplit to separate the belly armor to another subtool. Select it again and press the Mirror and Weld button (Tool > Geometry). This results in it being perfectly symmetrical. Turn on Symmetry by pressing X and, with the Move brush, adjust the form to create a spike at the top and bottom.

At this point I felt that the arms and head proportions were not matching the concept (Fig.12). To remedy this select the upper body, turn on Symmetry and mask everything except the arms. In Scale mode place one end of the transpose tool at the shoulder joint and the other along the length of the arm, and scale the arms to make them bigger. Next adjust the head size, masking it and scaling it to a smaller size.

Once again using the CurveSurface brush, create the forearm protectors by drawing strokes perpendicular to the arm length with Snap on. Adjust the curves with Snap turned off and use GroupsSplit. Use the Move brush to pull the edges around the arm.

To create the straps that hold the forearm armor, select the CurveTubeSnap brush (Fig.13). Change the Brush Modifier value to 4 (this defines the number of vertexes on the cylinder section). Draw a curve at the forearm. Adjust the curve with the Move brush so that the strap comes from under the armor. Change to Move mode and drag, starting at the strap, to create a transpose tool. Press Ctrl while dragging the inner center circle of the transpose tool to duplicate the strap. Reposition and scale the new strap to fit the wrist. Use the Move brush to finalize the adjustment.

The head protection will be created with a different process (Fig.14). Select the upper body subtool and, using the Standard brush, press Ctrl while painting on the model to

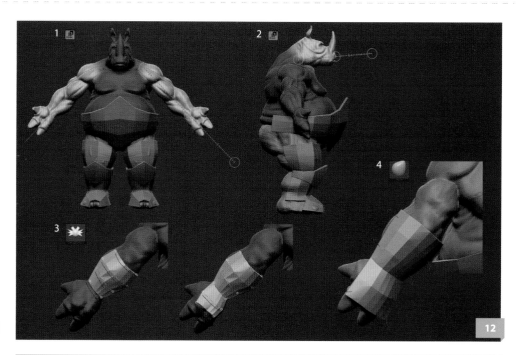

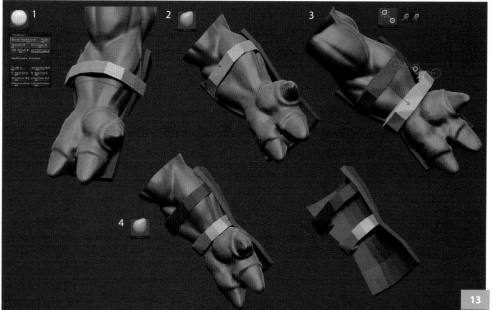

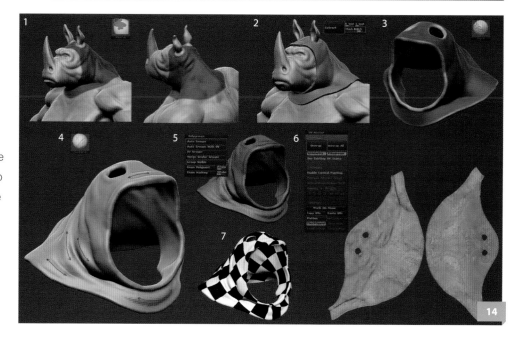

create a mask. Mask the protection area, leaving the face and the ears uncovered. In the Subtool menu go to the Tool menu, set the Thick value to 0.015 and press Extract. A new subtool will be created for the hood. If you select the new subtool you will notice that everything is masked except for the borders. Use the Smooth brush at the borders to make them round. Clear the mask (Ctrl and drag) and using the ClayBuildup brush with the Backface Mask option enabled, create some folds around the hood and smooth them with the Smooth brush.

When you extract a mesh from a mask, ZBrush automatically creates different polygroups for the inner faces and edge faces. Press Ctrl and click the interior surface of the hood to isolate this polygroup. Press Ctrl, Shift and drag on the background to invert the visibility. In the Tool menu, under Polygroups, click Group Visible. The exterior and edges of the hood are now part of the same polygroup. Press Ctrl, Shift and click the background to unhide the interior.

In the Plugins menu open the UVMaster. Enable Polygroups and press Unwrap to generate UVs for the hood. By pressing Flatten you can check the layout of the UVs. Press Unflatten to leave. If you wish to see a texture applied to check the distortion, pick a checker pattern in the image slot under Texture Map, but don't forget to clear it afterwards.

The creation of the base for the shoulder armor repeats the CurveSurface technique (Fig.15). Select the upper body subtool and hide the rest. Disable the symmetry because there is a single shoulder pad. Select the CurveSurface brush with Snap enabled. Draw the first curve at the shoulder near the neck, bearing in mind that this curve will be lifted to make the vertical protection (as you can see in the concept sketch). The second curve will be the line that creates the edge between the vertical and horizontal areas. Keep drawing smaller curves in the direction

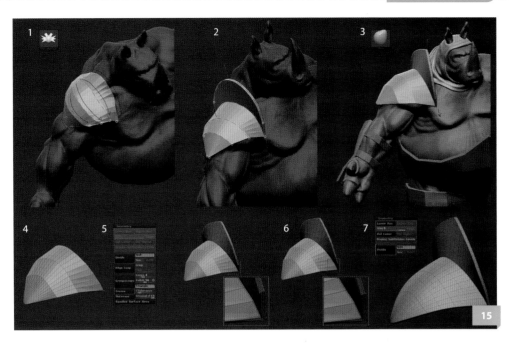

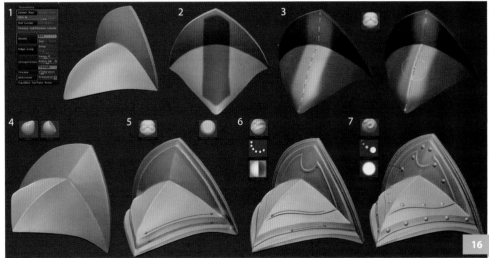

of the arm so to make a point at the end of the shoulder pad.

Disable Snap, make sure Bend is on and lift the vertical protection curve. Manipulate the curves to match the concept shape. Press GroupsSplit. With the Move brush, adjust the overall form a bit more.

Armor – Detail
Select the horizontal part of the shoulder protection, hiding the vertical portion. In the Geometry submenu (in the Tool menu) press Crease. You will notice that the harder edges now have an inner dotted line, which means that these edges will not smooth while subdividing the geometry. Press Crease again to define the hard edges on the vertical part. Press Divide four times.

The hard edges hold the form while subdividing, which creates the effect we want, however next time we subdivide it we don't want it to do this, so press Shift and the Crease button to clean all the crease marks. Divide it once more. You will notice that the edges between the two planes are now smoother (Fig.10).

Mask the central area of the shoulder pad, excluding the tips. Invert the mask and blur it (press BlurMask in the Masking submenu). Select the CurvePinch brush and draw a curve along the center of the shoulder pad. A crease is created at the center of the shoulder pad, while the mask prevents the tips from deforming. Clear the mask. With the Move brush, adjust the deformations near the tip. Use the Polish brush to even the surface.

Using the CurvePinch brush, create some decorative lines along the border of the pad. Press Alt while creating the curve to create a pinch inwards. To flatten the hard edges use the Trim Dynamic brush.

Load the Slash2 brush from the Brush/ Slash directory in the Lightbox. In the Alpha menu increase the Blur to 15 and enable LazyMouse. With this brush, draw some decorative lines to simulate some extra metal layers on the shoulder pad. To add a few decorative nails choose the Standard brush, set it to DragDot mode and pick Alpha 06. Adjust the Draw Size to set the size and place them along the edge of the panels.

The techniques used for the shoulder pad can also be used in the creation of the other armor parts (Fig.17).

For the belly armor start by increasing the tolerance slider value near the Crease button to 40 and pressing Crease. Then subdivide the model four times, disable the creases (Shift and UnCrease button) and subdivided it three more times. Then, using the Slash2 brush with the previously defined settings, create several decorative lines. Use the Smooth brush to smooth the marks on each side of the Slash2 strokes. Using the Standard brush, place the nails along the decorative lines. Select the Dam_Standard brush and reduce the LazyStep of the Stroke to 0.015. With a large brush size and while pressing Alt, create some decorative creases that reinforce the existing lines.

For the thigh armor, crease the edges, subdivide and use the Move brush to lower the sides at the top to create a more interesting curve. With the Slash2 brush mark the metal panels. Also add a rim around each panel with the same brush, using a smaller radius. Select the Dam_Standard brush with a large brush size and, while pressing Alt, create two creases on the armor to make it look faceted. Using the Standard brush, create nails around the panels as before.

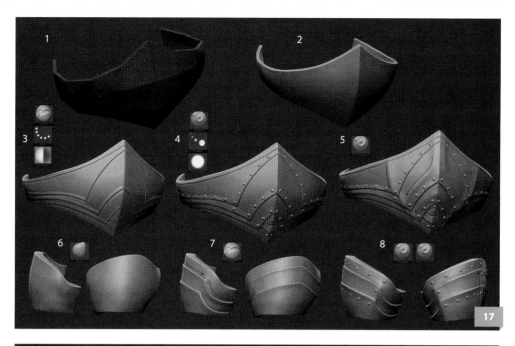

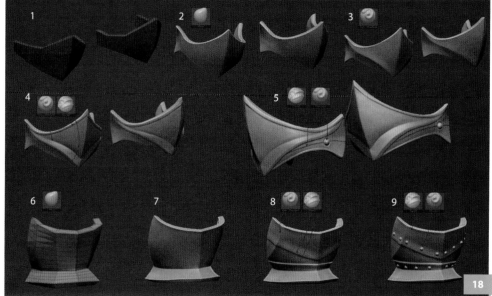

Use the same process to create the knee armor (Crease followed by subdivide) (Fig.18). With the Move brush, raise the ends of both sides of the knee protection and shape the spike at the center. Using the Dam_Standard brush and pressing Alt, create decorative creases on each side of the knee armor. With the Slash2 brush, mark lines at the edges of the form. Use the Dam_Standard brush to create a decorative crease inwards below the knee area. Add more decoration with the Slash2 brush and, using the Standard brush in DragDot mode, place a big nail at the pivot point of the knee armor.

For the shin armor, use the Move brush to make a clear edge at the transition between

leg and ankle. Hide half of the shin protector and use Crease to create a vertical creased edge along the leg. Unhide the rest and Crease it again. Subdivide this several times. Notice how the vertical crease is still visible. With the Dam_Standard brush and while pressing Alt, create a lateral crease on both sides of the shin armor. Use the Slash2 brush to create the edges of the metal parts. Still using the Slash2 brush with a smaller draw size, create a line on the contour of each metal piece. Use the Standard brush to place some nails along the edges.

To create the feet armor start by using the Crease brush on each half to guarantee a hard edge at the center and subdivide it.

Create some decorative creases with the Dam_Standard brush. Use the Slash2 brush to create the metal panels at the sides and add some nails around the edges with the Standard brush (Fig.19).

In the Tool menu select the Cylinder3D tool. In the Initialize submenu set the X Size and Y Size values to 60 and TaperTop to 95. Select the armored rhino tool, press Append (in the Tool > Subtool menu) and pick the cylinder you have changed. Move and scale the cylinder subtool to place it at the tip of the foot. Subdivide the cylinder and use the Polish brush to flatten the lower side and polish the top, creating a crease at the center. Use the Slash2 brush to create a height difference at the middle and the Standard brush to place some nails. To mirror the spike to the other foot, go to the Plugins menu, click on SubTool Master, choose Mirror and select Merge into one Subtool.

To detail the bracers use Crease and subdivide as you have done for the other pieces of armor (Fig.20). With the Move brush, pull the edge near the knuckles to define three sharp points. Use the Dam_ Standard brush with a large radius while pressing Alt to create a crease along the bracer and another perpendicular to the first at the wrist area. Using the Slash2 brush, create the edges of each metal panel. With a smaller size brush mark the edges of the panels with a line. Use the Dam_Standard brush again to create two extra creases at the upper arm. Add nails with the Standard brush. To create some sharp spikes on the forearm, select Alpha 36 for the Standard brush and set the Z Intensity to 100. Place the spikes evenly on the forearm.

Select the lower body subtool (Fig.21). To create the straps behind the leg armor pick the ClayTubeSnap brush. Set Draw Size to the width of the straps and increase the CurveStep (in the Stroke menu) to 0.8 so it doesn't generate too many steps. Set the Brush Modifier value to 4 to define the

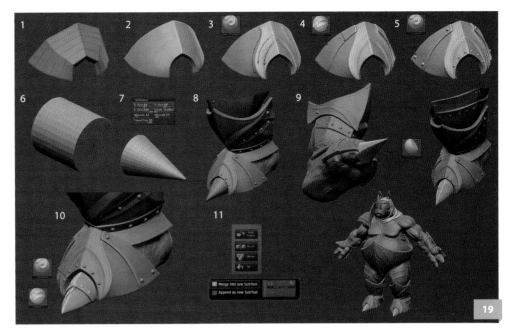

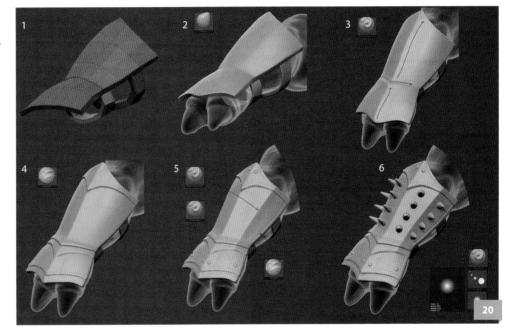

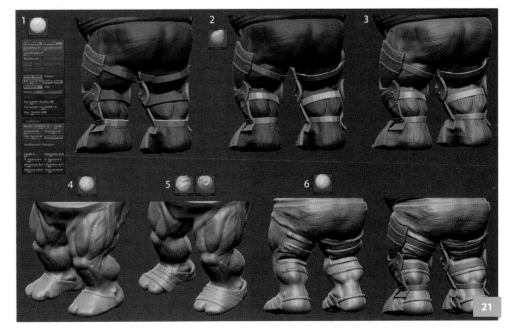

section as a square. Draw three curves that represent the straps that hold the armor to the leg. As the section is square, make it thinner by using the Move brush and adjusting the depth of the straps as well as their curvature. Hide the legs leaving only the straps visible. Choose Group Visible from the Polygroups menu in the Tool menu to make all the straps belong to the same polygroup. Then press GroupsSplit to move the straps to a new subtool. Select the straps subtool and Crease and subdivide it.

Select the lower body subtool and hide the rest. Using the ClayBuildup brush, sculpt the protection covering the foot and smooth the result. Sculpt a metal bar around the heel to support the protection. With the Slash2 brush create two cuts that suggest layered metal plates. Add a nail at the place where the bat meets the protection with the Standard brush. Smooth the lower leg and sculpt the edge of the trousers using the ClayBuildup brush, thickening the cloth in the areas around the fixation straps. Don't worry about creating a perfect finish as the legs are going to be posed and will therefore need some corrections later.

Pose

I prefer to pose the character before detailing it any further because the posing will lead to distortions that will have to be fixed and also because it will help to break the model symmetry. Do not forget to save before you start the modeling process.

We will use Transpose Master to pose the character. However the thin elements that make up the armor might suffer some distortions when re-importing the pose back to our model. To reduce the chances of that happening I would advise that you select each armor subtool, go to subdivision level 3 and press DelLower to discard lower subdivisions.

In the Plugins menu (Fig.22) select Transpose Master and choose TposeMesh.

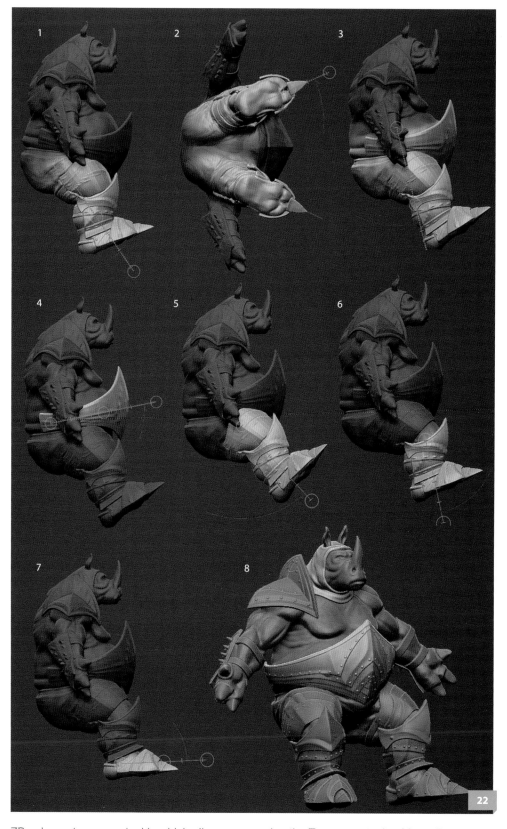

ZBrush creates a new tool in which all elements are represented at their lowest subdivision level and as part of the same subtool so that they can be manipulated together.

The process of posing consists of masking parts of the model that stay in place while

using the Transpose tool to Move, Rotate and Scale the unmasked area. When dealing with armor bear in mind that the metal pieces should not be distorted, unlike the flesh and cloth where it is desirable. So the armor elements should always be completely masked or unmasked, not including any gradients.

Let's pose the character in a seated position. Turn on Symmetry X. Unmask the whole leg and all its armor pieces, and rotate it forward in a side view. Change to a bottom view and rotate the legs outwards using the same mask. Then unmask everything from half of the belly down and rotate the lower body to the front so that the character's back can lie against the chair. Unmask only the belly protector and rotate it upwards to avoid intersecting the thighs. Unmask the legs again and rotate the thighs further forward. Unmask the lower leg, including the knee protection, and rotate it to make a 90 degree angle with the thigh. Unmask the feet and their armor and rotate them forward in order for them to lie flat on the floor.

The rest of the pose will not be symmetrical, so send the changes to the main model to check if everything went as planned. In the Transpose Master menu choose Tpose > SubT. The model should be posed and some intersections might happen between the fleshy elements and armor, which can be easily fixed with the Move brush. If you have projection problems with any of the armor elements, just open the tool you saved, select the part that needs to be replaced and append it to the posed model. Then move and rotate the piece to put it in place and delete the deformed one. As the armor pieces are not deformed this is easy to do.

Initiate the Transpose Master again (Fig.23). Now we will take care of the asymmetrical parts of the pose. Unmask everything from half the belly up and tilt the upper body to his right. From a top view, rotate the body to face towards his left arm. Unmask the head and rotate it further left and a bit up. Unmask the left arm and raise it (expect the worst deformations to happen while placing the arm in this position). Unmask the left forearm and bend it inwards from the elbow. Unmask the hand and bend it further inward to create the joint at the wrist. Unmask the right forearm (starting at half of the forearm and blurring the mask) and twist it together with the

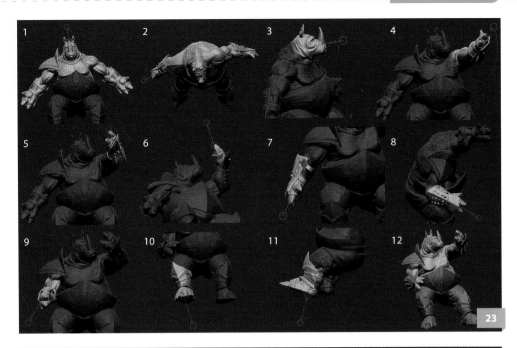

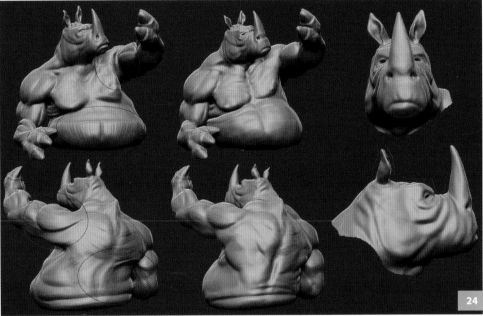

forearm protectors. Unmask the entire right forearm and bend it from the elbow to make it at 90 degrees with the arm. Unmask the right arm and rotate it to bring it closer to the body. Unmask the right lower leg in front view and rotate it inside to a relaxed position. Unmask the left lower leg and rotate it to the front. Also rotate the foot to make it more parallel to the ground. In the Transpose Master menu choose Tpose > SubT to transfer the pose to your model.

The next step is to correct the deformations that resulted from the posing process (Fig.24). Use the Move brush to reposition volumes and the ClayBuildup brush to

reshape the muscles and cloth. The deformations in your model might be very different from the ones in mine, so I will describe what I had to fix.

On the upper body DynaMesh is still activate so if you need to you can Ctrl and drag on the back at any time to even the sculpting surface. Disable Symmetry X. The raised arm suffered ugly deformations so I had to rebuild the muscles around the shoulder area and the stretching on the back. The belly had a big crease from the upper torso bending, so I re-sculpted it and added some compressed fat on his right side. On the back, the spine had to be corrected and the back muscles

were sculpted. The head suffered small adjustments, making the angles sharper. I made holes for the eyes and reshaped the ears to look more like a rhinos.

In order to give more expression to the character it is important to pose the hands (Fig.25). Starting with his right hand, which will be supported by the armchair, we want to achieve a relaxed look. Unmask the index finger and the thumb, as well as half of the palm, and rotate them inwards to create a curvature at the back of the hand. Unmask the thumb and rotate it inwards. Unmask the index finger and rotate it towards the palm.

The left hand will be holding a chalice, so let's position the fingers accordingly. Unmask the lower finger and rotate it towards the palm. Unmask half of the finger and rotate it some more towards the palm. Unmask the thumb and rotate it out so that it can assist in gripping the object.

Keep adjusting all the subtools using the Move and ClayBuildup brushes (Fig.26). Move the straps that hold the bracers to make them a tight fit on the forearm. I opted to reshape the form of the hood to give it a more angular look. With the ClayBuildup brush I created some cloth folds on the hood.

If the lower body has some deformations, add volume to the back so that the bottom touches the chair. I also sculpted the main cloth wrinkles, making sure that they were adjusted to the armor elements and the straps that hold them. The lower body is a DynaMesh so you can remesh it whenever you feel that you need even geometry at the deformed areas.

Details

Now that the character is posed it is a good time to add the straps that hold the shoulder and belly protectors (Fig.27). Select the CurveTube brush and set Brush Modifier to 4 and CurveStep to 1. Make sure Snap is not enabled. From the top view, create

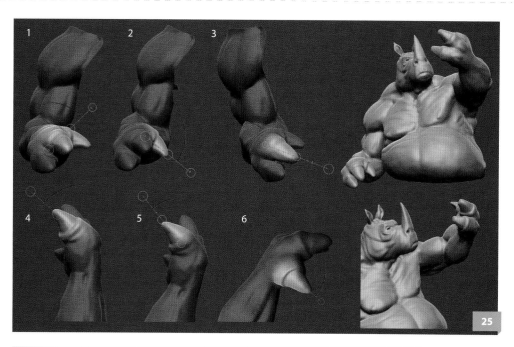

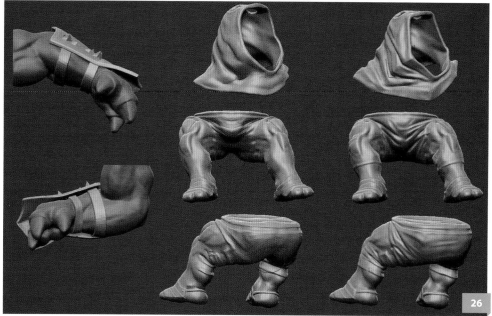

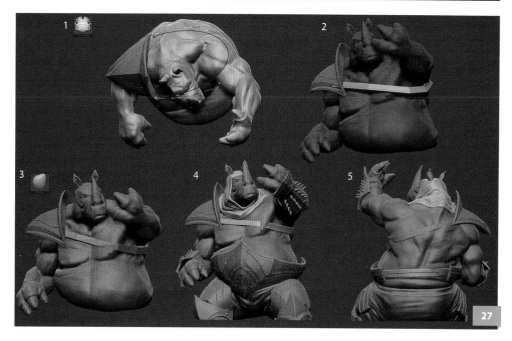

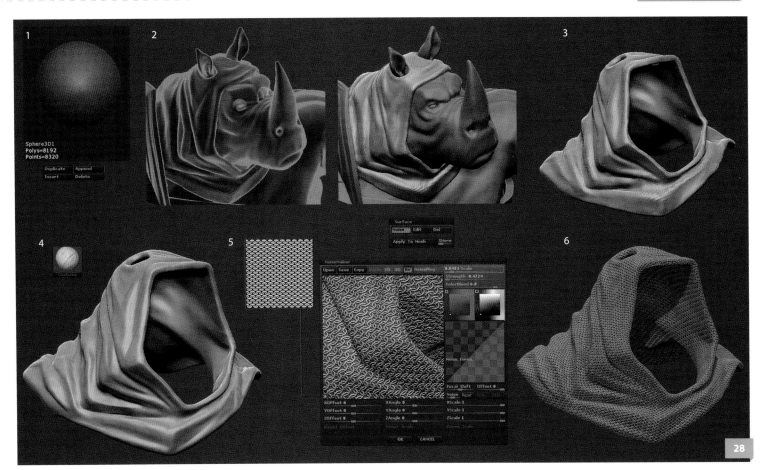

a curve starting at the right pectoral and create a large curve that goes around his chest and ends at the back near the shoulder armor. Adjust the curve to pass below the arm pit. Use GroupsSplit to send the strap to its own subtool. Using the Move brush, adjust the strap so that it looks like it has a certain tension against the body. Crease and subdivide. Using the same technique, create a strap at the back that holds the belly armor.

To create the eyes choose Append from Tool > Subtool and pick Sphere3D (Fig.28). Select the sphere subtool and scale it down. Move it to the eye location. To duplicate the oyc, press Ctrl and drag the center of the transpose tool in Move mode. Place it at the other eye location.

Select the hood subtool and subdivide it twice. Using the ClayBuildup brush, detail the folds and don't be afraid to exaggerate them as the chain mail texture we are about to apply will reduce their impact. In the Tool menu, under Surface, click on Noise. The Noise Maker interface will open. There is a

small sphere icon on the lower left corner of the model view. Click on it and load the alpha image of the tileable chain mail (downloadable from Pixologic's website in the Alpha library under Patterns). Enable UV so that the pattern is applied according to the UVs we have set before. Reduce the Scale to 0.048. Set Strength to -0.47 and ColorBlend to 0.8. Set the color of the right color palette to black and press OK.

If your chain mail pattern is stretched in some parts it is because the sculpting has deformed the surface and you will need to set the UVs again. To fix it just repeat the process we did earlier in the UV Master. Press BPR in the Render menu to render and see how the chain mail looks.

One important detail is the way that the straps interact with the body flesh (Fig.29).

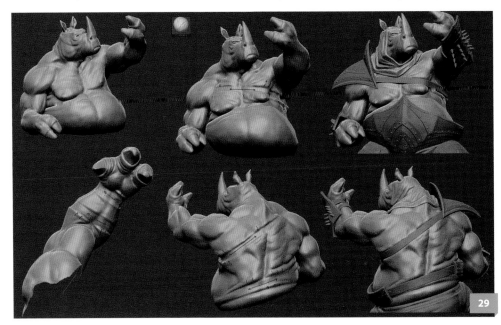

With the ClayBuildup brush, carve the area in which the strap and body make contact. Then sculpt the borders of the flesh to make them bulge from the tightness of the strap. You can also use the Inflat brush for this effect. On the back and on both arms do the same thing for the straps holding the belly armor and bracers.

Now you can start to work on the wrinkles on the head (Fig.30). To add some texture, cover each wrinkle with perpendicular brush strokes with the ClayBuildup brush followed by the Smooth brush. Carve the interior of the ears to make them thinner and add some horizontal wrinkles along the exterior of the ears. Define the nostrils, brows and eyelids. Create vertical wrinkles above the mouth and add volume to the lower lip, as well as some perpendicular strokes to define the mouth.

Load the Slash1 brush from the Lightbox (in Brush > Slash directory) and use it to create some scars and vertical cuts along the horn. With the Standard brush set to DragRect mode, load the LeatherySkin_15 alpha from

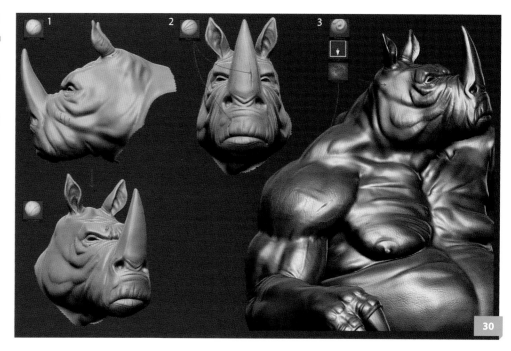

the Lightbox (in the Alphas directory). Lower the Z Intensity to 8 and while pressing Alt (to subtract), drag over small portions of the upper body. Cover the whole upper body with the wrinkly pattern to achieve the look of leathery skin.

To add detail to the straps use the Standard brush in Dots mode without alpha and create

some strokes along the strap (Fig.31). To create the buckle, use the CurveTube brush. As this type of brush can only be used in subtools without any subdivisions, select the eyes subtool and, starting at the eye (because it needs an existing point to start), create a C-shaped curve. Use GroupsSplit to separate the buckle to a new subtool. Move it to place it on the strap.

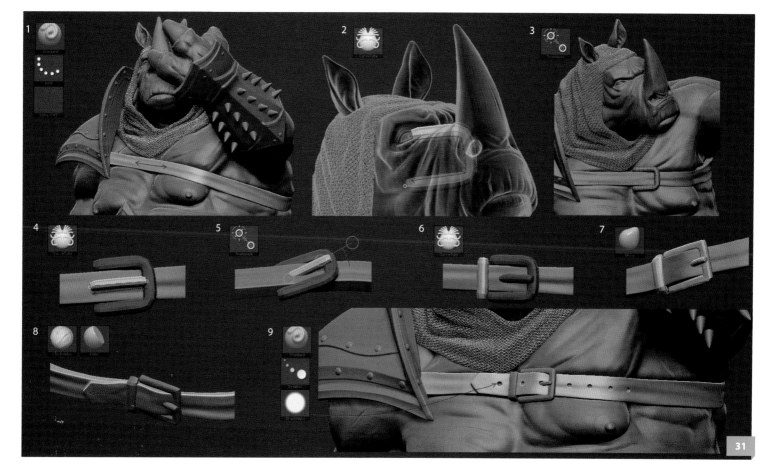

Using the CurveTube brush, draw a new curve starting at the middle of the buckle to represent the hook. Rotate and position it according to the buckle. With the CurveTube brush, create a vertical curve that will be the belt holder. With the Move brush, shape the elements and subdivide them. Use the Polish brush to flatten the buckle sides. With the ClayBuildup brush, sculpt the tip of the belt on the existing strap. With the Standard brush in DragDot mode and Alpha 06, press Alt and create the holes on the belt.

For a final touch, use the Standard brush in DragRect mode with the "leather.psd" alpha (downloadable from Pixologic in the Alphas textile directory) to add a leather texture to all the straps (Fig.32).

Select the lower body subtool and disable DynaMesh. Subdivide it and use the ClayBuildup brush to define the cloth folds. To recover the hard edges of the metal protection on the feet use the Pinch brush along the borders. To create the cloth seams on the trousers, use the Dam_Standard brush. Using the Standard brush in DragRect mode with "burlap.psd" set as the alpha (downloadable from Pixologic in the Alphas textile directory), cover the trousers with the burlap texture. Change the alpha to LeatherySkin_15 and apply it to the feet. Create a mask covering the feet armor and edge of the trousers in order to protect them from receiving the skin texture.

The armor would benefit from some marks of wear and tear (Fig.33) so, using the Standard brush in DragRect mode and some corrosion alphas that you can download from Pixologic's website in the Alphas > Effects directory, add texture to all the metal pieces. Use the Slash1 brush to create cuts all over the armor.

Props

I will briefly explain how the props were created (Fig.34). As you might have noticed in the initial sketch there are several skull

elements in the scene: the chalice on the throne and some skulls lying on the floor. I started by creating a basic skull which I used for all those elements.

You might want to create the skull as an independent tool. Start by loading the PolySphere tool from the Lightbox >Tool directory. Press DynaMesh to convert it and activate Symmetry by pressing X. Shape the top of the skull with the Move brush and then, with the ClayBuildup brush, start carving the orbits and adding volume to the zygomatic bone (cheekbone) and the maxila. Whenever you need to just press Ctrl and drag on the background to remesh the model. Carve the hole for the nose and carve the sides of the head to define the temporal bone. You can press ClayPolish (Tool > Geometry) to rapidly remove the sculpt marks and define the main planes of the skull. Sculpt the teeth and save the skull tool.

To create the chalice we have to open the top of the skull. With the Slice Curve brush create an horizontal cut on the top of the skull. Each side of the cut will be given a different polygroup. Next to the DynaMesh button there is a Group button; enable it so that each polygroup remeshes independently and Ctrl and drag on the background to remesh the model. Each part of the skull is now a fully closed object. In Move mode, press Ctrl and Alt and move the top part down. This will create a copy of the top, but as you pressed Alt while copying, DynaMesh knows that this volume will be subtracted. Below the DynaMesh button there is a Create Shell button, press it. DynaMesh will subtract the top and also give an interior thickness to the skull. To make the interior of the skull softer use the Smooth brush. Also use the Trim Dynamic brush on the edges of the opening to create an irregular cut.

The foot of the chalice was created with the CurveLathe brush (Fig.35). In front view, draw the contour of the chalice foot profile. Make sure that the axis line is vertical. The

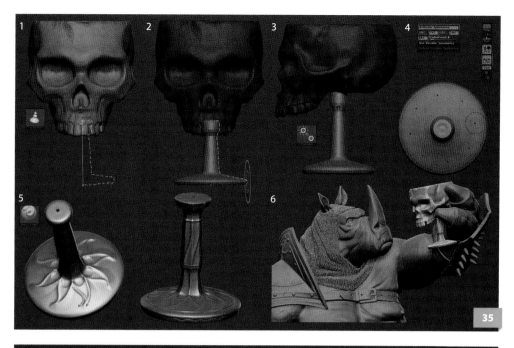

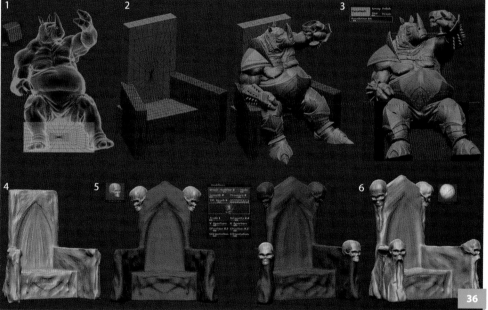

surface is generated and you can adjust the profile by moving the curve points. Use GroupsSplit to send the foot to a new subtool. Move it to place it below the skull. In the Transform menu activate Symmetry and set the axis to Y and enable R for radial symmetry. Enable the L Sym button to activate local symmetry. Now every stroke will be replicated around the foot. Use the Dam_Standard brush to create all the decorative elements. Disable DynaMesh on the skull and merge it with the chalice foot to be part of the same subtool (using Merge Visible). Change to the rhino model tool and Append the chalice subtool. Move, scale and rotate to place it in the hand of the rhino.

To start building the throne choose Append and pick Cube3D (Fig.36). Move and scale it to place it below the rhino. In Move mode, while pressing Ctrl, move the box to duplicate it. Scale and position the duplicated boxes to create the volume for the back and arm supports. Enable DynaMesh and reduce the Resolution slider to 64. Ctrl and drag on the background to remesh the volume of the chair.

My idea was to create a chair that looked as if it had been carved out of a block of stone. Using the ClayBuildup brush I carved the surface randomly to have a more organic base. Load the skull tool you created and

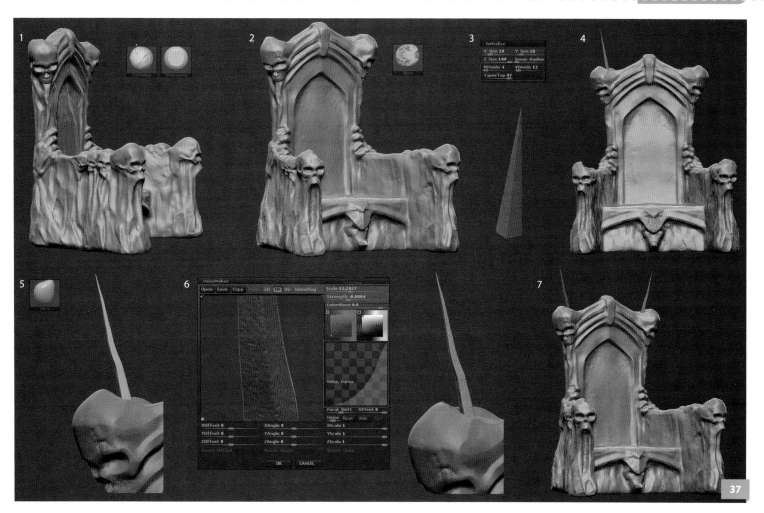

select the InsertCube brush. In the Modifier submenu in the Brush menu, click on the object window and pick the skull tool. Drag on the chair to place the skulls. You can adjust their position and scale after placing them. Place skulls at the top of the arm supports and the top of the back. Increase the DynaMesh Resolution slider to 100. Ctrl and drag the background to fuse the skulls with the chair. Use the ClayBuildup brush to create some rocky structures on the sides of the chair and to combine the skulls with the rocks.

Add more skulls along the arms of the chair (Fig.37). Create some arches at the top of the back and add some grasping hands holding the throne. Use the Trim Dynamic brush to create sharper edges on the rocks. Using the Noise brush, paint randomly over the throne to add some rock-like imperfections. In the Brush menu, under Surface, you can adjust the size of the noise with the Scale slider.

To create some spikes for the throne select the Cylinder3D tool and under Initialize set the X and Y Size to 20, Hdivide to 4, Vdivide to 12 and taperTop to 97. Append the spike to the throne tool. Place the spike on top of a skull. Subdivide the spike with Smt disabled and, with the Move brush, create some imperfections along the spike and click on

Noise (Tool > Surface). In the Noise Maker set Scale to 13.3 and Strength to -0.0004. Adjust the noise curve to something you are happy with. Press Duplicate to create a copy of the spike and position it on the other skull.

For the battle axe start by picking a new Cylinder3D tool (Fig.38). Under Initialize

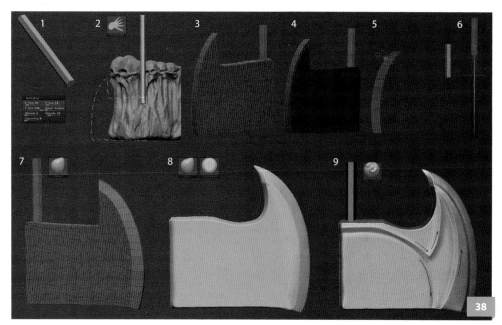

set the X and Y Size to 10, HDivide to 6 and VDivide to 30. Append this to the rhino tool and position it near the right side of the throne. Draw the contour of the head of the axe with the CurveQuadFill brush. An extruded volume with the form of your curve will be created with the depth of your brush size. Use GroupsSplit to make the handle and head of the axe different subtools. Mask all of the axe head with the exception of the faces at the cutting area. In Move mode, press Ctrl and move to extrude the faces at the blade. Scale horizontally to make the blade sharp. With the Move brush, reshape the blade. Enable DynaMesh to get an even sculpting surface. Use the Trim Dynamic brush to polish the edges to create bevels and the Move brush to shape the head. With the Dam_Standard brush create some dynamic drawings on the surface of the head.

Select the axe handle subtool (**Fig.39**). With the Move brush, pull up the vertex at the bottom of the cylinder to create a spike. Also shape the area that connects the handle to the axe head to make it larger. Disable Smt and subdivide it four times. Enable Smt again and subdivide it twice more. Using the

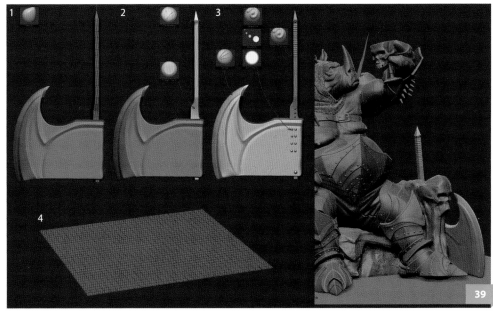

ClayBuildup brush, enlarge the area around the spike. To polish the surface, use the Trim Dynamic brush. Use the Dam_Standard brush to create some ridges at the handle to create a gripping area. Using the Standard brush in DragDot mode and Alpha 06, add some nails at the blade and handle. As with the armor, use the Slash1 brush to create scratches on the metal. Choose Append and pick a Plane3D tool. Position and scale it to create a floor plane. Place the axe against the throne.

Start the shield by choosing the Sphereinder3D tool (**Fig.40**). In Initialize set Z Size to 47, TRadius to 39, TCurve to 79, HDivide to 40 and VDivide to 41. Select one top, keeping one edge loop and hiding the rest. From Geometry choose DelHidden to delete the invisible polygons. Enable DynaMesh, which will automatically create polygons on the back. In the Transform menu enable Activate Symmetry and turn on the Z axis. Enable R for radial symmetry and change the RadialCount to 3. Select the

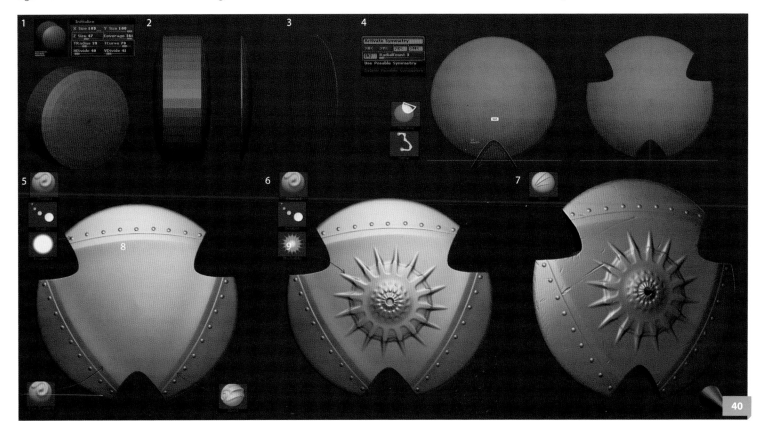

ClipCurve brush in Curve mode and clip the edge with a curve creating a decorative cut at the border.

The Slash2 and Dam_Standard brushes were used to create decorative lines, and the Standard brush with DragDot mode activated and Alpha 06 were used for the nails. Using the Standard brush in DragDot mode, pick Alpha 52 and create the decoration in the center of the shield. Use the Slash1 brush to scratch the metal and append a cone as a spike at the center of the shield.

Merge the spike and shield, and append it to the rhino model. Place it on the left side, leaning against the throne (Fig.41). Select the ground plane and subdivide it. With the Standard brush in DragRect mode, load the "SW_RocksandCracks_08.psd" alpha (you can download this from Pixologic site in Alphas > Rocks). Drag and press Alt to create cracks all over the pavement. Use the regular Standard brush to add some irregularities on the ground around the throne.

Painting

We will paint the model with polypaint (Fig.42). The only brush we will be using is the Standard brush, varying its mode and alpha. Select the Standard brush. Enable RGB and disable Zadd so that it paints, but doesn't sculpt. In my opinion the best base materials for painting are SkinShade4 and MatCap White01, so I alternate between the two while painting as the specularity of Skin_Shade4 might interfere a bit with your perception while painting.

Select the upper body subtool. Start by choosing a beige color in the color picker and choose Fill Object from the Color menu. Change to Spray mode, with a dark brown color, and pick Alpha 08. Paint randomly over the surface with low intensity to create some color variation. With a higher intensity, paint the darkest spots around the eyes, nails, nostrils, lips and nipples. Also darken

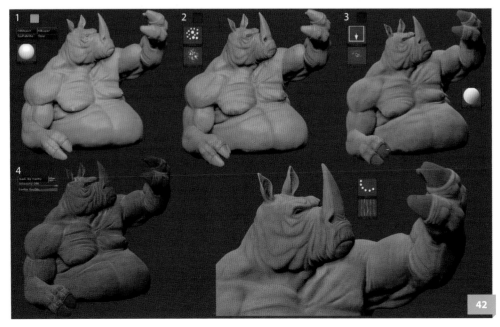

the color slightly around the muscle forms. Use DragRect mode and a dark brown, and choose some armor damage alphas (download them from the Pixologic website, under Alphas > Effects). Drag them over the skin to add stains.

To enhance the sculpted wrinkles, in Tool > Masking choose Mask by Cavity and invert the mask. Press Ctrl + H to make the mask invisible while you paint. Use a dark color with low intensity and a large brush to paint over the model to reveal the detail. Use the Standard brush with Alpha 58 to paint the fibers along the horn and nails.

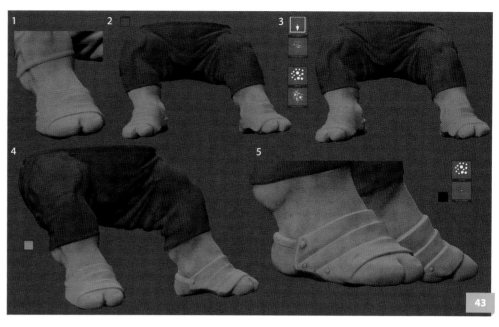

Select the lower body and paint the skin area of the foot, repeating the technique used for the upper body (Fig.43). Choose a reddish brown and paint the trousers with a uniform color. In Spray mode, with a lighter tone of brown, paint softly all over the trousers to create color variation. To add stains use DragRect mode with darker and lighter colors than the base, and use the same armor damage alphas from the Pixologic website.

Pick a mid-gray color and paint the metal protection of the foot. Mask it by cavity and invert it. Paint the scratches with black. Using Spray mode with a small brush radius, paint dark areas around the bolts and at the panel junctions.

All the metal elements were painted using the same technique (Fig.44). Select each armor subtool and fill it with a mid-gray color.

Mask it by cavity and invert it. Choose a black color in the color picker and set the RGB Intensity to 30. Choose Fill Object to paint the unmasked areas. Clear the mask selection. With a Standard brush in Spray mode with a small radius, paint dark areas on the junctions. Repeat this technique for all the metal elements, including the armor, buckle, axe and shield.

For the chain mail hood, fill it with mid-gray (**Fig.45**). Then paint some darker tones in the recessed areas with the Standard brush.

To paint the leather straps, start by filling them with a brown color. In Spray mode paint some varied tones of brown. Mask it by cavity and invert and paint the unmasked areas with a darker brown to reveal the leather cracks. Repeat this on all the leather elements.

The throne was filled with a light gray color (**Fig.46**). Then in DragRect mode, use the same damage alphas from Pixologic, with the yellow and brown color at a low intensity to add some subtle earthy tones. Paint the spikes on top of the throne in Spray mode, using rusty metal colors. Fill the floor with a dark brown and use DragRect mode with the same alphas and varying brown tones over the surface. Fill the floor cracks with a darker color by using an inverted Cavity mask.

The skull on the chalice was painted with varying tones of yellowish white and orange to achieve the bone color. Load and append the skull model you have created and paint it too. Distribute a few skulls around the throne. In order to provide better integration of all the elements, use Spray mode with a brown color to paint the parts of the model that touch the ground to give the impression that the objects are dirty from being in contact with the floor.

Composition

Create a new project and in the Document menu, set the document size to 1200 Wide and 1500 High (**Fig.47**). Choose pure black on the color swatch and choose the Back swatch in the Document menu to make the background black. Also set the Range slider to 0 to eliminate the gradient.

Load the rhino tool into the document, press Edit and turn on Perspective. In the Draw menu set the Angle of View to 30. Set the view of the model to what you think is best. In the Movie menu enable Show under Timeline

for the camera timeline to show at the top of the screen. Click anywhere on the timeline to create a key frame that will store the current view. This way you can go back to this exact view every time you click on the key frame in case you need to change the view for editing.

Remember that from this moment on you should save your project (File > Save) and not just your tool, otherwise you will lose all your work.

Lights

The lights and materials are not separable as they influence each other. In your creation process you will be constantly fine-tuning them simultaneously (Fig.48 – 49).

Use the LightCap system for the lighting. The first thing to do is to disable the default lights. Go to the Light menu and click on the light bulb icon to disable the light. Also set the Ambient light to 0 in order to make sure that there is no ambient light and that we will start from a completely black scene.

We will be setting the light first so it is important to assign a neutral material to the whole model. This material will be based on the existing basic material, with a few tweaks. Select BasicMaterial and under Modifiers (in Material menu), set Ambient to 0 and Diffuse to 100. This is our base, so save the material (Material > Save) as a basic material.

In the Plugins menu launch the SubTool Master. Choose Fill and enable the Material option. Choose OK to apply the basic material to all the subtools. Make sure that all the masks in each subtool have been cleared otherwise the material will not be applied to masked polygons.

There are a few important things to know when using LightCaps. Each light is separated into its diffuse and specular components and you can see each component by pressing the Diffuse or Specular buttons. For every light I will try to explain the setup; however bear in mind that the only two parameters that are independent are Falloff and Opacity – all the remaining parameters are common to Diffuse and Specular.

Another thing to be aware of is that the sphere in which you mark the light direction

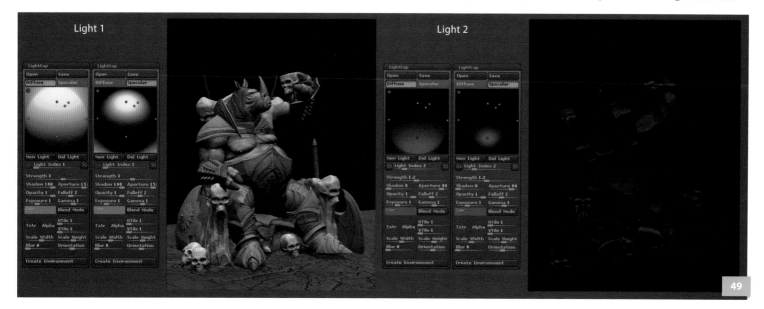

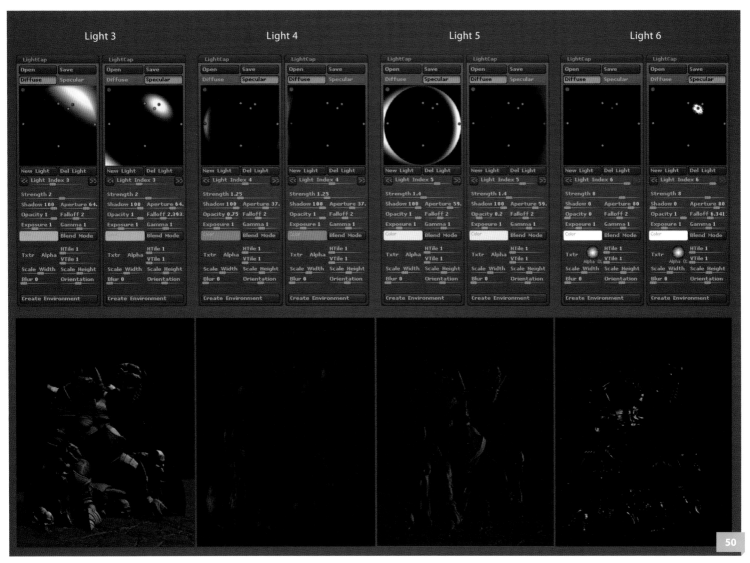

is not really a sphere. It is a squashed sphere in which the borders are actually the back of the sphere. So, if you want to create a light from the side it will be somewhere halfway between the center and the outer edge. Even though the viewport feedback is very good, it is important to render your image in order to have a correct idea of the final result, especially because the interactive viewport display doesn't show the shadows.

Go to the Render menu and enable Shadows in Render Properties. Under BPR Shadow increase the Res value to the maximum, set Angle to 0.5 and Blur to 2. To render this press the BPR button.

I will try to describe the role of each light. The red dot on the spheres indicates the light location. In the Light menu, under LightCap, click on New Light to create a new light.

The first light was set as a Dome light with the objective of simulating a sort of blue sky light coming from every direction. Place it above and change the broad value to 157 for the aperture. Don't change anything in the Specular section.

The second light will simulate the light bouncing from the floor. It is less intense than the first light and has the same brown tone as the floor. Position it coming from below and set the Shadow slider to 0 in order for it not to cast shadows.

The third light is the Key light (**Fig.50**). In the concept there is a strong light coming from the top right, which will be represented by this light. To reflect this, choose a golden color to represent the sun entering from somewhere above. In the specular settings, Falloff was slightly adjusted to 2.39.

The fourth light works as a Rim light to bring out the left contour of the character. Choose a saturated orange as if a fireplace exists on the left. The light should be positioned to the far left in order to leave a very subtle orange line on the character. In the specular settings the opacity needs to be lowered to 0.75 as the highlight might get too strong.

The fifth light is also a Rim light to reveal the silhouette on the right. Chose a light yellow to match the sun's color. For this light lower the opacity to 0.2 in the diffuse settings so that the specular settings have more relevance.

The sixth light is to create some highlights on the skin. This should be positioned in the top right and the diffuse settings should be completely discarded by setting their opacity to 0. Also set Shadows to 0. This will make the light strong and the Falloff should be

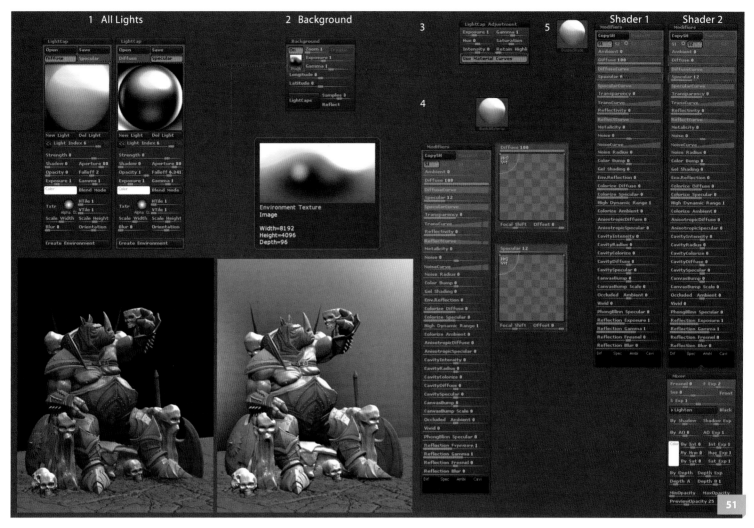

narrowed to 6.3. The objective is to create some really bright spots on the surface. In the Alpha slot choose Alpha 02 to break the highlights a bit.

At the bottom of the LightCap menu there is a Create Environment button (Fig.51). Press this and a spherical environment texture with the color and intensity of your light sources will be created and automatically applied to the background. We will not be using the image as the background, but we need it so that we can use the material parameters that are related to the environment reflections. Go to the Background sub menu (in the Light menu) and then disable the On button. By doing this we can see the environment texture on the reflections, but not on the background.

Materials
When using LightCaps, the specular and diffuse curves of our materials no longer

work because the LightCap dictates their look. However we can still tweak them if we enable Use Material Curves under LightCap Adjustments.

Now the diffuse and specular curves affect the LightCap speculars. When you enable the option the materials will immediately appear darker. Set the DiffuseCurve and SpecularCurve start and end points at the top, meaning that they accept the LightCap value at 100%. Now the material should look as it did before. Save it as a basic material. We will be using this as the base for simpler materials. Press CopySH in the Modifiers submenu to copy the shader to the buffer.

For more complex materials we will be using a material made from a combination of two shaders. This will allow us to separate the diffuse and specular/reflective components and use some mixing options to get finer results.

From the Materials list pick the DoubleShade material. At the top of the modifiers you will notice that S1 and S2 are active, which means that this material has two shader channels. Click on S1 and press PasteSH (to paste the basic material settings to this channel). Reduce the Specular slider to 0. Select the S2 shader and press PasteSH. Reduce the Diffuse slider to 0.

We have S1 set to Diffuse and S2 to Specular. Go to the Mixer menu (with S2 enabled, as each shader channel has its own Mixer values) and change the blending mode from Replace (Normal) to Lighten. Now you have a material that looks exactly the same as the basic material, but which has specular and diffuse separated. Save this material as DoubleShade, which will be the base for the more complex materials.

To apply a material, disable RGB and enable M in the top menu. This will mean that when

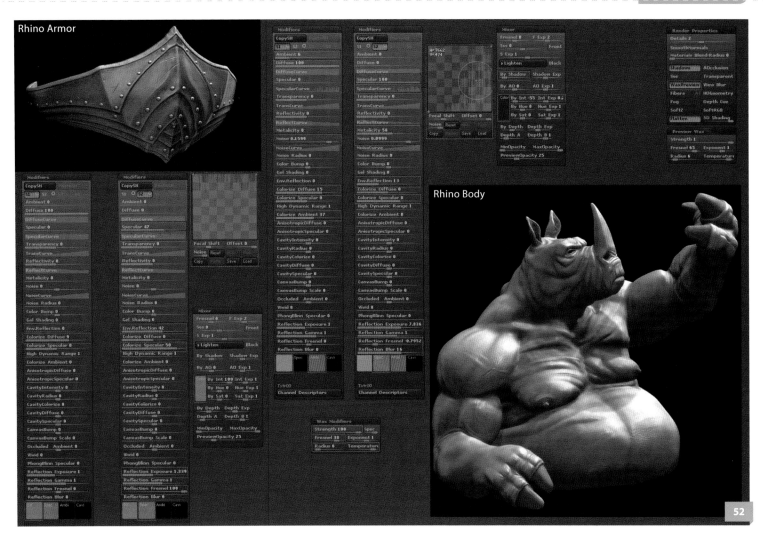

you paint or choose the FillObject option in the Color menu, the material will be applied instead of the color. If you need to apply the material to a part of the subtool, you can either paint the material directly on the surface or isolate part of the object and fill it with the material.

To create a new material, pick a slot that is not being used in your project and load one of the base materials we have created. Apply it to the parts that will be affected by the material before starting to change the settings so that you have interactive feedback from the viewport during the adjustment. After creating each material save it and give it a logical name.

Armor Material
Load the DoubleShade material. Apply it to all the metal parts (armor, chain mail hood, axe and shield) and also to the lower body, which will temporarily be all metal (Fig.52).

In the S1 shader, add a orange tone to compensate for the blue light by adding a brownish orange color to the Diff color swatch at the bottom and increasing the Colorize Diffuse slider a bit.

In the S2 shader increase the specular value to get brighter highlights and also colorized the specular with an orange tint by putting this in the Spec color swatch at the bottom and increasing the Colorize Specular value. Increase the SpecularCurve Noise value to make the specular irregular, which contributes to the look of a worn surface. The Env.Reflection value should be set to 42, enabling environment reflections (which are based on the background texture). To manipulate these reflections, increase the Reflection Exposure value to make them brighter and set Reflection Fresnel to 100.

In the S2 Mixer, set how S1 and S2 will be composited together. In the Color swatch

pick the medium gray color from the lighter areas of the armor pieces (drag from the color swatch to a part of your model to pick its color). Set the By Int value to 100. What you have just done is tell ZBrush that in the medium gray areas the intensity of the S2 shader is 100%. Where the color is not medium gray it will reflect less. As you painted the dirt on the black areas of the armor, the gray parts will reflect whilst the black parts won't. This will give the look of old scratched armor. Save the material as "rhino_armor".

Body Material
As we did on the armor, start with the DoubleShade material and apply it to the upper body. In S1 add an orange color to the Ambi color swatch at the bottom, raise the Colorize Ambient value to 37 and also the Ambient to 6. This is meant to add the effect of some light going through the skin. I increased the Colorize Diffuse using a

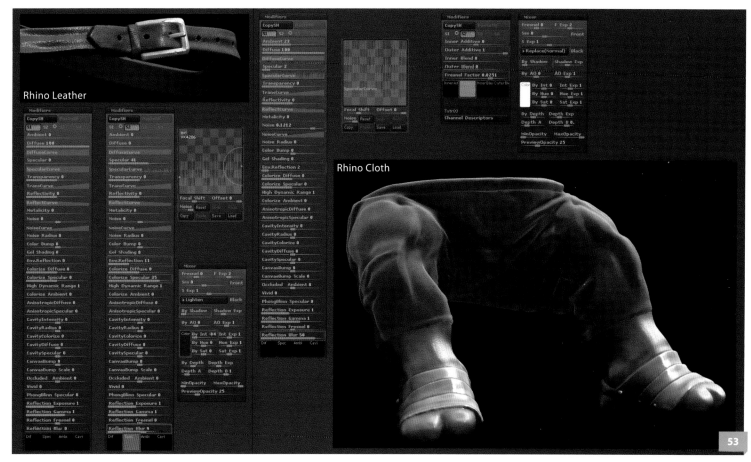

Rhino Leather

Rhino Cloth

53

brownish gray in the Diff color swatch to shift the diffuse color to a warmer tone. The Noise value was also set to 0.15 to create some irregularities on the skin.

For S2, Specular was set to 100 and the SpecularCurve was manipulated to tighten the highlights. Also Noise was set to maximum to break the speculars. Set Env. Reflection to 13 to reflect the environment. Increase Reflection Exposure to 7.8 and Reflection Fresnel to 0.79 so that the reflections show more at grazing angles, and increase Reflection Blur to 16 to make the reflections softer. Add a warmth to the speculars by setting the Spec color swatch to orange and raising the Colorize Specular to 8.

In the S2 Mixer the ByShadow slider should be set to -70 so that the specular highlights are reduced in the shadow. Pick the dark brown color from the skin cracks and put it in the Color swatch, and set By Int to -55 in order for the skin cracks to reflect less than the rest of the skin.

In the Render Properties (Render menu) enable WaxPreview. In the Material menu, under Wax Modifiers, set the Strength to 100. Set Fresnel to 38, Radius to 6 and Temperature to 70. Also copy this value to the Preview Wax settings in the Render menu to have a viewport preview that matches the render settings. This wax effect will fake some of the subsurface scattering that we are used to seeing in skin.

Select the lower body subtool and paint the material on the feet skin areas. Save the material as "rhino_body".

Leather Material
Start with the DoubleShade material. Apply it to all the straps. Don't change anything on S1. In S2 set Specular to 41, lower the start and end points of the SpecularCurve and use the noise slider to add noise to the curve. Env. Reflection should be set to 11 and Reflection Blur to 9. A reddish orange should be added to the Spec color swatch and raise Colorize Specular setting to 35. This will add orange to the highlights (Fig.53).

In the S2 mixer By Shadow needs to be set to -100 to cut the specular in the shadows. A dark brown from the leather cracks should be added to the Color swatch and By Int set to -84 to remove highlights from the cracks. Save as "rhino_leather".

Cloth Material
Start the cloth with the DoubleShade material. Apply it by painting the material to the trousers in the lower body subtool. This material works in a different way, so you need to put the diffuse and specular settings in S1 while using S2 to create a falloff effect.

In S1 the Ambient needs to be increased to make the material look flatter. Specular should be set to a value of 2 with the objective of activating the Env.Reflection parameter. If Specular is 0 the Env.Reflection won't have any effect. We need to add a lot of noise to the SpecularCurve so set it to 0.12 to make the material look soft. The Env.Reflection settings should be set to a low value and the Reflection Blur to 50, also contributing to the soft effect.

From the material list choose Fresnel Overlay, go to the S2 of this material and press CopySH. Go back to your cloth material and in S2 press PasteSH to paste the shader effect. Set Outer Additive to 1 and Fresnel Factor to 0.82. Change the OuterAd color swatch to a beige color. In the S2 Mixer change the blending mode to Replace (Normal) and set By Shadow to -80. This creates a falloff effect typical of cloth and prevents it from happening in areas of shadow. Save as "rhino_cloth".

Eye Material

This is going to be a very simple material. Start by loading the Basic Material and then apply it to the eyes spheres. Set Diffuse to 0 to make them black. Set Specular to 100 and manipulate the SpecularCurve to create a more concentrated highlight. To further increase the highlight raise the High Dynamic Range to 1.19. An orange color should be added to the Spec color swatch and the Colorize Specular set to 54 to make the highlight color warm. Save as "rhino_eyes".

Throne Material

The stone material of the throne starts with the DoubleShade material again. In S1 raise the Ambient settings slightly to make the stone less dark in the shadows. Set Noise to 0.25 and Colorize the Diffuse with a yellow color in the Dif color swatch to make the stone a warmer color (Fig.54).

In S2 set Specular to 11 and then set SpecularCurve to maximum noise to make sure the stone isn't shiny. The Noise value should also be set to maximum in order to break the highlights. Set Colorize Specular to 33 and then add a warm yellow in the Spec color swatch to add some warmth to the highlights.

In the S2 Mixer set ByShadow to -100. Choose white in the Color swatch and set By Int to 59, so that the brighter colors reflect more than the darker ones. Save this as "rhino_throne".

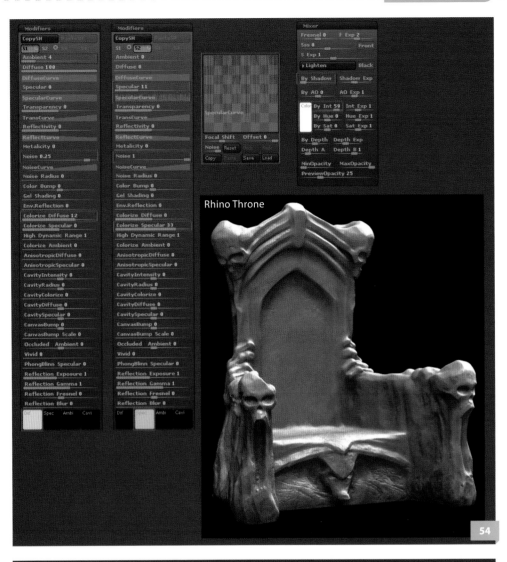

Skull Material

Start the skull with a DoubleShade material again (Fig.55). Apply this to all the skulls around the throne and to the chalice skull. Bone is a porous material, which means that it lets a lot of light go through it making Subsurface scattering very noticeable. So in the Wax modifiers increase Strength to 33, Fresnel to 100, set Radius to 3 and Temperature to 40. Set this to a yellowish color.

In S1 set Ambient to 10, choose a yellow color for the Ambi color swatch and set Colorize Ambient to 69 to increase the illusion that light is passing through the object. Set Noise to 0.082 to make it look more organic.

In S2 set Specular to 11 and add noise to the SpecularCurve. Add a yellow to the Spec color swatch and set Colorize Specular to 41, which adds warmth to the highlights. In the S2 Mixer the ByShadow should be set to -100 to cut the highlight from the shadow areas. Save this as "rhino_skull".

Ground Material

Once again, use the DoubleShade material and apply it to the ground plane. In S1 set Noise to 0.11 to add an earthy feeling to it. In S2 set Specular to 16, change the Spec color swatch to a mid-brown and Colorize Specular to 37 in order for the ground to look browner. In the S2 Mixer set ByShadow to -100 to cut the shadows from the specular. Pick a dark brown color from the ground cracks and use it in the Color swatch with a By Int of -100 to prevent the highlights showing in the cracks. Save this material as "rhino_ground".

Render

The model is ready so it is time to make the final render (Fig.56). In the Render menu, in Render Properties, enable AOcclusion. Under Bpr Ao increase the number of Rays to 20, set Angle to 160, Res to the max and Blur to 2 in order for the ambient occlusion to have higher quality.

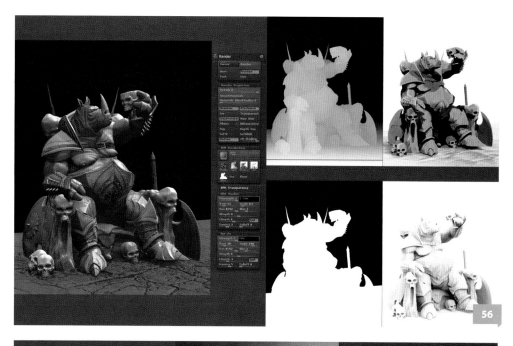

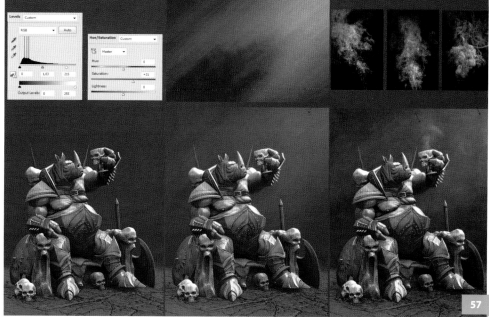

In Render Properties, raise the Details value to 3 and set the Materials Blend-Radius to 1 so that ZBrush slightly blurs the frontier between different materials.

Press the BPR button to render the image. After the image is rendered, the different render passes show under BPR RenderPass. You can click on each of the image icons to save the Shaded render, the ZDepth buffer, the isolated shadows, Ambient Occlusion pass and the mask (alpha).

Final touches

After saving the image you can do a few final touches in Photoshop (Fig.57). Adjust the Levels to make the image brighter and increase Saturation to make the colors more vivid. Blend the horizon with the background color. Paint some subtle light beams coming from the top right corner with a soft brush and blending mode set to Screen. Some dust particles can also be painted on another layer to enhance the mood. To finalize the image use some smoke photos from a texture site and set them to Screen blending mode to create the smoky fog and the steam coming out of the chalice.

Fig.58 shows the final image. I hope you found the tutorial interesting and enjoy using some of the features of ZBrush 4R2.

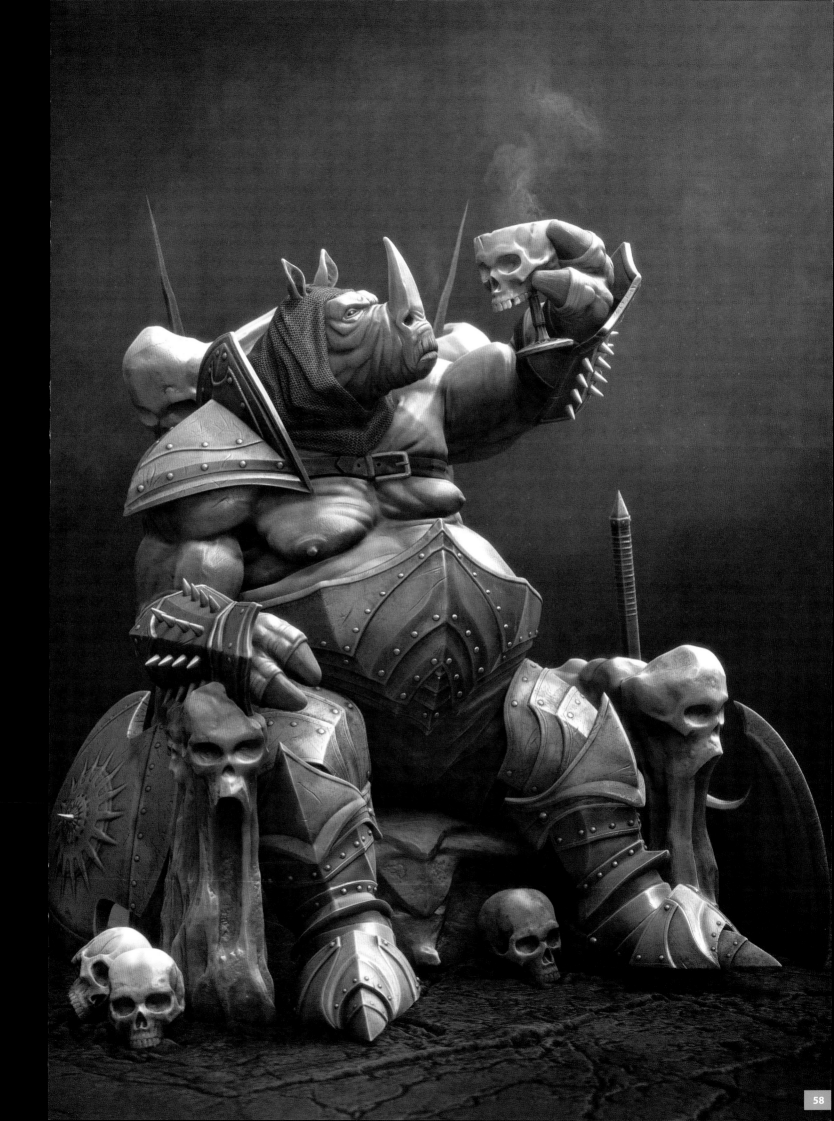

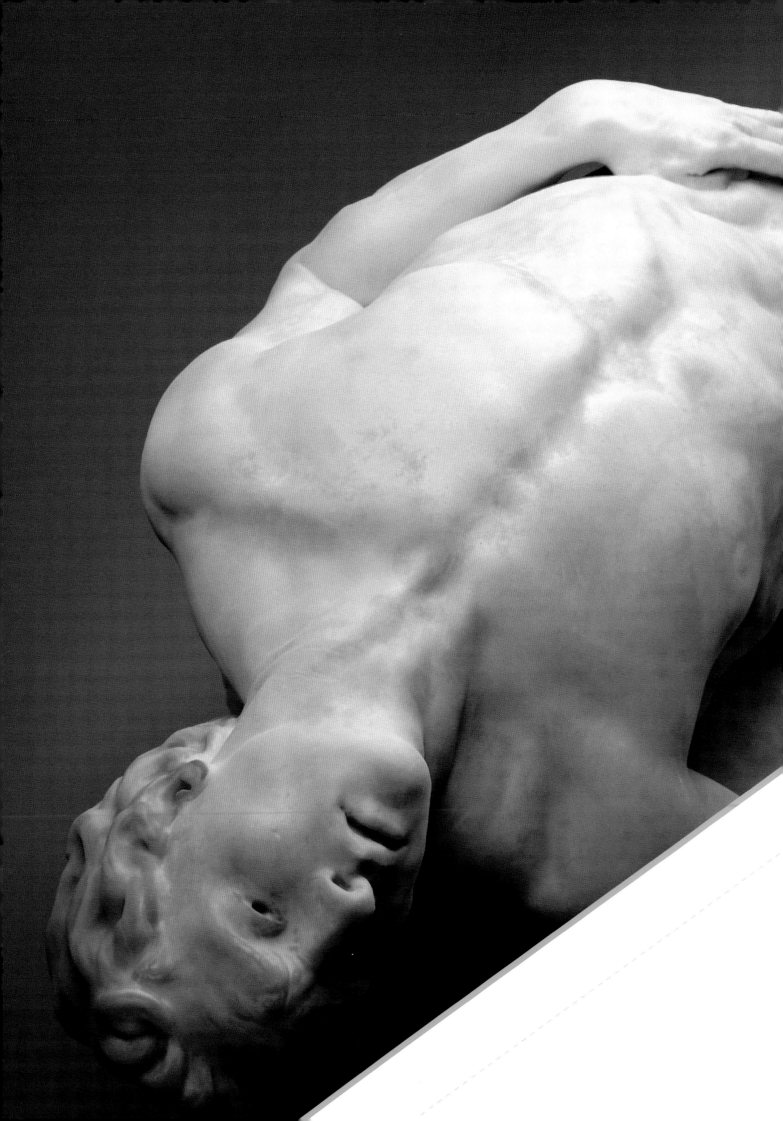

Classical Sculpture

Sculpting isn't a new invention. We can see classical sculptures all around us; in museums, on the sides of buildings or maybe adorning the odd fountain. What makes these sculptures stunning is not only their form and aesthetic attributes, but also their weathered and worn appearance. Rafael Ghencev will be showing us how to capture drama and feeling in your sculpts, whilst providing a masterclass on how to present them using basic materials and textures. As if that wasn't enough, he will also be giving us a brief insight into the history behind some of the most defining eras of this traditional artistic medium.

> **Classical artists spent more time on the hands and feet than the face, because they knew that these parts were important**

Greek Sculpture By Rafael Ghencev

Introduction

In this tutorial we are going to study some approaches to creating your own classical sculpture. I'm not a history of art professional, but I'll try to give a short explanation of Greek history. Ancient Greek sculpture is traditionally divided into six basic styles:

- Daedalic Greek Sculpture
- Archaic Greek Sculpture
- Early Classical Sculpture
- High Classical Greek Sculpture
- Late Classical Greek Sculpture
- Hellenistic Greek Sculpture

I'm going to be focusing on the last of these styles in this tutorial – Hellenistic – and how it evolved during the Baroque period, as in this period expression was used to dramatize the sculpts.

In the original Hellenistic period sculptors felt less compelled to portray the ideal world like their ancestors. They started to introduce topics such as pain, death and sleep, offering a variety of new forms and expressions to explore. The aim was to portray expressiveness and atmosphere; something that is particularly obvious in the portraits, where these were used alongside an accurately sculpted face to capture the character of the subject.

After the Hellenistic period ended, Greek traditions went into obscurity and only in the Renaissance and Baroque periods did the Greek traditions re-emerge, this time in Italy. We know this period for famous artists like Michelangelo, Benvenuto Cellini, Gian Lorenzo Bernini etc. This is the most famous period of sculpture.

In the Renaissance period artists were inspired by their predecessors from the Classic period. On the other hand, in the Baroque period the inspiration was Hellenistic sculpture.

At this stage a large driving force in sculpture was religion. Christian artists absorbed a variety of classical techniques and used and revitalized them in their own work. The vast repertoire of postures, gestures and expressions that had been founded by the Greeks enriched their own genius, and they applied these resources when illustrating saints, martyrs, myths and the heroes of the time. We're going to try and capture some of that movement and drama here in our sculpture.

ZBrush is Only a Tool

There's something very important that everyone should understand from the beginning. CG modeling software is only a tool, like a pen or carving tools used for sculpting. Nowadays I see a lot of guys starting out in CG and thinking that the only thing you need is to read comic books and know ZBrush. They have forgotten that sculpture is more than that; you need to work on improving your artistic skill and think about your motivation, background and feelings etc. Remember to always study classical arts, like drawing, sculpture and photography etc. This will make you a better artist.

01

Classical Sculpture

Starting the Process

First of all we need to collect references – a lot of references! This is to understand the style and the process. We need to study the poses, feelings and emotions that the classical artists achieved with their pieces. You can do this with a simple search on Google.

Planning the Piece

Before we start to build the model we need to plan what we'll do. The first thing I did was to think about the subject. I decided to represent man's fall in the Garden of Eden. My idea was to show Adam on the ground with the fruit at his side. Once you have an idea, start planning how you will build the piece and make it strong and dramatic.

We have a couple of options. Firstly we could draw something and make a few sketches to get an idea of what we want, but I know there are a lot of good artists that can't draw, so in this case I'll show you a different approach to planning your model. In the past artists used to build simple maquettes to understand and test the idea, pose and drama etc. So that's what we'll do here.

Preparing our Maquette

Open ZBrush, go into Light Box > Project > Mannequin and choose "8headMan Ryan" (Fig.01). This is a simple maquette that is easy to manipulate. This will help us to do some poses and layouts that will then allow us to decide how the model will look.

Using Move (W) and Rotate (R) we can play with the character, manipulating the arms, hands, legs and head etc (Fig.02). Using these tools I created three different poses whilst trying to improve my idea and make it strong and dramatic (Fig.03).

Starting the Model

Now we have decided how the model will look, we can start to build it. The first thing we need to do is make a simple mesh, which I like to use because there are no generic

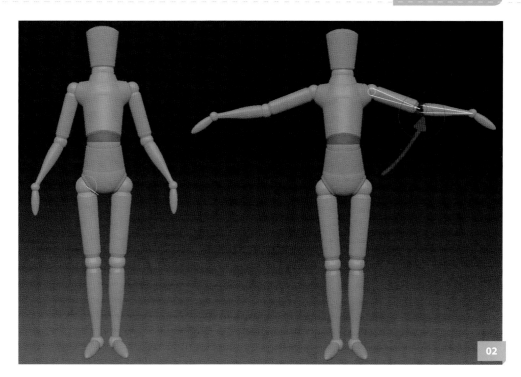

02

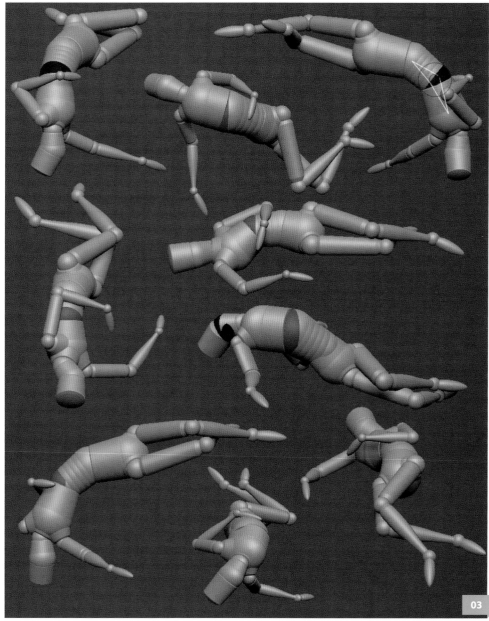

03

shapes in there, and nothing is pre-made. We need to think and transform the base into a unique model (Fig.04). With the base mesh in your hands you can start to build the basic shapes.

There is something we can use in our favor, and that is symmetry. We don't need to build one side at a time. However you do need to know the right time to use it and when to turn it off and starting working without it. I will show you when it's time to turn it off. By pushing the X button you will activate the symmetry and then by using the Move brush, you can start blocking in the basic shape of the model. At this point the important thing is to reflect correct human proportions.

Tip: Work on the structure of the model. Fewer polygons is better when working on the big shapes and defining the silhouette. Only divide the mesh if you have already made all the possible corrections in that level of division.

Once you have added one more division you can start to use the Standard brush to make some muscle mass and the basic form of the head. By adding one more division you can start to use the Clay brush to refine the individual forms, always checking if the proportions are correct. You can also add a little information on the head, like the mass to represent the hair. At this stage we can see

the structure of the model is already there. All the important volumes are in place (Fig.05).

Refining Muscles

Now you can add one more division and use the Clay brush to continue to work on the muscles and refine the face and head.

This is important as we can now see how the expression on his face will look (Fig.06).

For the body we need to create a more natural look by adding more muscle information and by trying to balance the bones, muscle and fat (Fig.07 – 08). This is

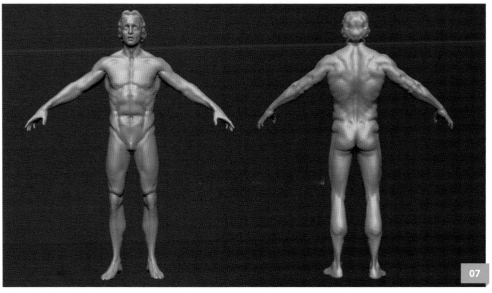

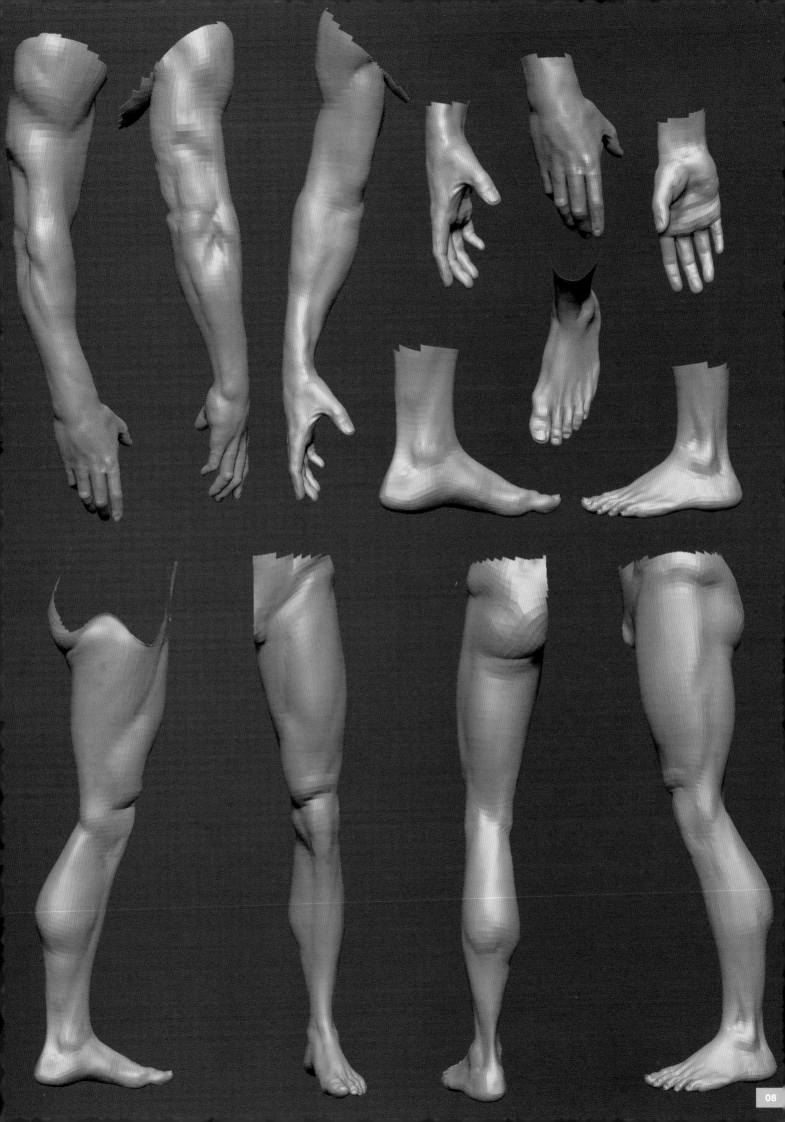

a good point to start working on the hands and feet. When working on these parts you should try to always use a lot of references, because these parts are very important and expressive. If these elements are not done well the model will not be strong enough. Classical artists spent more time on the hands and feet than the face, because they knew that these parts were important when it came to showing power and emotion.

Now it's time to turn of the symmetry and start to pose your character. You should always finish the structure of the model before you turn of the symmetry and then you can put the detail on each side differently, to show some imperfections etc.

Posing

The next part is the bit that scares everyone. This would be very difficult if we hadn't planned it before. With our simple maquette made, everything from this point will be easier to do. The first thing to do here is to get our maquette and do some snapshots with Shift + S. You should get some different angles to help as references (Fig.09).

Create a layer for our pose in Tool > Layers and name it "pose". This is important in order to protect the original model in case you make any errors. After this press the R button to activate Transpose (Rotate).

With the Transpose button activated we need to create a mask to start the posing. So hold down Ctrl and click on the part of the body you are going to edit. The important thing here is to always create the mask while thinking about how the bones work in the real life. Without this knowledge you can't get a good result using Transpose (Fig.10).

To organize the transpose process better I always start with the big areas and move onto the smaller ones. Firstly transpose the torso, legs, arms and head, but don't try to perfect the pose on the first try. Start by working on the basic form (Fig.11).

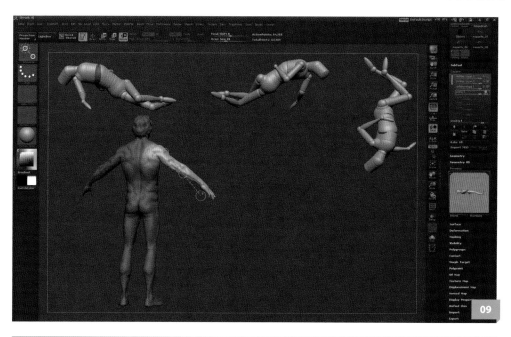

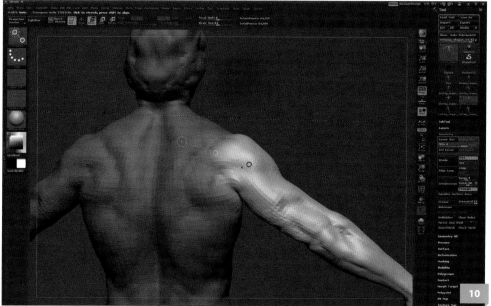

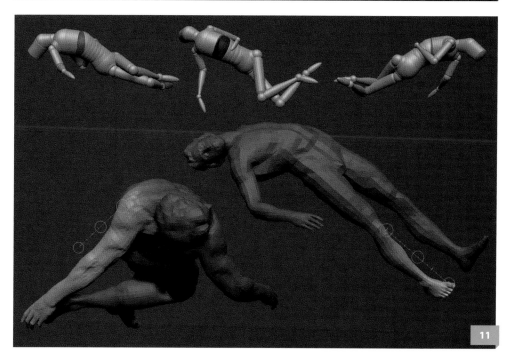

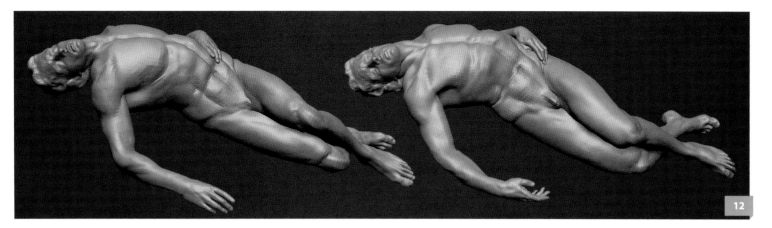

Tip: It is always important to fix the proportions and muscles when working with the Transpose tool, because sometimes this tool changes the model a lot and we need to fix things at the same time. In the image we can see a lot of errors in the proportions caused by using Transpose – like the size of the chest, which is too stretched – so we need to fix these using the Move brush (Fig.12).

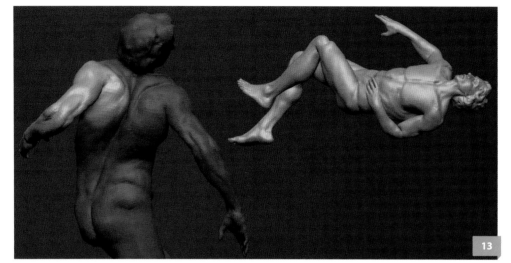

After that we start refining the pose, adding more drama in the arms and back, and flexing the legs a little (Fig.13). When every part is in place you can start to correct the pose of the hands and fingers. Then do the same thing to the feet. It's important to do these parts patiently (Fig.14).

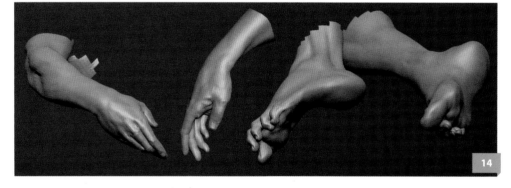

Adding skin details

With our pose defined it's time to finish our piece. Using the Clay brush, refine each element. Create the area where the skin compresses on the neck and back etc (Fig.15). Also, at this point, you should continue to refine his face and expression, and work a little more on the hair (Fig.16). This part of the process is a little complicated and will take some time to do, because we need to know how the skin behaves when pressed and how the muscles work in that pose to improve the natural look.

Creating the Base and Apple

Next it's time to create the base to your model. You should be asking: why didn't we do the base from the beginning? I didn't do this at the beginning because I didn't want to

limit my pose to the base. I prefer to try to get the best pose I can without worrying about the shape of my base. So now we can build a base and fit it onto the model. To create this we want to build a cylinder in another 3D package, bring it into ZBrush and start to push it around using the Move brush to fit it to the model (Fig.17).

After you have done this, start to work with the Clay brush and adjust things to add some volume. Then flatten these to make it look like a rock (Fig.18).

Then we can start to use the great Noise tool. This tool will help us a lot when creating the look of a rock. By playing with the curve and its strength you can create a good result (Fig.19).

Using the Planar we can create some flat areas in the middle of the rock (Fig.20).

To finish our prop, get a simple sphere and, using Radial symmetry, start to create the shape of the apple (Fig.21). With the basic shape sorted turn off the symmetry and bring some asymmetry to the apple.

To do the bite I used Clay Tubes and carved a hole; for the rest of the model the Clay brush will do the job. The only thing left to

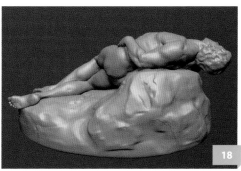

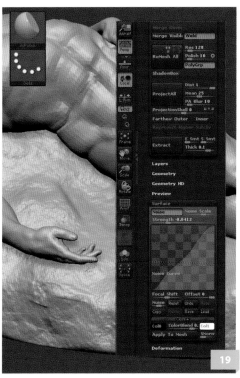

try to do is create some kind of teeth marks to add a little realism. Then I used the Noise tool to add a little more texture to the interior part of the apple. This time we need to paint

a mask on the external part to avoid the noise being applied to the whole apple. Then press Apply to Mesh to bake the noise to the polygons (Fig.22).

Finishing the Model

Almost everything is finished; we only need to put the apple in its place (Fig.23). I decided to add some little veins to his arms; not too much, just a subtle touch. We can do this using the Standard brush and then use Smooth to make some areas show up more than others (Fig.24).

We can do more work with the Clay brush by adding some volumes to the skin and use Inflat to compress the skin a little more against itself, for example, by the fingers (Fig.25 – 26). And here we have our piece finished (Fig.27).

We can see how we don't need a hyper-detailed model to see great quality in our work. The beauty of this art is in the form, not in the details.

Now we are going to learn a little more about the Greek tradition, particularly taking

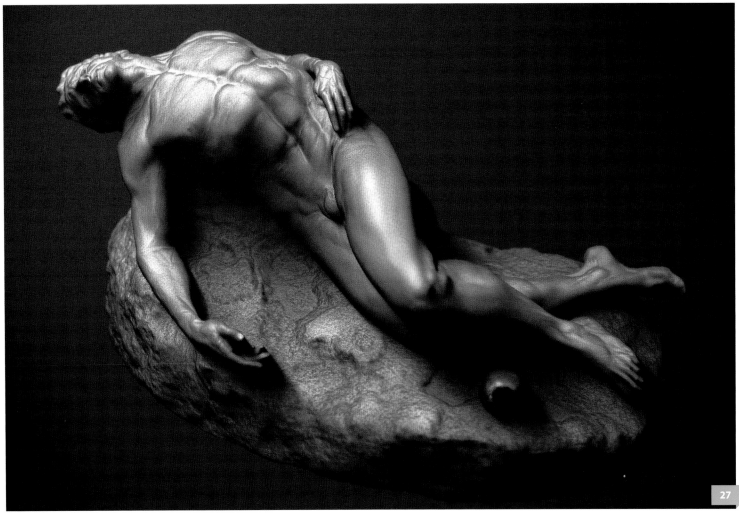

into consideration our subject: the render. How can we render the statue? How did the Greeks and the Greco-Romans finish their pieces? I'll try to answer some questions about this and provide a simple tutorial about how to achieve a good quality render.

Analyzing the Sculptures

When studying Greek traditions we can see that their sculptures were predominantly finished in marble. You will find that a lot of the sculptures were actually painted originally with, at the very least, the hair and the eyes being painted. With this in mind my intention was to make a marble statue with some painting in the hair and maybe in the eyes. I didn't want to make the sculpture look like it is totally finished and wanted it to look as if it has become worn over time. So it was clear that we would be adding some dirt and some faded paint.

It was important at this point to also think about the light. Of course, the Greeks didn't have to think about lighting as their sculptures were generally used in external environments. However, we don't want to deal with the lighting in a careless way, but instead concentrate on intensifying the tension and mood of the scene.

Preparing the Scene

Once you know a little about the history it's time to start our render. The first thing we need to do is create some lighting sets to find the best position and intensity for the lighting. The render is going to be done in V-Ray, so to start we need to export the model into 3ds Max. To do this, select the model and the division that has all the information that we need. You don't need the high resolution model at this point as this is just to test the lighting.

Now, in the ZPlug tab, open the Decimation Masters plugin (if your ZBrush doesn't have it, download it from the Pixologic site). This plugin will maintain all the model information, but will reduce your polycount a lot (Fig.28).

When you open this plugin you can see the option called % of Decimation 20. This gives us the option to choose what percentage of the actual polygons we want when the program finishes its calculations. So let's start with 20% of my polygons, which means that if the model has 1 million polygons, in the final version it will be 200,000 polygons without losing any detail information. When it's done we need to pre-process all the subtools. After the calculation is done we only need to use the Decimate All button and our model will be reduced. The next step is to click on Export All Subtools and save all the subtools as an OBJ file (Fig.29).

In 3ds Max it is better to work with a real scale. To do this open the Customize tab, then click on Unit Setup and configure the

scene as shown in Fig.30. Now our scene is configured to cm. The next thing to do is create our infinity background. I decided to do this to simulate studio photography. To start this we simply need to create a plane object in the Standard Primitive tab and set the scale of this object as in Fig.31.

To apply a curvature to this plane to make our studio background, open the modifiers list and pick the Bend modifier. Next adjust Bend Axis to X, Angle to -90, and turn on Limit Effect to find a good value to make a smooth curvature. Once you have done this your background is done (Fig.32).

When this is done you can bring in the statue. To do this go to Import and select your OBJ. When you have done this adjust

33

34

the scale of the statue to fit the background. In this case I used a simple box to work out a suitable scale for the model. I decided to make the statue a little bigger than a real person, a bit like a monument (Fig.33).

Lighting Tests

Once this is done we can do some tests to find the best lighting setup for our scene. First we need to open the Render Setup, then go to Assign Render and in the Production section pick V-Ray. Now we can adjust a few settings in V-Ray to make quick renders to test our lighting without needing to wait a long time.

By adjusting the settings to what is shown in Fig.34, we will have everything we need to run a test. The other thing we need to do is create a simple material and apply it to all the models. Open the Rendering Material Editor tab and create a V-Ray material (VRayMtl) with a light gray diffuse color (Fig.35). After that is done put this material in the Override Mtl slot in the Global Switches tab (Fig.36). Now we can create a V-Ray camera, configure it to 50mm and change some of the configurations like the aperture (f-number), ISO and shutter speed (Fig.37).

By clicking the C button we can see through our camera now. I like to turn on Safe Frame to see the exact proportions of my render in the viewport (Fig.38).

35

36

37

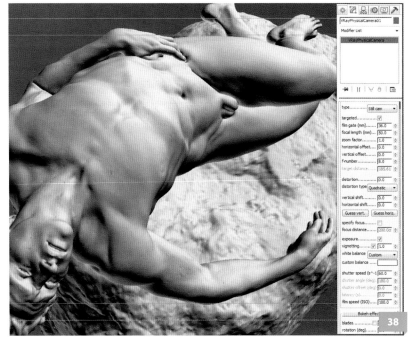

38

Now it's time to create some light. The lighting is responsible for the mood and tension in the scene, and also adds to the drama. From the beginning I was thinking about a dramatic light source coming from above, as if it was a light from the heavens. I decided to use the contrast between light and shadow to show how Adam is moving away from light, coming away from God.

I wanted to show that the important thing is not how much light you have in the scene, but the purpose of the light. So for this model we'll use only one light to show what a simple light put in the correct place can achieve.

Open the Lighting tab, choose V-Ray and give the light a green color. I chose green because I wanted to simulate fluorescent lighting (Fig.39). After some tests I found a position to create our chosen mood (Fig.40).

Texturing

After we have achieved the desired mood it's time to paint and texture the model. Like I said before, I tried to create a worn, dirty marble effect. So we need to come back to ZBrush to use Polypaint. First, pick a de-saturated and bright orange by going to the Color tab. This is going to paint the color onto the model (Fig.41).

Next turn on the Cavity brush by going to Brush > Auto Masking > Cavity Mask. This tool will simulate a dry-brush effect. With this tool we are going to paint the overall color of the model (Fig.42).

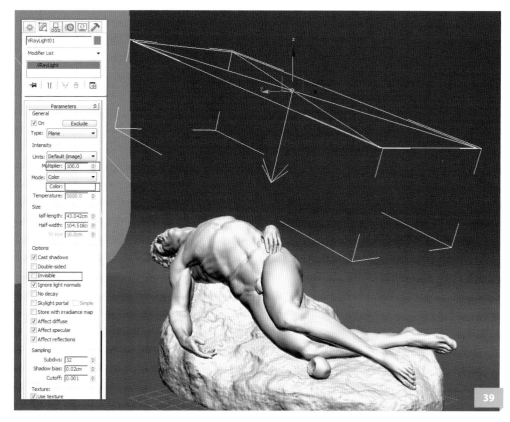

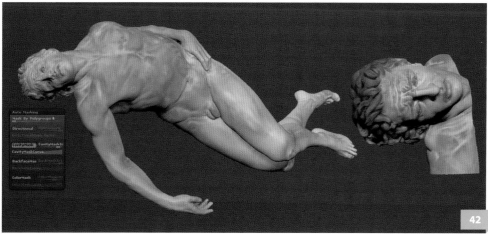

Now it's time to paint some imperfections and dirt into the model. To do so pick the Standard brush and choose the Drag Rect stroke option. For the alphas I searched the web for some images of dirt and worn paint, and projected them onto the statue. Sometimes I do this with a low RGB value to create some overlays (Fig.43).

Using the Dam_Standard brush (you can find it in the Lightbox > Brushes) add some little scratches to the model to create a naturally scratched look (Fig.44).

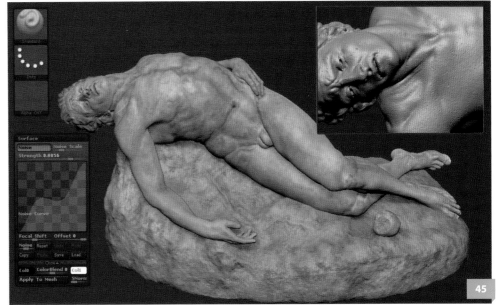

Now to finish the model we are going to apply some Surface Noise. The tool to do this is located in the tool palette. By changing some of the parameters you can achieve the look of old rock. Once you are happy with the effect all you need to do is click Apply to Mesh. Then repeat this texturing process on all the subtools (Fig.45).

Now it's time to create our maps and send the model to 3ds Max. The first thing we need to do is to create a UV for our model. For this tutorial we'll create a simple UV using the UV Master. This is a plugin for ZBrush that creates UVs easily and quickly.

Open the UV Master in the ZPlugin tab. Then click on Work On Clone; this will duplicate your model. Now with the copy of the model open click on Enable Control Painting and click on the Attract From Ambient Occl button (Fig.46). This will calculate the UV from the

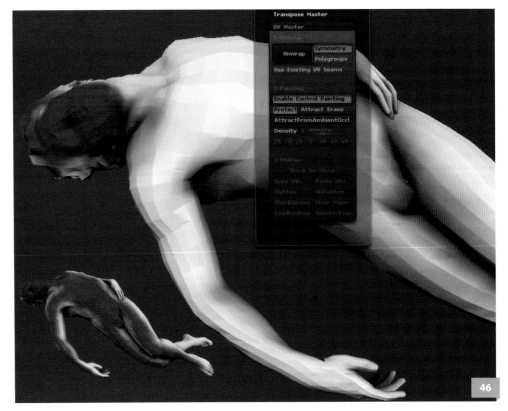

Ambient Occlusion. After that select the Protect button and paint on the area that you want to protect.

Then you only need to push the Unwrap button and click in Copy UVs. Now in the tool palette, select the original model (before the copy) and in the UV Master palette click on Paste UV (Fig.47). Now our model has a UV to apply the textures to.

We need to convert the polypaint to a Color map to apply the textures. Go to Tools > Texture Map and click on New From Polypaint. This will convert the color information into one map. Then we can export this map by clicking on Clone Txtr, then going to the Texture tab and clicking Flip V (to invert our map), then Export and Save (Fig.48).

We want to export one more map to help us in 3ds Max, which is a Normal map containing the finer details. This way we don't need to export the full resolution model into 3ds Max. To do that I selected the division I wanted to export – in this case it was division 5. Everything above this will be converted to Normal map information. To create the map, open Tool, then the Normal map tab, and then activate the Tangent and Smooth UV options. Then click on Create Normal Map and the map will be created (Fig.49).

To export this map use the same process as you did for the Color map. Now export the model again using the same process as you did in the beginning, using the Decimation Master. Don't forget to activate Keep UVs.

Shading

Go back to 3ds Max. We need to swap the old model for the new one, so import the new one and delete the old one. Now it's time to start our marble shader. Select a slot in the Material Editor (M) and then select VRay Fast SSS2 – it's an amazing shader for making translucent materials like skin or marble etc.

Use a preset to start with. In the options select Marble (white). Then change some of the parameters to improve the look (Fig.50).

Scale – additionally scales the subsurface scattering radius.

Overall color – controls the overall coloration for the material. This color serves as a filter for both the diffuse and sub-surface components.

Diffuse color – the color of the diffuse portion of the material.

Diffuse amount – the amount for the diffuse component of the material. Note that this value in fact blends between the diffuse and sub-surface layers.

Scatter radius – controls the amount of light scattering in the material.

As you can see, in the Specular amount I put 0 because I don't like to use the Specular for this shader. In my opinion there are too few options to control it so we'll blend it with a simple V-Ray material that has great Specular control. First, create a simple V-Ray material and adjust the Specular color to RGB with the value of 30/30/30 to create a highlight with a little glossiness (Fig.51).

To make some tests with the new Specular, apply this material in the Override Mtl and click Render (Fig.52). When you look at the Specular it looks too regular and not realistic (Fig.53). To improve the Specular a little go to your Color map and open it in Photoshop. Remove the colors and apply some level adjustments until you create a map with the correct glossiness (Fig.54 – 55).

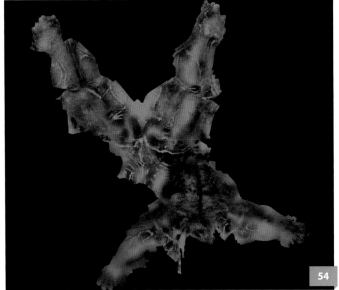

This creates an irregular Specular surface. In some places there will be more glossiness than others (Fig.56).

Now we have created a good looking Specular map we need to create a Blend material to mix both materials. Go to the Material Editor, select the VRay Fast SSS2 material and choose a V-Ray blend material. Click OK when it says "Keep old material

as sub-material". Now click and drag the Specular material to the first slot in the material and set the blend mode to 60% (Fig.57). After you have finished the material, duplicate it twice and apply it to the base of the statue and to the apple. Also change the maps for their relative maps.

Render Setup

Now we have our material finished. The only

change to make is some render parameters to give us a good quality render (Fig.58). Now we can go and make ourselves a coffee and relax a little while we wait for the render to finish!

Once the render is complete all that's left to do is make some color corrections in Photoshop. And here is the final image (Fig.59 – 60).

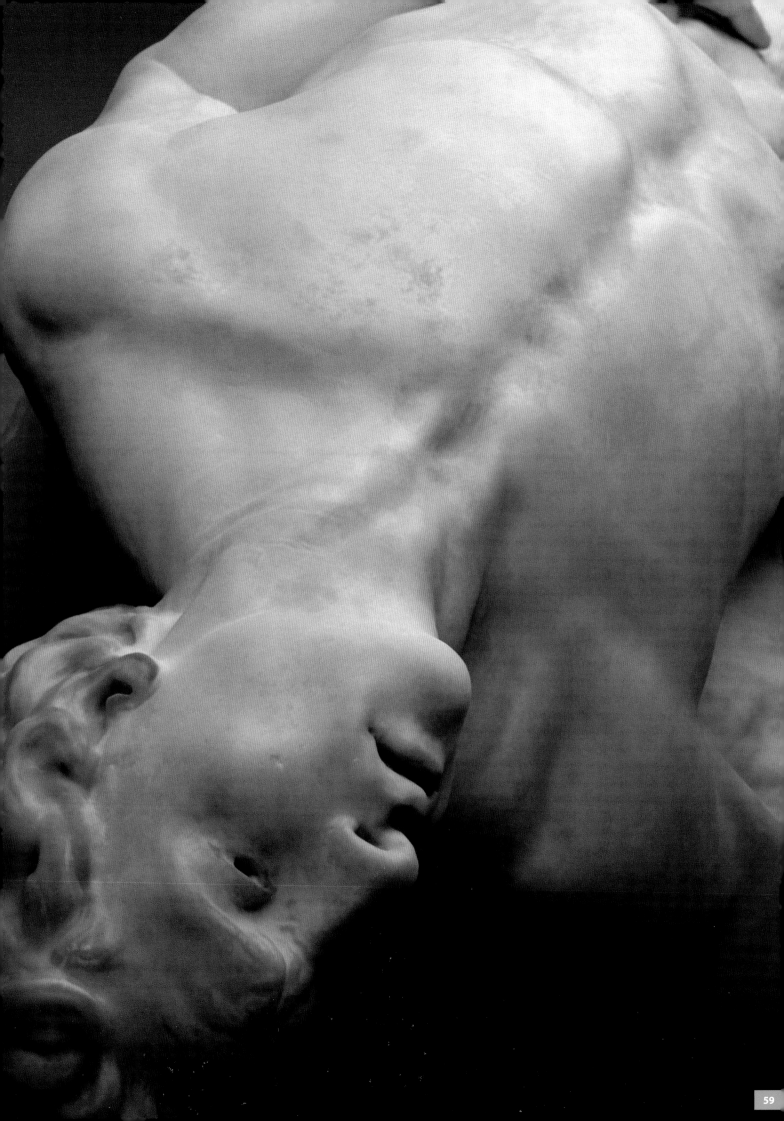

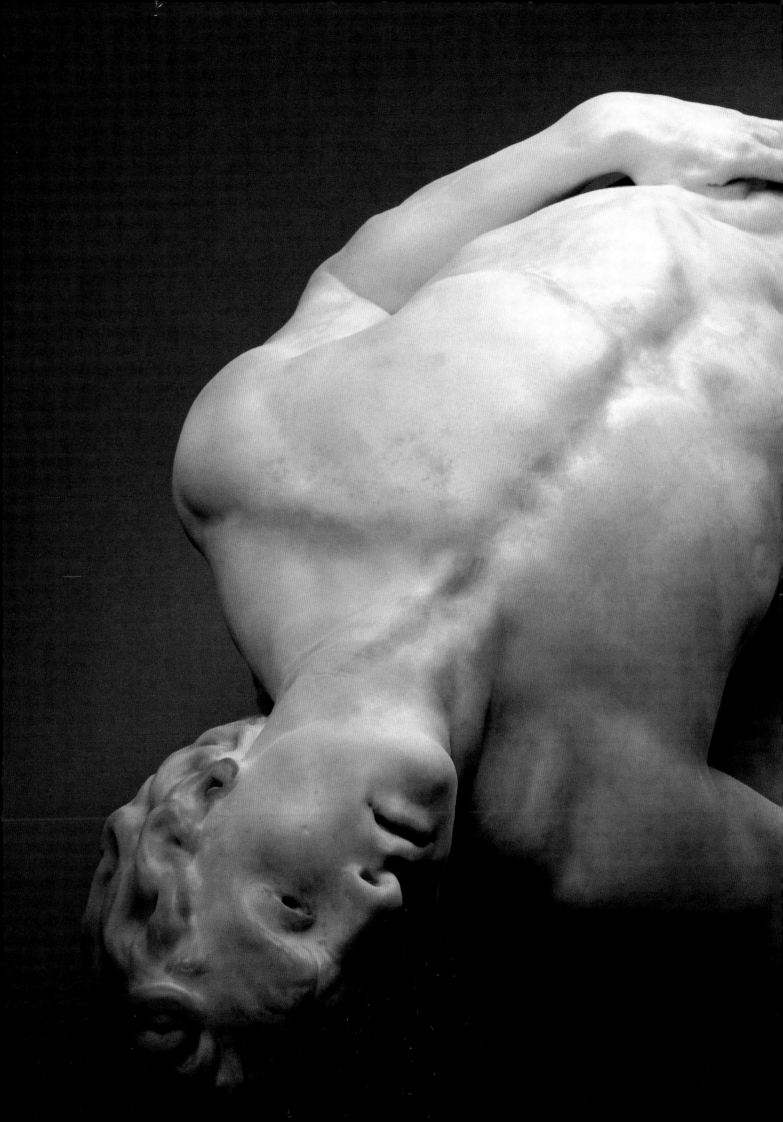

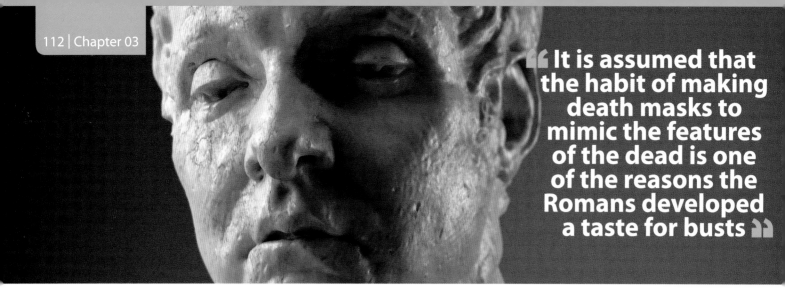

"It is assumed that the habit of making death masks to mimic the features of the dead is one of the reasons the Romans developed a taste for busts"

Roman Sculpture By Rafael Ghencev

Introduction

Roman sculpture was a way for them to create a portrait and they did this as a form of ancestral worship. They preserved the faces of important ancestors so they could have a lasting reminder of them. A good resemblance was therefore essential, so artists emphasized the most typical features of a face to capture the essence of their subject.

During the reign of the Flavian Dynasty (Emperors Vespasian, Titus and Domitian), a style developed called Flavian. The task of the portrait sculptor was to create a sense of realism whilst avoiding the sculpt showing any emotion.

In the second century AD sculpted portraits changed and started to show a lot of emotion. *The Caracalla* (211 AD) is a stunning portrait that achieved a high degree of expressiveness and this was the peak of Roman busts. But thereafter the Asian influence and an interest in geometrical elements meant that portraits began to look stylized and abstract.

About the Portraits

Emperors used portraits primarily as an assertion of power and their political program, but busts also decorated the altars, tombs and cinerary urns of past emperors. This tradition was linked to a long history of displaying death masks of wax or terracotta, honoring ancestors in funeral processions

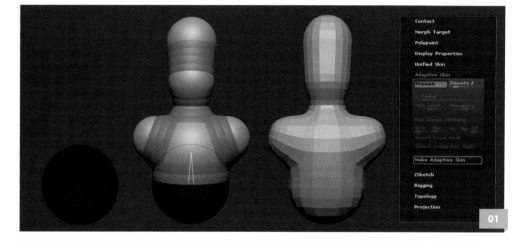

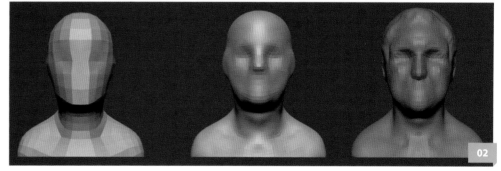

held to celebrate and certify their patrician lineage. These masks were proudly kept in the family shrine – the lararium – along with busts in bronze, marble or terracotta. It is assumed that the habit of making death masks to mimic the features of the dead is one of the reasons the Romans developed a taste for busts.

Knowing a little about Roman sculpture I decided to create a bust like *The Caracalla* sculpture I mentioned earlier.

Creating a Base Mesh

To start this model we are going to create a

base mesh from ZSpheres, so open the tool palette and select a ZSphere. Click on X to activate the symmetry and start to add two new spheres for the shoulders, one more for the neck, two for the head and one for the beginning of the chest.

By pressing the A button we can see our topology flow, so open the adaptive skin palette and click on Make Adaptive Skin. This will create a new object from your ZSpheres. This will be our base mesh (**Fig.01**).

Blocking the Structure

Now it is the time to work on the most

important part of the process: the basic shape of the head (Fig.02). This is the point where we need to concentrate and pay attention. Don't jump in and rush the details. As we did in the last tutorial we need to make the most of every division. We should start by creating the basic shape of the head using the Move brush and when the head requires more information, divide the model one more time and work on it until it requires more divisions and so on. At this stage you only need to use the basic Move brush and a little of the Standard brush to carve some big cavities, like the orbital cavity.

Secondary Shapes

Now it is time to add secondary information like the nose, mouth and muscle structures etc. So using the Clay and Clay Tubes brushes start to add the eyes and better define the shape of the face, working carefully on the nose style etc. Here the important thing is to work on the whole model at the same time. Don't finish one part then go to another. It is important to advance your model equally to maintain a convincing structure (Fig.03).

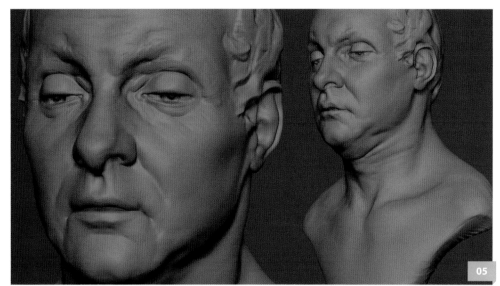

Using the Clay Tubes brush start to define the haircut. We don't need to make every hair strand; we only need to find the best look in its simplest form (Fig.04).

Refining the Shapes and Pose

Now it is time to add more nuances to his face. Using the Clay brush add a little fat to his face. Add some big wrinkles to his forehead and more details to his eyes to amplify his expression. I added some fat and wrinkles to his neck and on his chest too (Fig.05).

On the ears I worked mostly with the Standard brush and used the Inflat brush a little for the tragus, anti-tragus and helix rim (Fig.06). Now, using the Transpose tool, we can break the symmetry and find a simple but expressive pose to give him some life (Fig.07).

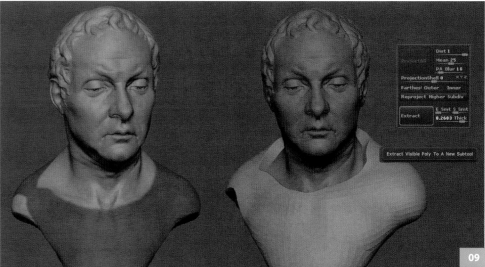

Details and Cloth

The next step is to work on the hair and give it more height and variation. To make the different parts of the hair more contrasting, add more depth to it to separate areas.

For the neck I added more fat and skin pressure caused by the pose. Everything was done using the Clay brush (Fig.08). It is then time to create the cloth. For this, we can use the Mask brush to paint the area that we are going to extract. After the mask is done you only need to go to Tool > Subtool, choose the thickness of the extraction and click Extract (Fig.09).

Now, using masks to protect the areas that don't need to be changed, select the Move brush and start to create the shape of the cloth (Fig.10).

Select the Standard brush and start to develop the drape of the cloth, making the folds (Fig.11). Now we need to be patient and create some flat areas using the Polish brushes, and also create more folds with the Standard brush (Fig.12).

Finishing the Piece

It's time to add the final touch. Select the Rake tool and create wrinkles and cavities simulating the effect of traditional sculpting tools. Try to use organic movements to create a natural effect (Fig.13).

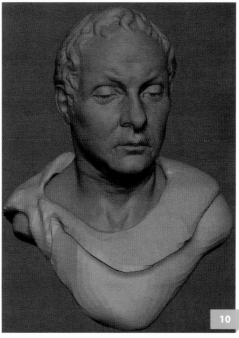

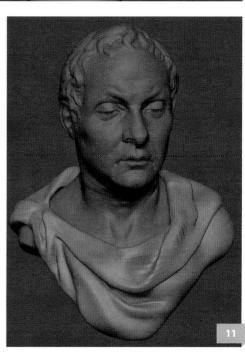

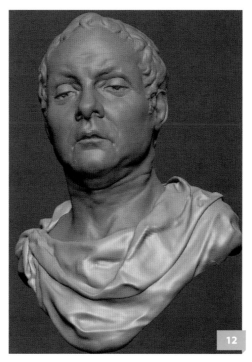

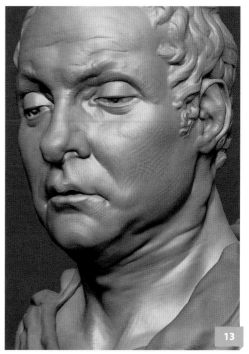

Now we only need to create noise on the surface to create the look of a traditional sculpture. Play with the noise curves until you find the settings that you need (Fig.14).

Here is the final model (Fig.15). Like I said before, the beauty of this kind of art is in the form not in the details. Always remember to concentrate on every part of the process, not only on the details.

Rendering our Roman Bust

In this section we will be looking at texturing the roman bust that we sculpted earlier.

Decimate the Model

To start the render process we need to prepare our file and send it to 3ds Max, where we are going to use V-Ray as our render engine. So open your model, go to the Zplugin tab and open the Decimation Master plugin. We need to use this to reduce the polycount of the model. For my image I had 9.7 millions polygons, which is too many to open in 3ds Max. So to shrink the count put your model in the last subdivision level and choose the proportion of decimation you would like to use. In this case I used the default 20%. Now you only need to click on the Pre-process All tab and wait a while for the process to complete (Fig.16). After this process has finished simply click on the Decimate All tab to apply the result to the mesh and export the models as an OBJ file.

Creating our Scene in 3ds Max

Inside 3ds Max we need to configure our scale to work in the real world. So open the Customize tab and select Unit Setup. Next configure the scene as it is in Fig.17.

Now our scene is set to cm we need to build our infinity background. We're going to do this to simulate studio photography. Create a plane object in the Standard Primitive tab and set the scale of this object as it is in Fig.18.

Now we need to apply a curvature to this plane to make our background (Fig.19). So

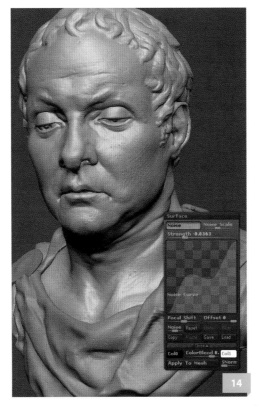

20

21

open the modifiers list and pick the Bend modifier. Now we need to adjust the Bend Axis to X, the Angle to -90 and turn on Limit Effects. Once you have done this choose a value that makes a smooth curve.

Camera Angle
Once you have moved your model into 3ds Max the first thing to do is define the camera angle. Create a V-Ray camera so it's pointing to the left side of his face, with an angle slightly lower than eye level. Make sure the

bust is in the viewer. Configure it to 85 mm and change some of the options, for example the aperture (f-number), ISO and shutter speed. You can see the settings in (Fig.20).

This camera angle is very important because your UV will be created from this. Take your time to decide what the right angle for you is.

Lighting
Now we are going to create the lighting so the first thing to do is configure V-Ray to

make quick renders so we can see the tests quickly. In Fig.21 you can see these settings. Create two V-Ray lights, one to his left and the second behind and slightly to the right, then configure them as they are in Fig.22.

Now create a V-Ray material to do some lighting tests. Open the rendering Material Editor tab and create a V-Ray material with a gray diffuse color. Once you have done that put the material in the Override mtl slot in the Global Switches tab (Fig.23).

22

23

24

Here are the test results (Fig.24).

Texture and Shader

Now it is time to create the texture, but before that the UVs need to be prepared to receive the texture. In the case of this image we are only making a still and not an animation, so we can do a simple Planar Projection through the camera. This will project the UVs so they work for the camera (Fig.25).

Now you only need to find a good marble texture to use on this project. In this case I used a texture from **http://cgtextures. com/**. You only need to apply this texture to the diffuse slot of the material. The Planar map will do the rest. Remember this kind of projection works well for still images, but not so well for animation. And in this case the scene has only one shader for the character, which makes things easy too.

Now we need to create the marble shader. Open the Material Editor (M) and select a V-Ray Fast SSS2 material, which will be used to make translucent materials. To start this shader pick a preset. In the preset option select "Marble (white)". You can change some parameters to create more of a natural look for this (Fig.26). In the specular amount

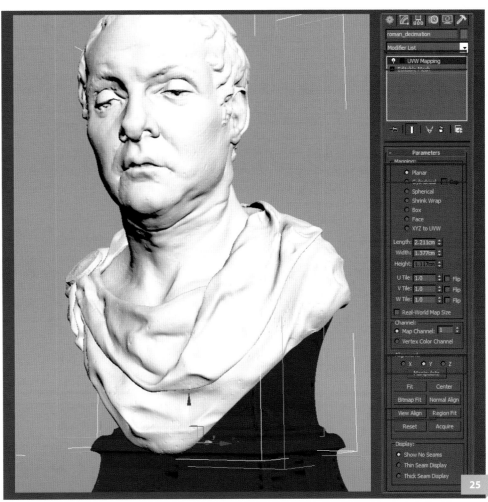

25

26

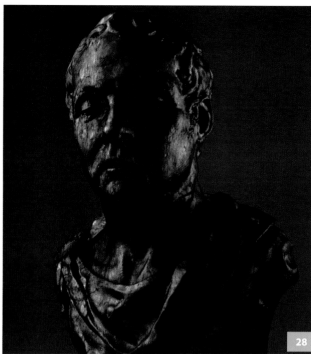

I put 0, because I didn't want to use the specular of this shader. Instead I did a blend with a simple V-Ray material that has great specular control. Before this, in Photoshop, I used Levels to adjust the marble texture to create my specular map. This creates an irregular specular on the surface. In some places there will be more glossiness than in others. Now we can create a V-Ray material with black diffuse and put the Specular map in the Reflect map slot (Fig.27).

To do some tests with the specular included apply this material in the Override Mtl slot and click on Render (Fig.28). When you have achieved a good looking specular you need to create a blend material to mix the materials together. Go to the Material Editor and create a new blend material and link it to the SSS2 shader at the base of the blend material. Then link it to the specular material in Coat 1 of the blend material and set the blend mode to 60% (Fig.29).

Render Setup

Now we have our material completed, we need to change the render parameters to achieve a good quality render (Fig.30).

If you like, you can adjust the levels and color in Photoshop. Here's the final image (Fig.31).

The Gallery

A collection of inspriational ZBrush sculpts from some of the
industry's best artists.

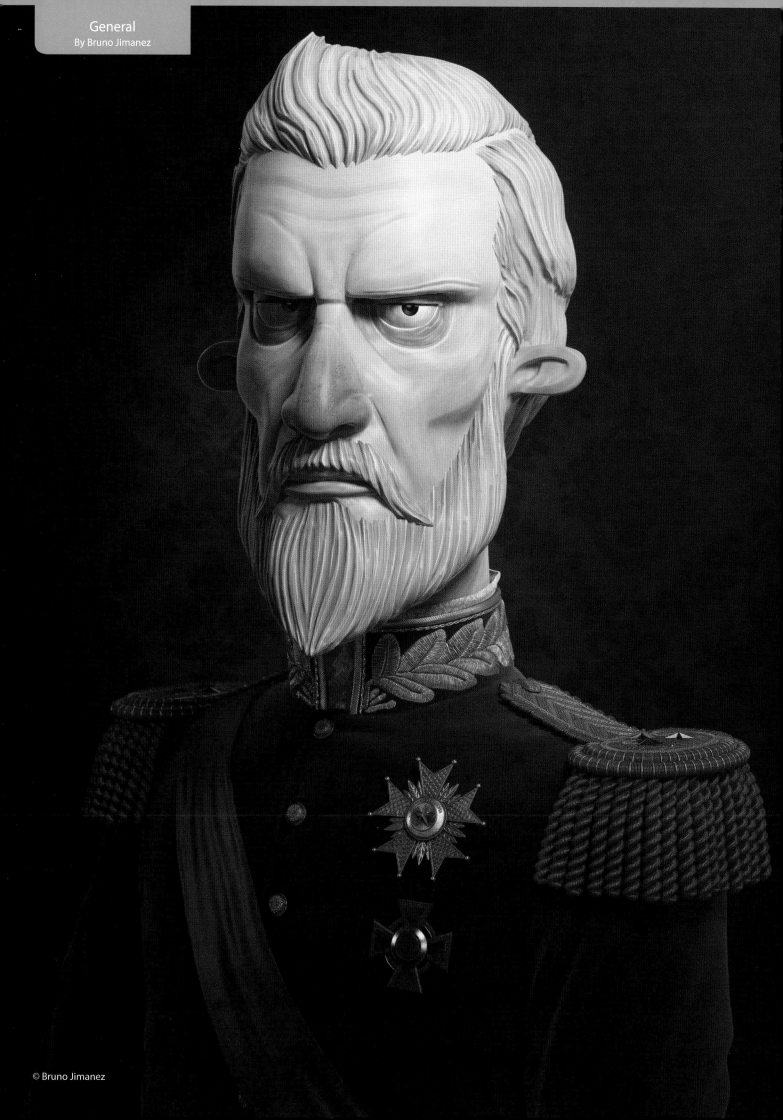

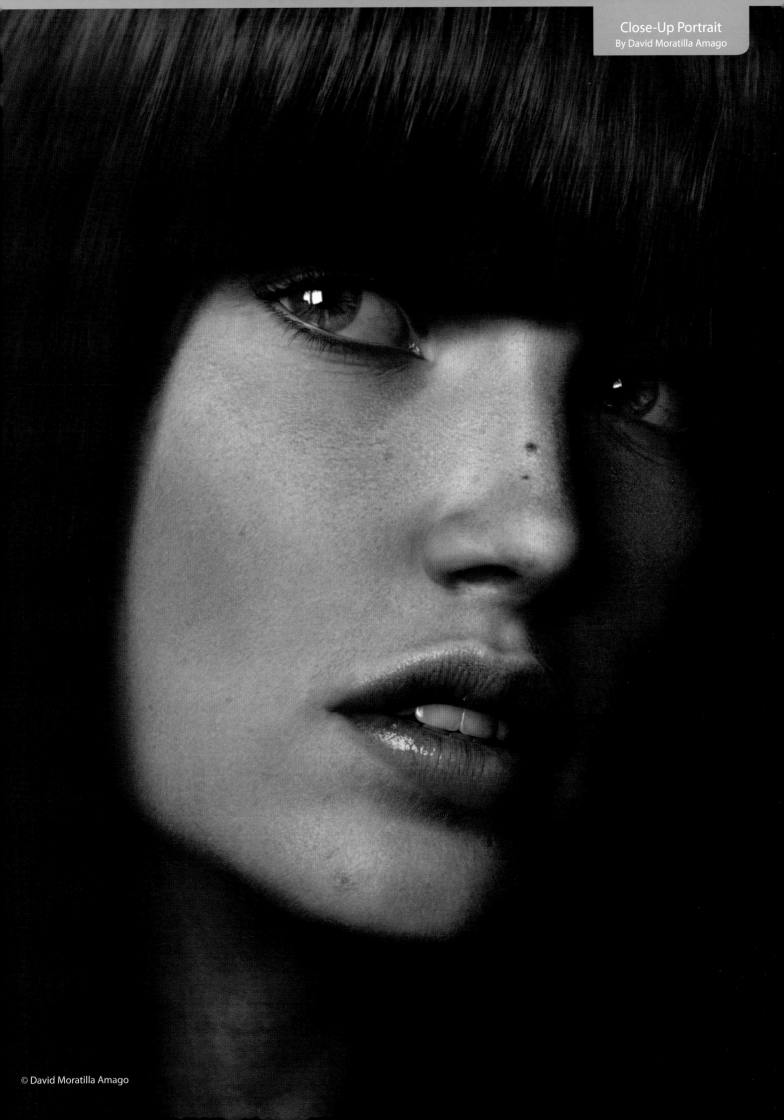

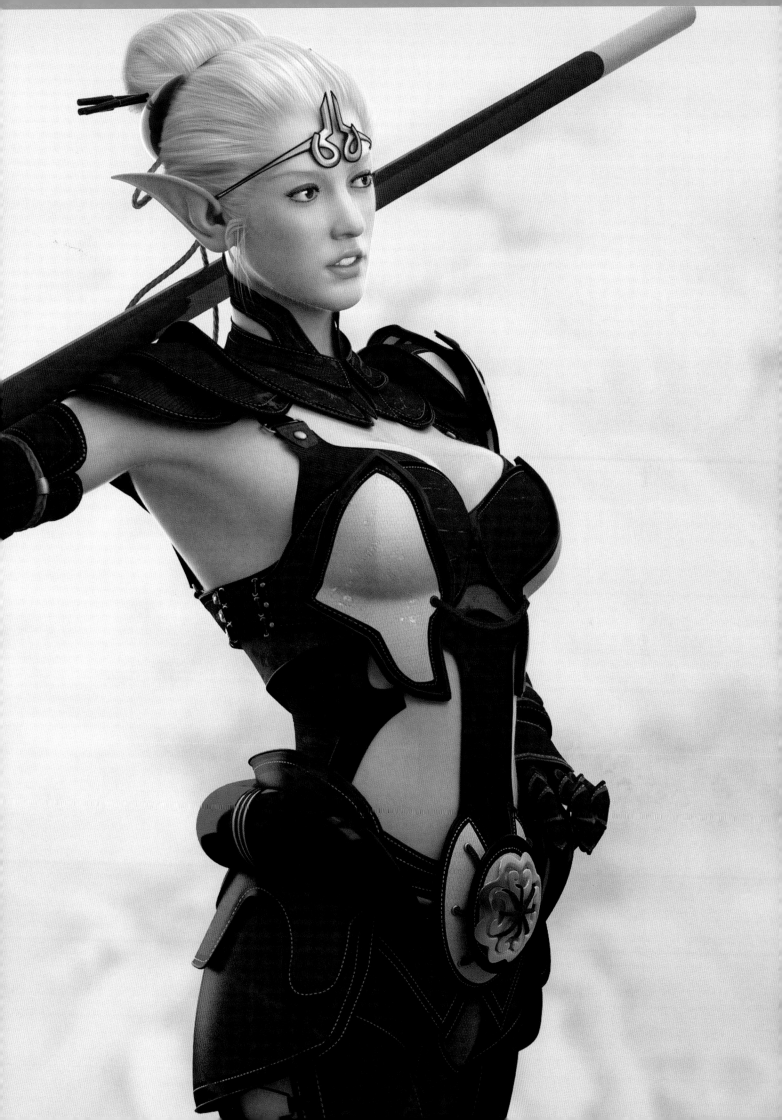

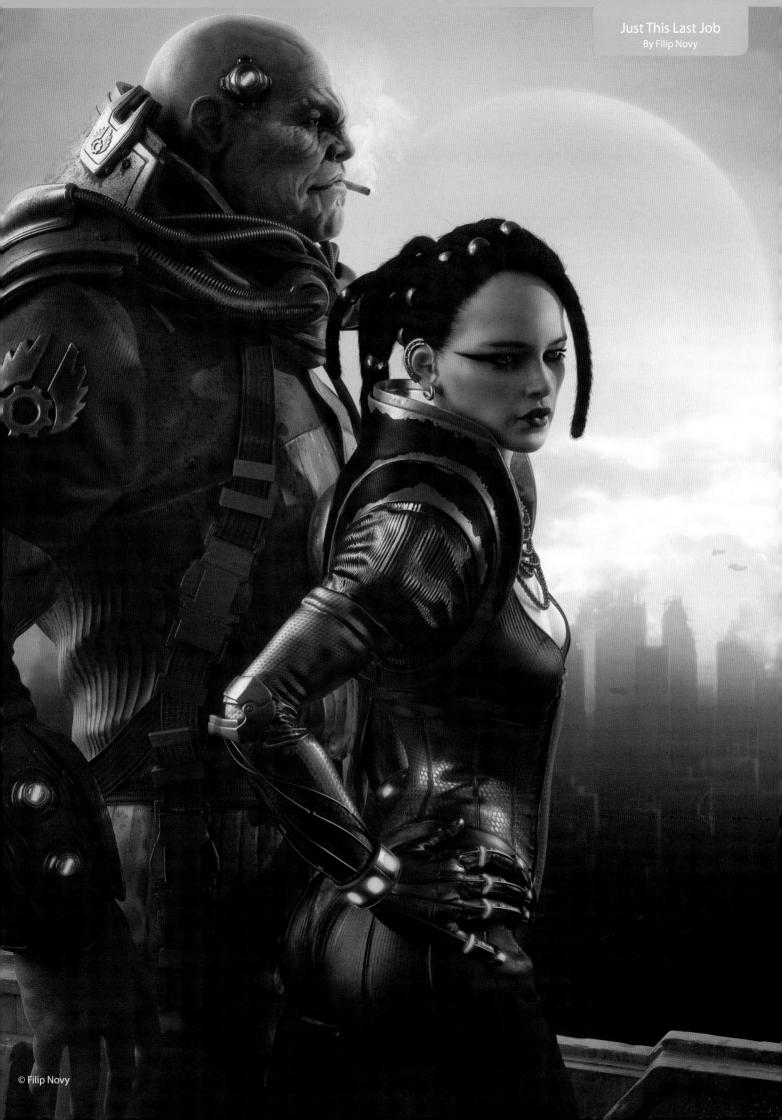

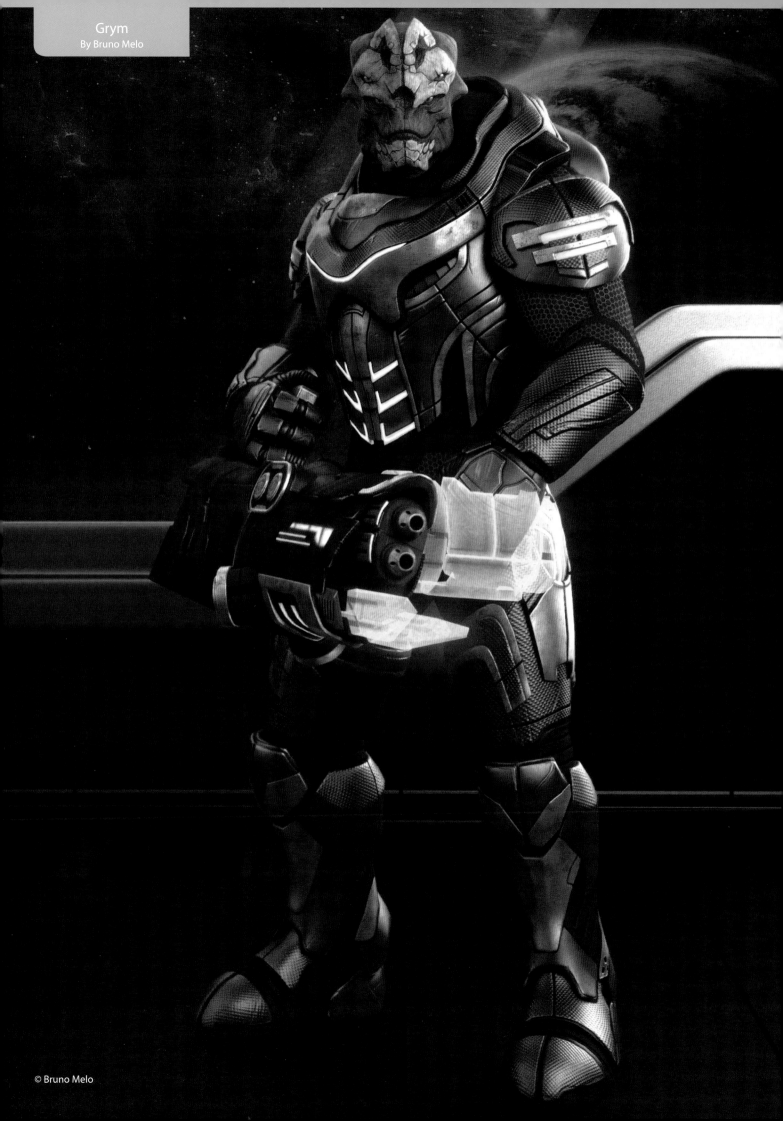

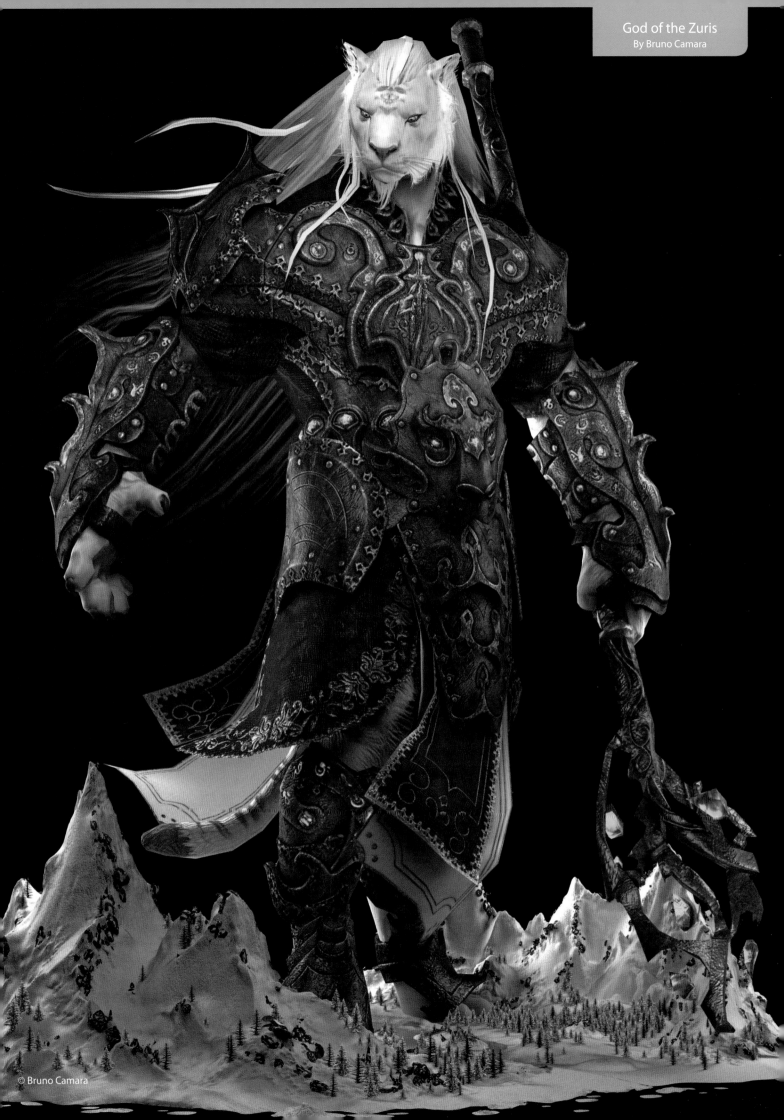

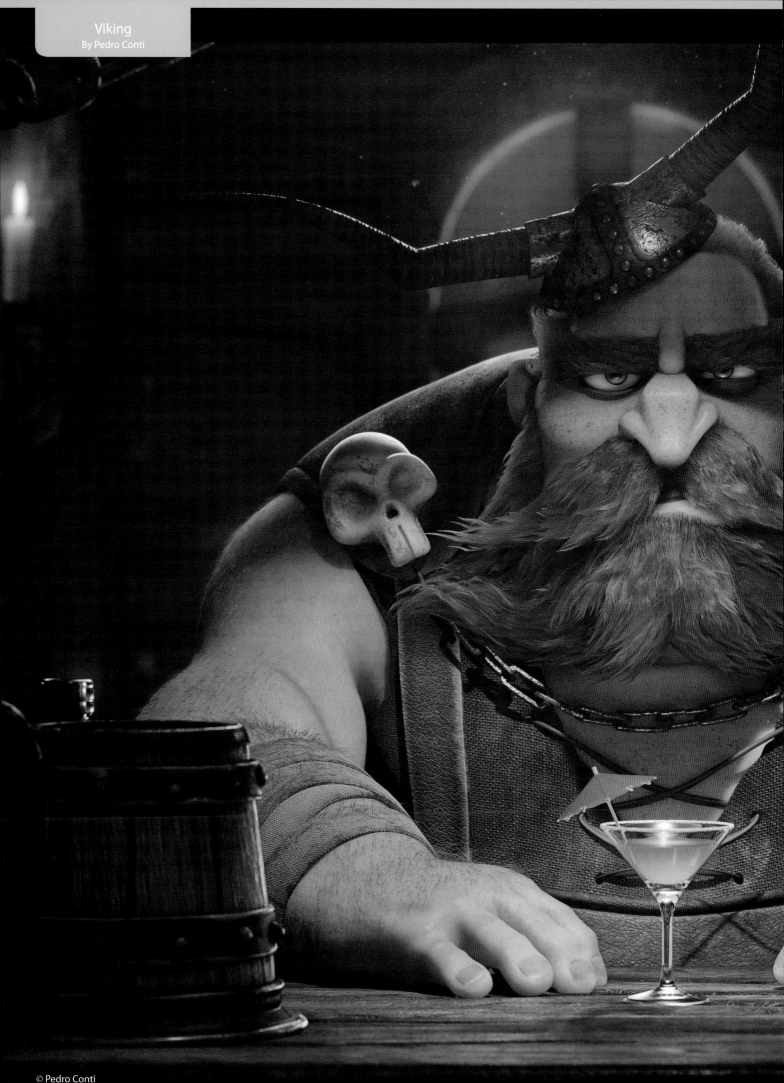

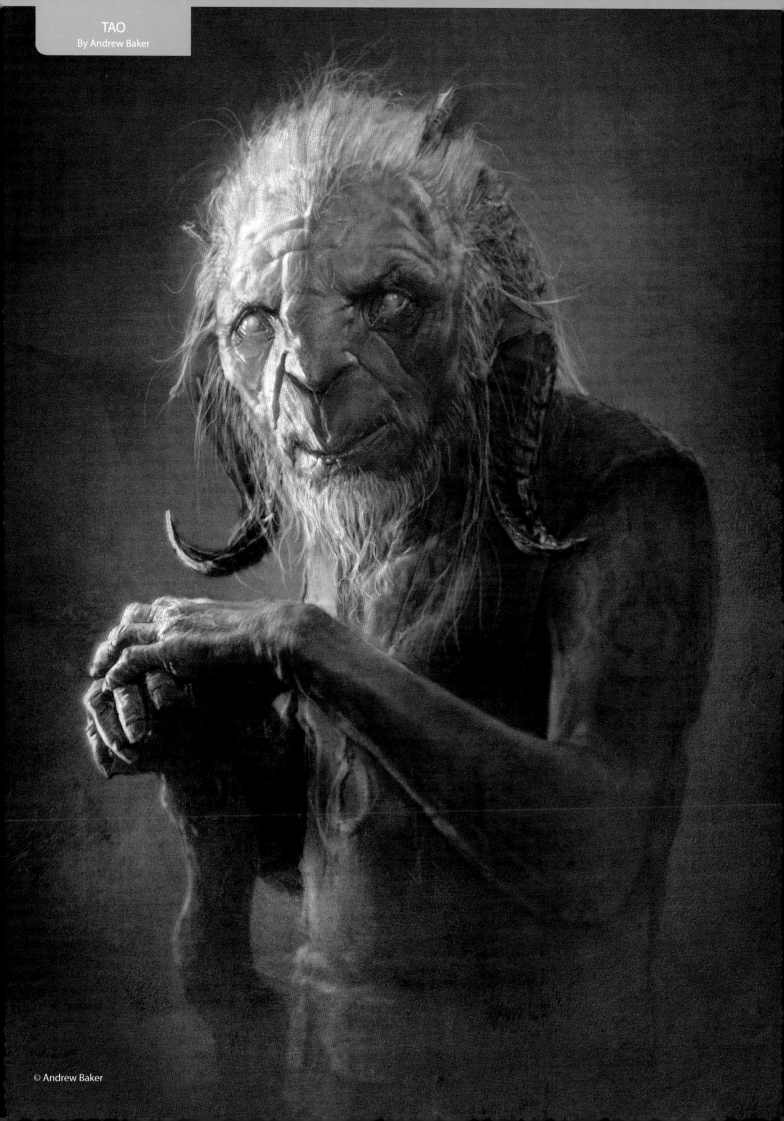

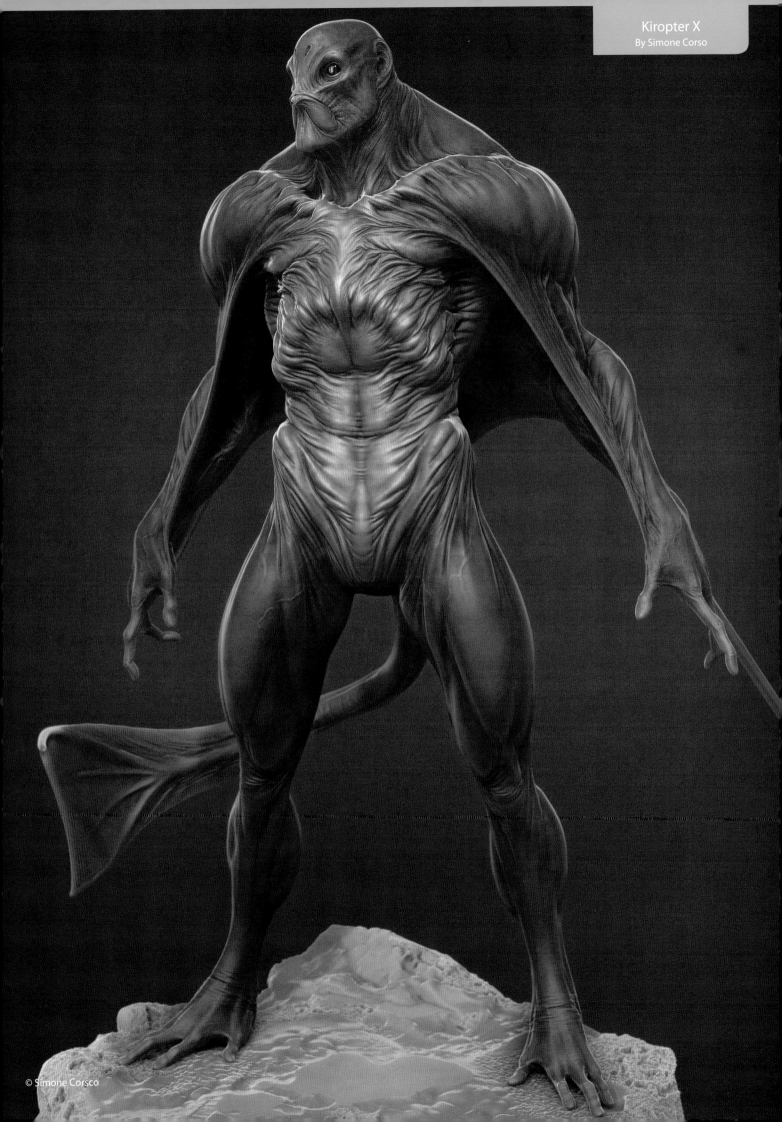

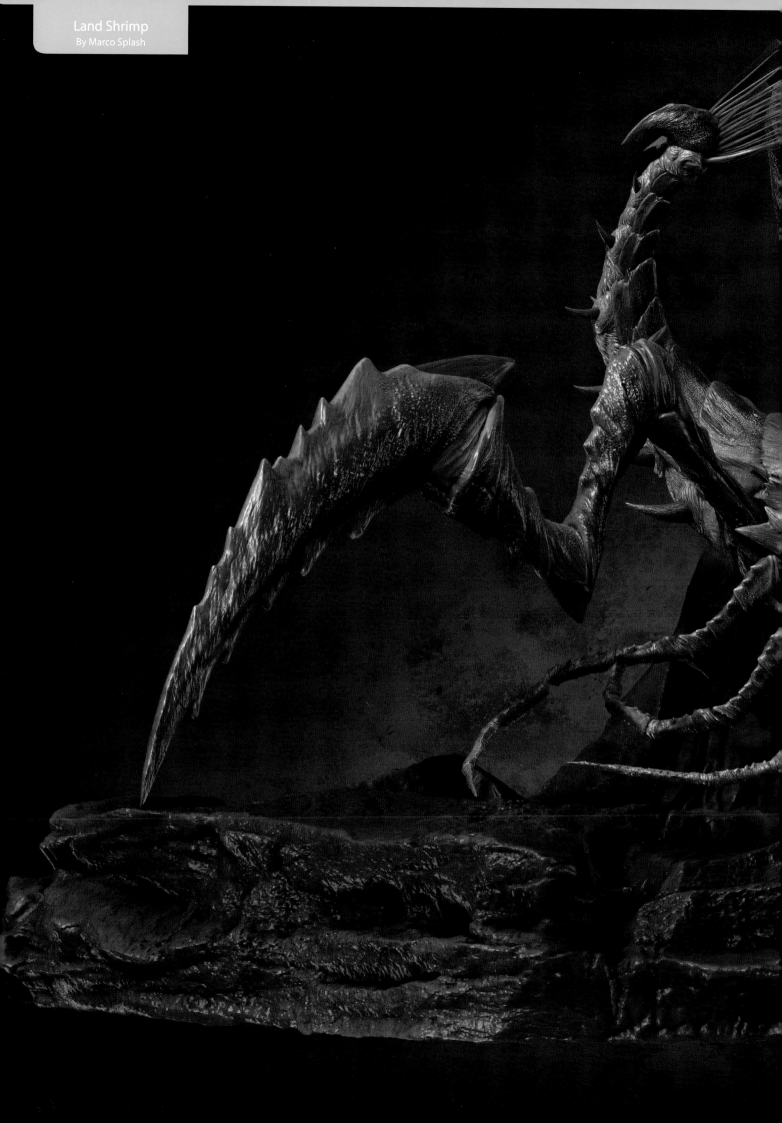

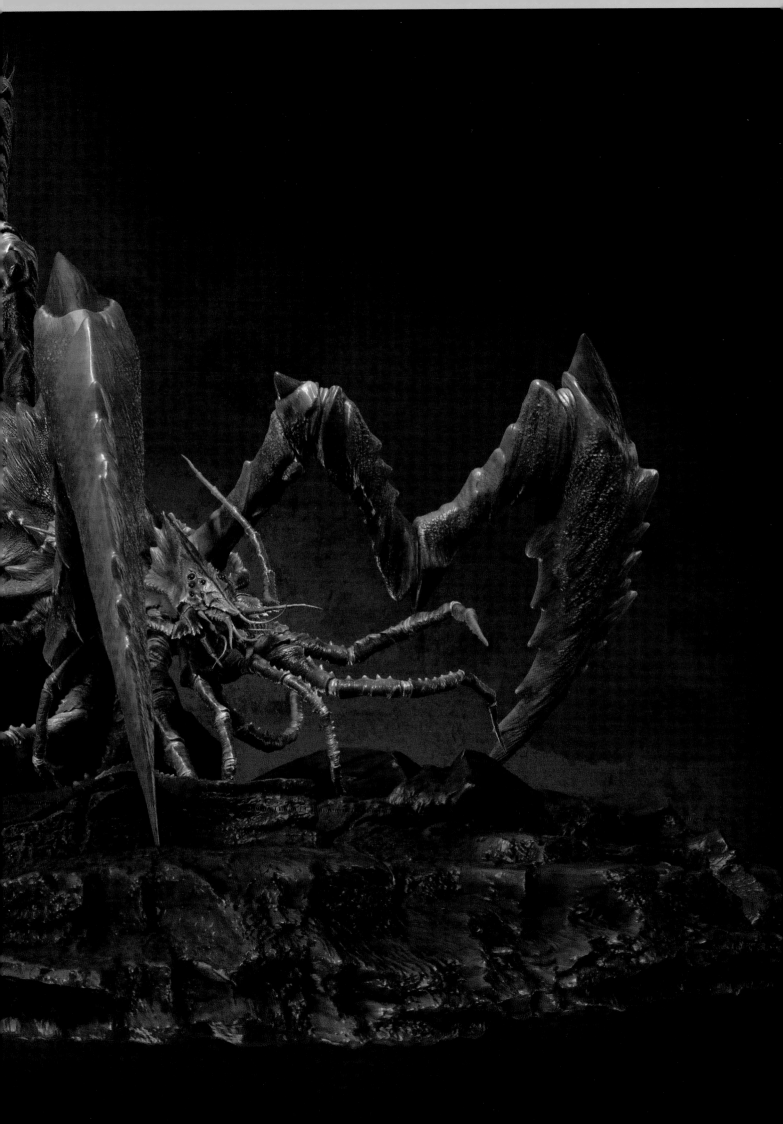

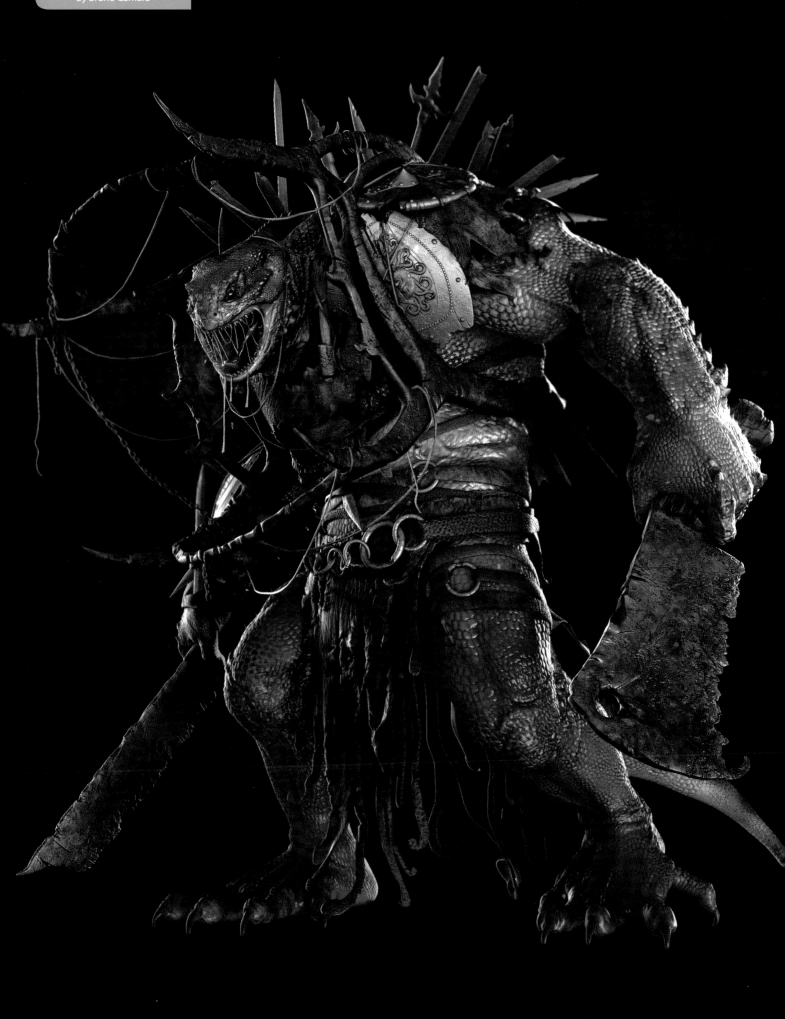

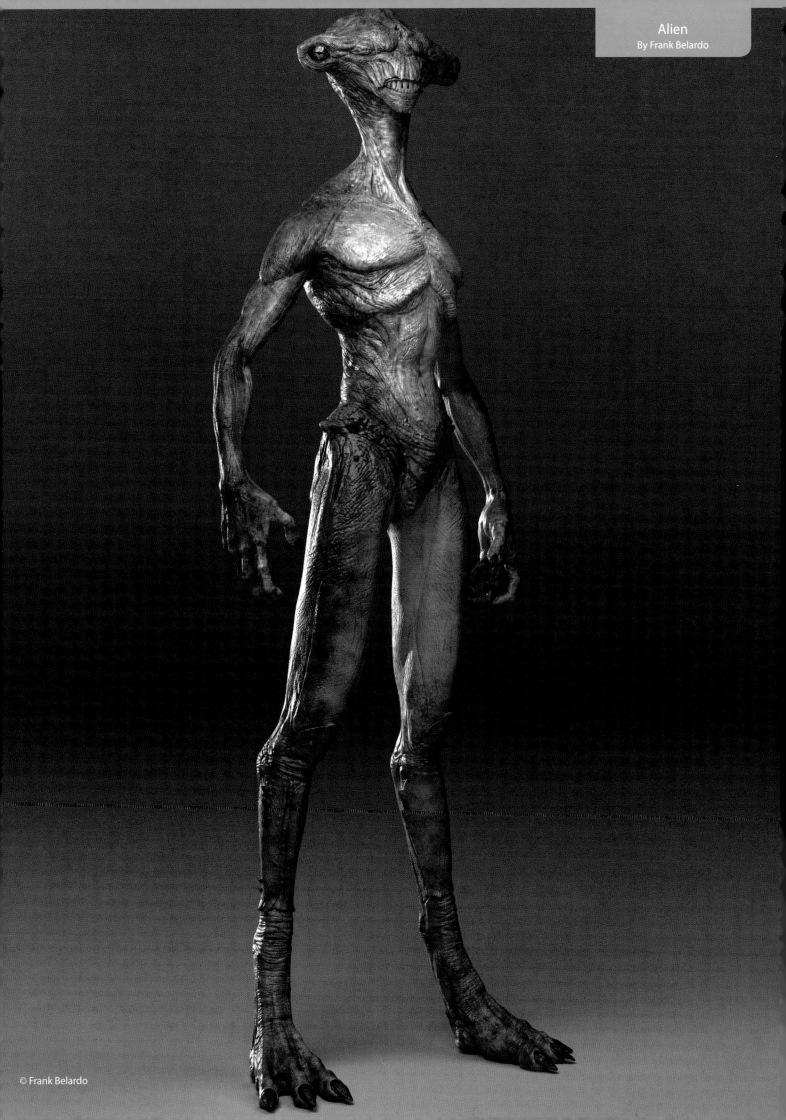

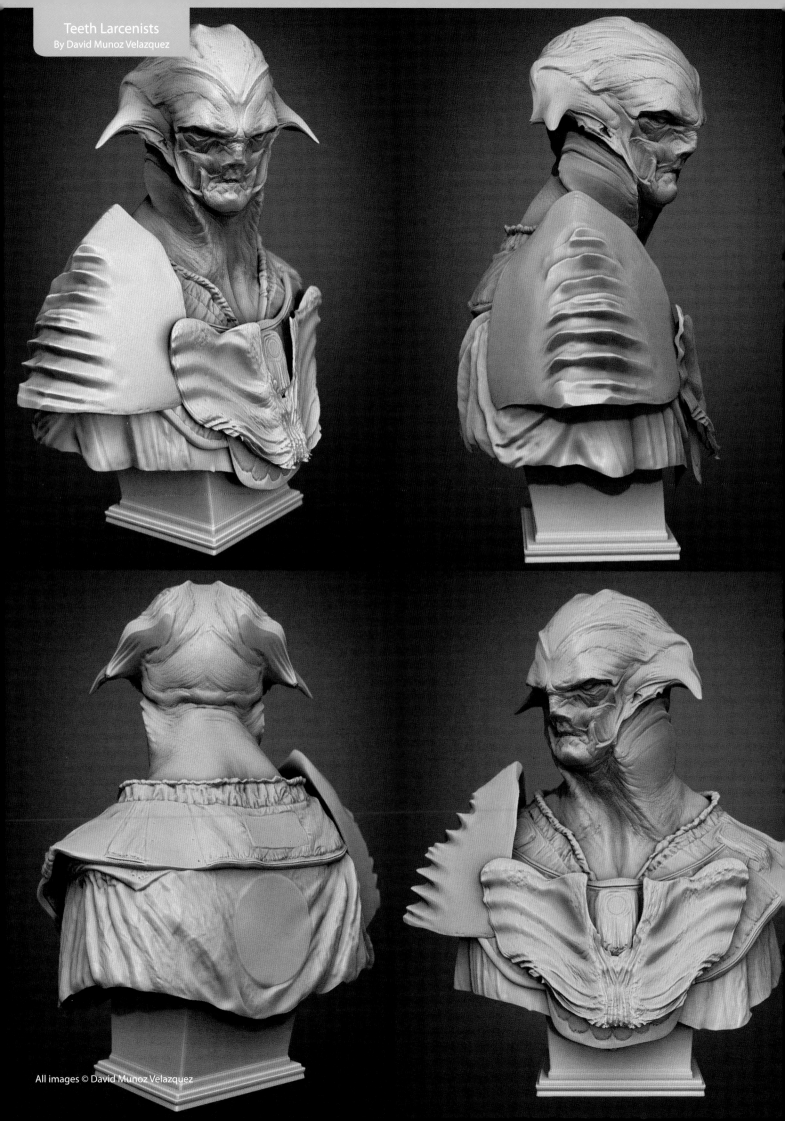

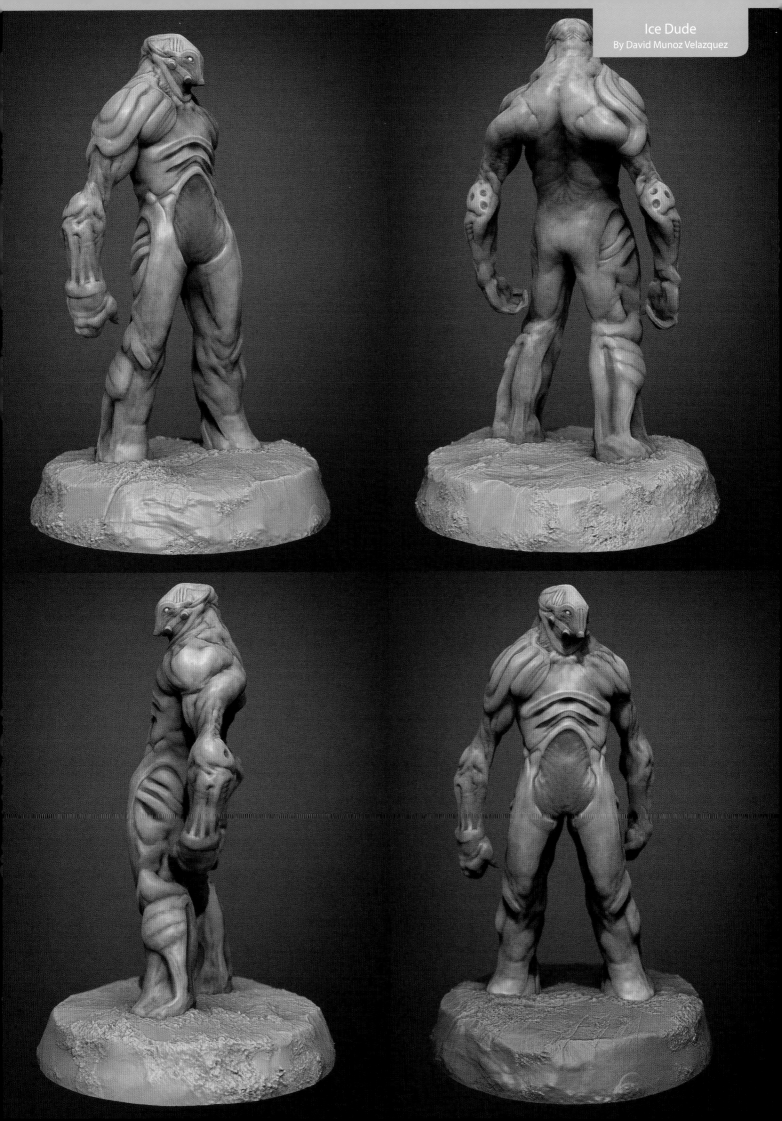

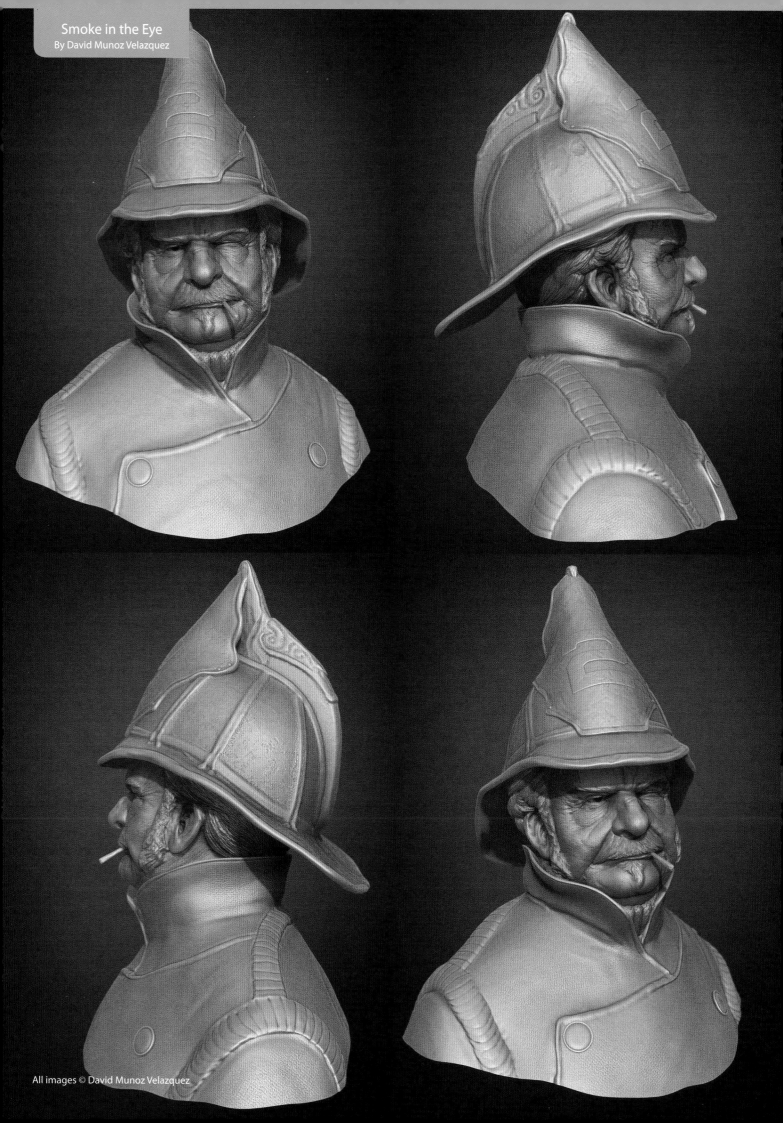

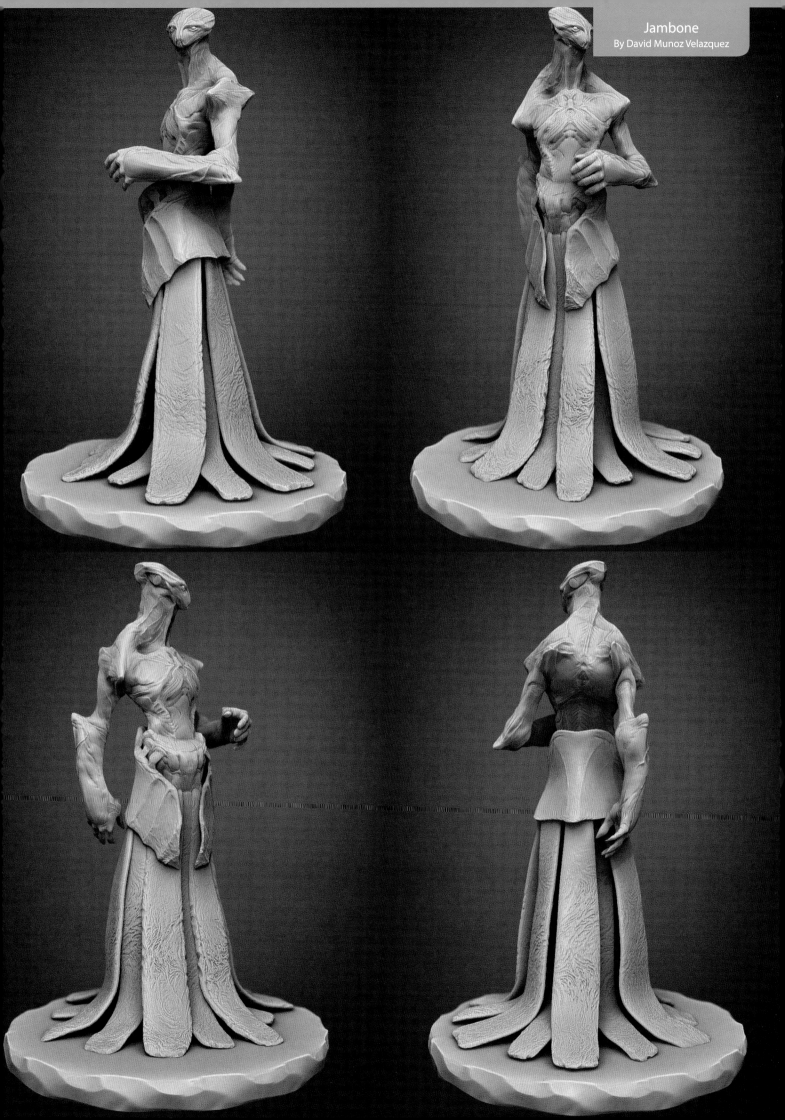

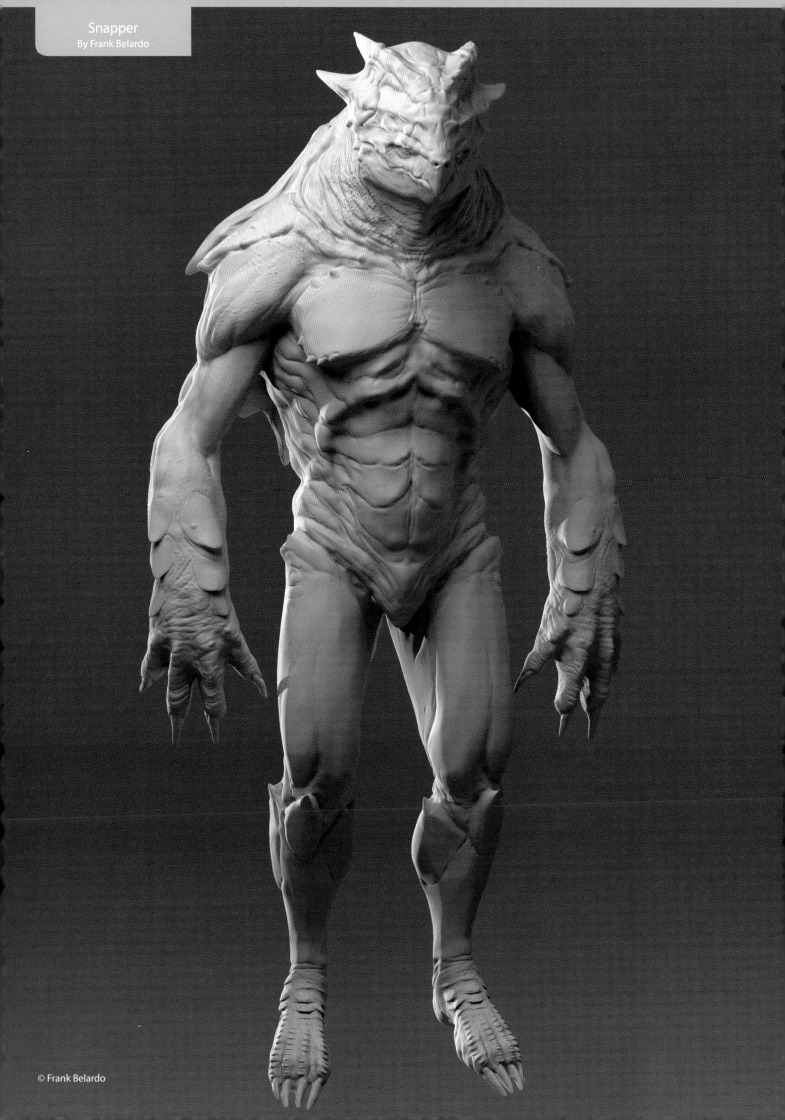

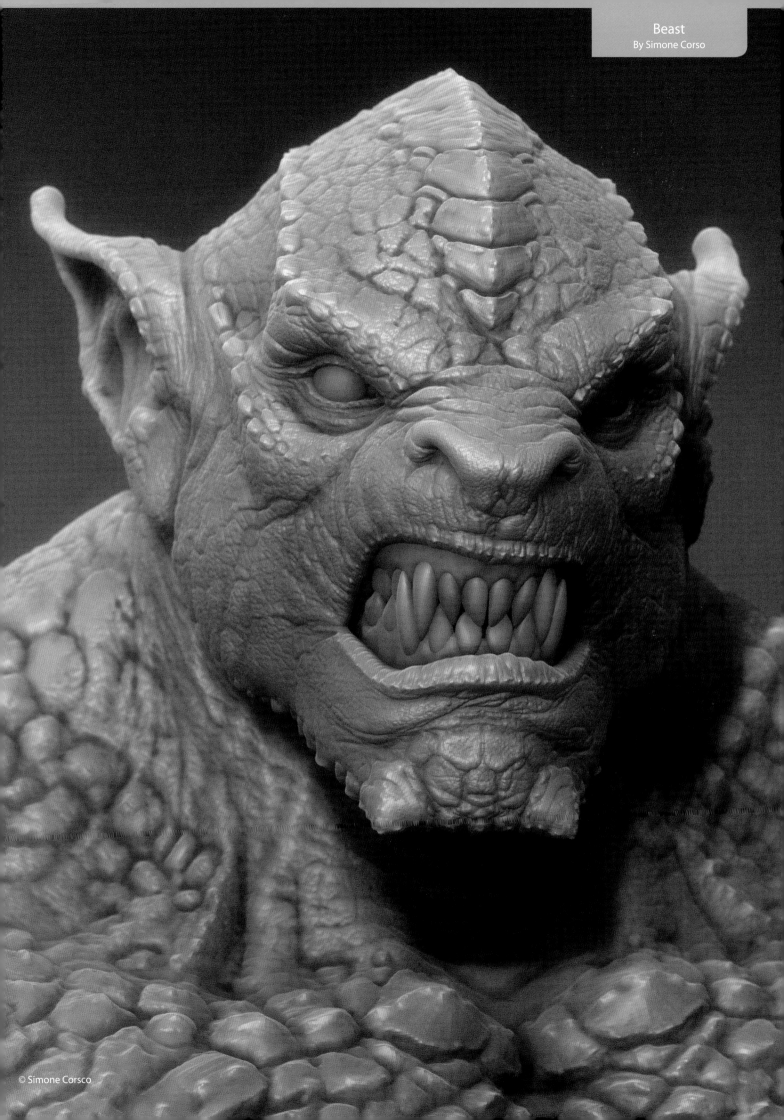

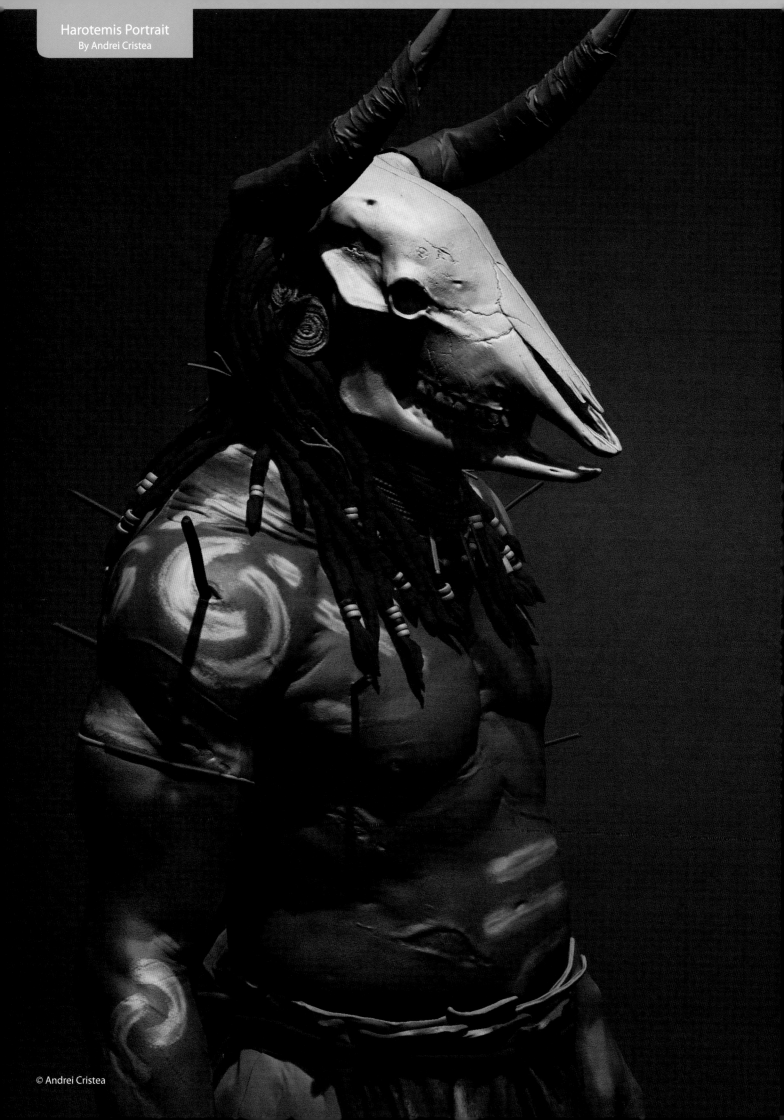

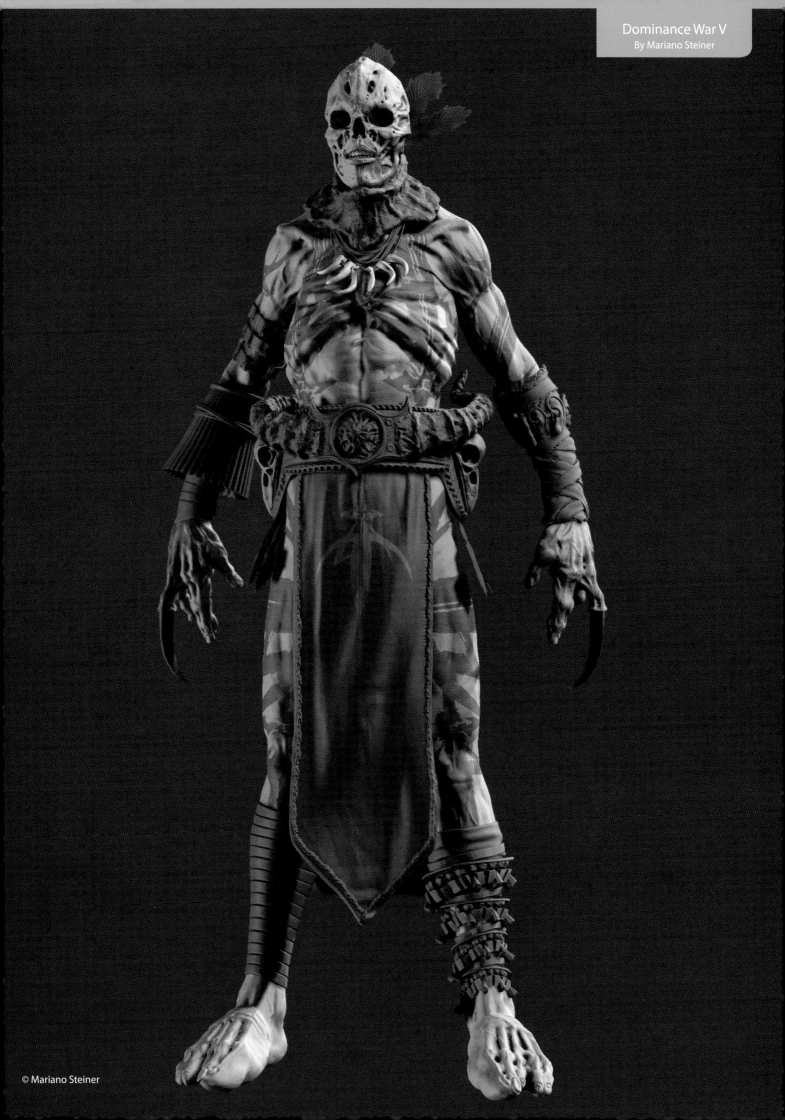

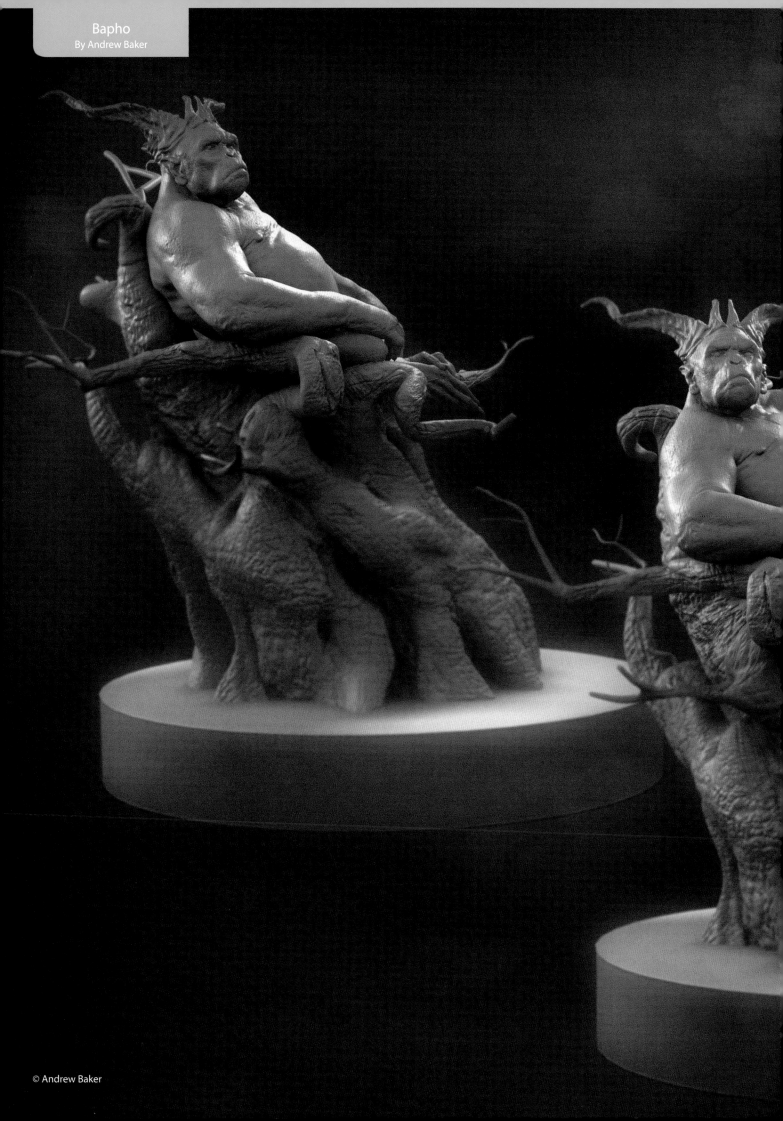

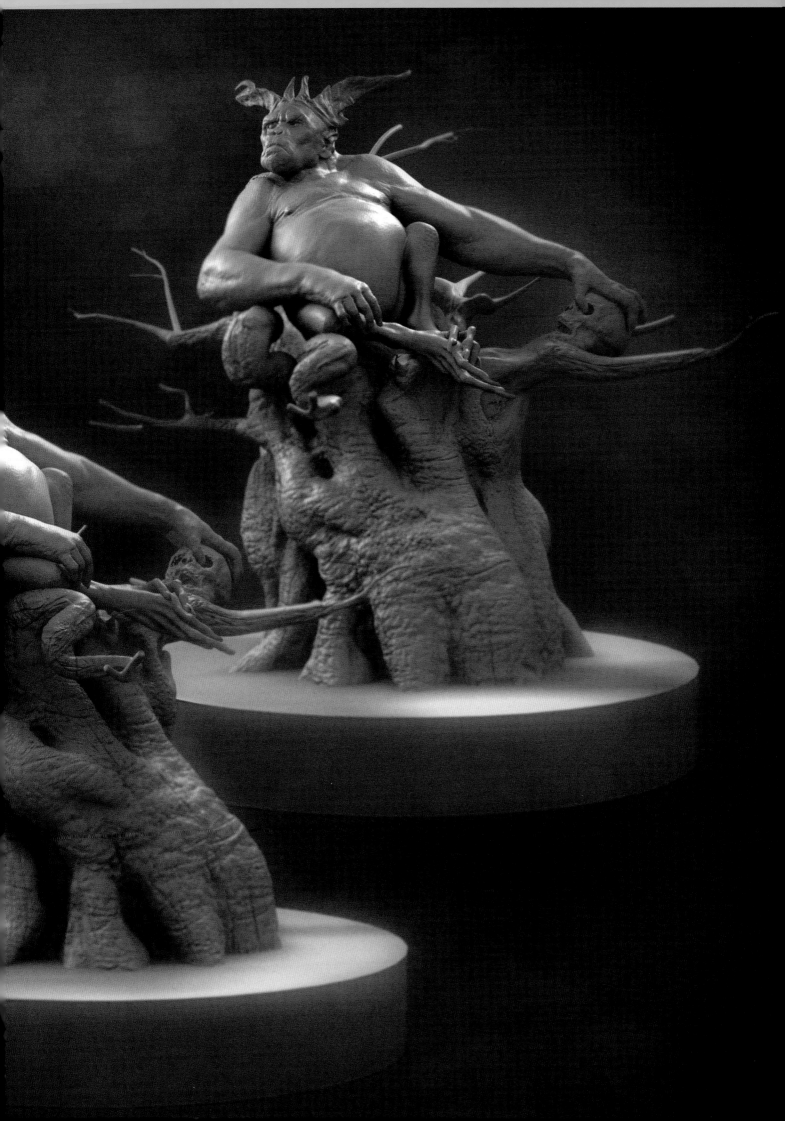

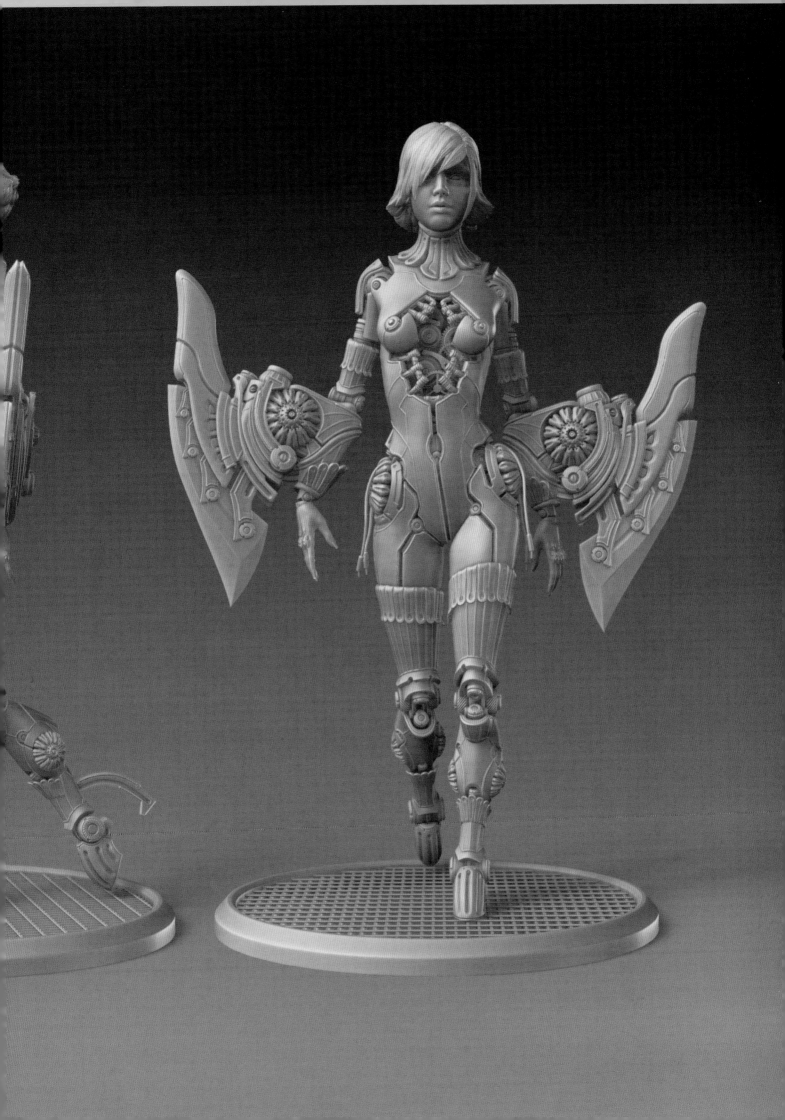

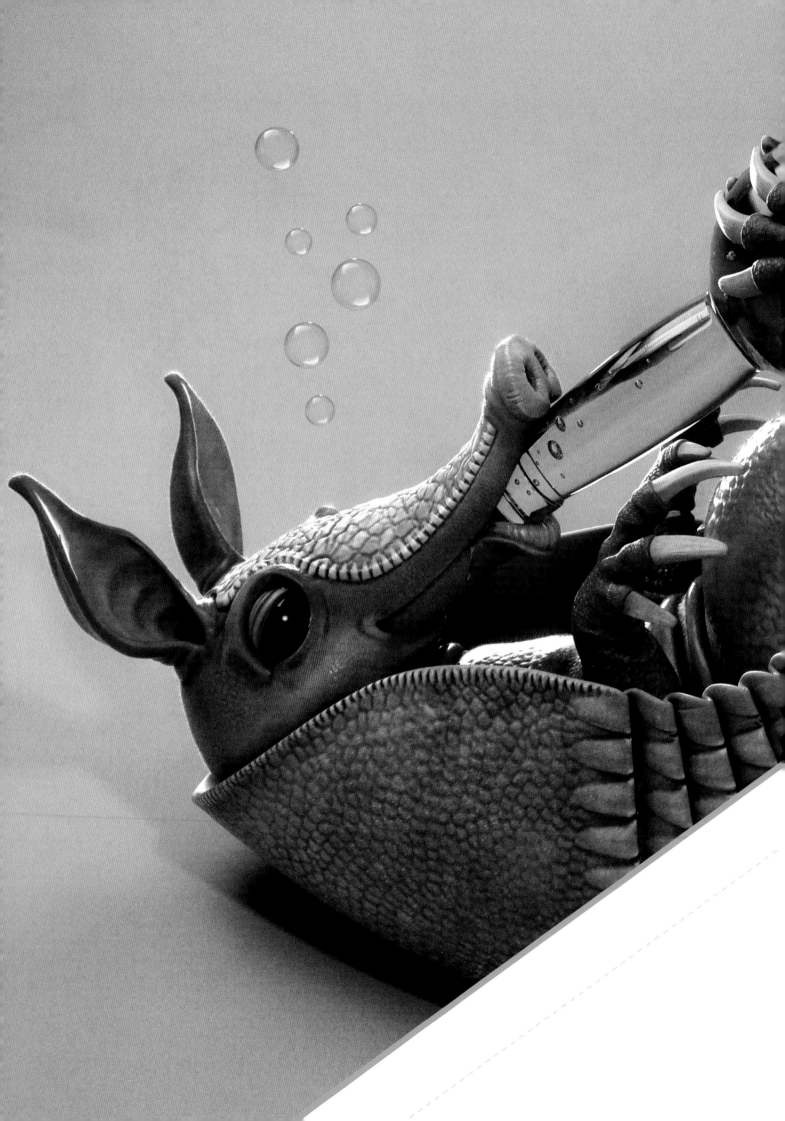

Monsters, Mercenaries and a Cartoon Armadillo

As the intriguing title suggests, a wide range of topics and subject matter will be covered in this chapter. The experienced artists featured in the following pages will be presenting a plethora of techniques and methods that can be used to create some stunning imagery. Hopefully whilst reading through these tutorials you will come across a few tips and tricks that you can adopt and apply to your own workflow.

> **I find ZBrush is a pretty cool tool that enables you to figure out good designs directly in 3D, without the need for preliminary drawings on every occasion**

Aquatic Man By Diego Maia

Introduction

I was asked to create a character for this tutorial under the heading of "Aquatic Man", which would show how ZBrush can be used to sculpt and texture such an extraordinary creature, thought up from the depths of my imagination by crossing human elements with those of aquatic beings. Here's how we'll go about creating such an amalgamation.

Base Mesh

I decide to work straight from the offset by sculpting directly in ZBrush from the base mesh provided (you can download the same base mesh with this tutorial), without creating a concept before starting. I find ZBrush is a pretty cool tool that enables you to figure out good designs directly in 3D without the need for preliminary drawings on every occasion.

Sculpting in ZBrush

So to start I choose a material for the base mesh that I think is most suitable and that will help in this initial sculpting stage. You can try different materials by clicking on the sphere on the left-hand side of the screen.

Using Transpose I manipulate the character into a pose closer to what I imagine the pose of the final character to be – something like that of a creature moving through the water (Fig.01). To use Transpose, you'll see at the top of the screen the Move, Scale and Rotate buttons – in this case I use the Rotate function. To make a mask in order to move individual elements of the model, you simply hold down Ctrl and drag your cursor over the model. You then simply need to draw a line from the rotation point to the point that you need in order to successfully move your model.

I try out this pose to illustrate a swimming creature. Unfortunately the base mesh has not been provided with any legs so I can't use the bottom part of his body to work into the concept, so instead I decide to have the creature's arms pulled backwards to give a sense of him gliding through water. I'm using fresh water fish as my references rather than salt water fish, because I want to work with aquatic references with fewer colors going on – I think sea creatures could be too colorful for this character.

Before I start the sculpting work, I like to subdivide my base mesh as much as possible, but I'll reduce all those subdivisions again before starting the modeling. I do this because sometimes you'll subdivide the mesh with some hidden parts and only unhidden parts will be subdivided. When using Transpose I like to work in the second or third level of subdivision. I do this because the mask function doesn't work very well on the first level of subdivision, and it's much harder to get smooth results on higher levels. So from experience I recommend using levels two or three at this stage.

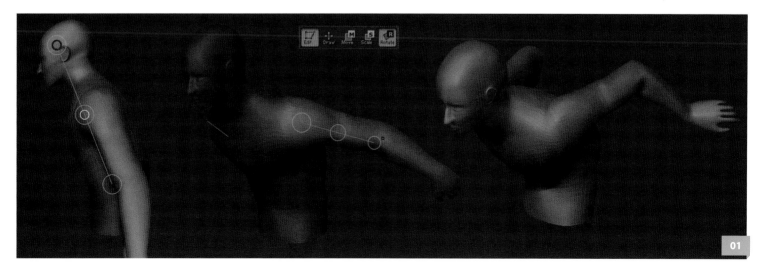
01

I don't have much of an idea about how my character's head will look at this stage, so I'm simply going to play around with the form and shape to find a good design for his face and head (Fig.02). I'm using the Standard brush and working in the third level of subdivision here.

As I work I keep checking the silhouette as often as I can, as it helps in finding a good design. To create a silhouette of your model, simply find the Flat Color material on the material palette, again by clicking on the sphere on the left-hand side of the screen. With the head design established first, it will be much easier to create the body.

I decide to add some skin plates and scales to the character to give him a fishy look, also I pull the jaw out quite a lot (you can see this in some deep sea fish creatures) all the while checking the silhouette is working and the design is strong (Fig.03). I'm still working in the third level of subdivision here, using the Standard and Move brushes. I'll sometimes also load in Alpha 39 into my alpha palette in order to achieve some stronger lines.

Because I'm still unsure about how the body will be in terms of its design, I decide to block in some simple human anatomy first to give me a starting ground from which to build upon, isolating parts individually and working on them separately (Fig.04a – b). I'm now working in the fourth level of subdivision, still using the Standard brush to find the shapes. To hide parts of your model you simply need to press and hold Ctrl + Shift on your keyboard, and draw a green mask over the model. If you need a different type of mask you can always hit Lasso on the right-hand side of the screen, or you can use the shortcut Ctrl + Shift + M.

The beauty at this stage is that I can work on just one side of the body, and then, using the SmartResym tool, simply copy the work done to the other side of the model (Fig.05). To do this, you simply create a

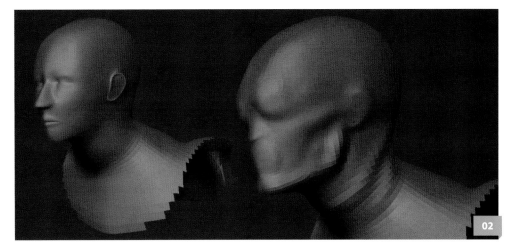

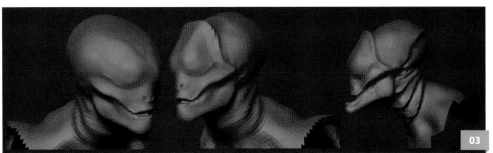

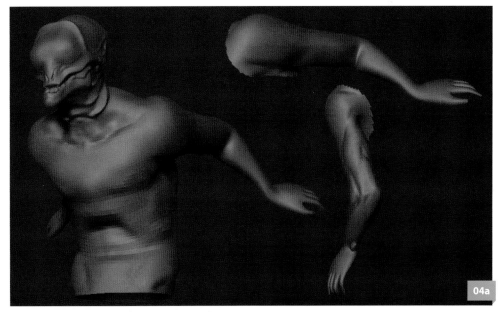

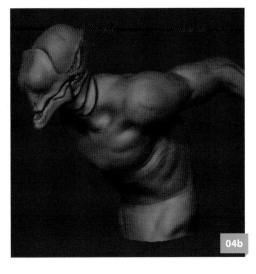

mask – again by pressing and holding Ctrl and clicking and dragging your left mouse button – where you've being working, leaving the untouched part of the model outside of the masked zone. Go to Tool > Deformation > SmartResym and you will see work copied across to the unmasked area.

Moving on from the torso and arms now, I start work on the hands, working with each finger separately (remember that to hide parts of your model, you simply need to press and hold Ctrl + Shift on your keyboard, and draw a green mask over the model). It's difficult to work on the inner parts of the hand when you have all the fingers in the viewport, which is why I prefer to work with them individually, using the Clay brush to give some volume to the skin at the joints where the skin creases and folds, and using the Standard brush to add lines and wrinkles to the skin (Fig.06a – b).

The entire block-in stage of the work has been done in subdivision levels four to six. The finer details are then added in the seventh level.

When I am happy with the detailing on the hand I can then create the hand's gesture and make it look more interesting using Transpose (Fig.07). As before, I use Transpose to manipulate the model to get the desired pose.

Here I add a fin-like element to his arm in order to give more detail to the silhouette, just using the Move tool at this stage to achieve the needed results (Fig.08). Using SmartResym again, I add the deformation to the other arm, balancing out the design to both sides of the body, as before (Fig.09).

At this point, I start to add some more skin plates, scales and fins to the body by drawing freely with the Standard brush, not worrying too much about the small details and simply trying to respect the natural flow of muscles in human anatomy (Fig.10). I also find the

06a

06b

07

08

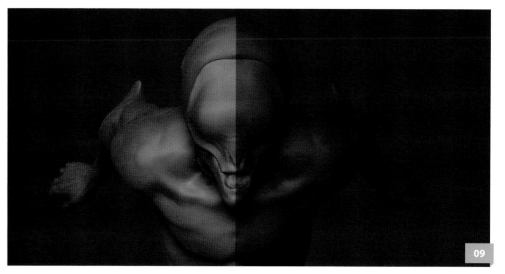

09

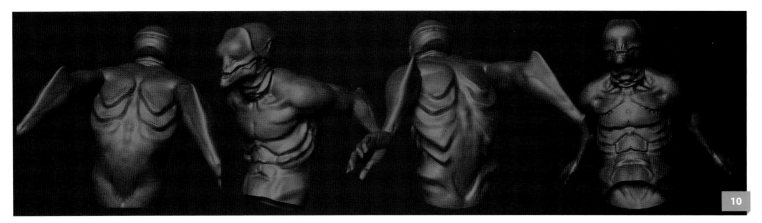

Clay brush useful to use here – it gives a more organic effect and it's a great brush to work on the skin's surface with.

Remember to regularly check your designs in silhouette by using the Flat Shader, as explained earlier.

I add even more skin plates and detail to the spine (Fig.11a – b), still working with the Standard brush and Alpha 39. I'm not using any direct references to sculpt; I'm simply trying to follow the flow of the anatomy and adding features that we'd generally recognize from fish.

To carry on the detailing work I add similar details as just given to the body onto his arms, in the same way as before – but this time sectioning off just the one arm to work on it separately (Fig.12a – b).

With the design nearly complete at this stage, it's a good time to check on the silhouette again to see if the concept is still strong before finalizing it (Fig.13). For me, design is a very complex thing. There are some techniques you can follow, but to me it is more about a feeling. You have to practice lots and you'll learn to know when to keep going and when you need to stop – it's all about building up experience and experimenting. I like to keep my silhouette very detailed, but it's also interesting to allow the eye to rest in some areas, as too much detail can be as big a problem as too little! I think the best training you can do is to observe and copy the work of great artists,

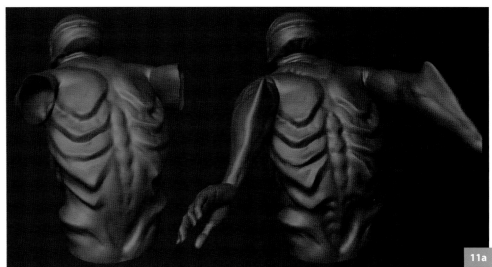

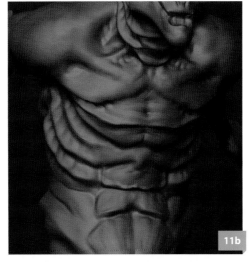

as well as use real life as a reference. Try to take notice of when the greats exaggerate details and when they don't. A good understanding of anatomy is a must-have, as well as drawing skills – drawing is a very powerful tool! I haven't drawn anything in this case, but it is a skill worth developing, even in 3D.

I feel the design is missing something here to be honest, so what I'm going to do is to add some more detail to the neck area to improve the concept (Fig.14). I'll created the new detail using the Standard and Clay brushes. This detail might seem useless, but it helps the eye to stop reading at this point. It's very important that the eye takes a couple of moments to pause when reading artwork and so I always aim to add some "accents" throughout my models' designs in order to achieve this.

Because organic creatures are not perfectly symmetrical, I'm going to break up the symmetry now at some points and add some final detail to finish up work on the head (Fig.15a – c). You can activate or deactivate Symmetry by using the X shortcut key. Again, I'm using the Clay brush to give the surface of the skin a nice organic feel, at this stage working in the seventh level of subdivision.

I do the same for the arms and the body, breaking up the symmetry further still to make the creature all in all more believable (Fig.16).

To start giving some relief and impression to the skin and get more realistic results, when working on a creature such as this it's often useful to use the alpha from animal photographs. I can use it by simply dragging and applying it, following the object's surface and the flow of anatomy (Fig.17a – b). To make an alpha you'll need to use Photoshop by opening up a photo that you like. Convert it to grayscale and make a soft, round border turning to black. Save this as a PSD and you're done. You can then import this new

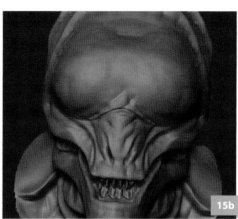

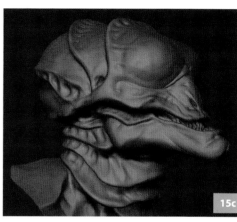

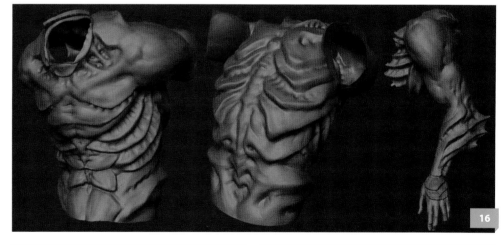

alpha into your alpha palette in ZBrush and to use it, simply change the stroke to DragRect and you'll be able to drag the alpha over the surface of your model. As for the pores, I use the Spray stroke and Alpha 07 to give the skin its ability to breathe and lose it plasticity, making it more believable to the viewer (Fig.18).

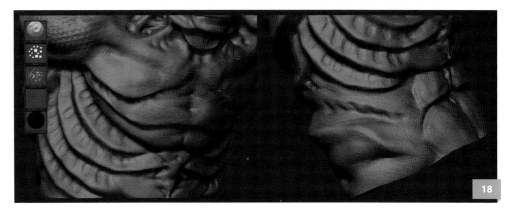

Texturing in ZBrush

Right then, it's time to start texturing in ZBrush now. I always use a fast shader for textures and avoid using colored shaders for this part of the process. So simply change the color to one that you prefer and fill the object (Fig.19). Choose the material from the material palette (remember it's the sphere on the left-hand side of the screen), and then go to Color > Fill Object.

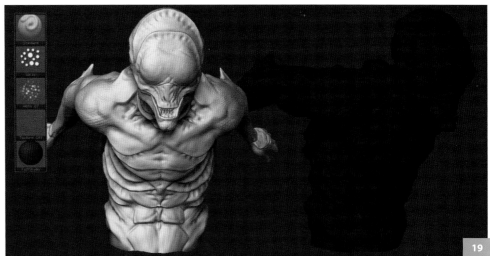

Photographic references are extremely helpful at this stage of texturing. For my own character I'm going to use a photo of a cold water fish and paint some areas with a lighter color. I use an alpha from an animal skin with my brush (Fig.20). Again, to create a new custom alpha you can simply take your photo into Photoshop and follow the afore-mentioned procedure. After you've imported it into your alpha palette you can then paint using the alpha as a brush.

I can also use the DragRect stroke to apply some color, remembering to turn off ZAdd for this part of the texturing process (Fig.21a – b). If you change the stroke to DragRect, you'll be able to drag the alpha over the surface. If you leave ZAdd turned on it will apply deformation on the mesh. At this point we just want the colors, so make sure that RGB is turned on. This technique is a good way to help you get a better blend from one color to another. Remember to check with the flat shader all the time as sometimes the shadows on the model can start to confuse you when you apply texture!

Here I am starting to introduce a third color to the model by painting some of his body with

a bluish gray, using the FreeHand stroke and an imported alpha from Photoshop of animal skin (Fig.22).

Working with Cavity Mask can be a great way to create better and more realistic results. Try to use flat color when you're doing this; you can edit the curve and the value of the cavity from 100 to -100 (Fig.23). Cavity Mask allows us to paint only into or around the depressions of our mesh. The values 100 and -100 are the setting to paint just inside and outside the cavity, but you can also edit the curve to get different results. Try playing around with the settings to get a better understand of how it works.

With the head and torso pretty much sorted color-wise now, I continue by painting the interior of the mouth and then move across the body, simulating shadows through a new range of blue tones (Fig.24). These shadows are sort of an "occlusion". Try to simulate some soft shadows on the contact areas – not actually a dark shadow from a point of light, but something soft.

Moving onto the arms now, I want to give them some more interesting colors – particularly the forearm. I go in with a mix of hot and cold colors (Fig.25).

The teeth need some attention now, and I paint them using a yellow tone with a hint of brown to give them a dirtier, aged look (Fig.26).

Nearly finished now! I just apply some veins by using DragRect and Alpha 22, trying out a variation of green, blue and red veins on the skin (Fig.27a – b).

I'm pretty happy with what I've achieved until now, so to finish up the texturing I simply take an overall look at the character and then go into areas to add more detail with Cavity Mask to really finish things off (Fig.28a – b). At this stage you have to make sure that there aren't any details missing – we have to try not to let our earlier hard work go to waste in this final stage!

And here is the final model, complete with textures (Fig.29a – c).

Rendering

When you're happy with the coloring of your ZBrush creation you can then go on and render it. You can find lots of great MatCaps at the ZBrush Download Center: **http://www.pixologic.com/zbrush/downloadcenter**. There's plenty of good stuff there, including some nice plugins and videos which are always very helpful.

Pretty much any default material in ZBrush is affected by light, as well as lots of other MatCaps too. But if you play around with lighting and some different MatCaps, you'll soon realize that not all of them are affected by the lighting scenario, so do be careful and pay attention when using new MatCaps.

Before you render you'll need to set up your lights first of all. So go to Menu > Light and there you'll be able to play with your light settings; you can change the direction of the lights by using your cursor and rotating the sphere. You can increase the number of lights if you need more by simply clicking on the small light icons. Below the lights you can change the light color and intensity of them. And if you open up the Shadow option on the bottom of the Light menu, you can change the shadow intensity by playing with the Aperture and Length settings. It's

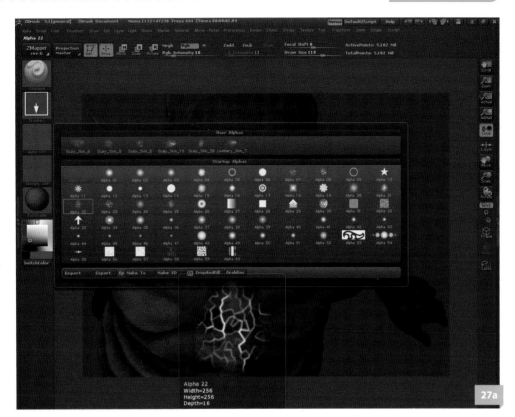

27a

27b

28a

28b

very important to make some quick tests, just playing around with all the different light settings, in order to better understand what each is used for and what it can achieve.

With your lighting setup ready to go, you need to render. So go to Menu > Render – there you'll find the render options. You can turn on the Fog and Depth Cue functions, and you'll also find a slider to change the intensity and range of the depth of field. If you open up the Fog menu (you can find it right below in the Depth Cue menu) you can change the color of the first and forth quads to a darker color (I usually use a very dark gray and a dark bluish gray). Once again, you can change the intensity and range of the fog using the sliders. As usual, play around with the settings to increase your understanding of what they do. When ready, click on the Best button to render.

To create a final image of my character I render out the following render passes:

- **Lighting** – a fast shader with no textures
- **Mask** – using Flat Color will allow us to separate the character from the background
- **Constant Diffuse** – using Flat Color with textures you can get back some of the texture detail lost after rendering, as well as getting better contrast over the final image
- **Depth** – this is really helpful to get the correct camera depth of field, and I create this pass by using Flat Color with no textures and playing with the Fog settings (to find Fog go to Render > Fog)
- **Occlusion** – using a MatCap called "White01", with no textures, I pull the color towards blue
- **SSS** – I use a MatCap called "RS_SkinBase" with textures
- **Specular 1** – I use the MatCap called "Bonus 02", which is a regular specular for skin
- **Specular 2** – I use the "ToyPlastic" MatCap with the black color to get a

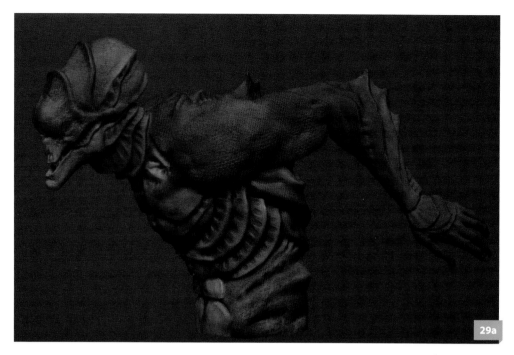
29a

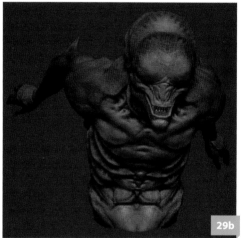
29b

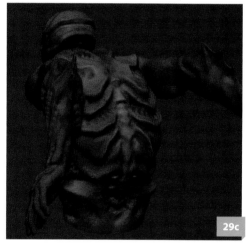
29c

wet-look appearance and to break up the specular, bringing the look closer to something we'd recognize on real fish.

With all my render passes done, I take them into Photoshop, relax and then have some fun playing around with the layer blending modes, Brightness/Contrast values, Hue/Saturation settings and the Blur filter. Here is the final result after some post-production in Photoshop (Fig.30).

Conclusion

I found the workflow that I employed for this piece quite successful, although I do recommend that you come up with a more exact idea of what you want to model before you start a new character design. With hindsight, I'm sure I could have come up

with a much better design for this creature if I had done some preliminary sketches at the beginning. Another nice process that can improve character creation is to retopologize your model, make a UVW map and export the maps (Displacement, Normal and Diffuse) in order to then render your image in other 3D software for better results. This is a particularly good and quick workflow for animation production.

You can download the base mesh (OBJ) file to accompany this tutorial from: **www.3dtotalpublishing.com**.

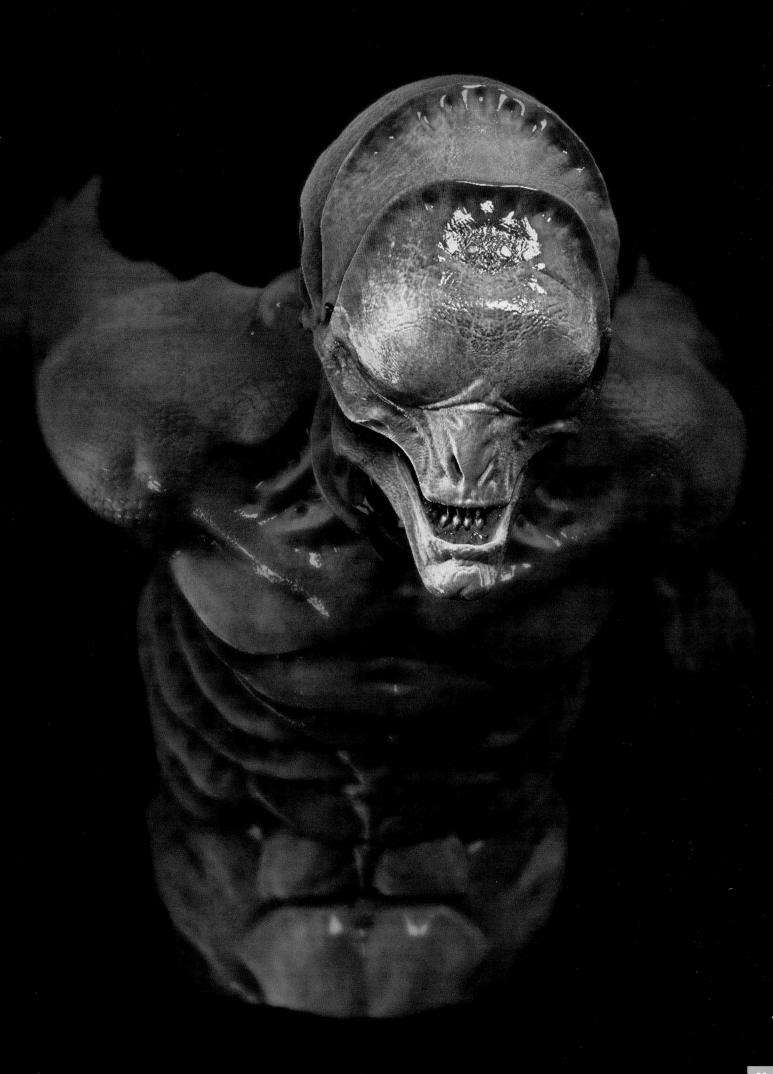

> **Brushing your model with alphas doesn't make it look prettier. Every wrinkle has to have a reason**

Sewer Monster By Federico Scarbini

Gather Information and References

In order to create a believable creature you have to do a lot of research. I read every book I had in my library about this kind of animal and in addition, I gathered tons of references from the internet and from Wikipedia. This is an important first step, because it is the foundation of your creative process. Without some kind of guidance you just randomly think about cool designs. That can be fine in some situations, but when you are asked to design a creature with very specific features you have to be very analytical.

The habitat in which my creature lives isn't really a habitat technically speaking, it's mostly an environment with some typical features. For example, it is very humid and the ground is generally flooded by shallow bodies of water.

There are a great variety of animals that could live in this environment: rats, frogs, fish, crocodiles and insects etc. Because of this variety, deciding what my creature should look like and which features it should have was a tricky adventure.

Creature Design

Since the most obvious feature of the environment I'm dealing with is its humidity, my first concern was the respiratory system.

Generally you could have two kinds of animal in a swamp: one with and one without gills.

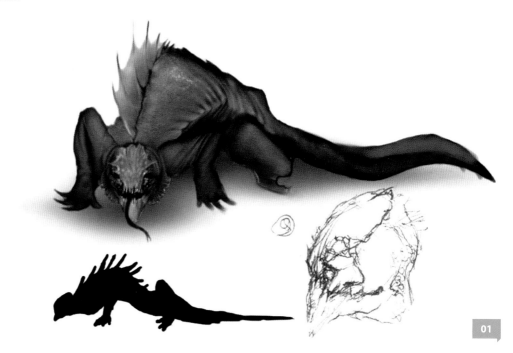

01

Gills are present in a lot of different animals and not just in fish; you can have modified gills on mollusks, crustaceans, insects and amphibians. I very much liked the flexibility that the gill design could lead to, so I wanted to explore this idea more.

Gills extract and dissolve oxygen from water that flows into the mouth of the animal. For my creature I wanted something less dependent on water; something that could also live in very humid land environments. Nature, as always, has the answer! There are animals that use their gills on land to extract oxygen from moist air, and there are also fish that use a primitive nasal cavity and lungs. As well as this there are frogs with a very interesting life cycle. They start as a tadpole, without lungs but with gills, and

then later on they develop lungs. All of this knowledge gave me a lot to play with. It was just a matter of finding the right answer to the organic puzzle!

My idea was a creature that uses gills and skin to extract oxygen from the humid air, and that has nostrils as a backup for its respiratory system.

So the skin is permeable to oxygen and carbon dioxide as well as water and it has blood vessels near the surface of the skin that, when underwater, transmit oxygen directly into the bloodstream.

The bone structure was another crucial thing to think about. When thinking about sewer or swamp-dwelling creatures the salamander

was my first thought, although I also liked the turtle's carapace design or the spiky skin of the crocodile. Since this step influences the final look of the creature heavily I decided to do some sketches.

I had a clear idea in my mind for its hands and feet. I wanted them to be finned because this way the creature would have the right thrust underwater and also a good grip on the wetlands. For practical reasons the creature needed to have the ability to catch prey, so I imagined a hybrid mutation where a thumb, index and middle finger were present and the ring and the pinky finger were mutated into a fin.

For the feet I went for real fins, although the internal bone structure is evident and solid.

Sketching

When considering the creature's appearance, at first I thought about crocodiles and turtles, with maybe a primitive carapace and a head like a snapping turtle's. With this in mind I developed a sketch in Photoshop after some doodling with pencil and paper. The design I came out with was very close to what I had in mind (Fig.01), but for some reason it appeared too "naturalistic" for a monster. It was not easy to admit that the design, though nice in itself, was not the right design I wanted for this creature... so I decided to explore some different designs.

I picked up ZBrush and, with a technique learned from Neville Page, created a 3D plane and converted it into a polymesh. I filled the plane with a neutral gray and then, with just the RGB for my brush turn on and Symmetry active, I started to sketch on the plane with Polypaint. At first I tried to not subdivide the plane too much, just two or three times. This way you cannot go crazy with details and you pay a lot more attention to the primary forms, since you are restricted to the mesh resolution. I came up with five different head designs (Fig.02) in the end. Sketch 1 and 1v.2 looked very cool. I liked

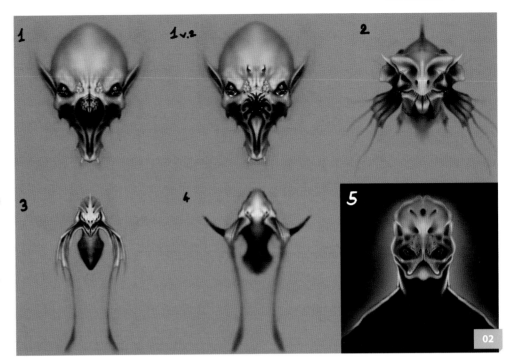

02

them a lot because they had the "monster" feeling that I was looking for, but to me they were a bit too vampire-like. 2 and 3 were okay, not particularly shocking, but with some nice elements I found interesting like the flower-like ears on 2. 4 was nice too, maybe too aquatic but a nice silhouette. I couldn't really fall in love with 5. To me it was because its features were too similar to a human's.

I found that using ZBrush in this way has really cool potential. Having Symmetry on whilst painting lets you get feedback quicker than when you're painting traditionally, and within two or three hours you can end up with five or six different designs. Another way I

use ZBrush in combination with Photoshop for sketching is to start sculpting from a sphere and then take what I have and do a paint-over in Photoshop (Fig.03).

Getting back to my creature, I went on to use ZBrush for a pure 3D sketch. I started using ZSpheres to build an armature for my creature, and then I used ZSphere2 to sketch the masses of the body on top of the armature. My suggestion here is to use a thin armature and use the ZSketch feature to fill the masses with bigger volumes. Try to use few strokes and use the Move and Bulge tools to manipulate them to give you the look you have in mind.

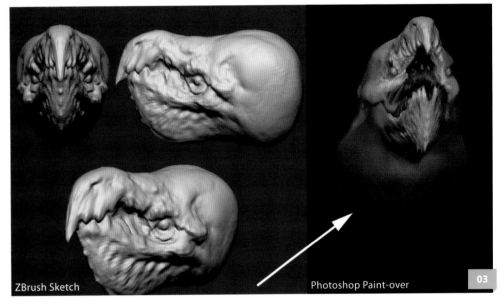

ZBrush Sketch

Photoshop Paint-over

03

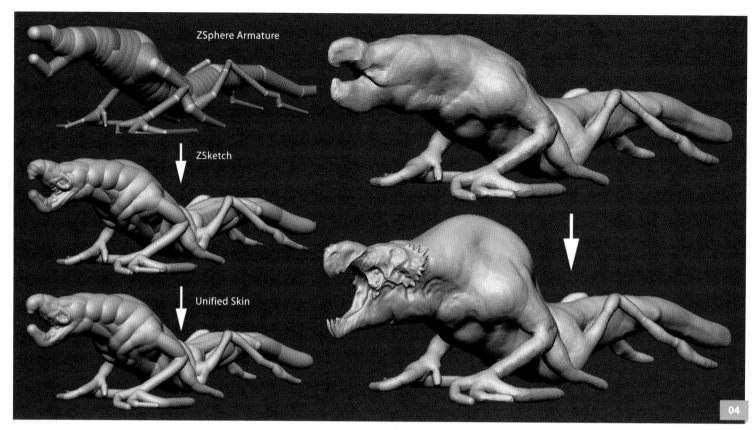

ZSphere Armature

ZSketch

Unified Skin

04

Once the forms are roughly in place, convert your ZSketch to a Unified Skin. With this newly created mesh you can start to develop the forms as you normally would with the sculpting toolset. I used a combination of the Move and the Move Topological brushes to adjust the silhouette and the masses, then with the Clay and Clay Tubes brushes I sculpted the mesh (Fig.04).

To me, sketching is not trying to find the right answer, it's just a visual way to collect ideas, get inspired by forms and explore your thoughts. It's hard for me to look at a sketch and say, "OK, this is what I was looking for!" More often it's just for inspiration, a guideline, and most of the time I use different elements I like from different designs.

As you can see I went for a very different design with very singular features, inspired by nature, but with a flexible degree of interpretation. With all of this in mind, and with my references and sketches in front of me, I started what would be my final design.

Base Mesh and First Sculpting Stage
Since I didn't have a very clear idea about

the final look of my model, I started out using ZSpheres. The goal at this stage was to capture the gesture and silhouette of the creature, so I didn't really create very specific features, but focused on the feeling that I wanted in the figure (Fig.05).

When I was happy with the ZSphere armature I converted it to an adaptive skin, to get my low poly base for the model. Now I had my base I started to adjust the

shapes as usual, using the Move and Transpose brushes. The combined use of these two tools is fundamental to get the best out of your base mesh, because at this stage is too early to even use the Standard brush.

A very valuable tool in ZBrush 4 is the Move Topological brush. This lets you move the surface of the sculpt according to its topology, so it automatically masks what it's near to. This is something I used to do

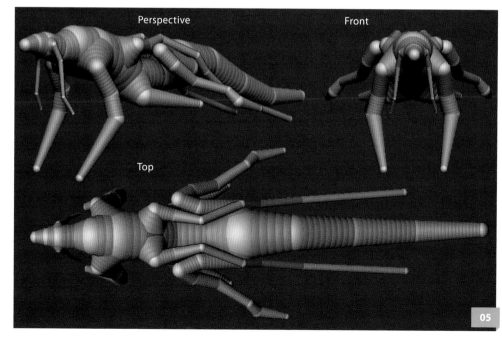

Perspective

Front

Top

05

manually with the Transpose Masking tool, but this new brush works perfectly, so no more back and forth between Transpose and Edit for masking!

After some tweaking I came up with a pretty decent looking base. The most important thing was that it had a good and defined gesture and silhouette, plus some initial hints of some features (Fig.06).

Refining the Base and Building the Foundations of the Creature

This stage is one of the two hardest steps in the creation process. You have to slowly try to refine the basic form of the model. Right now the form is temporary and it's time to find how you can develop that form. Sometimes I can spend hours just with the Move brush, looking at the model from every angle and doing minor adjustments. I then undo and redo rapidly to see the difference, and decide if I should make the changes. Once you have touched every polygon you will need more room to play, so it's time to subdivide.

Lately I have been using a technique that consist of blurring the viewport while sculpting. There is a button called VBlur (in ZBrush 3.5 it was under the Draw submenu on the Preferences Menu; now in ZBrush 4 you have it on the BPR menu under View Blur). When it's pressed a VBlur Radius slider appears – I usually set it to 3 or 4. Sculpting with the blurred viewport is very important in my sculpting process because at this stage the primary focus is the primary forms and with the blur active I can focus on this. I find that it's a good way to force yourself into good habits.

As I already said, at this stage I mostly work with the Move, Move Topological, Standard and Inflat brushes. Sometimes I also use the Transpose brush for some tweaks on the orientation of the limbs.

As with traditional sculpting, primary forms and looking for planes is an important thing

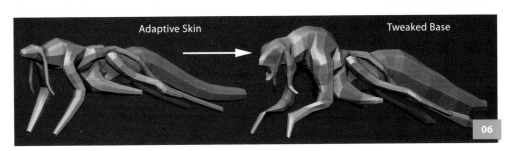

Adaptive Skin Tweaked Base

06

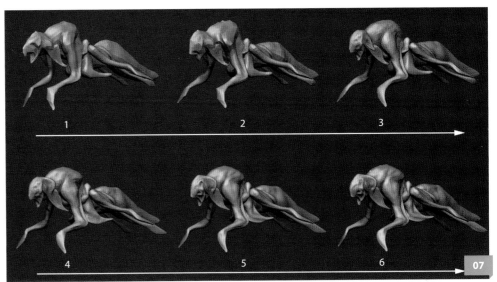

1 2 3

4 5 6 07

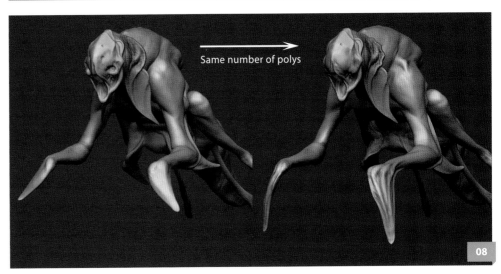

Same number of polys

08

to focus on. When you have some more subdivisions you can focus on placing landmarks such as bone structures that will drive the muscle placements.

Fig.07 shows the evolution from the tweaked base mesh to a level 3 subdivision. The changes were not huge; it was more of a controlled adaptation of the mesh to include some of the specific features that I saw on the initial model. In step 5 I started to add landmarks like the knee bones and cap, as well as some initial muscle sculpting like the shoulders and arms.

Bring the Model to the Next Level

By now the model had most of its major features in place, so it was time to develop the existing shape. The first thing I did was take what I had and compare it to references from nature and my initial sketches. I was looking to see if there was something that I could add or modify.

After spending some time looking at my references, I started tweaking the mesh. In the end, without subdividing it more, I used the polys I had and moved them until I reached the design I was hoping for (Fig.08

– 09). I've colored the parts that I changed in the process. Nothing drastic, but the model was now starting to have a better defined structure.

Then I started using the brushes I mentioned before, along with Clay and Clay Tubes with Alpha 06. When using these brushes I usually turn on Fast Sample (Brush > Sample) to increase the accuracy of the surface samples, giving more predictable stroke results. I also use the Backface masking features a lot when dealing with very thin surfaces like the ears. This prevents the stroke from passing through the surface and affecting the Backface. The Backface button is located in Brush > Masking.

These two brushes work really well when building muscle surfaces and when you have to construct planes because the strokes are very organic looking.

After a bit of work I decided to retopologize the model to have a better density distribution. To do this I used the GoZ plugin, which allows you to send your model back and forth between ZBrush and other software – in my case Maya.

In Maya I used standard polygonal modeling tools like the Split Edge tool, Append Poly, and Extrude, along with Merge and Collapse to manipulate the mesh to my needs. The

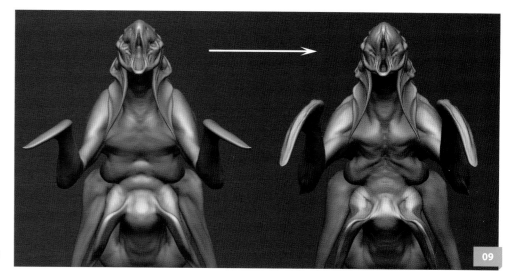

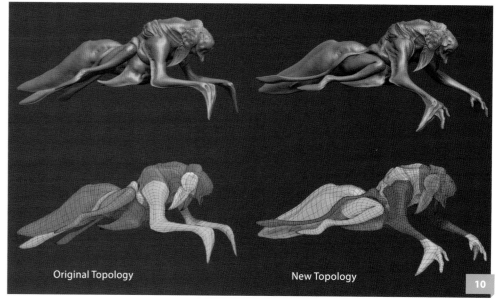

Original Topology New Topology

head and the hands were the parts that needed more attention because of the nature of the ZSpheres.

When finished I sent the mesh back to ZBrush and the software managed to re-project the high poly details onto the new mesh. Keep in mind that GoZ is just an automated process of importing and exporting, which is something that you could already do if you imported an .obj where the lowest subdivision level was active for your tool. This means that you have the same projection issues you would have in the manual process, so keep this in mind.

As a side effect of the retopologizing process you will lose the polygroups. To prevent this I use this little trick: before sending the mesh with GoZ, use the UV Master plugin to do

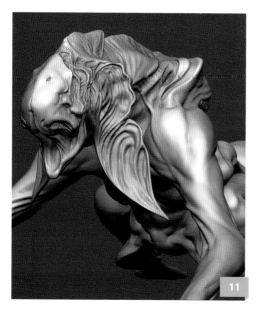

a rough unwrap, activating the Polygroups button on the plugin's panel. This way when your mesh is sent to the external software and brought back to ZBrush you can always restore the polygroups from the Auto Groups with UV feature in the Polygroups menu. Obviously if you edit the topology you also have to fix the new UV, but it's way faster than redoing the polygroups from scratch (Fig.10).

With the right topology to work with, forms started to adapt better to my strokes and I was free to define some more precise elements and patterns, like the top of the head, the ears and the wrinkled skin on the elbow (Fig.11). I took inspiration from fish like the frilled shark for some elements. The design of the gills was from an iguana and the look of the skin from a giant salamander.

Detailing

This is the second of the two hardest stages in the creation process. Detailing is a danger zone and you have to treat it very carefully. It can turn your model into a great model that people can enjoy and that generates interest, or it can destroy all the hard work you put in and turn your model into a mess. There is a simple, but very important rule to keep in mind when approaching detailing: details (or tertiary forms) have to be supported by a hierarchy of secondary and primary forms. Brushing your model with alphas doesn't make it look prettier. Every wrinkle has to have a reason. Every spike or little bump should be placed in the right position.

Think of the surface of your model as a map; mountains, valleys, lakes, streets, cities, stores and bus stops have a very logical distribution. The point of this example is that you wouldn't open a bakery in the middle of the desert – the same goes for wrinkles. You would never place wrinkles where there is no need for them to exist. This could seem obvious, but sometimes it's very easy to get lost in a frenzy of detailing without taking a moment to plan.

Now, don't get me wrong, I don't have a reason for every single bump and lump I place, but for most of them there is a logical placement inspired by nature. Having fun is part of the game, but always control your strokes and judge their necessity.

That being said, I tried to identify the areas where the skin would compress during movement and I started to create localized wrinkles, with a logical direction that followed the articulation. I used the Dam_Standard brush for this process. You can find it in the brushes section of Spotlight.

Besides wrinkles you have tendons and bone structure visible on the surface, and also veins and little bumps. A good aid when placing these kinds of details are references of real animals.

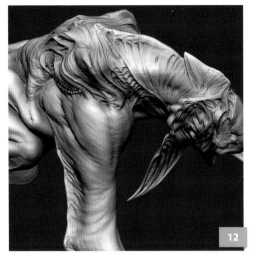

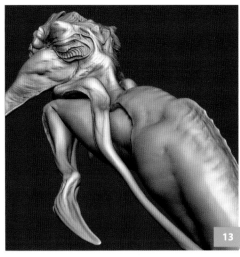

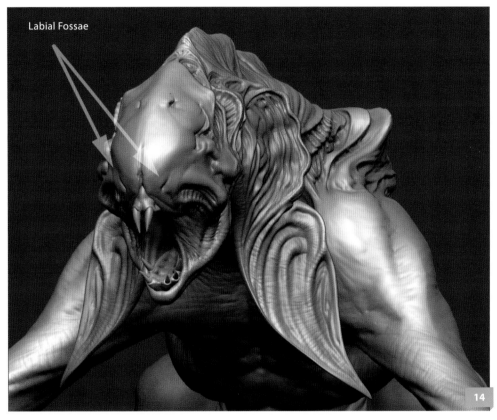

Labial Fossae

Generally I use the Standard brush with very low intensity and I build the details both conceptually and concretely using sculpt layers. By using layers you have full control over the overall intensity and it's always a good thing to have the ability to just turn off a layer if you don't like the result.

I then moved on to giving the gills on the monster's back a solid structure and I looked at the neck too. I used the Inflat and Pinch brushes in the areas where skin gets folded. The same goes on the tentacles, which I compressed near the legs (I didn't mention this before, but the creature has tentacles

for stability while swimming, like a jellyfish). I placed wrinkles at the end where the feet-fins are (Fig.12 – 13).

At this stage I also created some very rough geometry with Maya and some simple box modeling for the gums and teeth, and then imported then into ZBrush.

An example of the logical placement of a particular detail is the little depressions I sculpted just above the mouth (Fig.14). These depressions are not there for fun, but have a very natural explanation. Snakes, for example, have these and they are called

"labial pits". They are very unique sensitive organs that allow the snakes to "see" the radiated heat of warm-blooded prey, like infrared receptors.

I spent some hours detailing the whole body and finally my final model was finished (Fig.15 – 16).

Texturing

Before starting the polypainting I exported the model's lowest subdivision layer to Maya and created some UVs, mainly using the Unfold feature with some relaxing and using the UV Lattice Deformer where needed.

With the UV done I started the polypainting, using salamanders and amphibians as reference. I filled the model with a medium-dark green color and painted the surface with the Standard brush, with Stroke set to Color Spray and a combination of Alpha 08 and Alpha 22. When painting the skin of a creature try to use different colors and go for variety; variation gives skin a much more realistic look.

In the first pass I wanted to have general variations and to set the first color scheme (Fig.17). I placed some red/pink colors where the skin is supposed to be more irradiated with blood vessels.

I then baked the polypaint to a texture and created a Displacement map to be used on top of the texture to get some depth when used as an Overlay layer, and also to have a guide as to where to paint in Photoshop (Fig.18).

I imported the texture into ZBrush and baked the texture to polypaint from the texture palette on the Tool menu.

I then used Cavity Masking to paint different tones for different depth levels. Since the texture seemed to me a bit dark and green I tried to get a different color variation in the skin. When most of the features were

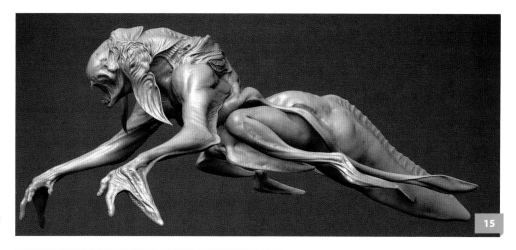

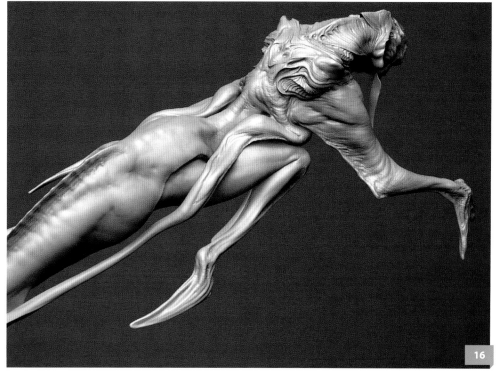

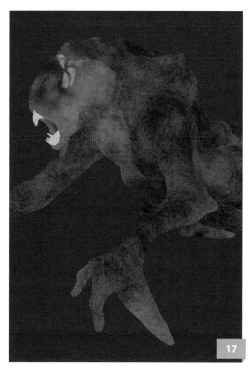

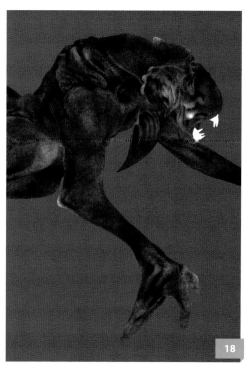

in place I decided to bake the polypaint to continue the paint job in Photoshop. Here is the texture before using Photoshop (Fig.19 – 20).

Once in Photoshop I was free to use some photographic textures. The best ones for this kind of texture come from the Total Texture DVDs by 3DTotal because of their great variety and flexibility. I used some masks to get the right placement for the textures in order to place the right patterns where I needed them to be.

Then, using the Standard brush along with some custom brushes, I started painting. At first I tried to follow the details I already had and reinforce them. Using the depth information I had from the displacement I had a very clear idea where to place additional elements. You don't want to hide your sculpted details, but paint on them to reveal the nature of the surface.

At this stage I used some references to get inspired. Nature is a very valuable material to study, as is the paint job done by maquette artists or make-up artists like Jordu Schell or Rick Baker.

This is the final look of the texture I then used in Maya for the rendering (Fig.21 – 22).

The gums and teeth were also polypainted using the same method described earlier, and then the polypaint was baked into a map and the models were UV mapped using the PUV Tiles inside ZBrush (Fig.23).

Posing

Posing a character is not easy. You have to grasp not only the action but, above all, the essence of the creature. This gives credibility to its structure and the impression that the "animal" is actually living and doing something. I had an idea inspired by iguanas in mind for his pose. When you see them moving slowly, their arms seems to grasp the air whilst they move forward.

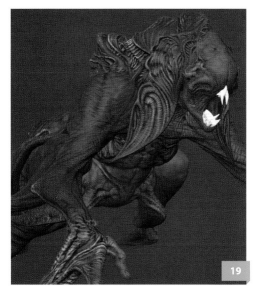

For posing I use the Transpose Master. There is a button named Layer, which is a real time-saver. It creates a new sculpting layer for each subtool with the new pose so you can switch back to the original pose at any time.

Using Topological Masking I started rotating the torso to conform it to the action; the same goes for the limbs and head. I paid particular attention to the legs and feet because I wanted to show the hybrid nature of the feet. They are fins, but because of their solid bone structure they could also be used as anchor points for moving around.

Once happy with the pose I transferred it to the high res sculpt and I adapted the skin where needed locally using the Standard brush (Fig.24).

Ground Modeling

To create the ground element I used a 3D plane converted to a polymesh and positioned it under my creature. Then in the lowest subdivision layers, I adapted its surface to support the creature's action with the Move and Move Elastic brushes. Once it was subdivided I sculpted it with the Clay brush to mimic a mud environment.

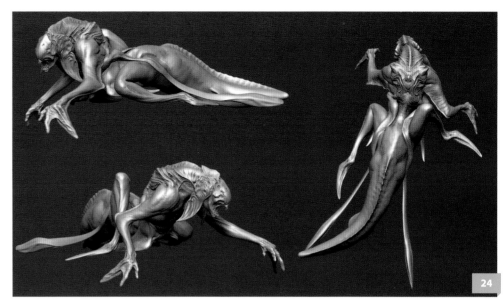

Next I applied different surface noises to different subdivision levels. Surface noise can be found in Tool > Surface and it displaces the surface following a profile curve in the surface slot. If you grab a curvature point in the noise curve, drag it out of the graph and then come back to the graph, you will have a linear break in the curve that is very useful when it comes to creating interesting valleys.

I applied different curves to different subdivision levels, taking care to change the noise scale each time just to give some variety and randomness (Fig.25). Don't

forget to press the Apply to Mesh button when you're happy with the look of your surface noise since it's behavior is to show the end result but not automatically bake it. You have to press that button to transfer the noise displacement to the mesh.

Maya Import and Modeling Environment Elements

For the creature I exported a mid-resolution level mesh and baked a Normal map to get the higher subdivision details. I then exported two different ground meshes: one decimated at 30% to become my high resolution mesh and another version decimated at 2% to be

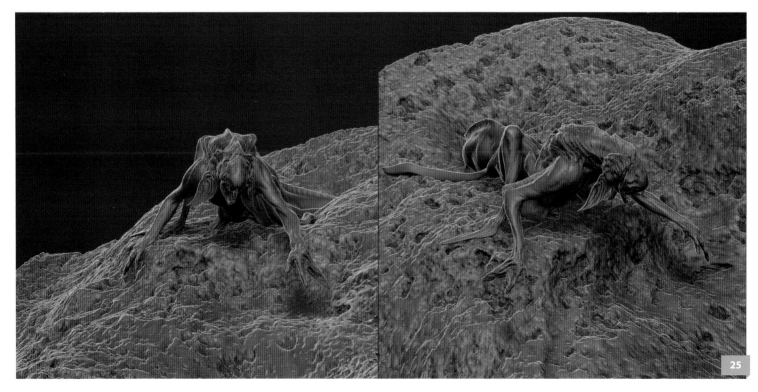

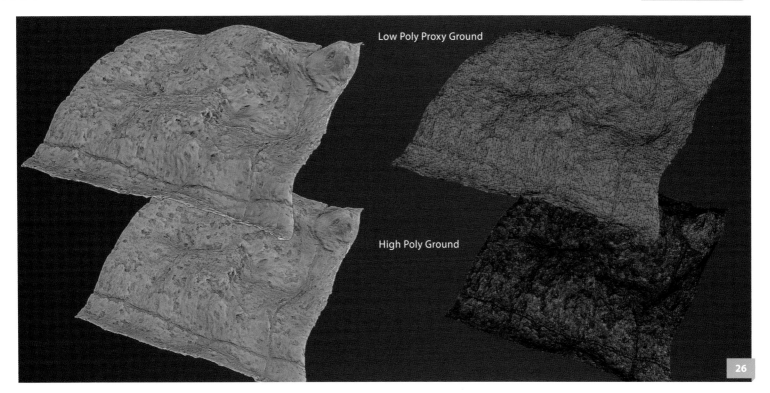

Low Poly Proxy Ground

High Poly Ground

26

the low poly mesh and to be used as a proxy (Fig.26). Once in Maya I create UVs for the ground by setting the viewport as Top and using the Create UVs Based on Camera button from the Create UV menu.

The gums and teeth were exported at their highest level because they were not that heavy, and before exporting them I used the PUV to bake the polypainting onto the textures.

The rusty iron tubes were made using a polygonal cylinder with a 12 subdivision axis and an evenly spaced number of subdivisions for its height. I extruded every other face to get variety in the surface depth going around the cylinder. Then, using a Non Linear Deformer called Twist, I twisted the cylinder to give it the appearance of steel tubes placed in reinforced concrete. I then create some UVs for the tubes using cylindrical mapping.

The grass was made with Paint Effects. First I made the proxy ground paintable (Make Paintable button on the Paint Effects menu). Then I searched in the Visor for the type of grass that I needed, and I started painting on the surface of the ground by placing the

grass where I wanted it to be. Strokes like this often need some adjustments so you can modify them after they have been painted using the Stroke Attribute editor. I played with its settings a bit and when happy with the look of the grass I converted all the strokes to polymesh by going to Modify > Convert > Convert Paint Effect to Polygon (Fig.27). The background is half of a cylinder with the face normals inverted, just to give the impression of a round, concrete surface.

Lighting

Since I was going for a real environment, trying to mimic that environment lighting was the key to creating a realistic mood. Lighting

is important to tie together all the elements of the image. With fake environment lighting it's very difficult to give the viewer the impression that the situation portrayed is actually happening.

For this image my idea about what's happening is that the creature is emerging from the darkness of the underground, maybe to find some food or just for curiosity. It is slowly approaching the land above, where the underground tunnel comes from.

Generally speaking, viewers' eyes are attracted more to the light than to the dark, and the same could be said for warm and

Open the visor

Make paintable

27

cold colors. For this reason I created a spotlight with a warm orange-ish color facing the creature to serve as my main light. I then created a second spotlight positioned to the right, a little higher than the camera, to be my Fill light and represent a sort of environment lighting or bounced light coming from the environment. Both the spotlights have the Decay rate set to Linear to give a gradual falloff on their intensity. Behind the creature I placed a direct light to create my Rim light. This helps a lot to enforce the silhouette of the creature and to make it stand out from the background. To create an overall dramatic mood I also placed an Area light above the creature to mimic the sky or an opening in the ceiling (Fig.28).

To have better specular on the ground I then created a point light, activated just the specular component and disabled Diffuse Contribution. Then I placed it at the right angle to affect the ground surface specular the way I wanted it to. Because I didn't want this light to affect any other element of the scene I opened the Light Linking editor (Window > Relationship Editor). Here you can set the inclusion or exclusion of single objects from each light.

Shading

For the creature I used the mental ray "Misss_fast_skin" shader. It can seem a bit tricky to set up, but the key to mastering this

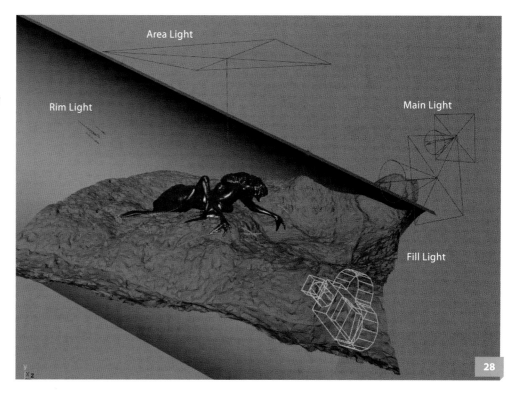

shader is to split its setup into several steps. To precisely set up the SSS component I set Diffuse weight and Specularity overall weight to 0. Then I started from the Backscatter layer and turned the Epidermal and Subdermal layer weights to 0.

You then basically have two parameters to set. One is Weight, which can be seen as the intensity, and the other is Radius (and Depth, which I usually set at the same value as Radius), which is how far the light penetrates into the skin.

I then did a test render to see how the shader looked with the default values. I wanted the intensity to be very evident, so I set the radius in such a way that if the weight was too low it would be easy to understand how much it would change if I turned it up a bit. Then I started tweaking the radius and weight values. If the radius or weight values are too strong then you can halve their values and do a render and so on until you get the settings you feel are right for the kind of skin you're going for.

Once the Backscatter is okay, I usually write the weight value in a notepad to remember the setting, turn it to 0 so it has no effect and

move on to the next layer: the Subdermal. It's difficult to say how the Subdermal layer should look. My idea is that this is a deep layer that should soften the shadowed area, but not be too intense. I used the same process for the Backscatter layer and once done copied the weight value on the notepad and turn it to 0.

For the Epidermal layer I used the same process once again. This is the nearest layer to the surface so its intensity and therefore weight value is higher than the Subdermal, and it contributes more to the diffusion of the light through the surface.

Once the three layers were okay, I copied all the values I'd written in the notepad to the respective layer weight fields and I had the SSS component set up. Then I turned the Diffuse weight to 0.6 or 0.7 depending on the kind of texture I had and did a test render.

The specular component was easy to set up and this shader does a very good job of representing the specular component. I also created a Specular map for it so I could set the intensity of the specular where I wanted. This is very important to give a realistic feeling to the skin (Fig.29).

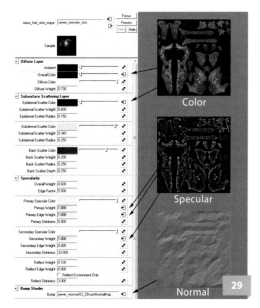

For the ground I used a simple Phong shader. In its color slot I placed a 3D "snow" texture and plugged in two different ground textures from the Neanderthal set of the Total Textures V9:R2 DVD in each color slot. I used the Specular and Bump maps of the same texture for the specular color and bump of the shader.

The concrete and the rust come from handmade textures created from a photo and custom brushes, and they are a simple Phong shaders. Nothing too complex here.

OK, so every shader was set and the lighting setup was done. Time to render the final image (Fig.30)! Besides the Beauty pass I also rendered two separate passes: a Color ID pass and a ZDepth pass.

For the Color ID pass I used a different surface shader for each element in the composition so I got a flat, colored result without the shading component (Fig.31).

For the ZDepth pass, since it's a bit tricky to set up in Maya, I downloaded a great shader called "p_z" that is part of a downloadable pack of shaders and utilities created by Ledin Pavel. You can download the whole pack from his website: **http://www.puppet.tfdv. com/download/shaders_p_e.shtml**.

Once installed you will find it on the mental ray Shader tab. The setup is very easy. Just assign the material to all the objects in your scene and set the near and far clip plane just as they were in the extreme limits of your depth of field. Once rendered you will have a Depth pass to use in Photoshop later (Fig.32).

Final Photoshop Post Editing

This is the relax stage. All the work has been done and now it's just a matter of tweaking the image and getting the best out of it!

At this stage I generally start doing some Level and Curve adjustments to push the

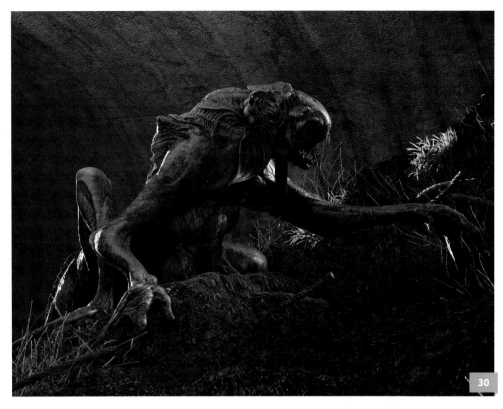

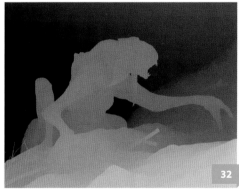

value of my image until I like it and to pump up the contrast a bit.

To create the effect of the moist air I used the ZDepth pass as a mask and filled a new layer with a white/bluish color. This created a sort of fog effect that I tweaked until I felt it was right for the image. I then used Color Balance to give the image the right mood and added some more Curve adjustments to get the cross processing effect, which is where you use the lighter value to have a different tint than the darker one. I used some more post-processing to get the depth of field using the Lens Blur filter with the Depth map I rendered earlier.

I then added a bit of breath smoke to give the impression that the environment is not

just humid, but also a bit cold. Then as a final touch, I added some strings of saliva in the creature's mouth using a Standard Round brush.

Conclusion

This project was very challenging. I tried to push myself to do better in many fields, not only the modeling but also the design, shading, lighting, composition – all the different aspects involved when creating an illustration from scratch.

I hope that this article can show you much more than the techniques I used to create the final image. I hope it also lets you understand a method you can use to develop a believable character (Fig.33).

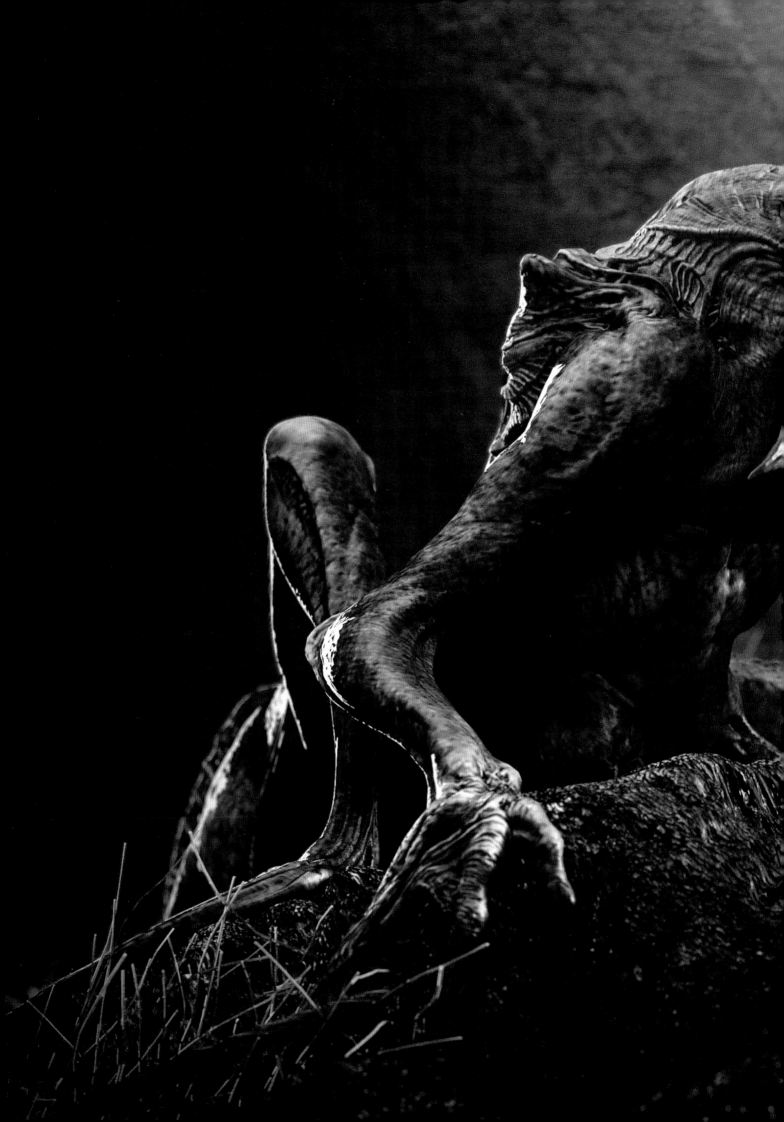

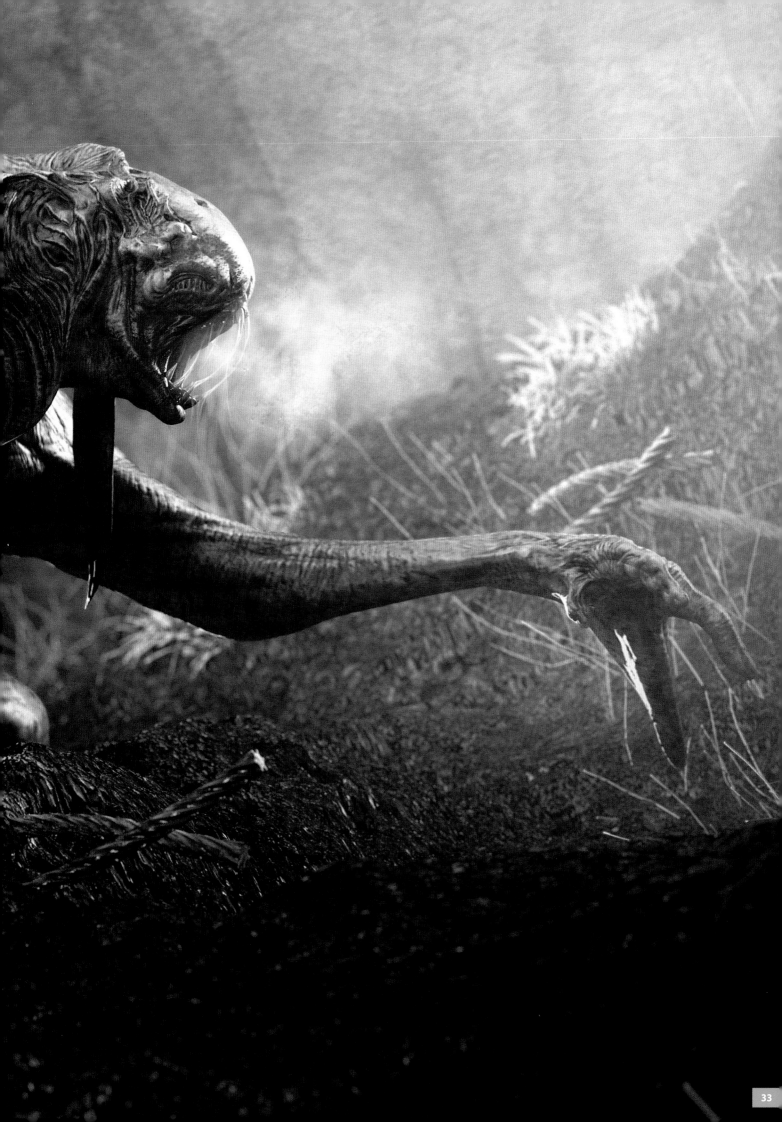

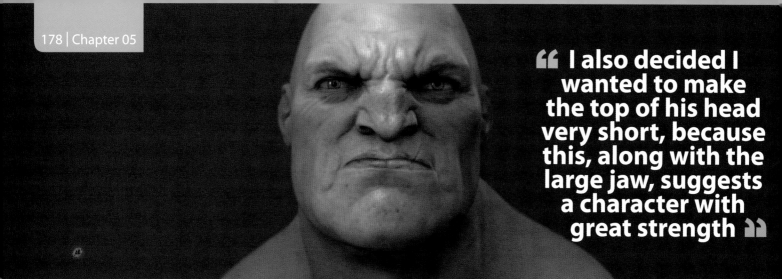

" **I also decided I wanted to make the top of his head very short, because this, along with the large jaw, suggests a character with great strength** "

Steroid Guy By Rafael Ghencev

Concept

For this character I already had in my mind what I wanted, so I made a quick concept for a muscle-bound steroid guy on paper. If you feel confident enough with sketching I would suggest giving this a go (Fig.01). I wanted to do something a little different that wasn't too realistic and that was quite stylized.

The first thing to focus on is how to achieve good proportions in order to give your character a greater sense of power. With the creation of a stylized, steroid-pumped guy some of the proportions can also be exaggerated that little bit further. In my concept I basically decided that I wanted to make his trapezius and deltoid muscles very strong and large, whilst having his head hanging quite low, so this means I will have to play around with his muscle proportions a little. I also decided that I wanted to make the top of his head very short, because this, along with the large jaw, suggests a character with great strength.

Finding the Shape

So with all of the decisions made with regards to the concept we can start to model. At this stage it is very important to concentrate only on the shape, forgetting the details and the temptation to add more levels of subdivision to your model. If your low poly shape is not good then increasing the polygons will do nothing to help anyway.

The first thing to do is to fix the proportions between the head and body using the Transpose tool. Select the tool, press the Control key to select the topology and then scale the head. Select the Move tool with large focal size and start creating the overall shape (Fig.02).

When the basic shape is okay add more levels of subdivision and start to refine the shape further. Using the Move and Standard brushes with low values, start to block in some of the muscles and parts like the mouth, eyebrows and nose, but remember

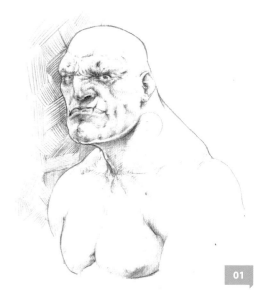

01

to concentrate on the overall shape (Fig.03). This is the most important part of the sculpting process so take your time to make sure you create a good model to work with.

Refining the Structure and Separate Parts

With the overall shape defined use the Clay brush to start adding more elements to improve the shape, such as variations in the

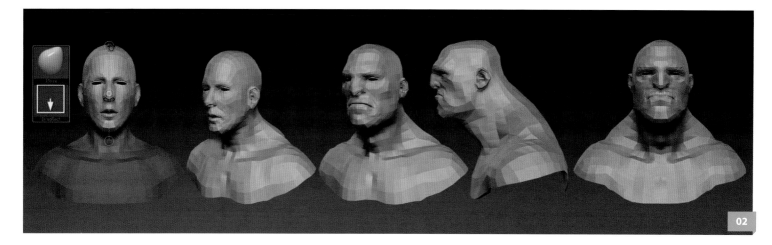

02

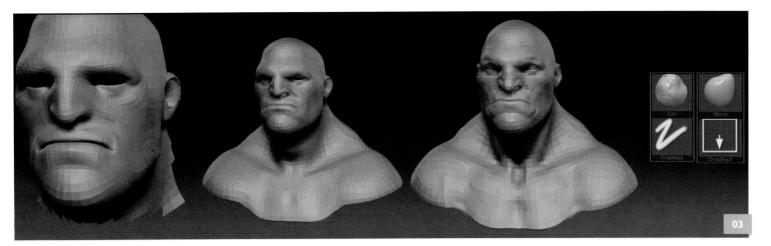

muscular volumes and the shape of the skull etc. At this point you can also start to refine the separate parts like the nose, mouth and eyes (Fig.04).

Note: Working in a low level of subdivision is very good for blocking in the overall shape, but to refine the individual shapes it's advisable to make one or two subdivisions to get more polygons to work with.

You can see from Fig.05 that I am sculpting my character's head into a triangular shape to give him a strong appearance.

Refining the Facial Muscles and Details

With the main shape done start to block in some of his expression, particularly focusing on the wrinkles on his eyebrows, and refine the muscles in the face.

Note: It can be very useful to hide some parts of your model to help you concentrate on specific areas.

You can exaggerate his facial muscles by making some subtle changes to the muscles under his skin using the Clay brush. In the eyebrows sculpt some wrinkles using the Standard brush with Alpha 38 and then use the Inflat brush with a low value to give a more natural form. For the mouth use the Standard brush to mark the division between the upper and lower lips (Fig.06).

You might like to work on the shape of the ear using the Standard brush and Move tool

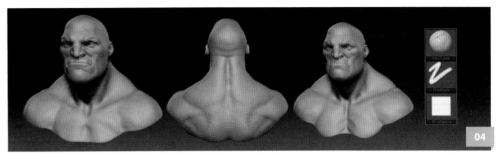

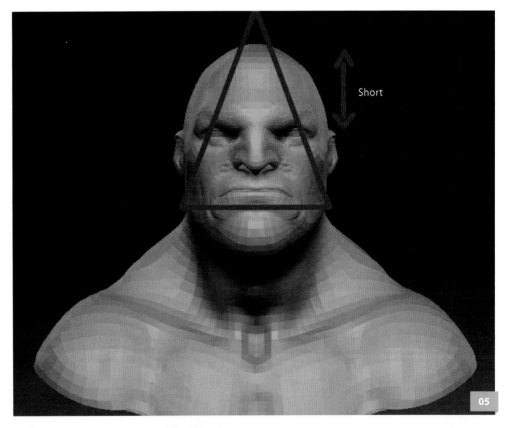

Short

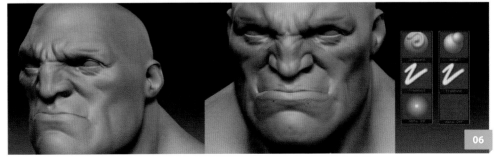

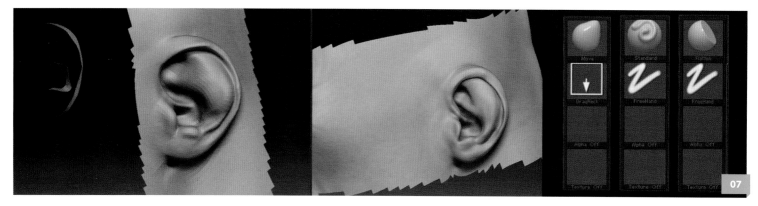

for the basic form, and then use the Flatten brush to create a more natural look (Fig.07).

You can then move on to his chest and start to mark the muscle connections with the Clay brush. The pectoralis muscles are connected in the humerus, ribs and sternum. With all these things in mind I try to give him a very natural muscular shape and I do the same thing on his back (Fig.08). I find it very helpful to search for references on the internet when sculpting; in this case bodybuilding pictures and videos were particularly useful.

Final Details

This is the time to start improving the details. I want to make my character fairly clean, without too much information in his face. I aim to put only the essential details in his face, along with some important wrinkles in the brow, around his eyes and on his neck, and some skin imperfections.

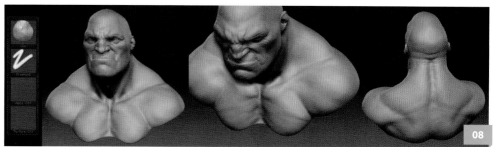

To refine the wrinkles in his brow and to make further wrinkles on his face, use the Standard brush with a low size and Alpha 38, and the Inflat brush with a low intensity. Use the same brush on his neck and also to add the scar across his lip (Fig.09). To make the wrinkles in your model look convincing it is very important that you use references to analyze the paths that wrinkles follow in particular areas.

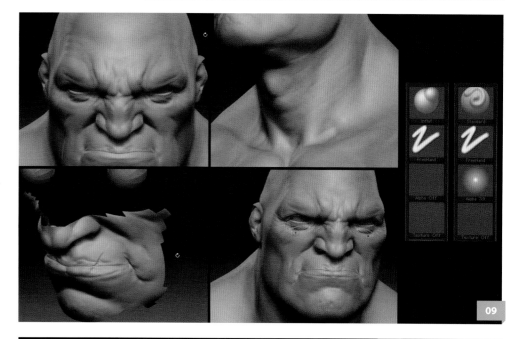

For the lips use the Clay brush with a low radius to add some volume and to show the effect of the tension between the upper and lower lips (Fig.10).

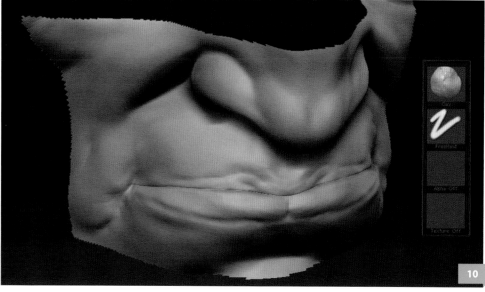

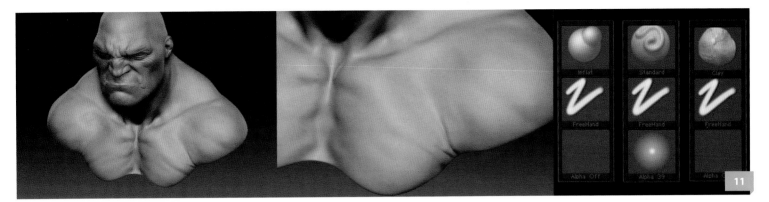

Where the chest and the deltoid muscle meet build up the skin using the Standard and Inflat brushes, and with the Clay brush refine the details of his chest muscles (Fig.11).

Take the model back down a few levels of subdivision and break the symmetry to make everything look a little more natural (Fig.12).

Stepping back up in the levels of subdivision, for the skin imperfections choose the Clay brush with a very low radius and the Mouse Average set to 1, and start to make them one by one. This is a lot of work, but the end result is great (Fig.13).

Here you can also add some veins to the character's head, neck, chest and shoulders, using the Standard brush with Alpha 01 (Fig.14). And here is the final un-textured sculpture (Fig.15).

Texture

I'm going to use a projection method to texture this model. The best way to do this in ZBrush is using the Projection Master because you will have total control and can change the projection of the images – just like the Liquify Filter tool in Photoshop.

To start the texturing process I start like I always do by changing the shader to a white one, creating a new texture for the texture palette and turning off the perspective to avoid any texture distortions.

Inside the Projection Master choose the Plane 3D object, select an alpha (in this case I'm using one with soft borders) and in

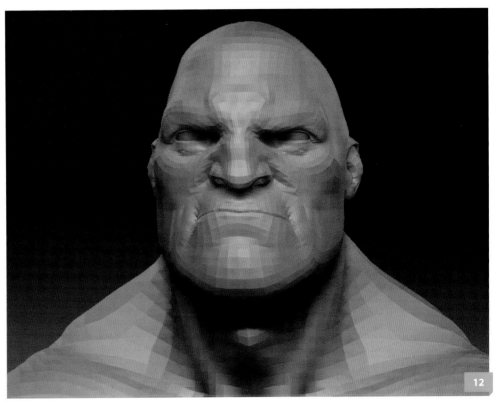

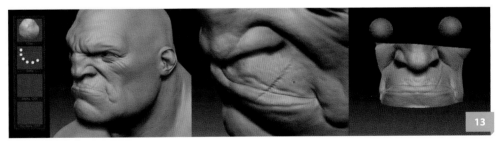

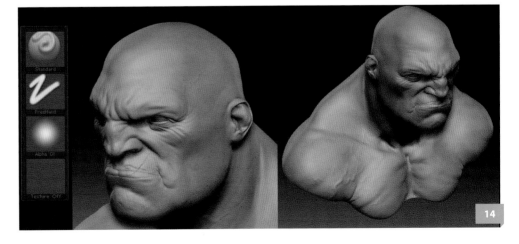

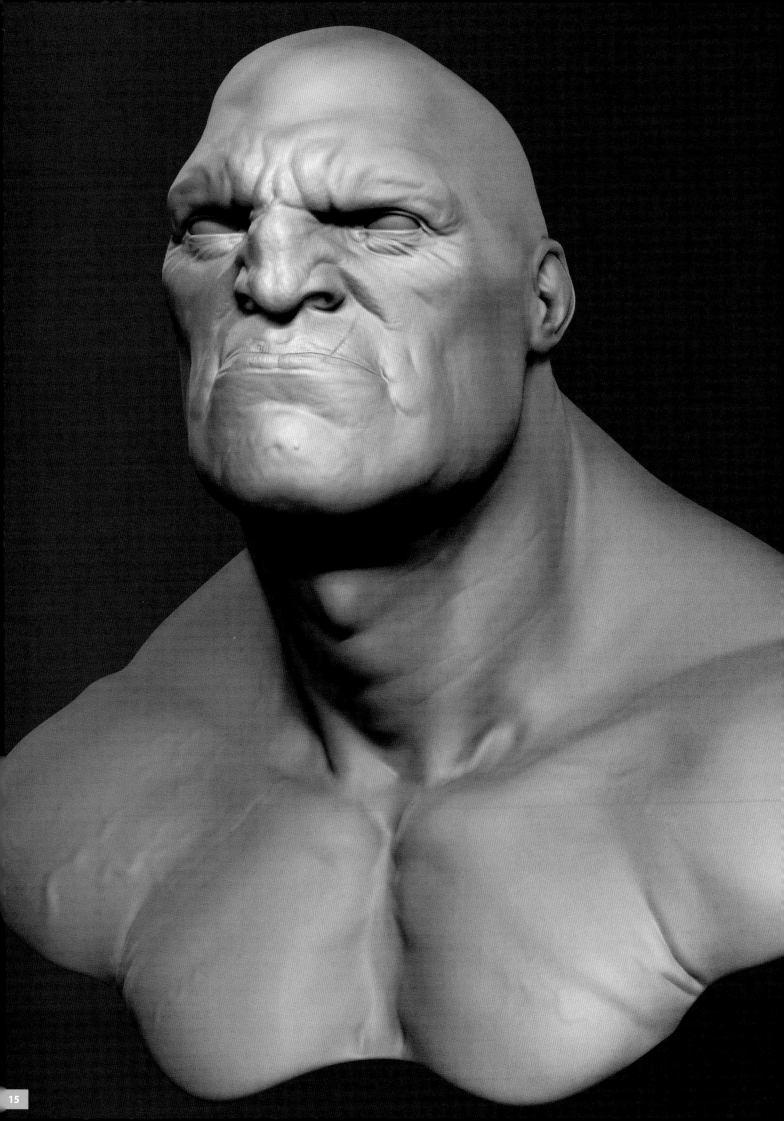

the texture palette channel pick the image that you want to project onto the model. I've created a library with some interesting skin tones to use for my character from personal photos and images from the internet.

Before starting the projection of the images, it's necessary to lower the Z Intensity value to 0, otherwise you'll get deformations in the model and you can't allow this. Also lower the RGB Intensity to block in the initial skin tones.

The first projection I do is the mouth. After you have projected the image turn on Edit mode, pick the Move option and then start to fix and snap the image to your character's mouth. Do the same thing with the eyebrows and the nose. Then you can start blocking the skin tone in; for this adjust the intensity to around 50 – 60. Once the skin tone is done, project some images of stubble onto the model (Fig.16).

It's always great to paint details and make corrections of some things freehand. Inside Projection Master pick the single brush and paint some color variations between cavities, like between where the muscles connect and where the skin wrinkles (Fig.17).

Change the color of the brush to a green tone and start to paint the veins, continuing to use the single brush. To finish off the

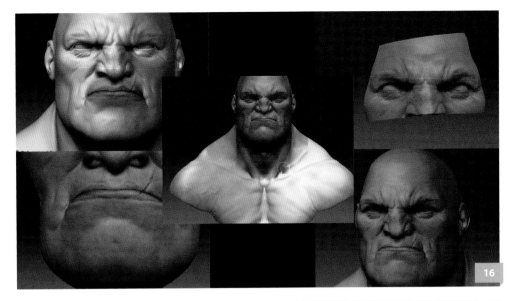

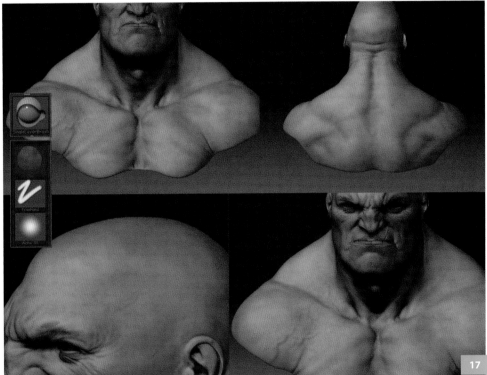

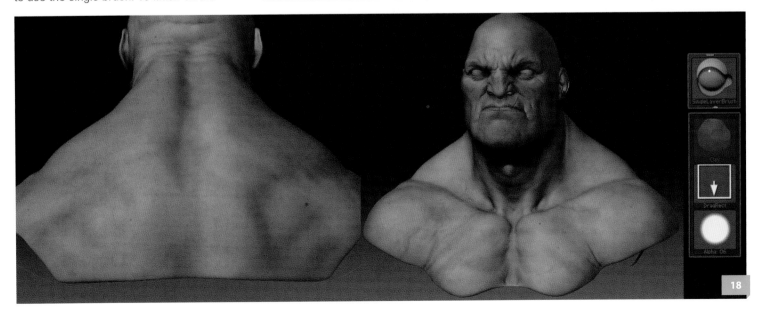

texturing add some spots/freckles all over the character to give him a more realistic appearance (Fig.18).

Also project the texture for the eye (Fig.19).

For the final render start by configuring the light. Increase Rays to 226, Aperture to 105 and Length to 500. Turn on ZMode to give a fake GI look (Fig.20).

For the shader choose a TriShader from the material palette and mix that with a free skin shader from the ZBrush Central MatCap library, making some changes to the intensity of the shader. For the eye, I simply use the toy shader from the shader palette.

And here is the final result (Fig.21 – 23) I hope you like it!

You can download the base mesh (OBJ) and videos (MOV) files to accompany this tutorial from: **www.3dtotalpublishing.com**.

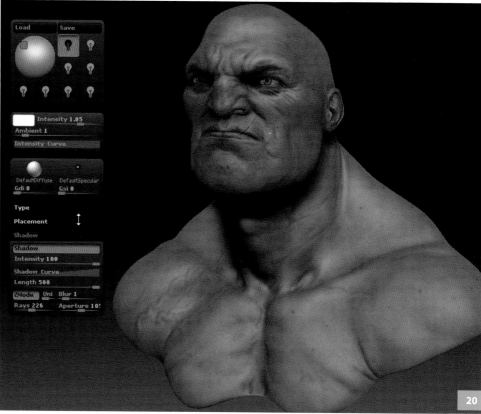

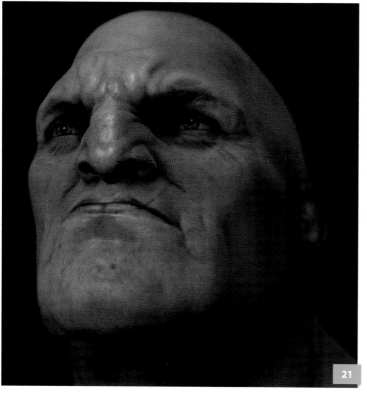

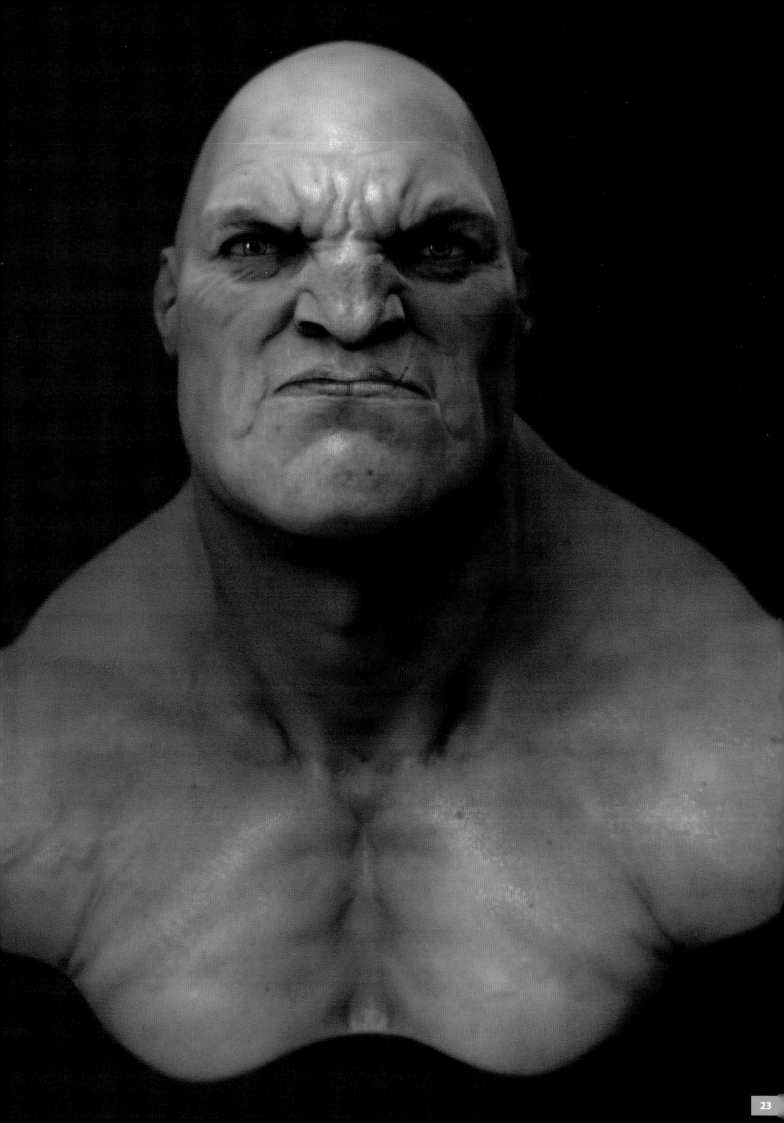

"You need to keep calm when sculpting and learn to walk before you can run"

Werewolf By Rafael Ghencev

Concept

In this tutorial I will be showing you how to create a werewolf. Before starting any project I recommend searching for references on the internet. In this case I searched for photographs of real wolves to help with the creation of my character.

Basic Shape

To start this character the first thing to do is to have a think about how to start the creative process using the references gathered to put together some ideas. Kick things off by loading up the base mesh, which you can download with the resources for this book. Working with Symmetry turned on select the Move brush and play around a little, using a large brush to simply search for good form and shape (Fig.01).

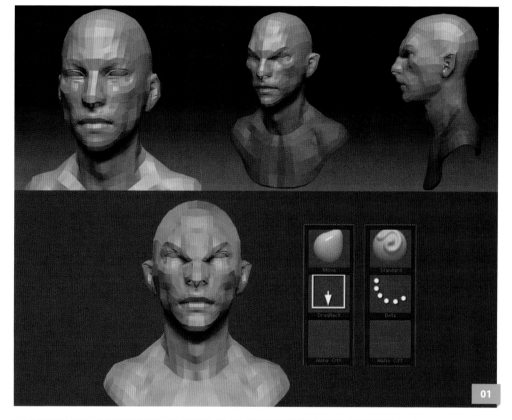

With the basic shape sorted you can start to refine the model by adding one more level of subdivision. Once you have done that you can start to use the Clay brush to show the bones and muscular structure of the entire model. Once that is done select the Standard brush and start to draw some specific volumes in the eyebrow and nose area. At this point on my model I decide to change his facial expression using the Move brush with a high radius, just to add more to the character's face (Fig.02).

Up to now the focus has been on finding a good structure and shape for the character. Details have not been important. You need

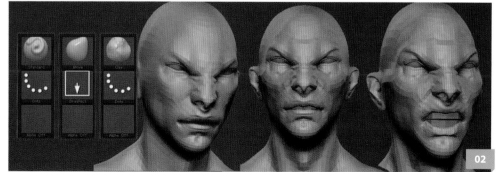

to keep calm when sculpting and learn to walk before you can run – there is no point running into the next stage without properly establishing a good base shape that you can work from. So with this now done, we can proceed to the next step.

Refining the Shape and Initial Details

Select the Clay brush and start to refine his bone and muscle structure, adding more volumes to the mouth orbicular, the zygomatic bone and the eyebrow structure etc. Remember that it is very important to

work with references in order to improve the quality of your work; in this case I'm using some wolf photo references to make my character's expression more brutal and animal-like. Select the Standard brush and draw skin folds in the eyebrow and chin areas to help refine his expression and add further detail to it, making it much more believable (Fig.03). I'm going for a tense jaw look and feel.

Now it's time to give more attention to the individual shapes and details of the face. Using the Clay brush, improve the shape of the nose. Then select the Standard brush with Alpha 38 to add wrinkles around his eyes, mouth and forehead (Fig.04). At this point you're still not into the little details, you are still just sketching!

Now you can start to work without Symmetry turned on to achieve a natural-looking character. In particular I work in between his eyebrows to take away the symmetry.

Details

To start the process of detailing select the Clay brush and start to add some skin imperfections, one by one, making little movements to create small eruptions on the surface of the skin. Then change the stroke for a Spray stroke, choose an alpha such as 38 and then change the brush to ZSub to create little cavities simulating pores.

Using the Standard brush with Alpha 38, start to add some wrinkles around the neck and eyes. To improve the volume of his wrinkles I select the Inflat brush with a low value and start to inflate the wrinkles to give them a more natural appearance (Fig.05).

At this point add some more small wrinkles to his eye area. When I did it I selected the Standard brush with Alpha 38 and started to draw some cavities. References are very important in order to understand the flow of the wrinkles. Once you have marked the selected areas use the Inflat brush again to

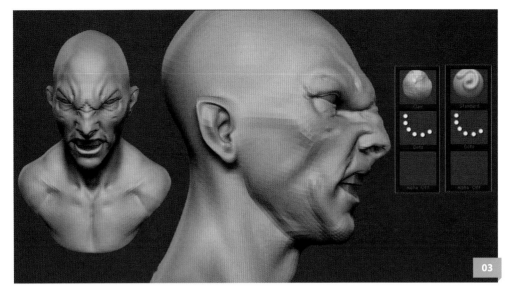

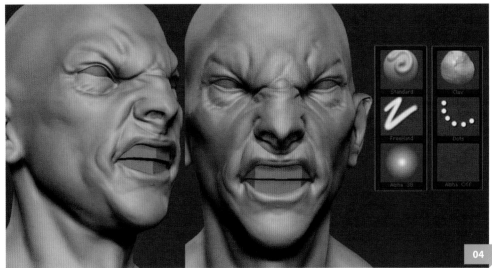

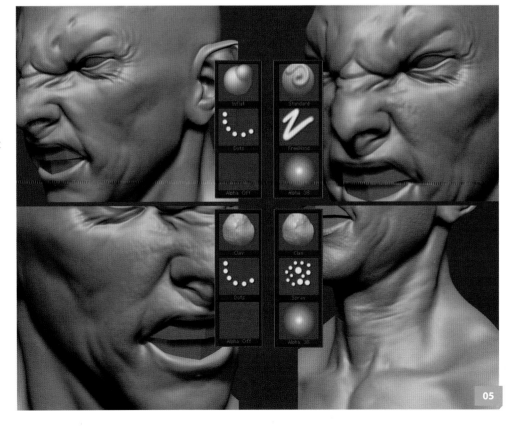

add more volume to the cavities (Fig.06).
Using the same process add yet more
wrinkles to the chest area, but this time after
drawing them select the Clay brush and paint
some skin volume variations, creating a look
which appears much more natural.

Select the Clay brush and change the stroke
to Spray and select Alpha 38 to start to add
some pores and skin imperfections. This is
a great way to suggest a growing beard, but
in this case it's not necessary because I'll be
creating the hair shortly.

To create the teeth make some divisions
and then select the Move brush. Start to
push the major teeth, creating the canines.
Select the Standard brush again to create
the separations between each tooth. To finish
the teeth choose the Clay brush to sculpt the
gums and refine the volumes of the teeth,
giving them a more natural finish (Fig.07).

Hair

To create the werewolf's hair select the Clay
Tubes brush; this tool is great for creating
large, flat volumes and is a variation on the
Clay brush tool. With this tool, start to sculpt
the form of the beard and try to show the
flow and movement of the hair. Select the
Standard brush with Alpha 38 and a low
radius, and sculpt some little edges to give
the beard a more interesting look (Fig.08a –
b). Use the same process to sculpt the hair,
starting with the Clay Tubes brush. Keep
repeating the process in order to refine the
shape of the hair's segments and use the
Smooth tool to add a cleaner look to some of
the areas. Again, select the Standard brush
and sculpt some edges (Fig.08c).

Here is the final result (Fig.09).

You can download the base mesh (OBJ)
and videos (MOV)
files to accompany
this tutorial from:
**www.3dtotalpublishing.
com**.

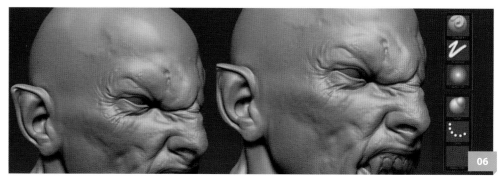

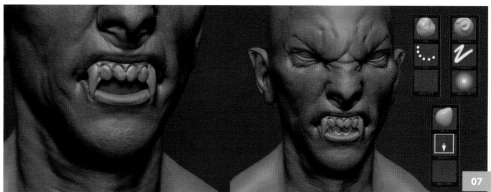

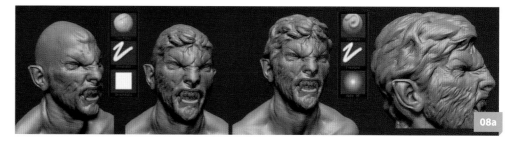

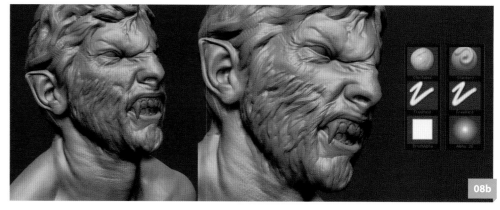

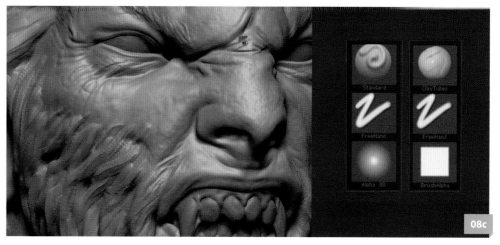

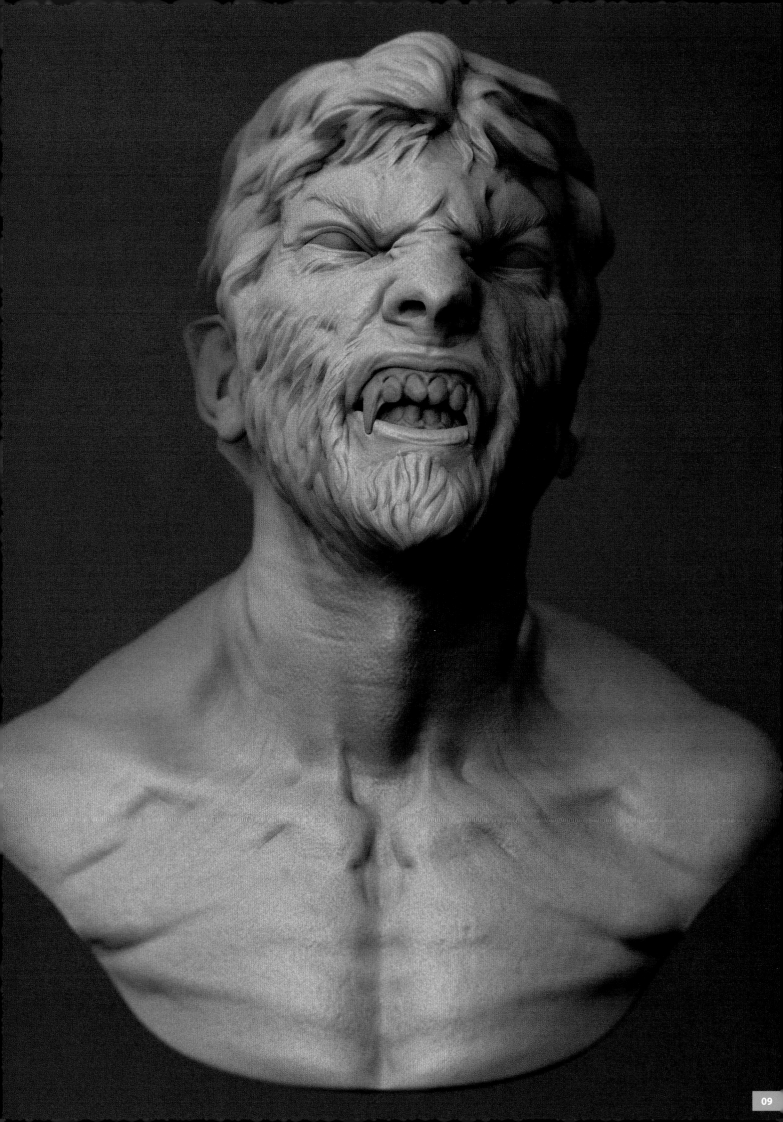

" **As the armadillo has quite short limbs, it's funny to imagine how he could drink from a bottle**

Cartoon Armadillo By Jose Alves da Silva

Introduction

In this tutorial I will guide you through the process of creating a cartoon animal. This time the victim is the armadillo!

Apart from being a curious looking animal with a hard shell that gets killed on the roads in Mexico, I didn't know much about armadillos and I'm sure I'm not alone in that. So the first thing to do is gather references and study the subject. The internet is your best friend when it comes to this, so start by searching for armadillo photos from as many points of view as you can. Also search for photos and schematics of the skeleton, as they will provide you with good information on the shape and angle of the limbs, joints, mouth position, number of toes etc. You should also try to read a few webpages about the animal's biology, geographic location and habits. With the animal photos, skeleton and bio in hand you will be surprised by the amount of new ideas that will come to your mind. Also, you will be able to avoid some simple design mistakes.

I have started by sketching the armadillo, trying to include all of its characteristic elements (Fig.01). I've chosen the nine-banded armadillo variety and its main characteristics are:

- A pointed snout it uses to reach food
- Long ears
- A hard shell made of several bands that allow it to be flexible

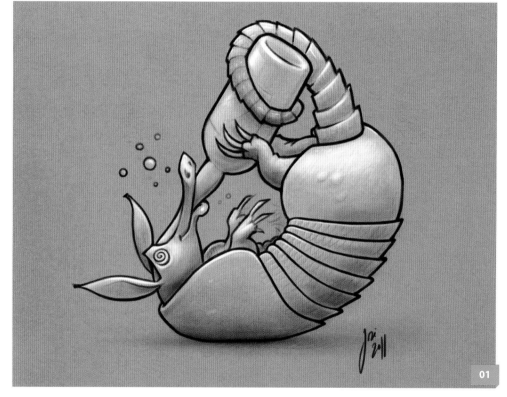

01

Nine bands

Long ears

Pointed snout

Hard shell

Ringed tail

Strong claws Four toes

Five toes

40 cm

35 cm

02

- Strong claws that allow it to dig
- Four toes on the front feet
- Five toes on the hind feet
- A long ringed tail.

The process of drawing the character will force you to analyze each of its parts and make you very conscious of each detail before you attempt to turn your armadillo into a cartoon.

Concept

The main purpose of this tutorial is to create a presentation shot of the character, so we should think about how to stylize it, but also how to pose and present it. A character's pose tells us a lot about its personality, so avoid using a T-pose or a neutral pose when the objective is to sell/approve a character.

The armadillo is an animal that exists in Texas and Mexico, so I have decided that a shot of tequila or a Corona beer could complement the character well. As the armadillo has quite short limbs, it's funny to imagine how he could drink from a bottle. I have sketched the idea (Fig.02) and simplified the forms a bit. Notice how I have reduced the number of bands on the back and tried to make the snout more geometric. I've also given more importance to the eyes.

Modeling

The character's pose depends a lot on the bottle so we will start by modeling a simple bottle. Then we will pose and build the character around it! We will try to keep the character as symmetrical as possible in the beginning and break that symmetry at a later stage. Not a very conventional approach, but it will ensure that the relation between the character and the bottle will be perfect in the presentation shot.

Through the tutorial I will assume that you've installed some free plugins that can be downloaded at Pixologic and set up GoZ to be connected with 3ds Max or have other modeling software you are comfortable with.

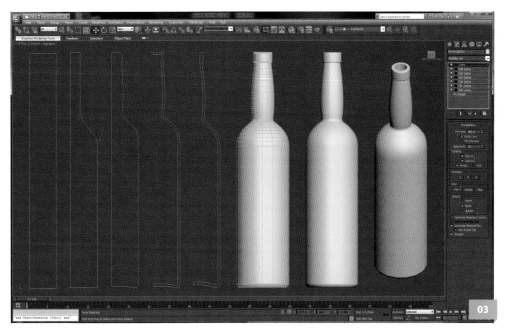

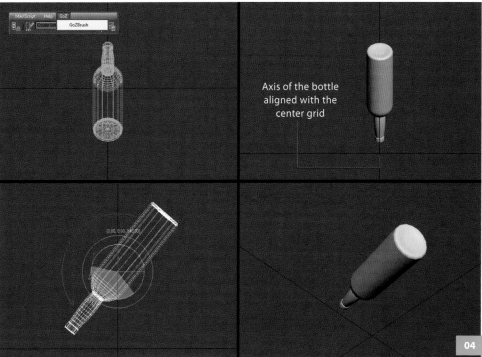

The Bottle

In 3ds Max or any other modeling package of your choice, start by creating a rectangle with a height of 0.3m and a width of 0.035m in the front viewport (Fig.03). Apply an Edit Spline modifier and insert two vertexes to define the shape of the bottle. Keep adding more vertexes and control the Bezier splines at each vertex to shape the outer surface of the bottle. Delete the vertical line at the center and in Spline Sub-Object mode select the remaining spline and drag the Outline value to 0.003m in order to represent the thickness of the glass. Erase the lines at the top to create the bottle opening. Apply a Lathe modifier, turning on the Weld Core option and setting the align option to Min, so that the revolution axis is at the left margin of the half bottle section.

Move the bottle to make sure that the center of the base is at the 0,0,0 coordinates point. In the left view rotate the bottle 140 degrees counterclockwise to match the sketch. Even though we will export this bottle to ZBrush, save this editable version as you will need to tweak it later. With the bottle selected, from the GoZ menu choose GoZBrush (Fig.04).

3D Sketch

ZBrush will open. For the bottle to show up, drag to the center of the screen and press the Edit button at the top. If you drag on the background while pressing Shift you are able to cycle through the orthographic views. Change to the front view facing the bottom of the bottle (Fig.05). From the Subtool menu choose Append and select the ZSphere. Decrease your brush radius to zero (as it is more practical to edit the ZSpheres) and select the ZSphere subtool. Press X to activate symmetrical editing. Move the ZSphere down to place it under the bottle (Fig.06).

While in Draw mode, if you drag on a ZSphere surface a new connected ZSphere will be created. If you drag at the symmetry line, a single ZSphere will be created, and if you drag on any other point of the ZSphere, two new symmetrical ZSpheres will be created. Use the Move and Scale modes to position the ZSpheres. If you click the chain between the two ZSpheres in Draw mode, a new ZSphere is created at that point.

Using the ZSpheres, create a form that approximates the character in the concept (Fig.07). Imagine that you are modeling the animal without the shell as that will be taken care of later. Start by growing the neck and snout from the base ZSphere as well as the main body shape. Refine the snout, body and neck by adding some extra ZSpheres. Grow a nose in front of the snout, add some ZSpheres in the place of the eyes and also grow a ZSphere on the top of the head to ensure that some more geometry will be generated there.

Grow the rear legs, positioning them as if they were supporting the bottle. Create the front legs and the ears in a relaxed position. Grow the tail in a vertical position, as we will detail it in this neutral pose before curling it around the bottle. From the extremities of the limbs create the fingers and claws, positioning them around the bottle (Fig.08).

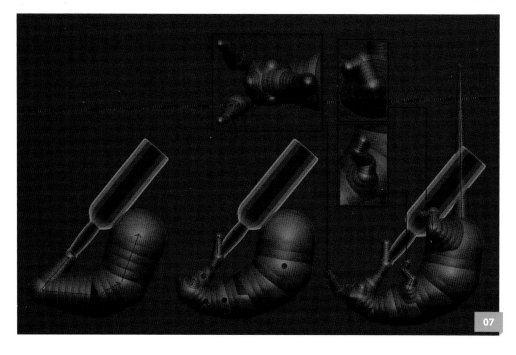

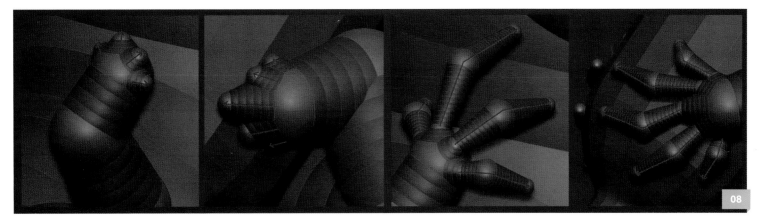

Remember that the armadillo has four fingers on the front paw and five on the rear one (Fig.09).

Press A to see the adaptive skin of the ZSpheres and then the GoZ button in the Tool menu to export the skin to 3ds Max. We will use it as a reference to model the shell.

The Shell

At this point we will go in to 3ds Max briefly to make the shell as it is easier here than in ZBrush. Start by creating a box in the Top view and make sure that it is located at the 0,0,0 coordinates (Fig.10). The box should be three segments long and two wide. Create a standard material with 50% opacity and apply it to the box; this allows you to see the model and reference simultaneously. Apply an Edit Poly modifier and a Symmetry modifier on top. Choose the Edit Poly modifier and reposition the vertexes to create a rough shell. Delete the polygons representing the lower part of the shell (Fig.11).

Add new vertical and horizontal edge loops between the existing ones and move the vertexes to make the shell rounder. Create two new edge loops between the polygons on the central part of the shell; each edge corresponds to a band (six bands will be created, as in the concept) (Fig.12). Also add edge loops to the front and rear of the shell and move the vertexes round the form.

Create edge loops near the edge of each band (Fig.13). Select the new vertexes

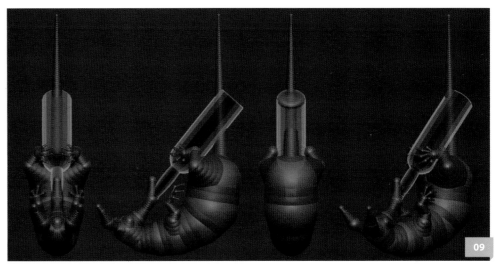

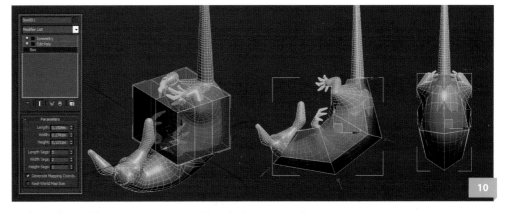

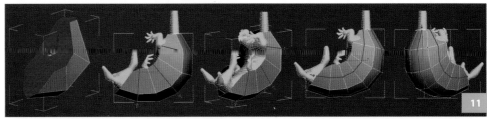

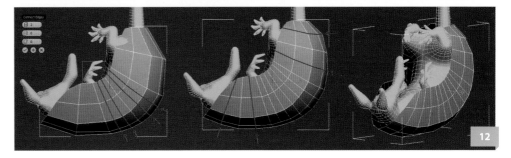

at the new edges, change the Reference
Coordinate System to Local and move along
the Z axis to move all the vertexes outwards
at the same time (after this operation you
need to adjust the vertexes at the mirror
plane by setting the X value to 0).

On a side view, select the same vertexes
of the newly created edges and, with the
Reference Coordinate System set to View,
move the vertexes to the side in order to
make the transition between bands harder.
Create new edge loops at each side of each
band (Fig.14). Adjust the vertexes at the
edge of the band near the belly to make the
ends curvy (Fig.15). Select the edge loop
at the interior edge and outer edge of each
band and chamfer it slightly with the Chamfer
tool in Edit Poly mode (Edge Sub-Object
mode).

Create a tight loop at the edge of the shell
(Fig.16). Then apply a Shell modifier to add
depth to the shell (about 0.0015m to the
inside and outside). In the Shell modifier
options enable the Override Inner Mat ID and
set it to 2; also enable the Override Outer
and Edge Mat IDs and set them to 1. This will
allow us to easily separate the interior of the
shell in ZBrush as it will accept the material
IDs as polygroups while importing. We also
want to use the TurboSmooth modifier with

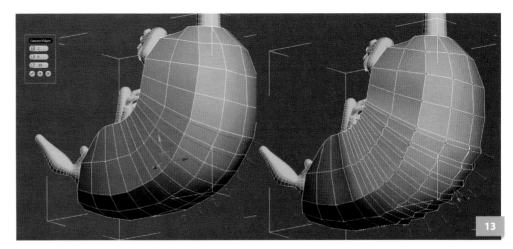

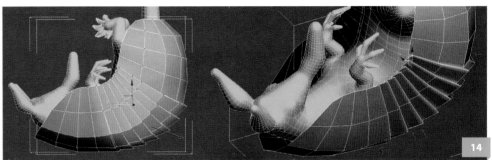

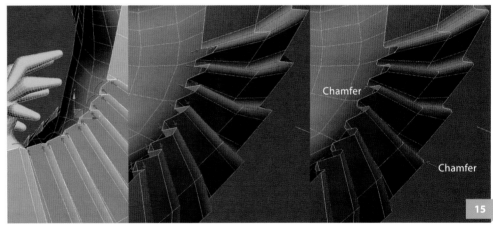

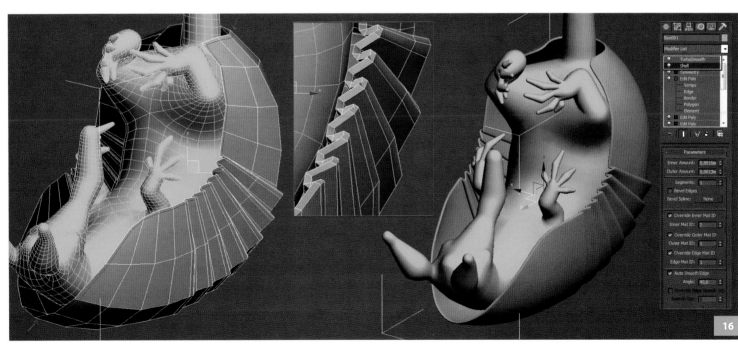

two iterations to subdivide the surface. Subdividing a surface in ZBrush or 3ds Max produces different results, so I have opted to divide it in 3ds Max first. Set the name of the shell to "shell".

Create a sphere, place it near the location of the eye and use a Symmetry modifier to create the other eye, mirroring the first one. Name this object "eyes" (Fig.17). Select the eyes and the shell and choose GoZBrush from the GoZ menu.

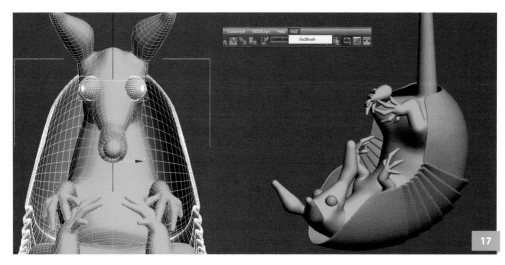

Refining the Body

In ZBrush a new tool will be created containing the eyes and the shell as subtools. Select the shell subtool. Change to the subtool for the armadillo's body, click on Append and pick the shell from the object list. Go back to the imported subtool and this time select the eyes. Choose the tool for the armadillo's body and append the eyes. You should now have a tool that contains the body, bottle, eyes and shell (Fig.18).

In order to generate an adaptive skin from the ZSpheres to be sculpted, select the ZSpheres tool. In the Tool menu, under Adaptive Skin, select Make Adaptive Skin. A new tool with the prefix "Skin_" will be created. Choose Append and pick the "Skin_" tool. We will be sculpting this subtool. You can hide or delete the ZSpheres subtool as we won't be using it again (Fig.19).

To block the form we will mainly be using the Clay brush. Select the Clay brush and under AutoMasking enable BackfaceMask so that when we are working on one side of a thin surface it doesn't affect the other side (Fig.20). Turn on Symmetry (press X) and subdivide the body once (under Tools > Geometry).

The bottle influences the pose of the armadillo, so it is advisable to keep it visible during some parts of the sculpting. Using the Clay and the Smooth brushes, make the snout curvy and flatten the tip. Carve the

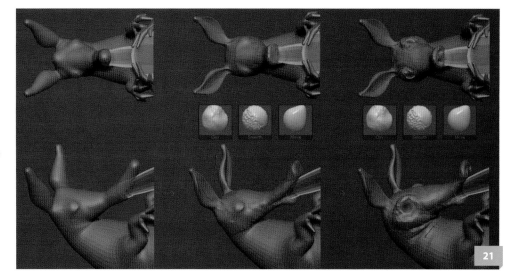

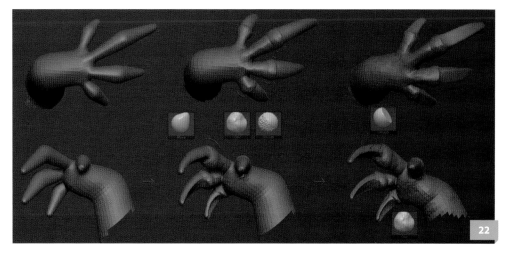

interior of the ears and also subtract from the outside to make the ears thinner. Carve the line of the mouth and add volume at the lower lip, as if the lip is surrounding the tip of the bottle. You can also adjust the volumes using the Move brush. With the eyes visible, carve the eye socket and add volume to the eyebrows. Bulge the cheeks and sculpt some wrinkles at the neck. Also don't forget to add the nostrils (Fig.21).

Still using the Clay and Smooth brushes, add some volume to the fingers of the front paw, marking the transition between the finger and the claw (Fig.22). Carve the bottom part of the claw to make it flatter. Use the Move brush to pull up the central part of the claw and make it curve. To add sharp transitions to the claws use the mPolish brush on the top, sides and bottom. With the Clay brush add some folds under the fingers and at the wrist.

Repeat the procedure for the rear paws. Make a nice, round belly using the Clay brush. Also add folds at the places where the skin is compressed. At this stage we have

blocked the main form. We will now start detailing (Fig.23).

Subdivide the geometry once more and keep refining the details. Try to put the maximum detail that each subdivision allows and only subdivide it when the mesh does not have enough resolution to support more detail. At this subdivision level, using the Clay and Move brushes, I have added some more skin folds, knuckles on the fingers and a clearer shape to the snout and lips. I have also marked the limit of the shell that covers the head.

Subdivide the body once more. In order to create the tail rings, hold Ctrl and change the mask selection mode to Rect (Fig.24). Still holding Ctrl, click on the brush alpha and select Alpha 27 from the list (rectangular gradient). Holding Ctrl go to the Alpha menu and press Rotate to rotate the gradient 90 degrees clockwise.

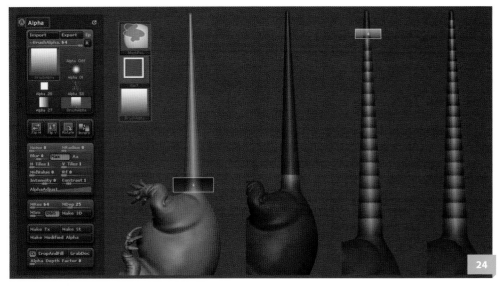

Now when you create a mask, you will create a rectangular gradient. Make sure you are on a side view. Mask the base of the tail and invert the mask selection (press Ctrl and click on the background). Press Ctrl + Alt to subtract to the mask and mask all the rings of the tail. From the Tool menu, under Deformation, increase the Inflat slider to 8 and then the rings will be created. You can then discard the mask (Fig.25).

Subdivide the body twice more (you should have a total of six subdivision levels). Smooth the tail rings, add a bit of volume to the edge and use the Pinch brush to sharpen the ring's edges (Fig.26). Start sharpening all the details using the mPolish and Pinch brushes. Notice how I have refined the head shell by using the Pinch brush at the borders.

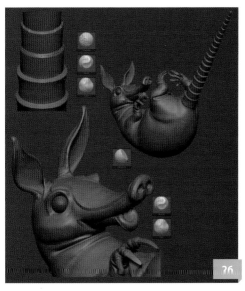

Select the shell subtool and make sure that Symmetry is on (press X). Use the Move brush with a large radius to move the shell in order to avoid intersections with the rear legs (Fig.27). Also use the Move brush to move

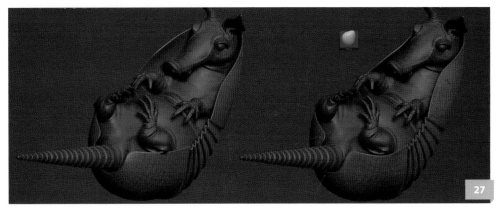

the borders of the shell in order to achieve a tighter fit with the body. Subdivide the shell four times. Save your armadillo tool.

Custom Brush

In order to create the scales on the armadillo shell, we will create a custom brush.

Start a new ZBrush document. In the Document menu, set the Width and Height to 1000 (do not forget to disable Pro, so that the scaling is not proportional) and choose Resize. The document is now 1000 x 1000 pixels. From the Tool menu choose the Plane3D tool (Fig.28). Drag on the center of the screen to create the plane, change to Edit mode and then press Make PolyMesh3D from the Tool menu. In Tool, under Geometry, disable the Smt button, so that the plane corners don't get rounded when you subdivide it. Press Divide twice so that you have three subdivision levels.

Load the Dam_Standard brush (from the Lightbox, choose the Brush directory and you will find it there – double click to load) (Fig.29). In the Stroke menu raise the LazyRadius value to 65. Make sure that the brush size is around 45 (press S to set the brush size). Facing the plane from the front create an arch that resembles one of the armadillo's scales.

Change to a Standard brush and mask the area outside the line. Choose the FormSoft brush and with a big radius stroke the unmasked area to create a raised scale. With the Smooth brush you can rectify any stretching at the borders.

Set the view to Front and press F to frame the view (Fig.30). Scale in a bit so that the borders of the planes are a bit outside the frame of the document. From the Alpha menu choose GrabDoc and ZBrush will create an alpha based on the viewport depth.

We will create our brush based on the Stitch1 brush, so choose that brush. Press on the

BrushAlpha square and choose the alpha we have created (named "ZGrab"). In the Alpha menu, rotate the alpha to be horizontal, set V Tiles to 2 and Mid-Value to 1 (you might need to adjust this value so that a rectangular marking doesn't show around the brush; try different values until you find the correct one). In the Brush menu save the brush and name it "ArmadilloScale" so that you can use it at a later date. Feel free to test the brush and adjust the values to your preferences (Fig.31).

Details

Open the armadillo tool in ZBrush, and load the ArmadilloScale brush that you have just created. Make sure that the VTiles value of the alpha is 2 (this value resets each time you enter ZBrush). Select the Shell subtool and create the scales at each band (Fig.32). In order for the strokes to affect only one band at a time, mask the bands that you don't want to affect. Reduce the brush size and create a stroke of small scales at the border of the shell.

Select the body subtool and, using the ArmadilloScale brush, create scales on each tail ring (Fig.33). Then use the Dam_Standard brush to make the division between the scales. I have also made some little arches between the scales with the Dam_Standard brush to simulate a stylized scale pattern. Use the ArmadilloScale brush to create scales at the contour of the head shell. Not very realistic, but quite stylish!

To create a brush for the shell and leathery skin, choose the Standard brush. In the Download Center of the Pixologic website (**http://www.pixologic.com/zbrush/downloadcenter/alpha/**) go to the Skins section and download the Lizard Scales02 alpha by Marcus Civis. Choose this as your brush alpha. In the Alpha menu set the Radial fade of the alpha to 15. Set the drawing mode to DragRect (Fig.34). Mask everything except the head shell and drag to add texture to the shell. Add the same texture

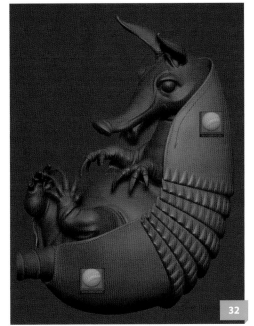

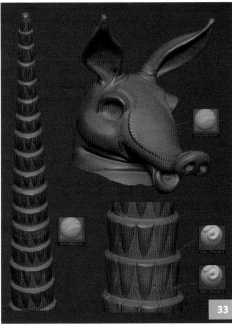

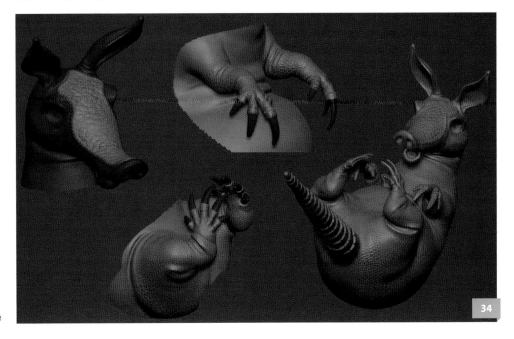

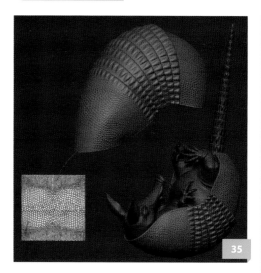

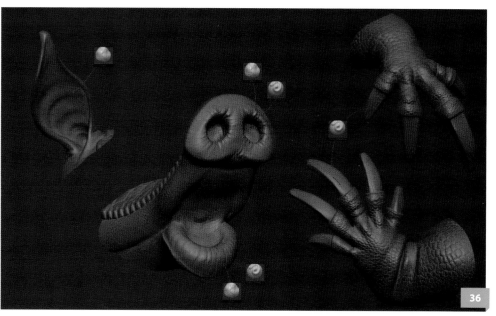

at a tiny scale to the rear and front legs while masking the nails. Then, with a reduced intensity and a tiny scale, add a bit of this texture to the whole body.

Choose the shell subtool and change the alpha to Lizard Scales07, which you can also download at the Pixologic website. Mask the scales of the bands and drag on the shell to create the texture (Fig.35).

Choose the body subtool. With the Clay brush, create the cartilage of the ears (Fig.36). With the Dam_Standard brush create some cuts around the nostrils and the lips. With the Clay brush, fill between the cuts to make the flesh bulge. Also add some cuts along the nails to represent their structure.

UVs

Let's set the UVs with the UV Master plugin. Launch the UV Master from the Zplugin menu. Select Work on Clone. Divide the model into polygroups as in Fig.37, separating the hands, feet, arms, legs, tail, body, head and ears. Make sure the Symmetry and Polygroups buttons are enabled in UVMaster. Choose Unwrap. You can check the layout of the UVs by pressing Flatten (press Unflatten to leave). Choose Copy UVs. From the Tool menu select the armadillo body subtool and press Paste UVs to transfer the UVs to the original model.

Select the Shell subtool and launch the UV Master plugin (Fig.38). If you remember, the

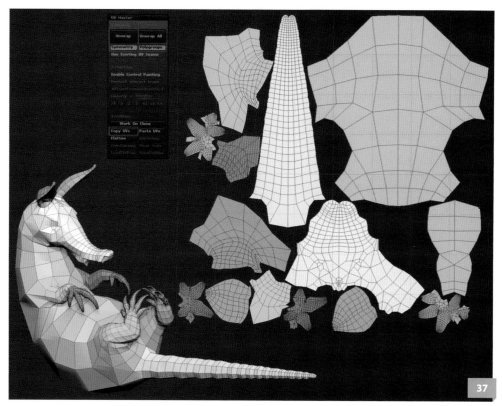

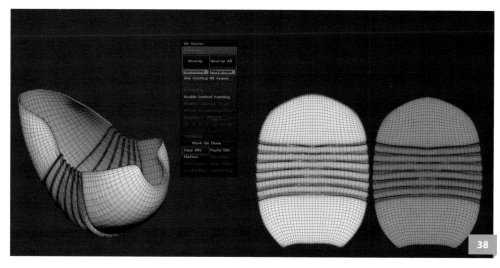

polygroups of the shell are already separated into inner and outer shell. Make sure the Symmetry and Polygroups options are on. Choose Unwrap. Once again copy the UVs and paste them on the original shell.

Polypaint

To start the painting process, choose the SkinShade4 material. It is a great material for polypainting because it is white while keeping some specularity, not interfering with the perception of the painted colors (Fig.39).

Select the Shell subtool and fill it with a beige color. In the Masking submenu (under the Tool menu) select the Mask by Cavity option and then press Inverse. Select a dark brown color and fill with this color (choose Fill Color in the Color menu). Clear the mask. All the little cavities are now dark. This way we will keep all those details in the texture.

As the cavities are too dark we can now paint on top of them with a reduced RGB intensity, which allows for the detail to be kept (Fig.40). Choose a dark color and mark the interior edges of the bands and the outer edges of the shell. Change the painting mode to Spray and choose Alpha 07 as the alpha. Paint with varied tones of gray all over the shell to add variety and reduce the impact of the cavities.

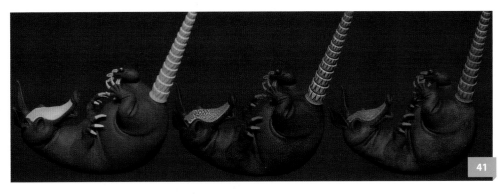

Select the body subtool. Fill the body with a medium brown and paint the tail, nails and head shell with the same beige color as the outer shell (Fig.41). Mask the cavities and invert the mask as we did before. Fill with a dark color to reveal the cavities. Once again, using a variety of grays, with a Spray brush paint the tail, nails and head shell. Also use some desaturated browns to paint the body and reduce the visual impact of the cavities.

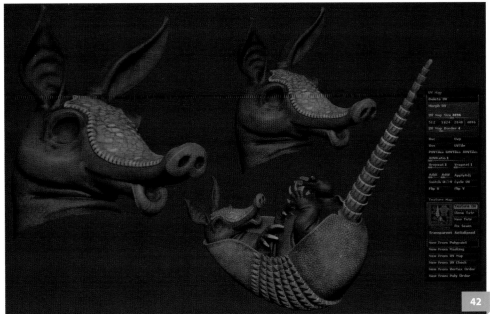

Choose varied tones of pink and paint the interior of the ears, nose, lips and around the eyes. As this armadillo loves tequila so much, I have decided to paint the cheeks with a deep red and spread a little bit of redness all over the face (Fig.42).

The painting is over so we will transfer the polypaint to a texture. In the Tool menu, under UV Map, set the size to 4096. In the Texture Map submenu press New from Polypaint to generate the map. Press Clone Txtr. In the Texture menu (at the top of the screen), choose Export and save the texture as "armadillo_body.psd". Choose the Shell and generate the texture in the same way and save it as "armadillo_shell.psd". You can see how all of the resulting textures look in Fig.43.

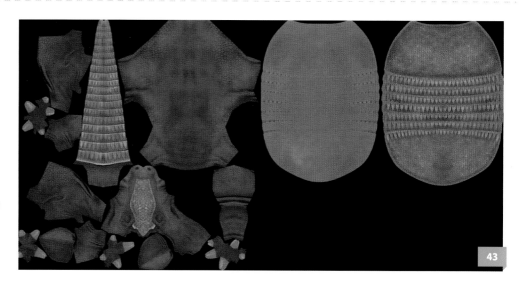

Just before proceeding to posing the tail, we will export two textures that we will need for the material creation: the Cavity maps for the shell and body (Fig.44). To do this, make sure that your selected color is white, go to the Masking menu and choose Mask by Cavity. Then, under the Texture Map submenu, pick New from Masking and ZBrush will generate a texture with the masking. Press Clone Txtr, go to the Texture menu and export. Save the maps as "armadillo_shell_cavity.psd" and "armadillo_body_cavity.psd".

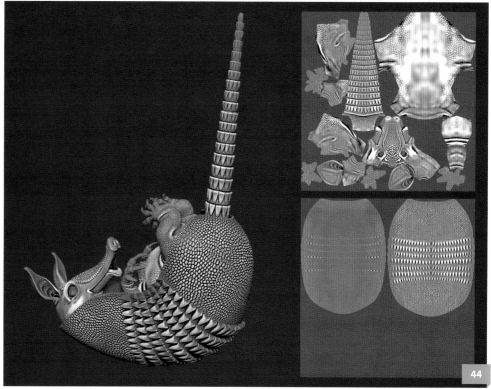

Posing the Tail
In order to pose the tail we will use the Transpose Master plugin. However, to keep the bottle as a reference and unaffected by the ZSpheres rig, a few weird steps will have to be taken.

Make sure the body, eyes and shell subtools are visible and that the bottle is invisible. In the Transpose Master menu (at the Plugin menu) enable ZSphere Rig and press TposeMesh.

A new tool with the "Tpose#1_" prefix will be created with a ZSphere and a transparent version of your model at the lowest subdivision level (Fig.45). Select the original armadillo tool and select the bottle subtool. Select the "Tpose#1_" tool, choose Append and select the bottle. As the bottle is in a different subtool it will not be affected by the ZSphere rig.

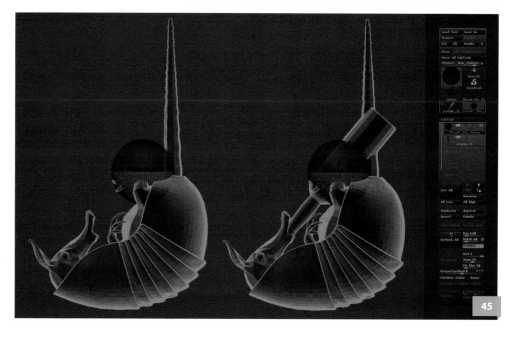

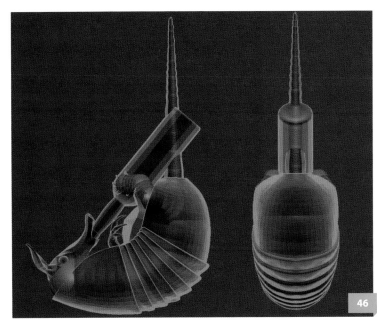

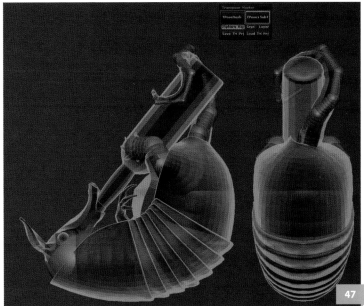

Position the ZSphere at the bottom of the armadillo and grow a chain for the tail (Fig.46). Also create some for the rough volume of the rear legs and to represent the volume of the body. These will keep the body and legs in place while we pose the tail.

In the Tool menu, under Rigging, press Bind Mesh. Move the ZSpheres of the tail to position them around the bottle. When satisfied with the position, select the bottle subtool and delete it. Go to Transpose Master and choose Tpose > SubT. The position of the tail and body will be transferred to the original model (Fig.47).

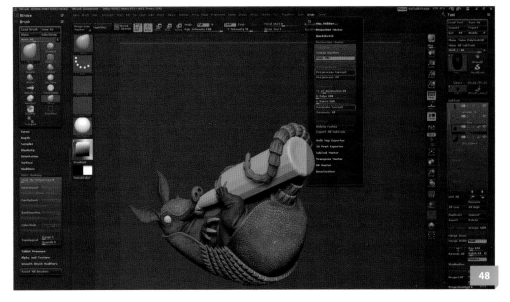

Export

In order to export the model to 3ds Max, we will first optimize its polygon count with the Decimation Master (Fig.48). Before proceeding, save your tool or you'll lose it later. Select the Shell subtool and in the Decimation Master menu (under Plugin menu) enable Keep UVs. Press Pre-Process Current and wait for the process to finish. Slide the % slide bar to about 6% and choose Decimate Current. The shell subtool has been converted to triangles with a much lower polycount. Select the body subtool and repeat the process.

Everything is set for exporting, so press the All button near the GoZ button (Fig.49).

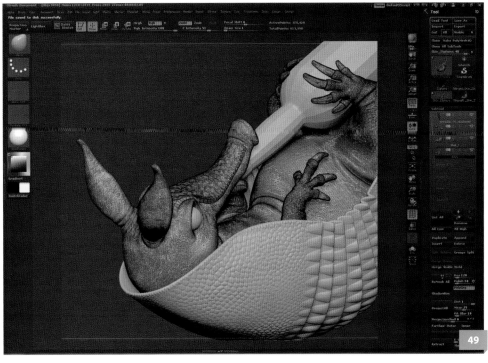

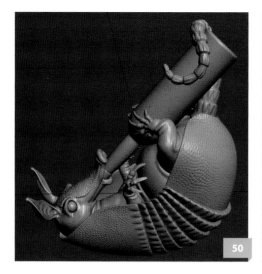

This will export all the subtools to 3ds Max. 3ds Max will open with the armadillo model (Fig.50). You can then delete the bottle and merge the original bottle you created at the beginning of the tutorial. If you've followed all of the steps correctly then the merged bottle should fall into exactly the same place as the exported one.

Eye Lid

At this time I have noticed that the character could be improved with an eye lid. To create the eye lid start by creating a sphere with the hemisphere setting set to 0.5 and adjust its position to the eye ball (Fig.51). Then delete the lower faces of the hemisphere and apply a Shell modifier to give it some thickness.

Press the GoZ button and subdivide and sculpt it in ZBrush with some horizontal wrinkles and a thicker edge. Use polypaint to match its color to the remaining model and generate the UVs with the UVMaster. Then export the polypaint as a texture named "armadillo_eyelid.psd". You can also generate and export a Cavity map with the name "armadillo_eyelid_cavity.psd". Press GoZ and you will be back in 3ds Max with a newly sculpted eye lid.

V-Ray

Choose V-Ray as the render engine. Set the output size to 1000 x 750. Set Adaptive DMC as the image sampler and the VrayLanczosFilter as the Antialiasing filter.

Under Color Mapping change the type to Gamma Correction and set the Gamma value to 2.2. Turn on the GI, under Indirect Illumination, and set Irradiance Map for the primary bounces and Light Cache for the secondary brushes. As we will be working with gamma correction, in 3ds Max's Preference Settings, under Gamma and LUT, enable Gamma/LUT Correction. Make sure the gamma is 2.2 and enable Affect Color Selectors and Affect Material Editor. Set the bitmap files Input Gamma to 2.2 and the Output Gamma to 1.0 (Fig.52).

Camera

I have created a "Target Camera" and placed it in order to see the armadillo from the side

so that his action is clear to the viewer. You can check the position of the camera in the image (Fig.53). I have set the camera lens to 40mm and tilted it to the left. Do not forget to turn on the Safe frame in the camera viewport.

Light

I have opted for a lighting situation similar to a studio setup (Fig.54). I have created a background plane with a curve that extends to the floor plane, as in a studio "cyclorama". The material of the plane is a simple VrayMtl with a light gray color (RGB: 100). In the image I have made an image showing the' position of the lights and numbered them so that it is clearer.

Light 1 is the main or key light. It is a spotlight with shadows set to VrayShadow. The intensity is 1.66 and the color is a light orange (RGB: 255,211,153). The decay type is set to Inverse Square starting at 0.52m. Under VrayShadows I have enabled Area shadow with a sphere size of 0.05m.

Light 2 is a warm fill light. It is a Vraylight plane with an intensity of 5 and color temperature set to 5070. Half-length is 0.23m and half-width is 0.29m.

Light 3 is a cool fill light. It is a Vraylight plane with an intensity of 2 and color temperature set to 8300. Half-length is 0.28m and half-width is 0.28m.

Light 4 is a rim light. It is a spotlight with shadows set to VrayShadow. The intensity is 4 and I have used a light blue color (RGB: 195,244,253). The Decay type is set to Inverse Square with Start at 0.33m. Also for this light I have placed the "cyclorama" in the Exclude list in order to have a strong Rim light show on the character without burning the floor.

Materials

The material base for the body, shell and eye lid is the same. Create a VrayFastSSS2 material with the "Skin(pink)" preset (Fig.55). Change the prepass rate to 0. Reduce the scatter radius value to 0.25. Set specular glossiness to 0.6, enable trace reflections and reduce the reflection depth to 1. In the Maps section, place the "armadillo_body_cavity.psd" in the specular amount slot, but be careful to set the gamma to override 1.0 when you open it, otherwise the values will be affected by the gamma correction. Also place this map in the bump slot with a value of 5.0. Place the "armadillo_body.psd" in the sss color slot (you might need to adjust the colors a bit in Photoshop; in my case I had to increase the image's brightness).

Apply the material to the body. Copy the material to create the new materials for the shell and eye lid, replacing the bump, specular amount and SSS Color maps with the ones for each body part.

For the eyes I have opted for a very simple solution: a black reflective material (Fig.56). It is a VrayMtl material, with the diffuse color set to black. Set the Reflect color to white and enable Fresnel reflections. Unlock the Highlight glossiness value by pressing the L button and set the value to 0.85. Apply this to the eyes.

The bottle material also starts with a VrayMtl material. Set the diffuse color to black. Set the Reflect and Refract colors to white. Enable Fresnel reflections and set Reflection glossiness to 0.9. Increase the Max depth of the Reflection and Refraction to 8 as there are a lot of inter-reflections in the bottle. Enable Affect shadows and change the fog color to a very light green (RGB:212,231,210). Apply this to the bottle.

Remember that I asked you to merge the original bottle into this scene? Make a copy of the bottle and edit the spline of the bottle shape, leaving the interior shape to create

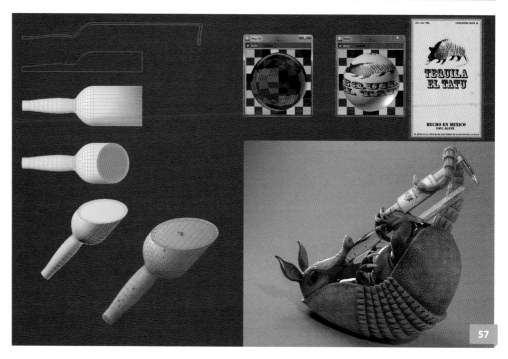

the volume of the liquid (Fig.57). Lathe again and use a Push modifier to expand the liquid volume just a bit, so that it intersects the walls of the bottle – this will make the refraction work properly. With a slice plane, cut the liquid horizontally and delete the top polygons. Use Cap to close the hole. Then apply an inset to the capping polygons and push the polygons down so that there is a bit of a curve where the liquid meets the bottle walls. Then add a few spheres, with the normals inverted, inside the liquid to create some air bubbles.

For the tequila material, just copy the material we have created for the bottle and change the fog color to RGB: 255,208,127. Apply it to the liquid and air bubbles.

To finalize, I have created the bottle label. The material is a simple VrayMtl with the diffuse texture of the label and Reflection Glossiness of 0.65 with Fresnel on.

Conclusion

I have rendered the final image at 4000 x 3000 pixels. In Photoshop I have made some minor color corrections and added some little bubbles to add to the idea that the armadillo is drunk (Fig.58).

I hope you have enjoyed the tutorial. If you wish to download the ArmadilloScale brush created during this tutorial, please visit my website: **www.artofjose.com** and you can find it in the Goodies section. See you next time!

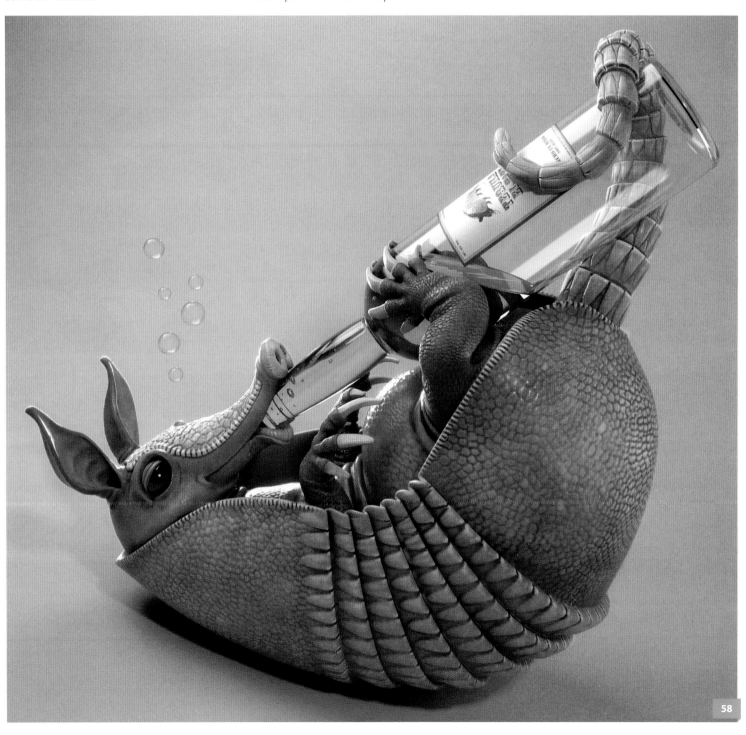

58

> **I do some quick thumbnails to figure out my composition. This helps me to plan exactly which parts will be seen in the final illustration**

Bugbear Mercenary By Christopher Moffitt

Introduction

This tutorial covers the process I used to create the ZBrush sculpt called *Bugbear Mercenary*. The creature is based on Jeff Murchie's bugbear concept for the game *Demon Stone*. I really wanted to capture the size and essence of this beast in the concept so I thought I would give him a slave girl to help convey how powerful and huge he is.

Have a Plan

Before getting started I do some quick thumbnails to figure out my composition. This helps me to plan exactly which parts will be seen in the final illustration and therefore the ones I will need to sculpt (Fig.01). This is a great guide for me since I sometimes tend to detail every inch of the character and lose sight of the end goal. I only make what will be seen from the camera. If I want a 3D print or to make a turntable I can always go back and finish it later.

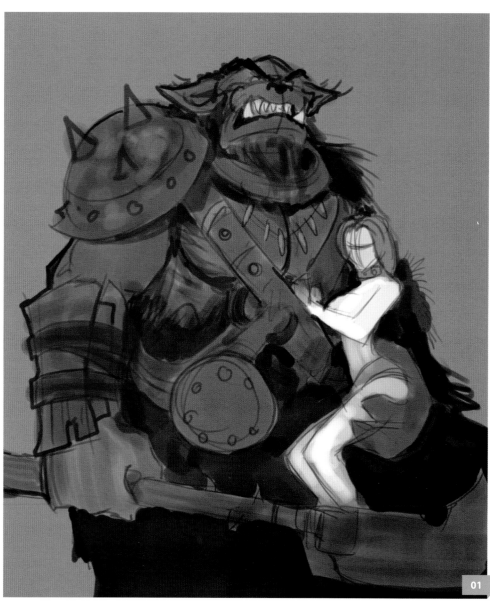

Building a Base

I usually start with a low poly base mesh that I create in 3ds Max and import it into ZBrush. Usually this is just the naked body (Fig.02). I know in advance that the girl will have a collar around her neck so I make the head mesh separate from the body since the seam will be hidden. This will also allow me to subdivide more if I need to and helps me avoid having to retopologize my mesh. For the Bugbear I only need the torso since I won't be showing his legs in the final image.

Once the .objs are loaded into ZBrush I subdivide each subtool once or twice and, with Mirroring on, I begin adjusting the forms using the Move brush with a large radius. The Inflat brush is also great to thicken up limbs or fingers if needed. I constantly try to view my meshes from all angles as I sculpt until I'm happy with the overall forms (Fig.03).

If I need to adjust a large area, for example, shortening the arms, I like to use the Mask pen with the Lasso stroke on and mask the lower half of the arm. I then blur the mask a couple of times, invert the mask so that the lower half is unmasked and then use the Move Transpose tool to shorten the arms (Fig.04).

Next I subdivide the model three or four more times and use the Clay Tubes brush to start building up the anatomy. During this stage I like to have an anatomy reference to glance at while I work, to make sure that my brush strokes are going in the same direction as the muscle fibers (Fig.05).

As I sculpt with Clay Tubes I'm constantly building up the surface and then holding Shift to smooth the surface out. If the Smooth brush only seems to smooth out the smallest details I go down a subdivision so that I'm smoothing the surface entirely. I'm careful not to smooth out where the muscles cut in and leave those as tight as possible (Fig.06).

When working under the arms or mouth I will use the Move Topological brush so that I only affect the area I'm touching. For example, this is great for moving the lower lip independently from the upper lip (Fig.07).

Gearing up
Once I'm happy with the overall forms and volumes, I export the meshes at the second lowest subdivision back into 3ds Max so I can start building the armor and clothing that will go on them. I try to keep the geometry simple and I use smoothing groups where needed

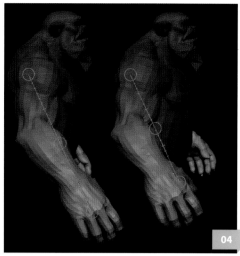

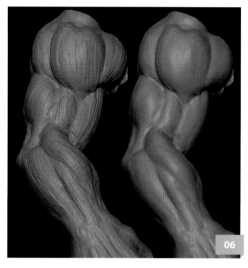

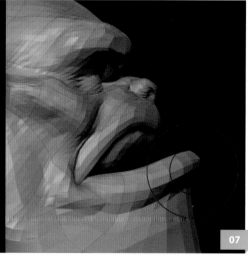

so that my meshes retain hard edges when I use the Smooth Group Import plugin later on in ZBrush (Fig.08). If a piece of gear in my concept is mirrored, I will usually mirror it in 3ds Max and combine the two as one object, so that once the object is in ZBrush I can just turn on Mirroring and not worry about trying to duplicate, mirror and combine an object in ZBrush (which requires a few more steps).

Once I have all the parts built, I export each piece individually as an .obj file with Smoothing Groups checked on in my export settings. Back in ZBrush I import everything individually through the Smooth Group Import plugin using Crease Groups under the Zplugin menu. I will subdivide each subtool two or three times then, holding Shift, I click UnCrease in the Geometry tab. This removes

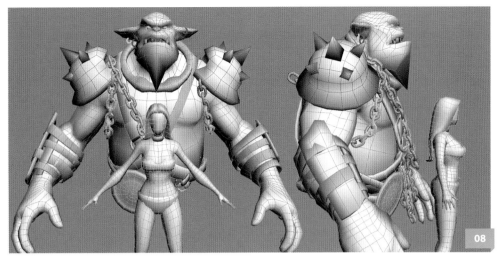
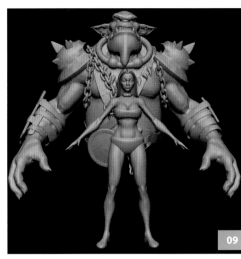

the bevels and now I can sculpt across those edges or smooth them if needed.

Pulling it all together

At this point I'm ready to start adjusting the larger shapes of all my parts. I move the teeth and eyes into place, and adjust the shape and scale of the straps and armor to fit the body. I do this to make sure everything has the right weight and so the gear looks like it's being worn by the characters (Fig.09).

Next I start adding medium details like bolts, fingernails, buckles and any other tweaks I need to make before the detailing begins. I like to work with a Standard material on everything because I can move the lighting around and make sure all my forms are casting shadows properly. MatCaps are not affected by lights and can sometimes have a dark cavity setting that will make you think you're sculpting deeper than you actually are, so I try to only use them when I'm ready to poly paint and render (Fig.10).

The Detail

When detailing I try to work on a separate layer, but that doesn't always happen. It's good knowing you can throw the layer away if something's not working, but I've gotten used to just smoothing out a certain area if I don't like how it's looking. For skin and smaller details I use the Dam_Standard brush with default settings. It's really great for cutting in tight wrinkles or pulling out sharp

folds of cloth. It's also great for creating wood grain, sharp metal edges and seams. I turn on LazyMouse with a radius of around 20 for creating wrinkles in skin. For veins I use a Standard brush with stroke set to Freestyle and the LazyMouse setting turned on with radius set between 20 or 30. I usually set my focal shift to -30 with the intensity set to 25.

When working on ears or double-sided parts that are thin like fabric, I will usually turn on Backface Mask, which is under Auto Masking

in the Brush drop down menu. This ensures I'm not affecting both sides with every stroke.

The Slash 3 brush is really great for creating scratches and nicks in metal surfaces, and the H Polish brush is good for creating dents or a "pounded metal" surface. For hair and clothing seams I use the Dam_Standard brush with LazyMouse on for control over my strokes. If I take the time to cut a seam in that follows along an edge only to realize I didn't go deep enough, I hit 1 a couple of

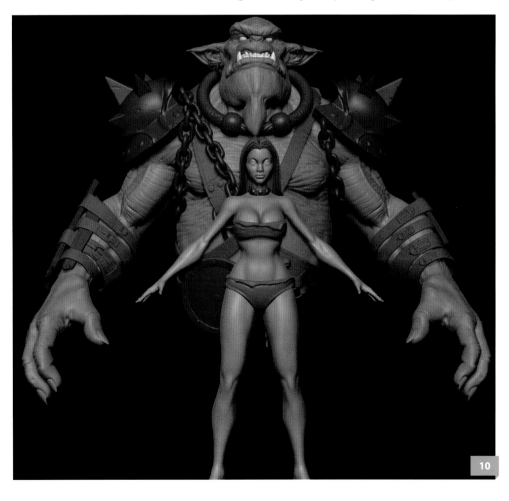

times to repeat the last stroke until I get the result I want. Make sure you don't rotate your camera after the stroke and then hit 1. It will just try to repeat your last camera movement.

Adding Color

This is one of my favorite parts of the sculpting process. Before polypainting details like hair and dirt, I try to fill each subtool with a solid color and MatCap close to what I want for the final look. With Mrgb turned on, and my color and MatCap selected, I go to Color > Fill Object. I repeat this for the other parts until I have a nice base to start with (Fig.11).

Once everything has a unique solid color, I can start painting some texture detail. For skin I like to use a Cavity mask found under the Masking tab in the Tool menu. With the intensity set to 10, I click Mask by Cavity and all the recessed areas automatically get masked. I then invert the mask by either clicking Invert or control clicking anywhere in the viewport outside the model. I turn off View Mask and now I can use Fill Color to fill in all the recessed areas. With RGB on and set to around 12, I like to fill the object with a darker, warmer color. This really makes the sculpted details pop. If you don't want this all over the model you can just use a brush and go over the parts you want filled in. I then invert the mask and turn off View Mask again. Using the Standard brush with the stroke set to Color Spray and the alpha set to Alpha 07, I pick a lighter color and start to paint over the highest areas with a large radius. For hair I use a Standard brush with the stroke set to Freehand and Alpha 58 (Fig.12).

Posing

At this point everything is sculpted, polypainted and ready to be posed. I save it as a new file (just in case I forget and save over my t-pose version with a posed version). I try to only pose what's needed so I pick a camera angle that I like and under the Draw menu, set my focal angle to 90 for this particular shot. Once I have my camera where I want it, I pull down the ZappLink

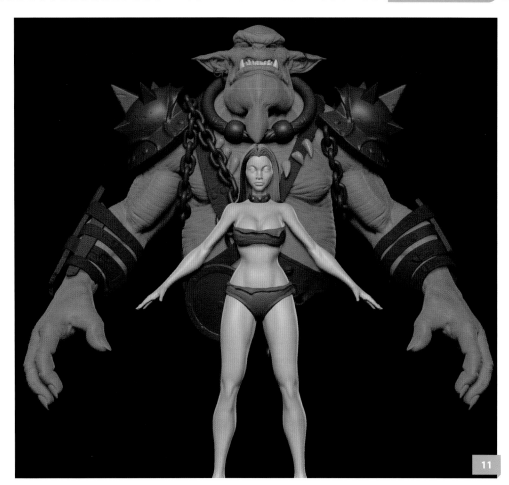

11

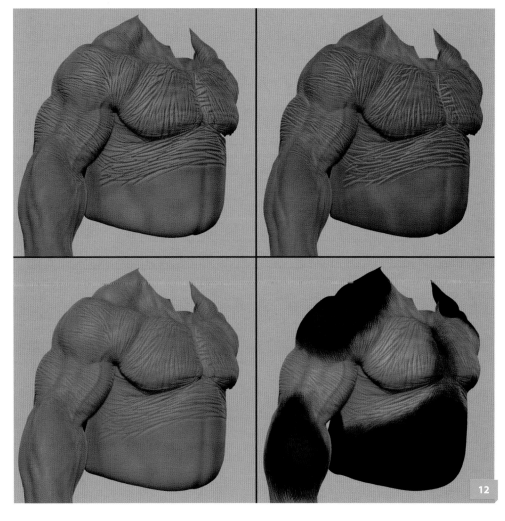

12

Properties tab under Document and click on Cust1 to set my camera. Then I click on Save Views to save out a view file with my focal angle value in the file name so I know what the setting was later on. Now whenever I open my file to render another pass, I can just go to Load Views, load my file, and then click on Cust1 to get my camera angle back. Don't forget to enter the focal angle value so that it matches up with your previous renders.

For posing I reduce my subtools to the second or third subdivision and then click on Rotate. When posing the arm, for example, I hold Ctrl and start drawing the transpose gizmo down the length of the arm until everything is masked except the arm. I then control click on the mesh a couple of times to blur the mask so that I'll have a nice falloff for deformation. Now when I rotate the arm using the gizmo, the shoulder deforms as if it's bound to a skeleton and I'm able to really bend things the way I want. Once I have everything roughed out in the pose I go back and clean up areas like elbows, knuckles, knees and anything that needs to be adjusted in the forms to look right (Fig.13).

Final Render

Now I'm ready to render so I set my document resolution to what I want and click on BPR in the top right of the viewport. This will be my base render. I'll do a couple more render passes for adding shadow depth, rim lighting and specular highlights. In Photoshop, I layer them all together and, using different blend mode settings, I adjust each until I have the desired look (Fig.14). The fur and fabric is all in shadow so I just paint that into the background. For fur I like to use the hair and fur Photoshop brushes by Zeoyn (aka Jose Alves da Silva). The clouds in the background are from a cloud brush I used by ChuckMate (aka Patri Balanovsky).

I hope you find this tutorial useful. ZBrush is such an amazing tool and I'm always amazed each time I discover something new that it can do. Good luck and have fun! (Fig.15).

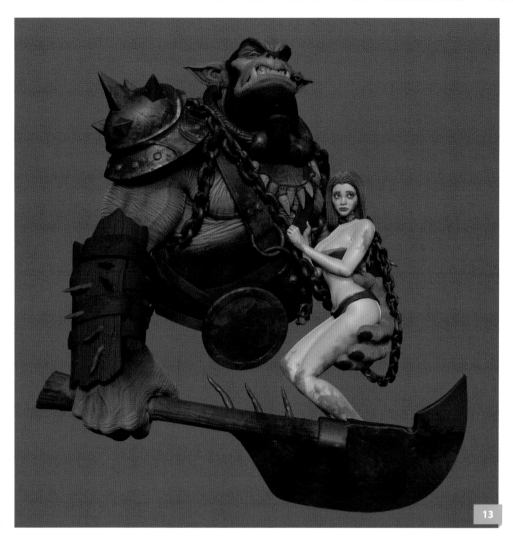

13

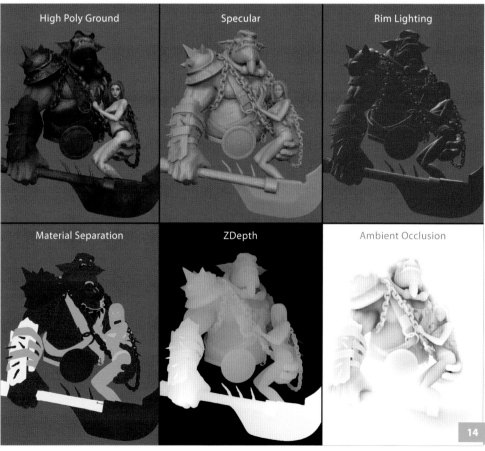

High Poly Ground Specular Rim Lighting

Material Separation ZDepth Ambient Occlusion

14

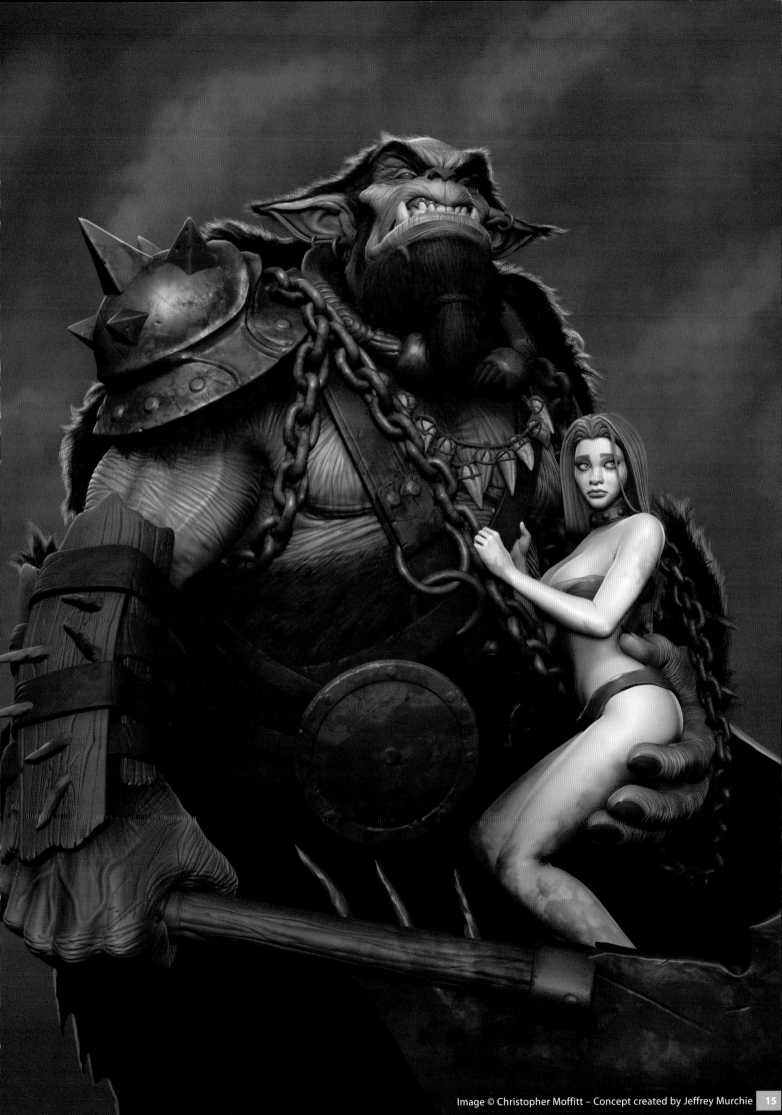

> **I want my troll to be big and strong, but also friendly and maybe a bit stupid**

Mountain Monster By Marthin Agusta

Introduction

Creatures and monsters are always interesting to build in 3D. For this tutorial, I will show you my workflow from concept through to sculpting and texturing a character using ZBrush.

Concepts

The theme given for this tutorial is a "mountain monster". After doing some research, I've decided we're going to create a mountain troll, simply because I think it will be interesting to design and it fits well into the mountain environment.

So first of all, we have to determine the personality of this troll. I want my troll to be big and strong, but also friendly and maybe a bit stupid. He might wear a very simple outfit, like an animal skin or fur, but it should be minimal since he is living in the wild.

I've made a couple of sketches for this creature, but here's the one that seems to work with the description above (**Fig.01**). As you can see I initially wanted to give him a weapon to hunt with, like a bat or stone axe, but I later dumped this idea because I don't want to make him look violent, which is contrary to his personality description. Although this concept is rough and far from finished, it gives us a good picture of what we're going to sculpt later in ZBrush.

Modeling/Sculpting

After the concept is done, it's time to enter

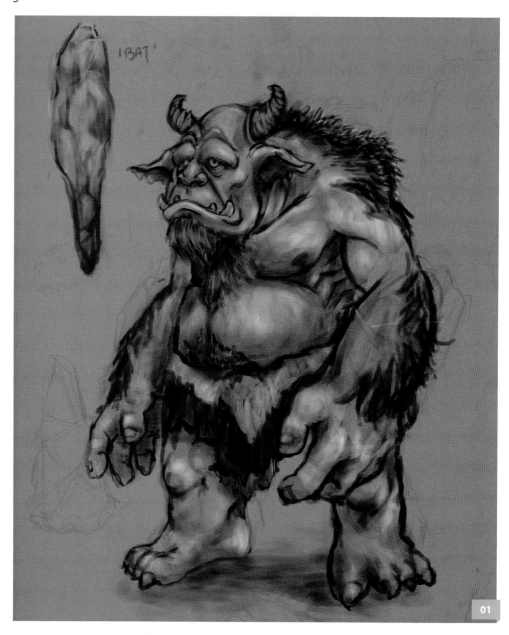

01

the modeling stage. I tend to start off projects by building the head in order so that I can get the overall feeling of the character. So let's begin our mountain monster by picking PolySphere from the tool palette.

You may notice that the standard polysphere has too many polygons. Go to the Geometry tab, then slide the SubD slider to 1 or press Shift + D (pressing D will have the opposite effect; it will increase the subdivision).

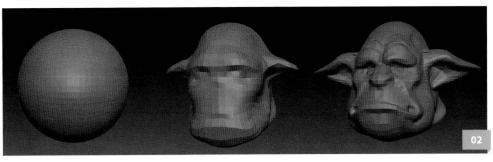

Always work on the lowest subdivision possible, so for now we will keep on SubD 1. Press X to work in Symmetry mode and then activate Perspective by pressing P. Now we will begin to pull the sphere around to form the basic head anatomy. To do this, click the brush palette on the left and choose the Move brush.

Use the Move brush to shape the face, making some extruded features such as the ear and nose. When the base form is done you can continue in a higher resolution. Slide the SubD slider into SubD 2 (press D once).

Add more details to the head using the Standard or Claytube brush. The Claytube brush is great for adding muscle definition, like in the forehead or cheek muscles. The Standard brush is used for generic purposes like the eye socket, nostril, lips, etc. The default mode for the brushes is ZAdd, which is similar to adding clay/material to a sculpture. Holding Alt while you are sculpting will activate ZSub, which reduces the mass of the model (Fig.02).

Continue doing this until you reach SubD 3. You will notice that 3 is the maximum subdivision level at the moment. We can add more subdivision and details, but at this stage I would like to see the troll with some eyes. So we're going to postpone sculpting the head any further and go to Subtool > Append. In the box click PolySphere and you will get another sphere in the Subtool list. To adjust the eye sphere use Transpose, which includes Move, Rotate and Scale. All three can be found on top of the canvas. Press the Transpose button on the right of your palette to make the un-selected subtool (in this case the head) invisible.

After you have finished adding one eye, all you have to do is mirror it. Use a plugin called SubTool Master, which you can find by going to ZPlugin > SubTool Master. Simply click Mirror and check Merge into one subtool, with X as the mirror axis.

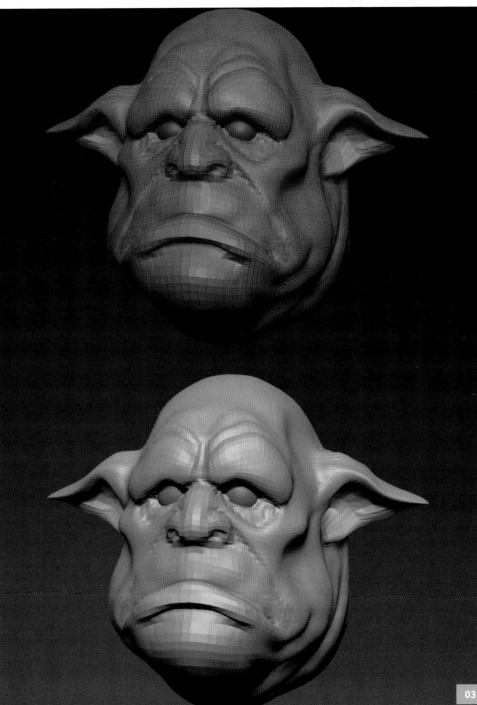

Using different materials (MatCaps) can sometimes help you work better. I usually use MatCap Gray for modeling purposes, which can be found in the material palette on your left menu (Fig.03).

Now we will begin detailing the face. Press Geometry > Divide to increase the subdivision. I mainly use three brushes to detail faces, which are Standard, Clay and Clay Tubes. My usual workflow is to use Clay

Tubes as the "base sculpt" and after that apply the Clay or Smooth brush to soften the texture (Fig.04).

With these basic brushes, continue sculpting. Sometimes we'll need to sculpt smooth lines; to do this press L to activate LazyMouse.

Next we will add some teeth popping out from his mouth. To do this, we're going to use another sphere and do the same here as we did with the eyes. Append a polysphere from the tool palette and pull the top of it using the Move brush. Then duplicate it with the SubTool Master. This is how the troll head looked in SubD 6 (Fig.05).

To construct the body, we will use a different technique. The best way to do it is using ZSpheres. First, we need to attach the ZSphere to the head mesh. To do this, click Append below the subtool list then select ZSphere from the list. The head might be covering the ZSphere so if you can't see it, simply press Transform. Position the ZSphere in the center of the body using Transpose > Move (shortcut W) (Fig.06).

Now we will start to build the body. Press X to activate Symmetry. To add another ZSphere use Draw (shortcut Q) and then drag from the center out. Use Move (W) to reposition any of the ZSpheres you created. You can also use Scale to increase the size of your ZSphere. After a few minutes of building the ZSphere here's what I came up with (Fig.07).

Since this character has natural seams at the waist, separate the body and the feet. This will also mean there will be more polygons to work with later.

You can preview what the mesh will look like by pressing A (or go to Adaptive Skin in the tool palette and press Preview). Pressing A again will switch back to ZSphere mode. Make any further adjustments needed, and then press Make Adaptive Skin (also in the Adaptive Skin menu) to convert the subtool

Standard Alt + Standard

Standard with Alpha 39 Alt + Standard with Alpha 39

Clay Clay Tube Clay Tube + Clay

04

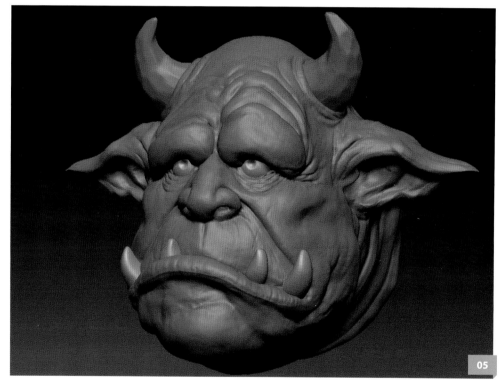

05

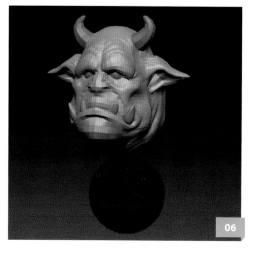

06

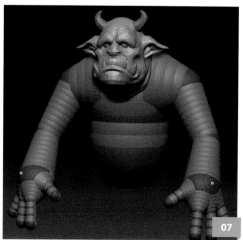

07

into a mesh. The result will appear in the tool palette. We will need to add this tool to the existing subtool, so go to Subtool > Append and select the new body mesh.

Using the same method build the feet from a ZSphere. Turn it to Adaptive Skin and then append it as a subtool (Fig.08).

Tip: To switch between subtools, just Alt + click the subtool mesh you want to activate.

After the base mesh is finished continue to work on the body, sculpting more muscles and adding more subdivision and details. My body, for example, is sculpted until SubD 7. I'm using the same brushes as I did on the head: Clay Tubes for the base muscle and then the Clay or Smooth brush to smooth it. Always go back to a lower subdivision if you want to cover larger areas to sculpt. Sculpting at the highest subdivision without any base in previous subdivisions can result in a clumpy and ugly shape (Fig.09).

Another useful feature in ZBrush is masking. Basically we paint certain areas that we want to protect when sculpting. To do this, simply hold Ctrl and paint the mesh. We can invert this masking by pressing Ctrl + clicking in the canvas (outside the model) (Fig.10).

This will be useful to protect other areas from sculpting, or to isolate certain parts that we need to focus on. Another way is using Transpose > Move. To do this, press W and hold Ctrl while dragging in the direction of the area you want to expose (Fig.11).

After finishing the upper body, continue to add the clothing. To create it, we're going to extract some mesh from the lower body. First we need to mask the areas that we want to extract. I'd advise doing the masking in SubD 2, to make sure there are enough polygons to work with later. After you have done the extraction the mesh will appear in the subtool list. Try to shape it using the Move and Standard brushes (Fig.12).

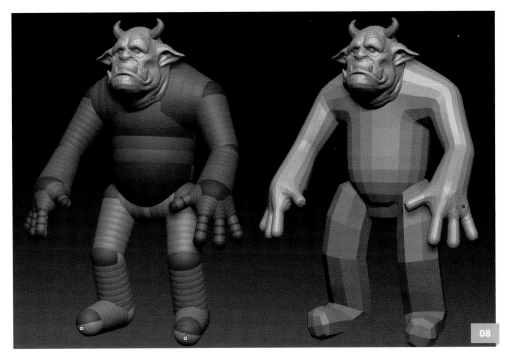

08

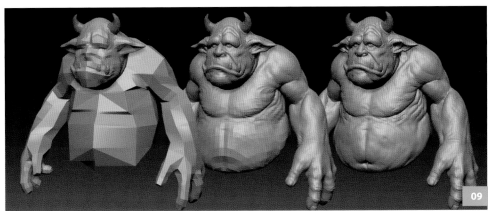

09

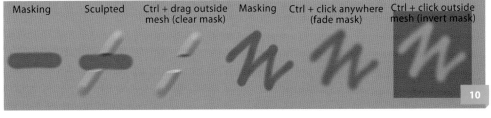

Masking Sculpted Ctrl + drag outside Masking Ctrl + click anywhere Ctrl + click outside
 mesh (clear mask) (fade mask) mesh (invert mask)

10

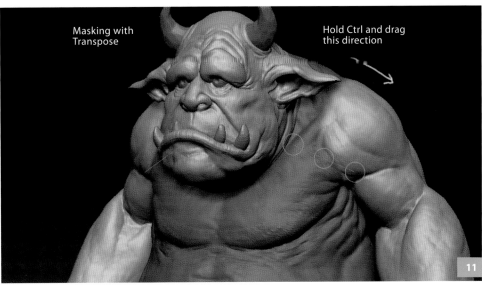

Masking with Transpose

Hold Ctrl and drag this direction

11

After that, continue sculpting the lower body. I'm doing mainly what I did on the upper part: just building some muscles using Clay Tubes and then smoothing them using the Clay or Smooth brushes.

A simple gesture or expression will bring more life to the model. For this troll let's add a bit of a smile and rotate the eyes and body to make it look more natural. Then continue refining the sculpt. Here's what my sculpt looks like after adding the simple expression (Fig.13).

Extract the chest fur mesh from the body. Then add some subdivision and use the Snake Hook and Move brushes to sculpt the fur strands. The Standard brush with a thin alpha (e.g., number 39) is also good for sculpting the fur.

Now we can take this model into the next level, by doing some texturing. ZBrush has a very good texture painting feature that allows us to paint without UVing the model. This is known as Polypaint. In Polypaint, the denser the model, the better resolution of the texture

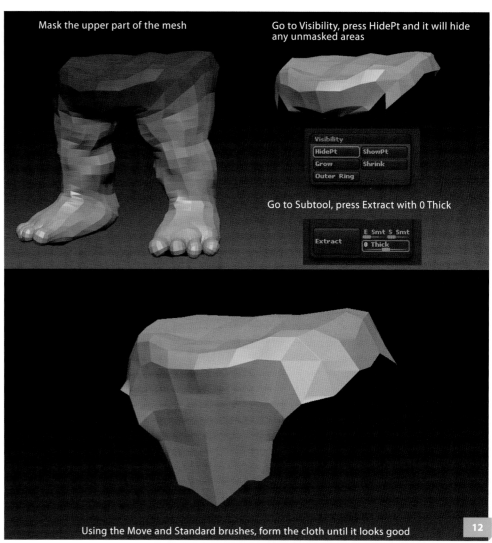

Mask the upper part of the mesh

Go to Visibility, press HidePt and it will hide any unmasked areas

Go to Subtool, press Extract with 0 Thick

Using the Move and Standard brushes, form the cloth until it looks good

12

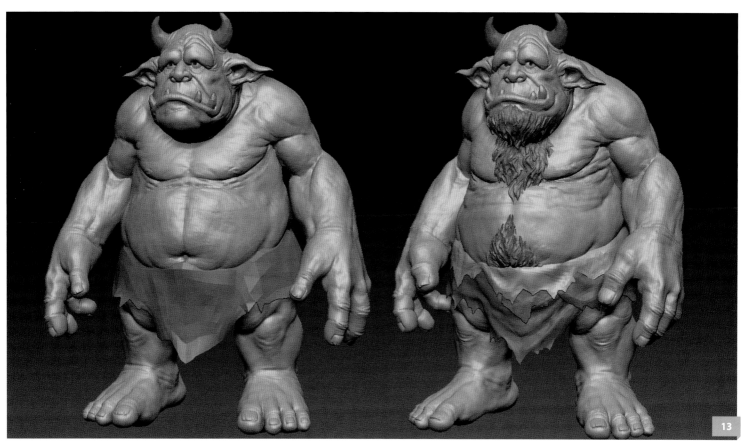

13

paints. So it's always good to have a good amount of subdivision before you get started on the painting.

The first step is adding color to the model. Make sure the RGB button on top of your canvas is turned on. Then pick any color from the color palette and go to the Color menu. Click Fill Object and the color will then be assigned to the active subtool.

Once the basic color is assigned, we can start to paint. Choose the desired Stroke type from the stroke palette on the left of canvas (the default will be dots). After you have done that, pick Alpha 04 from the alpha palette. This alpha will give a good texture when creating skin. Now we can drag to paint the texture. Fig.14 shows my progress when painting the troll.

As you can see I'm mainly adding reddish colors to bring the face to life.

Tip: To pick the color from your cursor position, simply press C. To switch the color from the foreground to background, press V.

It is also good to have a skin material assigned to the model. ZBrush has one named "Skin Shaded4", or you can download another material from the internet.

Masking is also a great feature to help us when polypainting. In this case I am using a Cavity mask. Go to the Masking tab in the

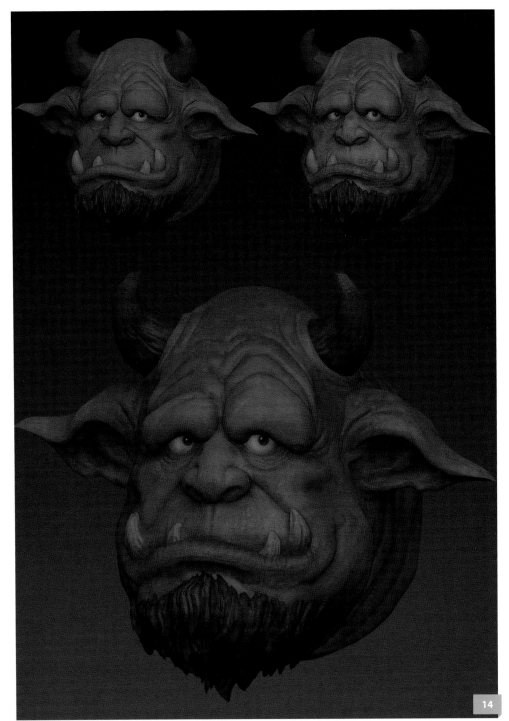

14

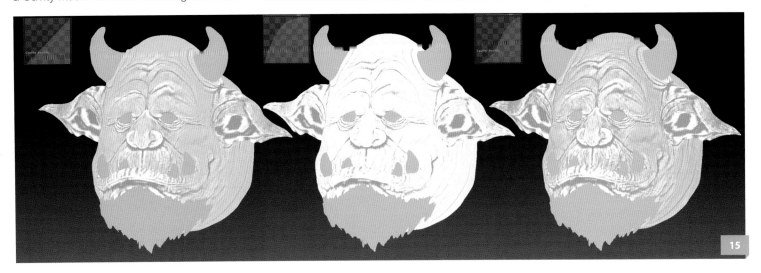

15

tool palette and then you can see there are many masking options. To create a better result, press Cavity Profile. It will open a curve that we can adjust to control the masked areas (Fig.15).

After we have done the masking, it's time to paint all the cavities. Experiment with either lighter or darker colors to make it contrast with the base skin color.

Tip: When painting whilst using the Cavity mask, turn off the mask visibility by pressing View Mask. Press it again to turn the mask visibility back on.

Here's what I had after painting the whole body (Fig.16). Go to Render > Best to render the model. You might notice that the model is quite dark right now, so the next step will be adding some lights.

Adding light can really improve your render. Here's my sculpt after tweaking the lights (Fig.17). The default light is one Sun light. You can add as many as eight lights. To create the image I'm using six lights, with two of them being Sun lights and the rest Point lights. To change the light types, go to Types and pick Point Light. Other settings that we can use are Intensity and Ambient.

The light placement is important, so try to experiment with different light positions. Turning on Shadow in the Shadow tab can also add depth to the model.

And that's the end of this tutorial! I hope you've learned some useful things about sculpting in ZBrush and thanks for reading.

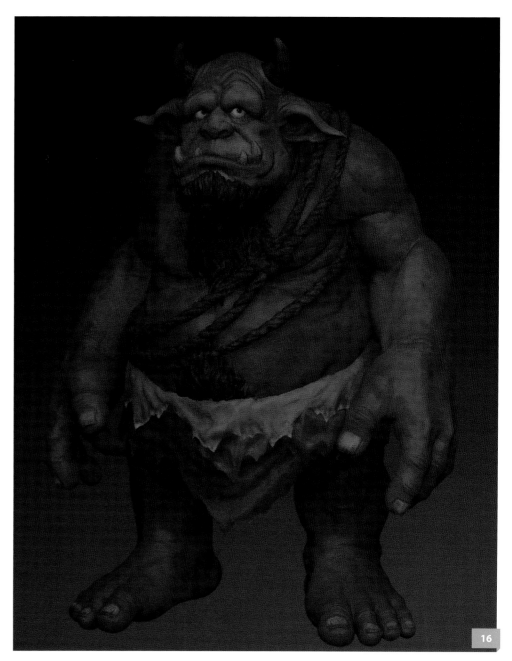

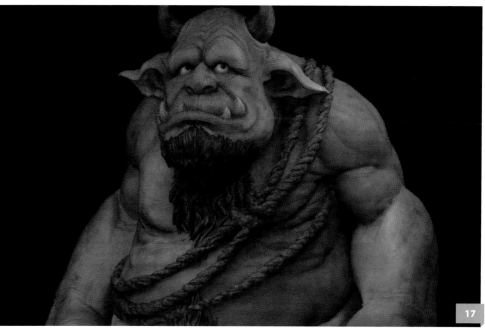

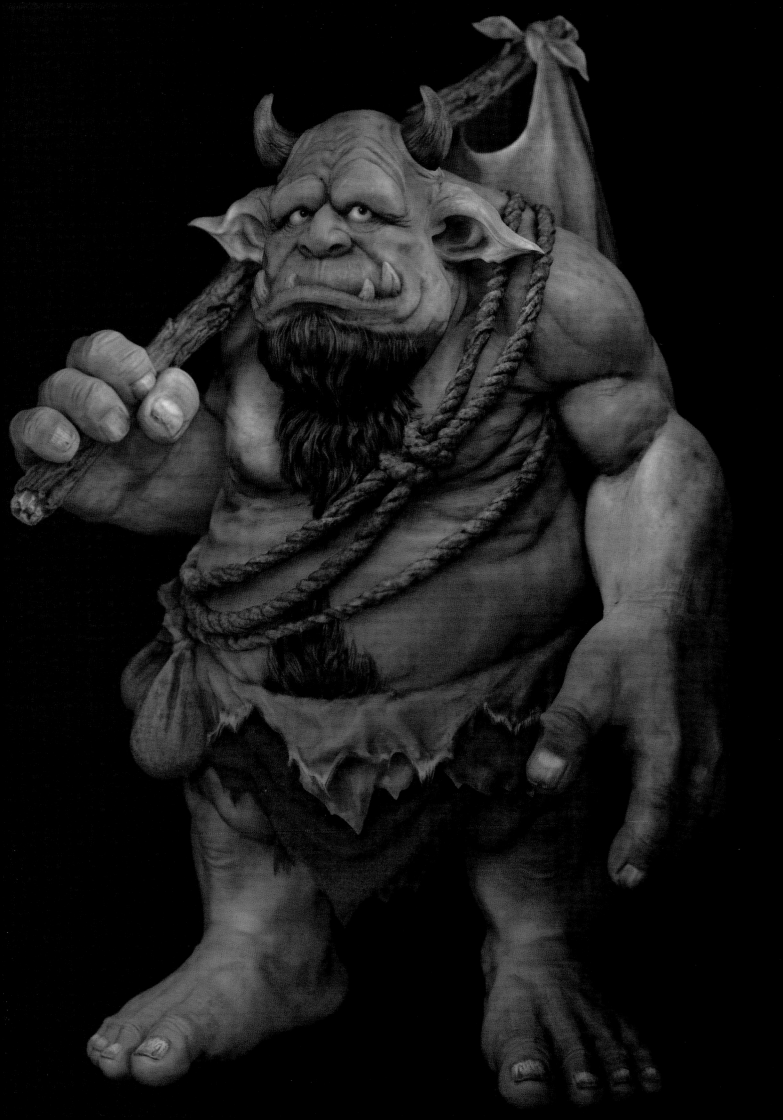

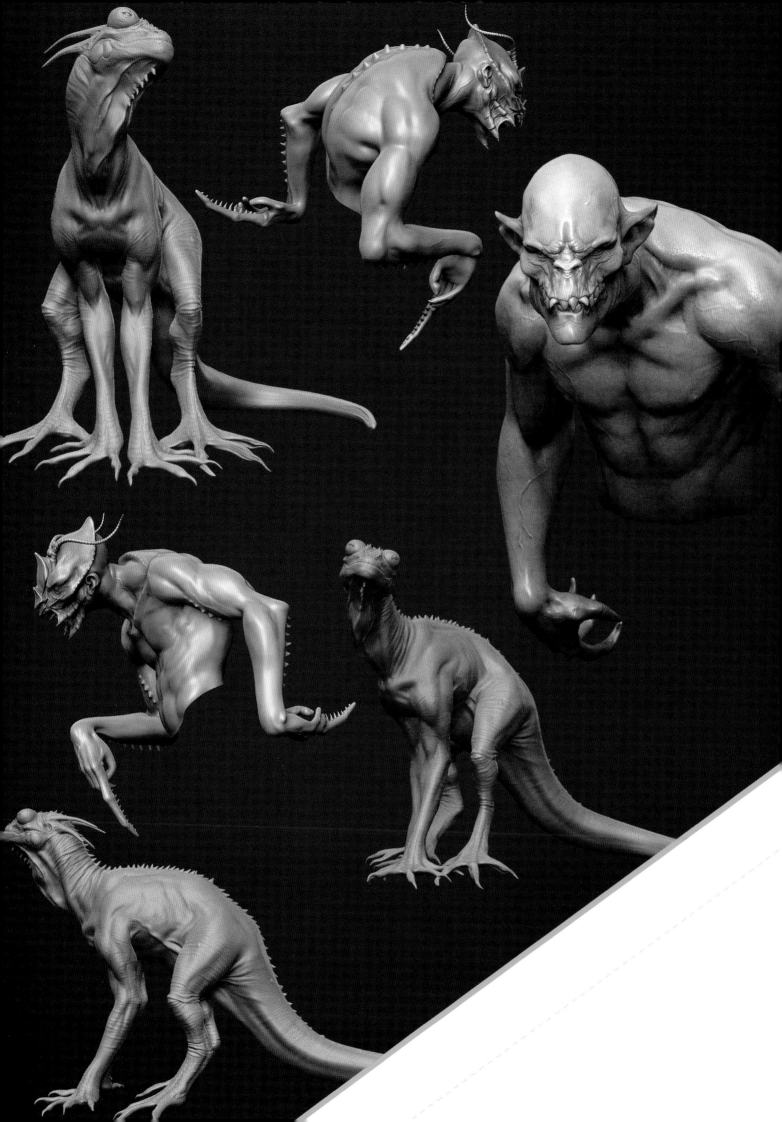

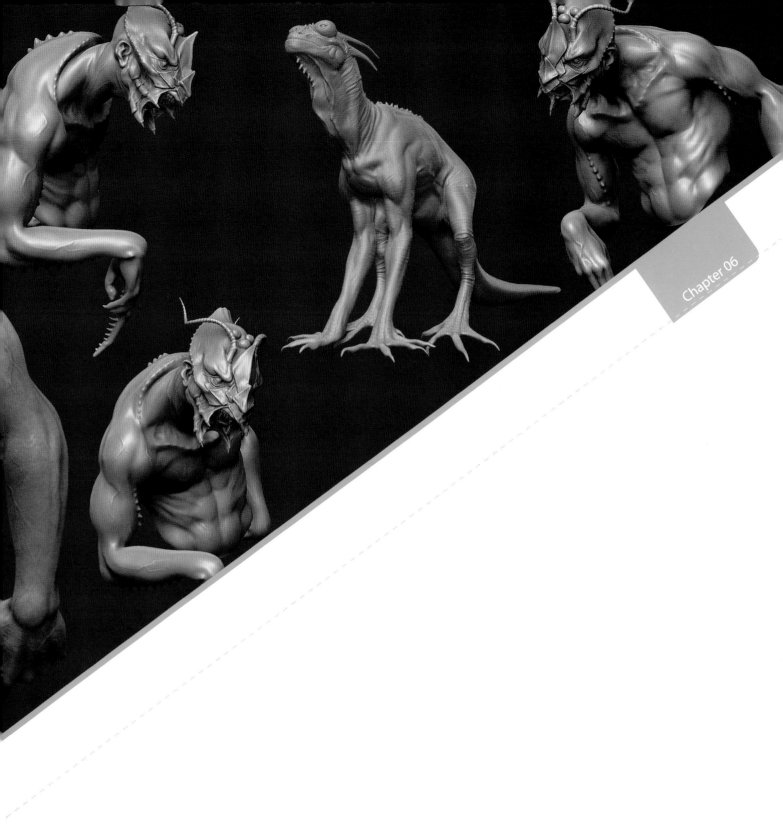

Speed Sculpting

The previous chapters have been full of polished sculpts where the end goal was to create a perfect image. In this section our artists will be demonstrating a slightly different technique, with the intention of creating an impressive image in as little time as possible. Starting with a base model, which is provided in the downloads section of the book, each of the authors will demonstrate how to manipulate form, achieving the best possible results in the most economical way. If your goal is to sculpt impressive results within a limited time frame then this section is for you.

" You can often lose a lot of time by reworking something when starting from scratch would be so much faster "

Creature of the Night By Rafael Grassetti

Introduction

Speed sculpting is something that really helps me to improve my modeling techniques. I made a lot of them when I was starting out and I still like to create them when I have some free time.

I usually start my models from a really simple base mesh. I think it's faster and more enjoyable to block-out forms in ZBrush. I also think it's a lot easier to retopologise things nowadays; one of best features of ZBrush is the Retopology tool, which I personally think is amazing! For this piece I used a base mesh and adjusted the shape and details.

Concept

When I think of a "creature of the night" I usually think of vampires and as I'm a fan of this particular theme I had this in mind right from the very beginning. However, I then considered doing something different, so I did some quick research on the internet and found some photos and references of what I thought would fit into the theme of "creature of the night".

Speed Sculpting!

After importing the base mesh into ZBrush I started messing with the Move, Clay and Standard brushes to add volume, while making sure I didn't go too high on the subdivision levels. The main focus at this point wasn't detailing, it was on the shape of the silhouette and volume, so I kept my polygon count low at the beginning and focused on the gesture and basic form, trying to find the best design sculpt as I didn't have a final creature in mind at the time.

The design sculpt is intended to represent the finished model. Its main purpose is to suggest forms that we will later make more precise. So when I found the design that I wanted for the model, I continued subdividing and adding details (Fig.01).

I remade a few parts that I'd blocked out in the beginning. Sometimes it's best to start a mesh again rather than work from a detail that has already been started. You can often lose a lot of time by reworking something

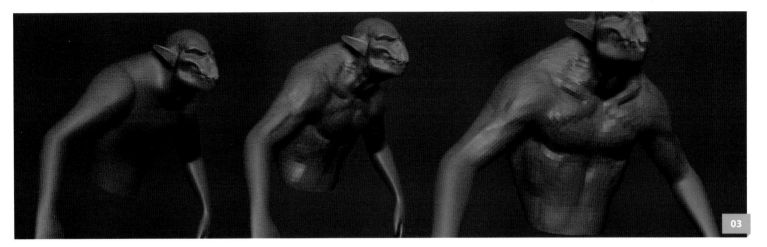

when starting from scratch would be so much faster! This is something that I usually see myself and friends doing – don't be too lazy to go back to the beginning again!

In the mouth area I smoothed the entire section and remade the teeth and the form of the mouth. I sculpted this part using the Standard brush and finished it with masks and the Move brush. If I wanted to animate this model, or use it with an open mouth, I would retopologise and continue sculpting with a better distributed base mesh (Fig.02).

As I didn't have too much time to work on the details, I blocked out the main body proportions and added a few small details (Fig.03). If I'd had more time, I would have spent longer on it, adding brushes and alpha details. The silhouette and proportions are the things that make a character, but details like pores, wrinkles and veins really help to sell it! I also used the LazyMouse to achieve clean, smooth lines on the small details.

The next step is to adjust the shape and pose using Transpose. The basic idea of this is to deform a level of your mesh using masks and polygroups; it's a really easy and intuitive way to pose your model. By masking the mesh and using the Ctrl key with Move, Rotate and Scale you can change the forms. You have total freedom to do what you want with your character (Fig.04)!

As I didn't have too much time to finalize the model, I didn't make an extreme pose

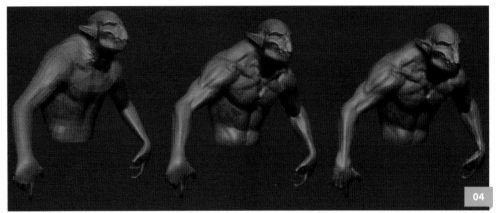

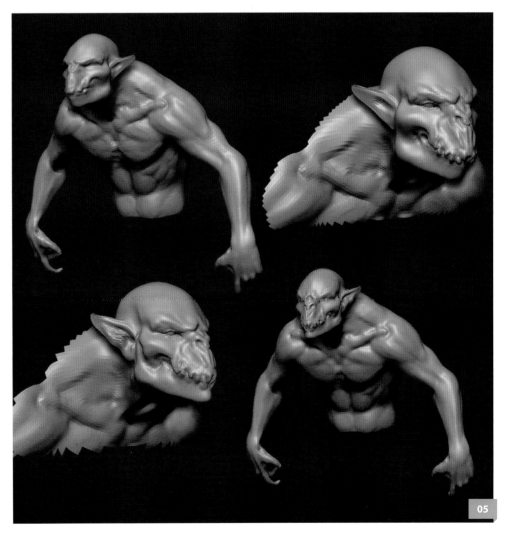

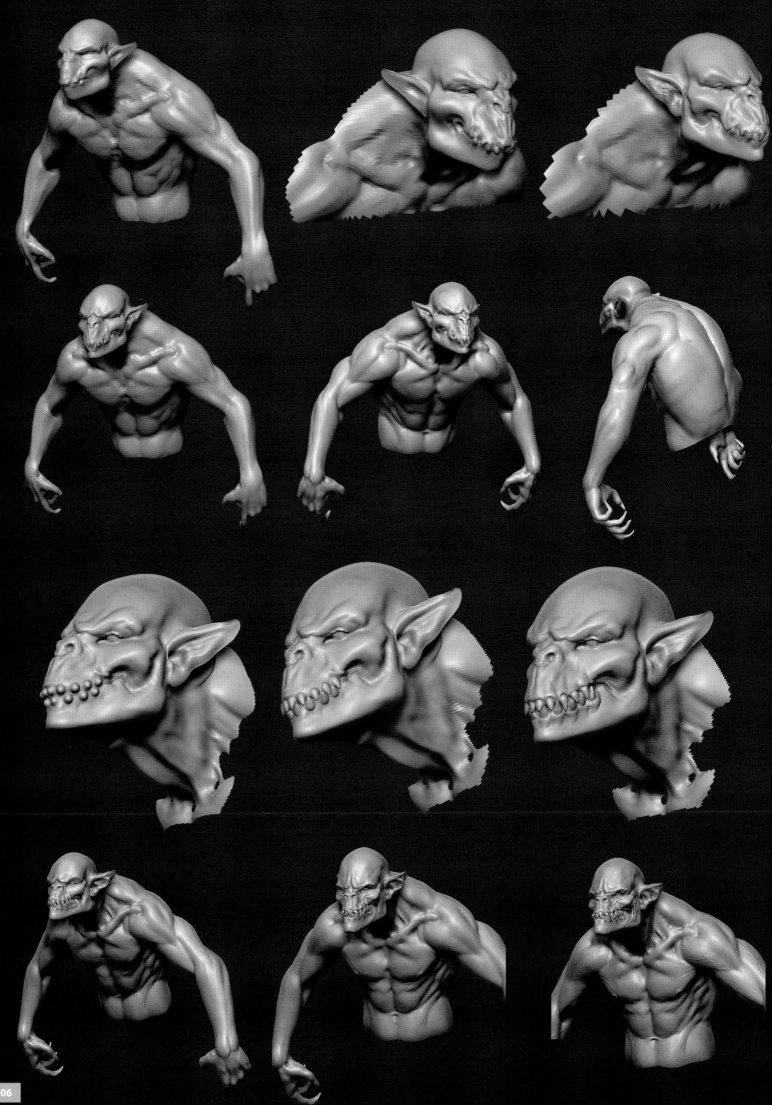

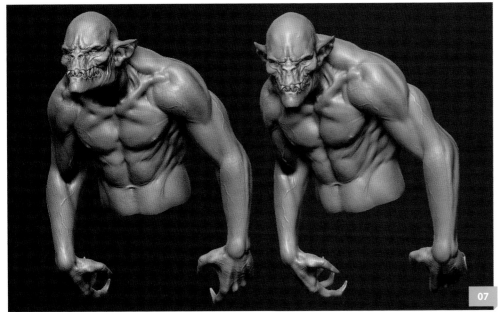

because although Transpose is a great tool, you often have to re-sculpt some parts due to the badly posed muscles and enveloping. So after finding a nice pose, I refined the posed model by adding more detail and fixing the look of the posed muscles (Fig.05 – 07).

With all the modeling done I usually play with the Polypaint feature in ZBrush and give some color to my models. With this piece I simply played with some materials and lights to create a final image (Fig.08 – 09).

Overall I spent three hours and twenty-five minutes working on this model, from the initial base mesh through to completion. I had a great time working in it and writing this little tutorial to help explain some of my modeling techniques and the creation process, and I hope you've all enjoyed this as much as I have. Creating speed sculpts is something that will help us all to become better modelers and every new character will be better than your last one!

You can download the bash mesh (OBJ) file to accompany this tutorial from: **www.3dtotalpublishing.com**.

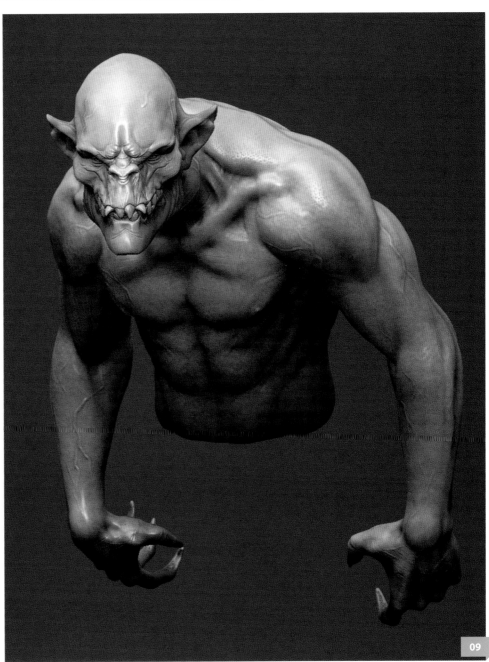

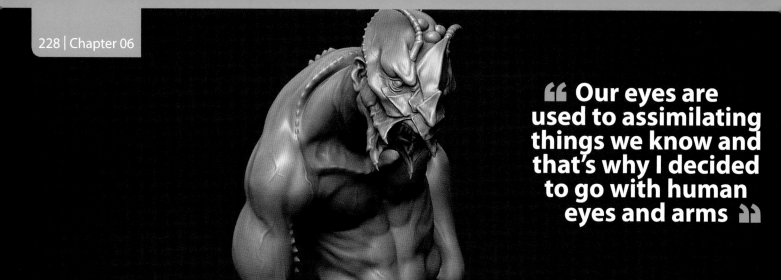

Vegetation Creature By Rafael Grassetti

Introduction

In this project I wanted to have more freedom with the creative process than in the other projects I usually do. So I started by doing some basic research around the theme: "Vegetation Creature". I found a lot of great images, but the things that really interested me were the vegetation bugs I found. So I took a look at the references and the features that got my attention were the hooves, thorns and mouths of the insects, which are spectacular. So even while I wasn't going to fully follow the references, I knew that I would incorporate some of these elements into the final model. This is something that I usually do when I'm designing a character – having some elements in mind always helps.

The Sculpting

The base mesh I started with was limited, so I started to play with the proportions as quickly as I could, without thinking about it too much. Using the Transpose and Move tools I finally got something that I was happy with and then I added some edge loops so that I didn't lose much information in the base when I was adding the final details (Fig.01).

Once I had good proportions, I started to play with some forms, adding fast and intuitive details and forms in the face and body. I thought I had a design I wanted to finish the third time I sketched it up, so I wasn't worried about making mistakes (Fig.02). I tried to incorporate as many bug forms as I could, but was careful to not lose the human form.

Our eyes are used to assimilating things we know and that's why I decided to go with human eyes and arms.

With the polygon count being low in the beginning, I focused on creating gesture and basic form while trying to find the best design for my creature. I then continued subdividing and adding more details using the Clay, Standard, Move and Smooth tools (Fig.03).

When I found the final design for the mouth, I exported a low mesh OBJ and created the teeth in 3ds Max (or you could use any 3D package) by using and duplicating cylinders. When I was happy with the overall look, I imported it back to ZBrush (Fig.04).

By using Isolated Selection (Ctrl + Shift), I started to add small details to the face (Fig.05). I had a few pieces that I needed to

03

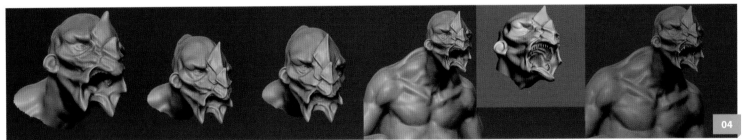

04

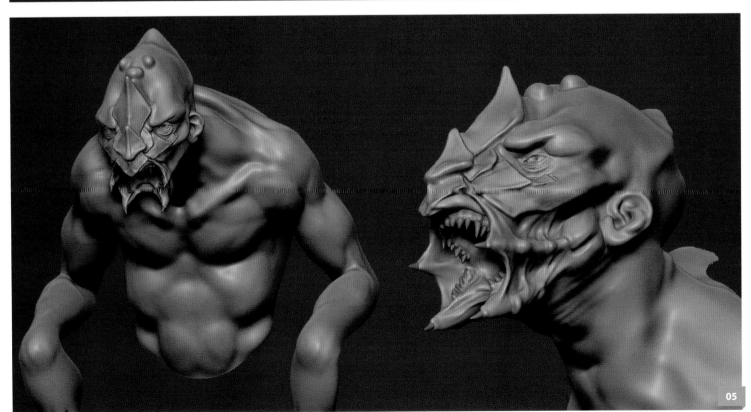

05

create because the base mesh wouldn't allow me to – like the antenna – and so I created them using ZSpheres in a separate tool and appended them into the main model. To get both antennas I used the SubTool Master, duplicated the subtool and used the Mirror button (Fig.06).

I started working on the body and then I decided to add a few hooves onto some parts of the torso, like a mantis. So using the Ctrl key I created a few masks and with the Move and Inflat tools I extruded a few hooves (Fig.07).

Then I just continued to add details to the final mesh, like muscles and veins. I used the Standard and Smooth tools, always with LazyMouse on. This helped me to get a nice, clean line. With this model I didn't have much time to work on the smaller details because I still needed to work on the final pose within the time I had left (Fig.08).

With this model I had few subtools, so I used Transpose Master, a ZBrush plugin. With this tool the software merges all subtools into the lowest level and creates a unique tool that you can use for posing. When I'd finished posing the model by using masks and the Rotate and Move tools, I just brought

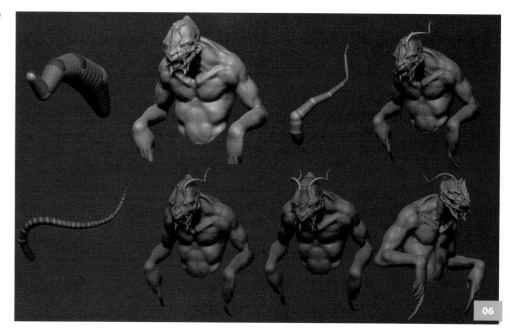

06

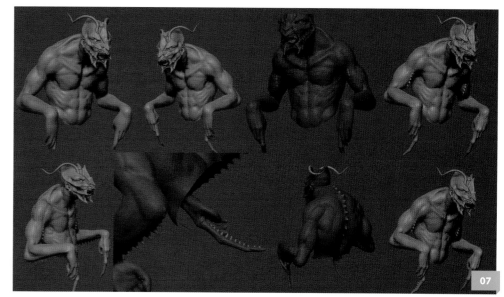

07

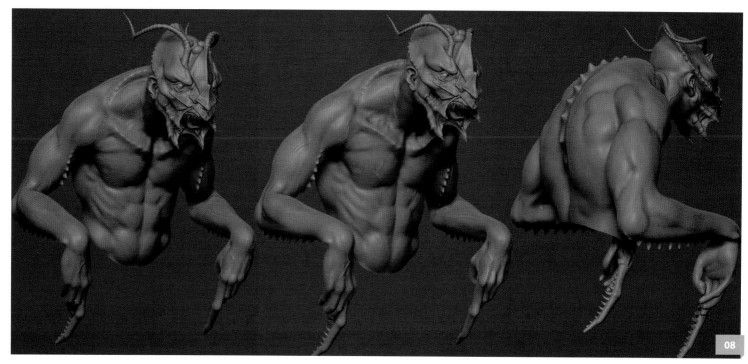

08

it back to the subtools and I had everything separated with their subdivisions restored (Fig.09).

For the final presentation I set the screen resolution to 3000 and made it half size – this helped a lot to clean the anti-aliasing. Then I created a render with one simple light and exported it as a TIF image (Fig.10).

I hope you enjoyed reading how I made this model; as it was a speed sculpt, I didn't have much time at the end to change any things that I didn't like about it. But I think that this is one of the best ways for modelers to study. Overall I spent three hours and thirty minutes working on the model, from the initial base mesh through to the end result.

You can download the bash mesh (OBJ) file to accompany this tutorial from: **www.3dtotalpublishing.com**.

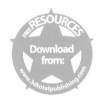

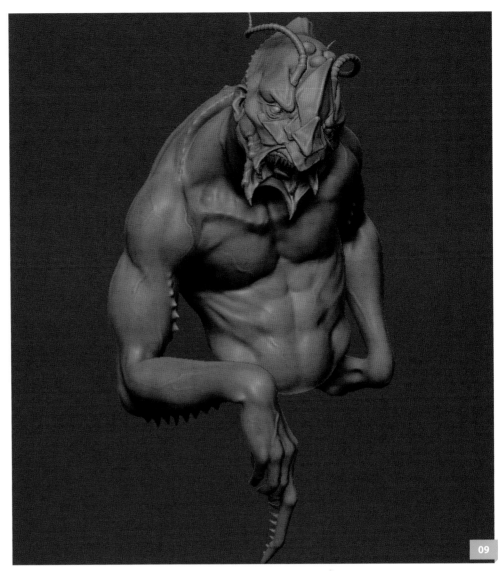

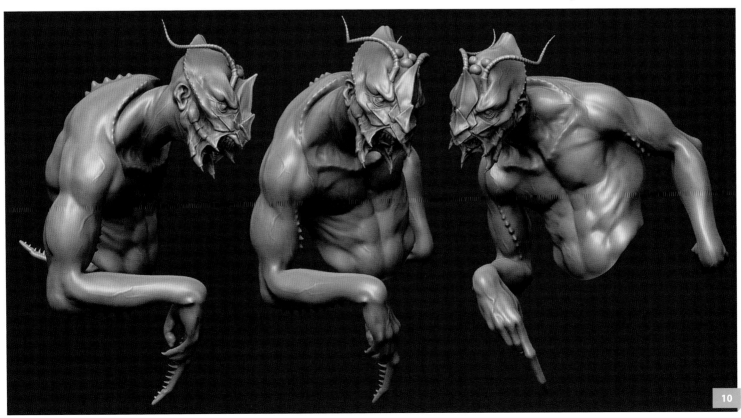

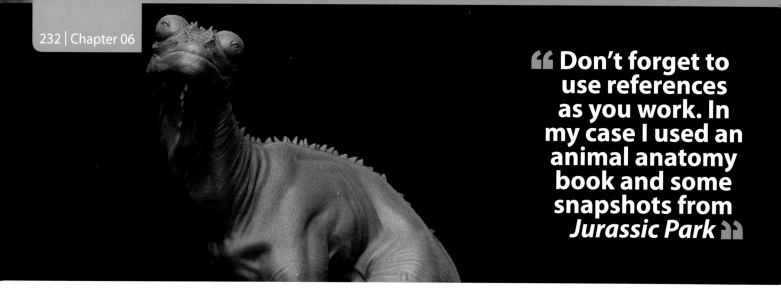

Fantasy Dinosaur By Diego Maia

The Sculpt

To begin I created a quick sketch in Photoshop to help me come up with a cool and interesting design. I didn't want to make an ordinary looking dinosaur, so I tried some different proportions and played around with the design of the elements a little (Fig.01).

Try to do some of your own studies before starting your modeling. This will help you to come up with interesting ideas and concepts that you may not have come up with otherwise. Avoid working without references; for this piece I used plenty of pictures of lizards and dinosaurs in order to create a realistic and original character.

Here is my base mesh from the front view (Fig.02) and in profile. I chose a suitable material and moved things around with the Move tool until I was happy with the proportions of the model (Fig.03). I always advise setting some shortcuts for certain tools that you use frequently whilst you sculpt in ZBrush, such as for the Standard, Move, Smooth, Flatten and Pinch tools etc. You simply have to click on the tool whilst holding Ctrl and pressing a number on your keyboard.

After getting close to the desired proportions for my character, I increased the level of subdivision and started finding the generic volumes using the Move and Standard tools. It's not necessary to worry about the small details at this stage (Fig.04 – 05).

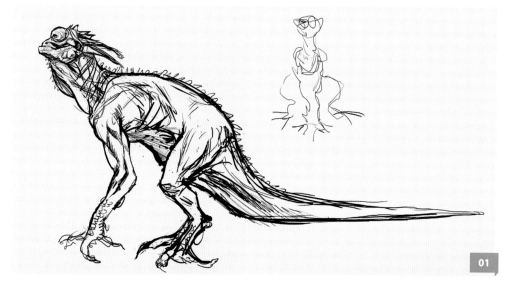

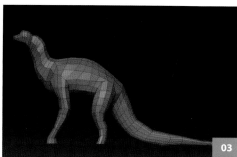

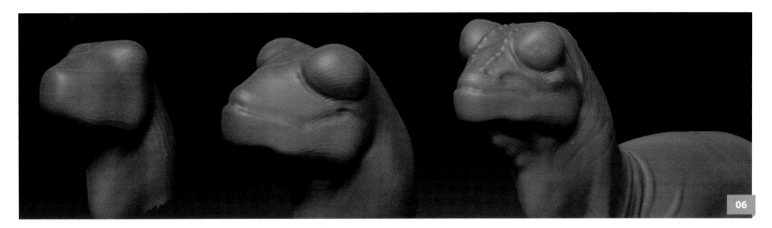

You can block out the forms of each part and hide the rest of the body. I was just using the Standard brush for this part of the process (Fig.06).

Don't forget to use references as you work. In my case I used an animal anatomy book and some snapshots from *Jurassic Park*. This simply helps you to create characters that look "real", so try to understand how anatomy works and it will help you with your modeling work and character studies.

The base mesh I started with didn't have any fingers or toes, so to create these I used the Snakehook tool and pulled them out from the base model (Fig.07). I used the same technique for the horns as well. Try not to use this tool if you're creating a character for animation though; just use it for quick sketches and sculptures like this.

At this stage, I was ready to start adding some skin folds and more detail to the body, as you can see from Fig.08, using the same tools as previously mentioned.

Once satisfied, I could then start to go in and really refine the character by adding extra detail. For the head I used the Snakehook tool again to create small bumps down the center of the face, and the Standard tool was used to draw the larger scale ones (Fig.09 – 10).

Here, I started to break the symmetry up in certain areas, adding to the believability of the character (Fig.11).

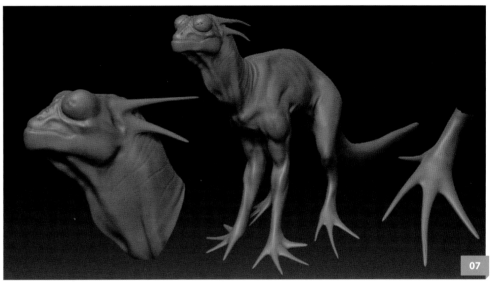

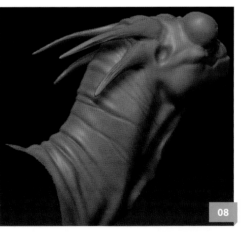

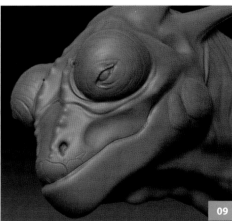

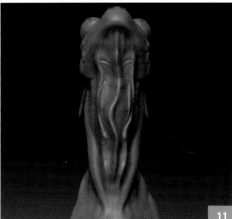

I also recommend trying out different materials on your model as you work, to give yourself a fresh view of the design and to look for any flaws in the sculpt (Fig.12).

At this stage of development I was defining each and every part of the model, as after this process came the sculpting of the final details (Fig.13).

To create the skin texture on the dinosaur I used the Standard brush (Fig.14). A good tip here would be to use the LazyMouse feature to assist you with your detailing – simply please L on your keyboard to turn the function on.

I wanted to add some scales at this point, and I did so using the Clay Tubes tool (Fig.15).

After sculpting as many details as I could within the six hour time frame allotted for this "speed sculpt", I imported some alphas and applied them to the model, using the Drag Stroke tool (Fig.16). You can, of course, create your own alphas in Photoshop, using some photographs of animals.

Here, I declared it to be the end of the sculpting process, but then swiftly decided that I wanted to make the dinosaur look a little more lizard-like and so added some spiky scales along his spine to create the desired effect (Fig.17).

And so, here is the finished dinosaur character (Fig.18 – 19). I hope you like it and that you've found something useful to take away from this tutorial. Thanks for reading.

You can download the bash mesh (OBJ) file to accompany this tutorial from: **www.3dtotalpublishing.com**.

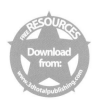

Featured Artists

Alexey Klimov
klimovart@gmail.com
http://jips3d.daportfolio.com

Andrei Cristea
andrei@undoz.com
http://www.undoz.com

Andrew Baker
androo.baker@gmail.com
http://andbakerdesigns.blogspot.com

Bruno Camara
bruno19bc@hotmail.com
http://bruno-camara.blogspot.com

Bruno Jimanez
br1.jimenez@gmail.com
http://www.brunopia.com

Bruno Melo
bmmsouza@gmail.com
http://bmelo.net

Cedric Seaut
cedric.seaut@voila.fr
http://www.khalys.net

Chen Ken
chenken326@hotmail.com
http://chenken.cghub.com

Christopher Moffitt
cmoffitt7@hotmail.com
http://www.chrismoffitt.com

David Moratilla Amago
dmoratilla@gmail.com
http://www.davidmoratilla.com

David Munoz Velazquez
munozvelazquez@gmail.com
http://www.munozvelazquez.com

Diego Maia
maia3d@gmail.com
http://maia3d.blogspot.com

Federico Scarbini
fede@federicoscarbini.com
http://www.federicoscarbini.com/wp

Filip Novy
info@filipnovy.com
http://filda.cgsociety.org/gallery

Frank Belardo
frankbelardo@gmail.com
http://chiselingpixels.com

Jose Alves da Silva
joalvessilva@netcabo.pt
http://www.artofjose.com

Marco Splash
marquo@hotmail.com
http://www.marcoplouffe.com

Mariano Steiner
marianosteiner@gmail.com
http://mastein3d.blogspot.com

Marthin Agusta
marthin84@yahoo.com
http://threedsquid.cgsociety.org/gallery

Michael Jensen
mikered@gmail.com
http://jensen.cgsociety.org/gallery

Park Gun Phil
kmcism@hotmail.com
http://www.oxcube.com/cgpark

Pedro Conti
pedro_conti@hotmail.com
http://www.pedroconti.com

Rafael Ghencev
rghencev@yahoo.com
http://rafaelghencev.wordpress.com

Rafael Grassetti
rafagrassetti@gmail.com
http://grassettiart.com

Raphael Boyon
raphaelboyon@gmail.com
http://www.bohemond.fr

Simone Corso
simocorso@gmail.com
http://3distortion.blogspot.com